· ·

Women and Film History International

Series Editors
Kay Armatage, Jane M. Gaines, and Christine Gledhill

A new generation of motion picture historians is rediscovering the vital and diverse contributions of women to world film history whether as producers, actors or spectators. Taking advantage of new print material and moving picture archival discoveries as well as the benefits of digital access and storage, this series investigates the significance of gender in the cinema.

A list of books in the series appears at the end of this book.

Universal
Women

Filmmaking and
Institutional Change
in Early Hollywood

Mark Garrett Cooper

University of Illinois Press
Urbana, Chicago, and Springfield

Library of Congress Cataloging-in-Publication Data
Cooper, Mark Garrett.
Universal women : filmmaking and institutional change
in early Hollywood / Mark Garrett Cooper.
p. cm. — (Women and film history international)
Includes bibliographical references and index.
ISBN 978-0-252-03522-7 (cloth : alk. paper) —
ISBN 978-0-252-07700-5 (pbk. : alk. paper)
1. Universal Film Manufacturing Company—History.
2. Women motion picture producers and directors—United States.
3. Women motion picture producers and directors—History—
20th century. I. Title.
PN1999.U57C66 2010
791.43023'30922—dc22 2009027087

For UFF-FSU

Contents

Acknowledgments

Grants from Florida State University allowed me to conduct the research for this book, which would not have been possible absent the resources of numerous archives and the amazing professionals who staff them. I thank the Margaret Herrick Library of the Academy of Motion Picture Arts and Sciences and especially Barbara Hall, whose generosity and wisdom benefited the project throughout its gestation, Kristine Krueger, and Lea Whittington; the Los Angeles Public Library; the Special Collections Department of UCLA's Charles E. Young Research Library, especially Octavio Olvera; the Seaver Center for Western History Research, particularly Betty Uyeda and Beth Werling; the Pacific Region U.S. National Archives in Laguna Niguel, especially Lisa Gezelter (and I would like to thank G. Russell Overton for his advice on navigating that collection); George Eastman House; the Museum of Modern Art, particularly Charles Silver; the Library of Congress and especially the indefatigable Madeline Matz and Rosemary Hanes; the British Film Institute, particularly Kathleen Dickson and Vicky Hedley; the National Archives of the United Kingdom; the British Library; the Centre National de la Cinématographie, especially Eric Le Roy and Sandra Larrosa; the Amsterdam Filmmuseum, particularly Elif Rongen and Ronny Temme; and the Swedish Film Institute, especially Jon Wengström and Magnus Rosborn.

In addition to these public archives, three experts on Universal's early history generously shared their insights and personal collections. Richard Koszarski allowed me to invade his dining room for a day of research interrupted only by an excellent pastrami sandwich. Robert S. Birchard and Marc Wanamaker each generously provided me with materials and advice. I hope they will recognize something of their Universals in my account, but in any

case, it would not have been possible without them. I did not have the opportunity to speak personally with Anthony Slide, but I would like to express my gratitude for his pioneering work on the Universal women and for generously depositing his research materials with the Herrick Library, where I consulted them. I am grateful to Jan-Christopher Horak for sharing his knowledge of Universal's record-keeping habits.

In my travels, Mark McGurl, Jasmine Alinder, Aims McGuinness, Brad Macomber, Nicole Ritchie, Michael Ting, and Stephane de la Rue du Can not only provided homes away from home but also helped me figure out where the research was heading. Cathy Jurca very graciously did this more than once. I thank them all.

From start to finish, the project has drawn inspiration and guidance from the biennial conference on Women and the Silent Screen. Although I did not attend the inaugural 1999 conference, "Gender and Silent Cinema," organized by Annette Förster and Eva Warth in Utrecht, I have followed friends and collaborators from Santa Cruz to Montréal, Guadalajara, and Stockholm. The organizers of and participants in these wonderful conferences have my gratitude. I would particularly like to thank Jane Gaines, who provided crucial research leads and enthusiastic encouragement throughout; Kay Armatage, for her generous and insightful readings of the manuscript at two different stages of completion; Shelley Stamp, for graciously sharing her investigations of Lois Weber and proving an invaluable interlocutor as I have sought to piece together this story; Denise McKenna, for her pathbreaking work on labor relations in early Hollywood; Jennifer Bean, for unearthing remarkable information about early Hollywood studios; Karen Mahar and Giuliana Muscio, for generously sharing work-in-progress; Leslie Midkiff DeBauche, for her insights into early motion-picture advertising; and Jennifer Horne, Mark Lynn Anderson, and Richard Abel, for an array of insights too vast to map here.

Early in the project, several of my former colleagues at Florida State University nurtured my interest in institutions. Ralph Brower, Jack Fiorito, Edward Gray, Patricia Martin, Robert Schwartz, and Phil Steinberg each contributed to the first framings of the project from the perspectives of their different disciplines. Many of these colleagues also belonged to my union. In addition to extending my scholarly network outside my discipline, union involvement provided many practical lessons in how organizations work. In both ways, this is a union book. I owe special thanks to Irene Padavic, who not only

took the time to guide my forays into social science but also gleefully shredded early drafts. I am grateful, too, for the steady advice and provocations of my redoubtable friends in the English department: Barry J. Faulk, Robin Goodman, and Ralph Berry. Ralph provided an especially pivotal reading of what became the first chapters. Chris Sekulski assisted me with the research in early days, and I thank him for it.

On occasions too numerous to list, Jennifer Ting contributed her expertise as a researcher and her insight as a filmgoer to the project. I will single out but one example. As investigations were drawing to a close, she heroically gave up her weekends to help me make several last forays through the microfilm. That was fun.

I believe John Marx may have suffered less with this book than he did with my first. When I note that there is not a sentence here for which he could not claim partial credit, therefore, I have some hope that his sense of accomplishment might overwhelm his sense of relief at having it off his desk. Thank you, John.

The book benefited tremendously in its final stages from a careful reading by Heidi Rae Cooley, who also found in it the beginnings of my next project. Stay tuned.

An early version of part 2 appears in the *Quarterly Review of Film and Video* 25.1 (2008) as "Studio History Revisited: The Case of the Universal Women."

Preface

A Puzzle, Some Premises, and a Hypothesis

This book describes how institutions transform the possible into the all-but impossible. It tells the story of how the Universal Film Manufacturing Company, arguably the most enthusiastic employer of women directors the U.S. film industry has ever known, decided that women should no longer direct. The company reached this decision by the end of 1919 and made it during a time of important changes in the U.S. film industry and the world at large. Scholars of American modernity often mark 1920 as the end of a period of intense social, political, and economic transformation than began around 1880.[1] By 1920, too, filmmakers had developed the type of film that became familiarly known as "a Hollywood movie" along with the industrial apparatus necessary to produce, distribute, and exhibit that type of film globally for profit.

Universal's participation in these changes informed its gendered division of labor. Accordingly, the transformation of possibility into impossibility cannot be understood merely as a foreclosure. It enabled a new configuration at the expense of an older one—new types of films, new sorts of business organization, and a new sense of audience. When Universal banished its women directors, it simultaneously participated in broader cultural and industrial changes and redefined itself. This book describes how a particular division of labor was instituted, made regular by and within the corporate movie studio. In the process, it strives to explain what it means to conceive of the Universal Film Manufacturing Company as agent and object—an entity that, like all institutions, acts and also forms the setting for action. But that gets ahead of the story.

The Puzzle

From its inception in 1912 through 1919, the Universal Film Manufacturing Company thought women might make excellent directors. The studio credited eleven women with directing more than 170 films during these years, and its publicity department trumpeted their successes. The superstar Lois Weber accounts for most of the pre-1916 credits, but beginning in 1916 Universal created something of a pipeline. It attributed at least nine titles each to the supervision of Ruth Ann Baldwin, Cleo Madison, Ruth Stonehouse, Elsie Jane Wilson, and Ida May Park. Evidence suggests that these women and others, such as the serials star Grace Cunard, actually directed more often than official credits indicate.[2] Even allowing for an undercount, however, women directors amounted to a small proportion of Universal's total when considered in absolute terms. Yet, in relation to historical figures, their proportion is significantly larger. At their most numerous in 1917, eight out of 113 named Universal directors were women (about 7 percent), and Universal credited them with slightly more than 6 percent of its films.[3] Overall, the average of titles credited to women for the years 1916–19 is lower, about 4 percent. Intriguingly, however, women were concentrated in feature films, as opposed to the large volume of shorts and serials Universal released. In the same three-year period, the studio assigned 12 percent of its Bluebird brand feature films to the direction of women. In the 1990s, Directors Guild of America statistics demonstrate, the industry paid women to direct between 7 and 9 percent of the days worked in film production.[4] Martha Lauzen's survey of credits shows that early in the twenty-first century the proportion of woman-directed titles declined from an anomalous high of 11 percent in 2000 to 5 percent in 2004 and had rebounded to 6 percent in 2007.[5] Allowing for variations in the way work has been organized and irregularities in the way it has been recorded, one can safely say that during the 1910s Universal's record of crediting women directors exceeds the historical industrial average and argue that it exceeds the average for feature films by a substantial margin.

Habits change. In 1919, Universal credited five feature films to women directors. The following year, for the fist time in its history, it credited not a single title to a woman. With the sole exception of Weber, who returned to supervise three features in the mid-1920s, the studio did not name a women director again until 1982, when Amy Heckerling made *Fast Times at Ridgemont High*.[6]

The change certainly seems decisive, yet it is far from clear who decided or

how a decision to change was made. Apart from a few chance survivals, internal company documents are inaccessible, lost, or destroyed. The studio's in-house newspaper, the *Universal Weekly*, gives no indication of a shift in employment policy. Other trade publications announced the individual departures of the Universal women and continued to follow a few of their careers. Which is to say, their collective disappearance was not noticed until well after the fact.[7] Surviving scraps of private correspondence provide little insight. With a few exceptions, it is unknown whether the members of the initial cohort were fired, left directing for personal reasons, or sought better opportunities elsewhere. This last possibility might seem unlikely in retrospect, but it is well documented. For instance, Park's 1920 entry on "moving-picture director," written for the advice volume *Careers for Women* around the time of her departure from Universal, confidently describes directing as an "open field" for women who are "hardy and determined."[8] Park might have found reason for optimism in the large number of smaller companies then headed by women.[9] In any case, while it is clear that Universal effectively closed the door to women directors by 1920, we will almost certainly never know whether any of the many individual participants in this historical change foresaw it.

Given the nature of available evidence and the lack of a distinct culprit, it is tempting to class the entire phenomenon as one of history's many insoluble mysteries, a product of contingencies too numerous and choices too poorly recorded to submit to a plausible narrative of cause and effect. And so it would be, if not for the web of connections linking changes at Universal with the evolution of the industry in general.

Put simply, the Universal women flourished during the decade that called "Hollywood" into being. They were among the filmmakers and businesspeople who assembled, in rough outline, the ensemble of practices and the cultural geography bearing that name. Granted, there have been major revisions. Nonetheless, a number of Hollywood's defining characteristics congealed in the 1910s. Most importantly, the decade established the feature-length film as the industry's primary product, a change that made weekly programs of one- and two-reel films obsolete. Secondly, now-familiar lines separating a variety of filmmaking occupations were established, along with a hierarchy relating them; for example, the producer's role was distinguished from that of the director and the screenwriter. The star system developed, with all that it entailed for the production, marketing, and consumption of movies. Finance

capital became seriously interested in the industry, which in turn adopted business practices developing within the corporate sector more broadly. Finally, the Los Angeles area displaced rivals such as Chicago; Philadelphia; Fort Lee, New Jersey; and Jacksonville, Florida, as the center of U.S. film production for a global market.

Universal led the industry in some respects and trailed it in others. The "Big U" was unarguably a pacesetter when it opened its huge, state-of-the-art facility at Universal City in 1915. A decade later, however, the studio had acquired a reputation for being outmoded. President Carl Laemmle, the legend goes, made two miscalculations. First, he was slow to invest in theaters, a move that relegated Universal to "minor" status as a producing and distributing firm through most of the 1920s. Second, he continued to market a weekly shorts program to smaller theaters while the rising industrial powers, led and emblematized by Paramount–Famous Players–Lasky, emphasized big-city premiers of select feature films. Nepotism is said to have compounded both errors; "Uncle Carl" liked to find jobs for his relatives.

While not without foundation, this explanation of Universal's change in fortune is misleading to the degree that it casts the company as a relic of an earlier, less businesslike age.[10] True, Universal outlasted other major brand names of the early 1910s (such as Vitagraph, Selig, Lubin, Essanay, Mutual, Biograph, Triangle, and Thanhouser). It did so, however, not by maintaining the status quo but by developing the type of bicoastal business organization that would come to define the studio era. From New York City's Mecca Building, Universal's senior administration planned national advertising campaigns and coordinated production at Universal City. There, according to a 1916 report, some 1,500 persons cranked out 150,000 feet of film per week. By year's end, this amounted to 914 films released, over one hundred of them feature-length. The City's general manager supervised a complex hierarchy including screenwriting and other support departments. In addition, he oversaw forty producing companies, each of which comprised a director/producer, assistant director, property man, leading actor and actress, and miscellaneous cast members.[11] In so organizing production, Universal helped pioneer the role of central producer, which remained a standard position through 1930.[12] And although Universal came late to the table in buying U.S. theaters, it was an early mover in international markets, cultivating distribution circuits as well as theater holdings abroad.[13] In key respects, Universal was not so much the last of the old movie businesses as the first of the new ones.

Other firms of the 1910s that grew to become majors in the 1930s—Paramount, Metro-Goldwyn-Mayer, Fox, and Warner Bros.—assumed that directing would be men's work, and the business historian Karen Mahar argues persuasively that the increasing influence of finance capital, necessary for the creation of the giant producing-distributing-exhibiting firms, played a central role in more clearly gendering the occupation. It is well known that, industry-wide, women found more opportunities to direct before the mid-1920s than they did from that point until the 1970s.[14] Mahar shows that vertical integration proved especially lethal to the remarkable numbers of independent and semi-independent firms headed by women in the late 1910s and early 1920s. At the same time, industrial standardization tended to rigidify work roles, limiting the ability of actors and screenwriters to move into directing and thereby closing the professional road most early women directors had traveled.[15]

The case of Universal plainly shows, however, that to attribute a shift in the gendered division of labor simply to the triumph of big business risks oversimplifying that transformation to the point of mystifying it. Universal *was* a big business in the 1910s; it helped develop professional specialties; and nonetheless its practice of promoting women to the director's chair distinguished it from its contemporaries. Vitagraph, its nearest rival among the larger studios, credited perhaps three women as director.[16] Nor did the structure of Universal's business change fundamentally when the studio closed its doors to women directors in 1920. Thus, the case of Universal suggests that the connection between the growth of the film business and the establishment of a particularly gendered division of labor was not inevitable, and this difference makes the puzzle of its women directors impossible to set aside. Here is the test case, the exception through which we might better understand what made the rule.

Thanks to decades of historical research, it is possible to exclude several hypotheses that, singly or in combination, might have accounted for Universal's peculiarity. First to go was the claim of Carl Laemmle's 1931 biographer, John Drinkwater, that the phenomenon derived from the founder's "revolutionary suffrage."[17] In his 1977 *Early Women Directors,* Anthony Slide set the tone for subsequent investigation by doubting Laemmle's "concern for women's rights" and seeking an explanation grounded in business sense.[18] Appeals to Laemmle's beneficence also pose a problem for explaining why Universal stopped hiring women directors after 1919, when he remained at the helm.

Slide speculates that Universal, facing a labor shortage given the number

of films to which it was committed, found it easier and cheaper to promote women from within than to recruit men from outside. The lack of reliable comparative salary and employment data makes this proposition difficult to confirm, and it is called into question by Richard Koszarski's observation that Universal "was certainly not the only cheap studio in town."[19] Moreover, at least two of the directors, Cunard and Weber, were highly paid by industry standards.[20]

The historical record also emphatically rules out the hunch that the Universal women directors replaced men called to war. The upward trend in women's director credits precedes the signing of the Selective Service Act in May 1917, and they continued to win directing jobs after the studio slashed production later that year in response to a wartime tax on entertainments and the declining popularity of its shorts program—a fact that further troubles the hypothesis that Universal turned to women simply to meet production quotas.[21]

The timing of the women's departure coincides a bit better with the extension of the franchise via the Nineteenth Amendment, which was proposed in June 1919 and ratified in August the following year. Yet the theory of a backlash inspired by impending or accomplished ratification finds no support in existing documentation. More notable is the upwelling of corporate enthusiasm in 1913 for the fact that its female employees could vote in California. (Male voters there extended the franchise by referendum in 1911.) Suffrage struggles encouraged the phenomenon of woman directors far more than they thwarted it.

Finally, an early professional association of directors (the Motion Picture Directors' Association [MPDA]), while clearly a "boys' club," was not organized enough to have played a decisive role in shaping employment practices at Universal, or indeed at any other studio. The MPDA lacked formal mechanisms to encourage the hiring of its members or to compel wages and working conditions, and although the association probably did give definition to the emerging profession through its network of personal relationships, it is not clear that women directors were outside that network. In 1923, for example, the nominally all-male MPDA listed two of the Universal women, Park and Weber, as "honorary" members, and *Motion Picture News* reported Weber as "the only woman member" in 1917.[22]

Universal plainly had more substantial, or at least more complex, reasons to promote women directors than a mere quest to cut costs or to overcome a labor shortage. The most potent explanations for the phenomenon of early

women filmmakers in general presuppose that it had something to do with how the culture understood "women" and refer us to the shifting and often contradictory terrain of early-twentieth-century gender roles.

Mahar, for example, notes a concentration of women directors in serials and short comedies, on the one hand, and feature-length social-problem films, on the other hand. Developing the work of cultural historians and film scholars, she associates serials and comedies with the figure of the New Woman and points us to the contemporary fascination with that independent, mobile, public, and sometimes unruly figure. The social-problem film participates in related but distinct contemporary discussions that sought to specify women's social authority. For example, in their address to viewers they tested the proposition that the moral influence of the nineteenth-century middle-class woman could be extended outside the home. For Mahar, Progressive Era contests over the meanings of "women" thereby complement a flexible division of labor (inherited from the theater) in encouraging women directors. Accordingly, finance capital had a cultural collaborator in banishing the women in the form of the postwar consensus that transformed the Progressive Era's version of the New Woman into a flapper. This change established that "women" were better understood as consumers and as men's sexual playmates than as globetrotting adventurers or uncontainable comic bodies. Meanwhile, on a slightly different schedule, courts, filmmakers, and a number of institutions and pressure groups concerned with regulating cinema's effects joined forces to develop the consensus that movies should entertain rather than polemically engage social problems.[23]

I fully agree that we will not understand the film industry's gendered division of labor until we appreciate the uncertainty that accompanied pronouncements about women in the 1910s and attempt to grasp how that uncertainty translated into attempts to address an audience. Nonetheless, the trends Mahar finds at the scale of the industry as a whole are of limited help in understanding developments at Universal. From the outset, Universal's women were far better represented as directors of short dramas and Westerns, for example, than they were as directors of serials and short comedies. Moreover, corporate efforts to capitalize on the success of Grace Cunard's and Francis Ford's serial *Lucile Love, Girl of Mystery* (1914) notably refused to cultivate the kind of professional partnership its codirecting costars exemplified. Nor does the social-problem film correlate particularly well with women directors at Universal. After 1917, when Universal's production of feature films credited

to women was at its peak, the films women directed were more likely to address other women as consumers interested in getting or keeping a husband than to address them as agents or objects of social reform. Again, Universal exhibits exceptional qualities when set against the trend. This suggests that there may yet be something to learn about how the trend developed.

We do not know why Universal cultivated an unusually high concentration of women directors and then dramatically reversed course. We do not understand how those decisions were made, nor do we exactly understand the "who" or "what" that appears to have made them. The fragmentary nature of the available evidence only partly explains our lack of understanding. If Universal presents us with a puzzle not visible at the scale of the industry or culture, it may be because historians have tended to understand the former in terms of the latter. That is, Universal looks peculiar precisely because we understand the normal course of history in particular ways—e.g., as "cultural"—and perhaps above all because of the sense of inevitability, even naturalness, inherent in the observation that Hollywood's success, as a business and as a form of mass culture, has both required and reproduced sexism. To take the institution seriously as an institution, we ought to abandon the twin assumptions that industrial developments and the resiliency of patriarchal culture suffice to explain it. Only in this way, it seems to me, can we hope to pursue the mystery of the Universal women as a phenomenon capable of revealing the possibilities of history rather than as a mere oddity that confirms a trend.

Premises

If prospects for women to direct were about as good—which is to say, just as bad—at Universal in the early days as they have ever been, sexism certainly seems to be to blame. In which case, there could be a number of reasons why powerful men might allow a small number of women to exercise authority over others, and it might be interesting to figure out what these reasons were. But surely we would need no book to explain their change of heart. The rising prestige and capitalization of the film industry during and after World War I must have made directing seem an increasingly important and risky occupation. Men at the top would have turned to directors they considered reliable, hardworking, and able to command others: no one would be surprised to learn that men like themselves appeared to fit the bill better than the handful of

women they had recently promoted. Sexism abides, this story tells us; why make a mystery of it?

There are a few good reasons. If, for instance, the term "sexism" subsumes all distributions of authority favorable to men, it does not follow that it names the same types of relations at all times and places. Still less does that classificatory feat serve, in and of itself, to prove the existence of a continuous force in history or to demonstrate that such a force, if it exists, has a necessary relationship with other forces such as the profit motive. Divisions of labor in the 1910s and in the 2010s might both be sexist and yet pose very different challenges for those seeking to transform or maintain them. Finally, to understand sexism as a puzzle is to deprive patriarchal culture of its sense of inevitability. It is to acknowledge that gender has a history and therefore a future, and it also reminds us of the contingency that dogs any historical explanation: no matter how pellucid the unfolding of causes and consequences, events might have gone otherwise. For this reason, as Joan Wallach Scott explained in 1986, the late-twentieth-century emergence of gender as an analytic category was one aspect of a more general epistemological upheaval that also called the nature and value of historical inquiry into question.[24]

I aspire, in part, to cultivate an appreciation of the possibilities that attended early-twentieth-century gender formation in the United States. As we now know it, this history was thoroughly entwined with the manifold changes composing turn-of-the-century modernity. Four vectors of transformation merit particular mention.

First, beginning in the 1880s, the rise of a professional managerial class reconfigured class relations more broadly and gender relations along with them, altering the dynamics of social mobility and revising the domains of family and work.[25] Emphasis on professional qualification through training and merit opened professions to women, and the percentage of employed professional women in the United States increased from 8.2 percent in 1900 to 14.2 percent in 1930.[26] This openness was relative and produced new forms of distinction: feminized professional specializations (such as nursing and social work) and, within masculine professions, tokenization and limits on mobility (the glass ceiling). The growth of the white-collar sector also entailed the feminization of clerical work and produced the modern business enterprise as a newly problematic arena of courtship (which became "dating"), so that in practice the regulation of labor, of kinship, and of erotic life were closely related at the office.[27] To the extent that such places as colleges and office

buildings became marriage markets, and to the extent that professionalization dissociated authority from inherited wealth, the process of class reproduction was disconnected from the traditional domains of family and community. At the same time, for women of all classes marriage no longer meant giving up, or avoiding, paid work. By 1890, the proportion of married women working for wages outside the home had begun its long, unsteady, upward climb—that is, the start of a general uptrend is discernable, although the decades that follow witness periods of reversal as well as of gain.[28]

Second, by the time the Nineteenth Amendment finally enfranchised women in 1920, a politics of feminism had emerged as something other than a campaign for "women's rights" or "women's suffrage." This development can be regarded as both a symptom and a cause of major changes in the polity and its imagination of the relationship between public and private. The innovation of a movement called "feminism," as the historian Nancy Cott explains it, was to name "a set of principles not necessarily belonging to every woman— nor limited to women."[29] Such principles could articulate an individualist politics focused on women's demands for sexual freedom or fair treatment at work, or they could call for a sweeping social transformation that would eliminate all prescribed gender roles. Politics thus indicated a territory both narrower and broader than that of the state—a change often described as its "culturalization." In this shift, to speak "as a woman" remained a meaningful political gesture, but that gesture alone did not suffice to define a community of interest. Differences within the category of "woman" posed new political problems, and so too did the difference between persons encompassed in the terms "men" and "women," as the ideology of separate spheres became a residual formation.[30] Although the association of women with domestic space persisted, it no longer distinguished political from moral authority.

Third, the rapid growth and expansion of commercial mass culture proliferated images of women and also addressed them as ideal consumers. Without ceasing to strike commentators as "new," the New Woman received periodic updates between the 1880s and the 1920s. The historian James Livingston aptly identifies the 1920s version as an "emblem and agent" of consumer culture.[31] No mere economic figure, this New Woman condensed a problem of desire and how to manage it: in her vicinity, commodities tell a tale of sex.

Fourth, to understand what made this figure's agency seem so emblematically new, it helps to place her in the city. Turn-of-the-century fiction and visual culture made certain types of women seem endemic to America's

booming metropolises, especially New York and Chicago. Unaccompanied, but not necessarily unrespectable, they linger on the sidewalk to gaze through the plate glass, or else they work behind the department-store counter. Their movements and aspirations are encouraged, but also limited and imperiled, by the shocking speed, scale, and anonymity of urban life. These women might come from the city or, more likely, travel there. Cities were also destinations networked to the rest of the nation, indeed the globe, by railroad, steamship, and telegraph. Any number of writers, filmmakers, and artists collaborated to make the woman consumer emblematize this entire state of affairs. The shopper moves through and lingers in public spaces. She looks and wants. While the gazes of passing men treat her body as if it too were a commodity, the city also arranges a countersurveillance designed to insure that these impolite looks remain just that. In short, through successive revisions, the independent mobility of America's New Woman evoked the astonishing and novel circulation of persons and goods made possible and required by urban modernity.[32]

Universal's 1913 film *Traffic in Souls* aptly illustrates this configuration when it demonstrates how easily women who enter the legitimate urban traffic flow might find themselves diverted into the illegitimate traffic of the white slave trade. It does so, as Kristen Whissel explains, to assert that the two sorts of traffic can and must be distinguished by the vigilance of the police, new and better technologies, and women themselves, if they are savvy and alert.[33] The city, which offers women new freedoms of movement and choice, also presents novel dangers and lures: thus the need for new forms of regulation, in which state apparatuses collaborate with self-discipline.

Although accounts vary in describing precisely how and when norms changed, the broad outlines of a shift are clear enough. By the 1920s, the incitement to desire modulated by commodified leisure activities had redefined the normative heterosexual union of the 1880s. Marriage acquired a new sexual preamble in the form of dating, which helped create the expectation that wives and husbands both would find sexual satisfaction in their union.[34] "Have fun!" became something of a cultural commandment, one that entailed new responsibilities along with new pleasures for men and women alike.

The movies surely ranked among these new pleasures. It should come as no surprise, then, that feminist film historians would be among the most adroit chroniclers of the new century's revision of womanliness.[35] Two pronouncements from this rich field of inquiry are particularly telling. Lauren Rabinovitz concludes her study of moviegoing in turn-of-the-century Chicago with the

observation that cinema "invited women to find pleasure in their bodies and experience unrestrained passions while it simultaneously constructed them as the object of (male) desire and of immature emotions that need to be tamed and controlled." Thus, she argues, consumer culture encouraged female desire so that it could be made useful for capitalist patriarchy.[36] Janet Staiger winds up her study of women's sexuality in U.S. cinema through the mid-1910s with the observation that (that decade's) New Woman was an object of intense investigation by middle-class commentators (including women) too numerous to agree on a comprehensive definition: "Who a woman is was by no means settled," she underscores.[37] Taken out of context, these two propositions could be construed as opposites, with Rabinovitz positing the durability of patriarchal control and Staiger insisting on its openness to change. Yet Rabinovitz plainly aims to describe as new the bodily habits women acquired while learning to see and be seen in the city, while Staiger is every bit as aware as Rabinovitz that whoever the New Woman was, she did not participate in public or private life on terms equal to men. Although they agree that "sexism" remains a relevant term, recent histories unite in presenting the sexism of the 1920s as qualitatively different from the sexism of the 1880s.

The relationship between gender and power changed. By 1920, the privileges men might expect simply because they were men differed from those they could have expected as little as two decades before. For many women, gender must have seemed less determinative of where one could go and what one could do—if no less determinative of how one was expected to conduct oneself in those locations or occupations. These changes entailed more than a revision of gender ideology; they contributed to and were shaped by a sweeping shift in the whole terrain of power relations, from the management of economic process to the character of public space and the constitution of political power.

Like the range of histories on which it draws, my summary of these changes rejects the proposition that a body's sex determines a person's authority. It always takes a bit of explanation to get from the fact that men do not bear children, or may have a certain brain chemistry, to the proposition that they are better fit to rule, manage other people's money, or direct films. I am among those who think such explanations more determinative than the biological facts called upon to support them.[38] "Gender" in this sense names a principle through which "culture" categorizes various bodies, relates those bodies with practices, and in the process distributes authority.

Whereas I put gender in quotation marks above to indicate that I am defining the term, the marks around "culture" are meant to underscore the concept's insufficiency with respect to the case at hand. Cultural change will not explain what made Universal different. To solve the mystery, we must attempt to take the institution on its own terms first and then relate it to broader assemblages. As a case study, this book works out what it means to "take the institution on its own terms." The immediate task is to explain what leads me to suppose that such an enterprise will disclose anything worth knowing about gender's changing relation to work.

In the abstract, it is surprising how little the observation that gender has a history tells us about what it means for gender to change. In other words, whether the developments I just surveyed really mattered or can be shrugged off with a "plus ça change . . ." is not only an historical question but also a theoretical one. In fact, the assertion of gender's historicity can predicate diametrically opposed accounts. For example, the rejection of a biological determinism could lead me to deem inconsequential any alteration that preserves an essentialist explanation. By those lights, I would be forced to say that no significant change occurred at Universal, or in U.S. culture more broadly, during the 1910s: most places one looks, the difference between men and women seems fundamental. Alternatively, I might be expected to measure progress toward an eventual goal of gender parity. Here the problem is not that gender abides but that it determines a distribution of power. My opening gambit suggests this form of argumentation when it expects readers to be intrigued by Universal's early interest in women directors and provoked by the industry's failure to make much progress when it comes to hiring them. I could be read to imply that the problem of sexism would be "solved" if women director's credits reached 50 percent. No doubt, it would be gratifying to see the day. But it would be perilous to assume that such a set of affairs would necessarily abolish the bad faith that conflates merit with masculinity. Moreover, the very metric of equality would have enshrined an ideal configuration of genders—in which there are only two—as a kind of second nature.

Among those urging us to suspect such an ideal, Judith Butler has perhaps been the most successful in providing an alternative conception of change. Defining the gendered binary as a regulatory norm, Butler develops a line of argument that begins with Michel Foucault and extends through Mary Poovey, François Ewald, and Pierre Macheray.[39] These thinkers strongly distinguish norms from laws. Whereas the law distinguishes the permitted from the for-

bidden, norms thrive on comparison: they do not punish violations so much as measure and regulate degrees of deviance. Thus, while one might break the law, it boggles the mind to consider "breaking" the norm. As Butler puts it, "The norm governs intelligibility" so that deviance and abnormality are liable to increase the authority of the norm qua norm. Whenever we assume that the difference between "man" and "woman" exhausts the options—no matter how good or bad at being men and women we consider ourselves or others to be—we perform "a *regulatory* operation of power that naturalizes the hegemonic instance and forecloses the thinkability of its disruption."[40] This regulatory operation is very difficult *not* to reproduce.

Nonetheless, although the norm cannot be violated like a law can, it does not vacate the possibility of a different future because of the manner in which the complexity and unpredictability of human practice subtend it. Unlike laws, established through feats of sovereignty, norms stem from interpretations of practice. Practice is what the norm regulates and the field from which it derives its intelligibility and force. Thus, Butler insists, we ought not regard gender as something imposed on our practices from the outside—even if it can seem that way at the doctor's office, in the classroom, or at the movies. Rather, "As a norm that appears independent of the practices that it governs, [gender's] ideality is the reinstituted effect of those very practices." Butler envisions a process in which a variety of ways of acting like a man, a woman, or someone who does not quite fit either category gives rise to a convention that makes a particular distinction between "a man" and "a woman" supremely meaningful and defines conduct in relation to that ideal. This insight leads her to two closely related points. She proposes, first, that "the relation between practices and the idealizations under which they work is contingent"—it is not determined in advance by natural or philosophical necessity but depends on a particular historical conjuncture—and, second, "that the very idealization can be brought into question and crisis, potentially undergoing deidealization and divestiture"—so that practice might be regulated differently (or perhaps not all, insofar as it is possible to conceive regimes of social power other than that of the regulatory norm).[41]

This book is most explicitly concerned with the relation of two sorts of practices: gender and making movies. Part 1 begins by describing a moment in which movie making led, if not to the "deidealization and divestiture" of the gendered binary, then at least to a playful attitude toward it that was replete with that potential. Part 2 describes how gender's ideality was

reinstituted in and through the division of movie-making labor. Contrary to Butler, I see the latter moment as more interesting. This is not because I am committed to an idealized gender binary (quite the contrary!). Rather, my greater concern with the moment of gender's reinstitution derives from the insight that the case of the Universal women is, precisely, institutional in character, that it therefore has something to teach us about how institutions work, and that changes to larger-scale phenomena like the industrial division of labor or film genre might be profitably considered at the institutional scale. If the movement from institutional possibilities to the institution of a limit described herein looks like more or other than simply the reinstitution of the gendered binary, it will be because the content of that binary changes in relation to new sorts of work. It seems to me that to notice such changes improves prospects for future play.

I understand "institution" a bit differently than Butler does. In *Undoing Gender,* the verb "to institute" designates a moment when an ideal comes to regulate practice. By this Butler means not only "to establish" in the sense of to stabilize and ensure the reproduction of but also, in a Foucauldian sense, to exist in and through specific disciplinary apparatuses, such as medicine and sexual-harassment codes. This Foucauldian model implies, but does not well describe, the institution in which I am interested: a place where people work and where the organization and regulation of their work also constitutes an object of interpretation for them. In truth, such institutions are more commonly encountered in the work of social scientists than humanist historians and film critics, but they are not entirely foreign to the latter. The definition of "institution" just offered, for example, can be derived from thinkers working independently in either area, and I propose that there exists a much greater contiguity of concern among social scientific and humanist inquiries than is customarily acknowledged.

Because of its interdisciplinarity, my argument develops from a set of premises that may not be entirely familiar to all readers. The "gendered division of labor" here is not the sexual division of labor Engels found in the family, although it is doubtlessly a descendant. It is more directly indebted to historians and philosophers such as Scott, Butler, and Denise Riley. It also bears a debt to a landmark work of feminist sociology that many humanists have never read: Rosabeth Moss Kanter's 1977 *Men and Women of the Corporation.* Kanter demonstrates that the stereotypical "problems" of women in management stem from the fact that corporations often give women nominal authority

without substantive organizational power—a state of affairs perpetuated by the very stereotypes it generates.[42] In any case, from such diverse sources I adapt the following points of departure:

» Gender is an analytical category such that it makes sense to ask how, when, and to what degree occupations are gendered.
» Gender is also an historical category. It has been possible for historians to show that the meanings of "man" and "woman" have changed and to question the ability of those terms to explain human conduct in particular times and places.
» Gender's relation to practice is best grasped as that of a regulatory norm. Norms are institutionalized interpretations of practice.
» This activity occurs concretely in large business organizations such as the Universal Film Manufacturing Company, so that we can expect to find Universal's constituents interpreting their own practices and instituting or reinstituting the gender norms that regulate them. Of course, not all of the company's constituents will be equally empowered to do this, but more importantly, even the most powerful will be constrained by the field of practice he seeks to explain and by precedents for interpreting it (including the precedents that establish this "most powerful" actor as a "he").

Hypothesis

I propose, first, that researchers have not discovered how and why Universal first promoted and then eliminated women directors for reasons ultimately less evidentiary than methodological. Specifically, we have lacked the tools necessary to describe decisions made at the institutional scale. Histories of the industry and of cinematic culture make the problem too diffuse to account for Universal's specificity, and studies of particular directors focus on the individual at the expense of the organization. We lack a way to study Universal that does not subsume it in culture, subordinate it to the industry, or reduce it to a group of auteurs. I am not the first to note this lack. The film historian Janet Staiger suggested in the mid-1990s that the critical genre of the studio history could be given new life through a theoretically acute and empirically precise account of the relationship between "production conventions" (the formal and informal rules governing the work of filmmakers) and "product conventions" (film form, genre, style).[43] Implicit in this call is the insight that aesthetics, businesses practice, and individual creativity encounter one another most concretely on the studio lot.

The fate of the Universal women, I conclude, was decided by the manner in which Universal interpreted its films. What exactly it means for an organization such as Universal to interpret, where and how its interpretations mattered, how onscreen conventions produced and were in turn produced through a division of labor—these crucial questions will need the full span of subsequent chapters to answer. Throughout, however, I approach movies as the causes and consequences of an interpretive activity that considered any number of factors peripheral to the artworks themselves: from the organization of film distribution to understandings of the strengths of particular employees, from management struggles to the cultural geography of the workplace, from the development of new advertising methods to World War I. Films constituted a nexus of interpretation that proved consequential for the gendered division of labor: this is the burden of my argument.

The consequences of cinematic interpretation appear most clearly in part 2, which reveals how the evolution of film genres made women directors disposable by insisting that their films be womanly. Part 1 reveals how such a paradox could arise by explaining why, before late 1917, the womanliness of films directed by women was a muddled issue and much less consequential. Initially, Universal interpreted itself in ways that encouraged gender experimentation. I briefly introduce each part separately.

To understand how and why Universal made it possible for women to direct in significant numbers, we might start by considering what, exactly, the Universal Film Manufacturing Company is. What does "Universal" name? To understand this corporate entity is a goal as well as a requirement of this book. Accordingly, the chapters comprised in part 1 develop a method of institutional analysis along with a consideration of how changes at Universal through 1917 affected its gendered division of labor. In that analysis, first, Universal's brand names indicate a sequence of provisional but relatively stable institutional arrangements. Second, an investigation of formal and informal decision-making hierarchies illuminates how Universal moves from one arrangement to the next. And, third, a look at the imaginative and lived geography of the corporate movie studio reveals how filmmaking entailed gender play, which in turn informed the organization of work.

The name "Universal Film Manufacturing Company" indicates a certain ambition. In truth, it declares one so boldly that it is difficult not to infer a self-conscious boast—as if, with a wink, the company acknowledged the practical impossibility of omnipresence but expected us to admire its pluck in staking the claim. Contemporaries to Universal's 1912 founding may well have favored this playful interpretation. It was an age of showmanship, and there is no mistaking the ring of hucksterism in the company slogan: "The Largest Film Manufacturing Concern in the Universe." Meanwhile, the corporation's trademark claimed planet Earth as its territory by running a ring around it, suggesting velocity as well as an ability to fix or bind.

Nonetheless, the U.S. film industry did grow remarkably at this time, establishing by 1920 planetary, if not yet cosmic, dominance. For a brief time

Universal Film Manufacturing Company trademark, ca. 1912. Courtesy Richard Koszarski Collection.

in the 1910s, Universal led the pack. The "U" moved quickly into Europe and pioneered exploitation of the East Asian market. By the end of 1916, it boasted offices in London (through which it distributed to Africa and Australia), Paris, Berlin, Copenhagen, Vienna, Budapest, Barcelona, Vilna, Petrograd, Rio de Janeiro, Buenos Aires, Havana, Manila, Calcutta, Singapore, Japan, and China. A Java branch opened in February 1917.[1] Braggadocio notwithstanding, one must conclude that Universal's name sincerely indicated a business aim to cover the largest territory possible.

What would it mean for a company to be disarmingly self-conscious of over-reaching? What, in any case, does it mean for a corporation to want? More specifically, what might it mean to say that this corporation wanted women to direct? Whether we imagine the film-manufacturing concern pursuing universality with the monomania of Gordon Gekko or puffing its chest with the bravado of P. T. Barnum, Universal's name attributes desire to an entity whose desires we do not really know how to describe. For one thing, it has nonhuman aspects we would do well to consider. "Universal" names an entity that includes such properties as land, buildings, machines, and, not least, films. Similarly, to say that Universal "wants," "decides," or "hires" can occult the participation of the many minds at work within it. To posit Universal as an agent unavoidably raises the question of what kind of agent it is.

Usage complicates this question by implicitly anthropomorphizing the corporation. Because it avows a wish to be universal, Universal's name invites us to interpret it as an entity that also interprets itself. If the company could intelligibly use the first person, it would say, "I want it all, and I know it." But this is a misleading analogy. Universal does not say "I"; its wishes are

equally forthright but less self-conscious. Not only do its human constituents have minds of their own, but its unity exists moment to moment absent the existential difficulties of the self. It will not die, though it might lose identity through merger or dissolution, and its others do not complete it. Unbidden, language endows Universal a monstrous desire in the form of an individual wish come to life in an inhuman body.[2] While such a frightening and paradoxical characterization does indeed encompass the legal fiction that establishes corporations as artificial persons, that fiction will make it difficult to grasp institutions themselves, insofar as they are not only social actors but also scenes of social action, sites of struggle for the people who build them and work within them.

In simultaneously indicating a unity to which desire may be attributed and a heterogeneous assemblage of individuals supposed to work toward a common purpose, "Universal" poses a difficulty—and an advantage—as old as the word "institution" itself. The term unites the abstract and the concrete. Since the fifteenth and sixteenth centuries, according to the *Oxford English Dictionary*, the English word "institution" has meant "the action of instituting or establishing; setting on foot or in operation; foundation; ordainment," and has referred to "an established law, custom, usage, practice, organization, or other element in the political or social life of a people." Since the eighteenth century, "institution" has also signified "an establishment, organization, or association, instituted for the promotion of some object . . . e.g. a church, school, college, hospital, asylum, reformatory, mission, or the like." Thus, "institution" and its variants now name both social conventions and particular enterprises, durable feats of establishment and open-ended processes, widely shared habits, norms, or rules and specific locations where one might live or work. Every particular entity worthy of the name takes up a function within the abstract field of relations we call "society." At the same time, such entities distinguish themselves as concrete assemblages of persons, places, and practices.

English-speakers continue to use the term in the older sense alone. When we call the family, the law, religion, the economy, or gender "institutions," it is typically their durable role in the "political or social life of a people" that we name. One of the earliest such usages had to do with "the establishment or ordination of a sacrament of the Christian Church, esp. of the Eucharist, by Christ." Even at a far bureaucratic remove, the word retains a whiff of sacred mystery, and it certainly has not ceased to connote legitimacy.

The later development of the term tells us more about the world we have come to inhabit, however. "Institution" participated in the eighteenth-century semantic shift identified by Raymond Williams in which nouns "of action or process" such as "culture," "society," and "education" came to serve as "general and abstract noun[s] describing something apparently objective and systematic."[3] "Society," for example, was synonymous with "association" when Shakespeare wrote of "my Riots past, my wilde Societies," in *The Merry Wives of Windsor*, but the term served his seventeenth-century successors to distinguish "civil society" as "an association of free men" from "the state" as "an organization of power, drawing on all the senses of hierarchy and majesty." The earlier, "active and immediate" sense of "society" as "association" persisted well into the eighteenth century. By 1770, however, Adam Smith could confidently use the word as we do to declare, "Every society has more to apprehend from its needy members than from the rich."[4]

Williams proposes that this shift in usage abetted a sweeping historical transformation. Inapprehensible as the rise of another dynasty, the long Industrial Revolution depersonalized power. Once retooled, the old nouns of process could objectify new forms of authority. Like "culture," "society," and "education," "institution" describes power that cannot be embodied in a sovereign. Unlike those more abstract terms, however, it also identifies the concrete machinery through which impersonal authority has historically worked: "education" needs the school; "society" entails not only "the law" but the various institutions of the state that make and enforce it; and "culture" requires publishing houses, museums, libraries, movie studios, and the like. In vernacular usage, "institution" unites an abstract sense having to do with social function and a concrete sense designating specific places, persons, and the enterprises in which they are engaged.

The relation between individuals and such abstractions as society, culture, education, economy, ideology, and discourse has been described in ways too various to catalog here. It is worth recalling, however, that a customary dividing line separates two general orientations. One approach, clustered in economics and political science, presupposes individuals equipped with universal powers of reason and describes social forces as the aggregation of their decisions. To pick the paradigmatic example, the market sets prices through the accretion of more or less rational choices by the buyers and sellers who compose it. More than the sum of these choices, the market can be called an agent. Nonetheless, the force of its invisible hand ultimately derives from

individual calculations. The other approach, clustered in sociology, anthropology, and the humanities, insists on the already social character of individuals. Accounts of this ilk emphasize that shared categories of thought, norms, or values precede human individuals, point out that material distributions of power and resources precondition collective action, and chart the force of habitual practice. For example, the conviction, secured by law, that "the market" equals a domain apart from the state limits the range of choice and sets distinct rules of rationality within each domain: market choices take "profit" as an aim; choices of state emphasize, at least nominally, "the good of the people." On this view, decisions we might experience as personal have been directed in advance by the social context in which they occur. Opposed in their premises, individualist and collectivist approaches share an analogy; neither camp believes social thought and action to be identical with individual thought and action. Nonetheless, through the connoting power of language if nothing else, each characterizes them as similar.

Probably it is impossible to describe "decisions" without implying something like a human mind at work. Because it points in two directions at once, the category of "institution" resists analogical description of the relationship between the individual and the collective. Although scholarship provides ample examples, everyday life reveals this readily enough. What functionary has not had occasion to marvel at the difference between what one says and what the institution does as a consequence, between personal contribution and institutional decision? The bigger the organization, the greater the difference is likely to be, as level upon level of committees, supervisors, reports, and memoranda pile up between idea and implementation. Nonetheless, even very large organizations seem not to generate universal cynicism. As if by some miracle, institutional constituents remain convinced of their ability to "move" the organization, to affect outcomes, and even the most hardened may point to instances of having done just that. Such accomplishments might appear as strictly personal in an annual review or resumé, but they invariably entail a back story involving the diverse precedents, procedures, and people that hindered and aided every achievement. Our quotidian experience of institutions militates against an analogical understanding of the relationship between individual and collective agency because institutions engage us concretely in practices that simultaneously distinguish and link individual acts and collective outcomes.

"Institution" therefore frames the problem of impersonal power in a fun-

damentally different way than terms such as "society" and "culture" typically do. It neither calls for ontological disputes over whether collectives are prior to individuals nor presents the epistemological dilemma of what finally constitutes reason. "Institution" designates the pragmatic face of impersonal power and invites us to appraise the mediations uniting and distinguishing various sorts of doers and deeds, thinkers and thoughts.

It is in this light that Universal's name helps us to understand its division of labor. The name interprets the assemblage of people, places, and things comprised in it; it also offers the whole thus composed as an object of interpretation. As is often the case in human affairs, no ontological distinction can be made between "the institution itself" and the symbols through which it acquires identity. The institution could not exist absent its name, which legally and publicly composes diverse elements into a unity. But if describing an institution and bringing it to life are, pragmatically, the same thing, this does not mean that the institution may be reduced to the sum of its interpretations or that one interpretation is just as good as another. Characterizations vie for authority. The virtue of any interpretation, including historical descriptions of interpretations themselves, can only be judged within a context that defines some propositions as habitual, others as polemical, and still others as outré.[5] If, for a time, Universal wanted to employ women directors and then changed its mind, the explanation lies not in a psychology it does not possess but in interpretations that acquired the force of habit—interpretations like, for example, its name.

Or rather many names, since the company had several arrayed in what would now be described as a "brand or 'naming architecture.'"[6] Alterations to this arrangement as well as extensions and contractions of the domain of persons, places, and products comprised in particular names amounted to de facto changes in how the institution understood its component parts. In turn, arrangements institutionalized in the brand architecture conditioned how individuals could interpret and reinterpret the institution.

Thus it is significant that the dramatic increase in the number of women credited as director in 1916 and 1917 accompanied the creation of the brand name Bluebird, under which Universal distributed a weekly schedule of five-reel feature films separately from its shorts program and its prestigious road shows. The name was at the center of arguments within the company over the type of films Universal should be making, how much it should spend to make them, where it should make them, and how they should be brought

to market. Women did not direct Bluebirds exclusively, but they did direct them more frequently than they did many other brands, and no new women were hired to direct after the brand was phased out in 1919.[7] The creation of Bluebirds does not suffice to explain the rise of the Universal women, but it begins to explain what made it possible by revealing that phenomenon's relation to shifts in how the organization understood its product and the elements necessary to assemble and sell it.

If name changes indicate struggles shaping the young institution and affecting the fate of its women directors, they tell us little about the distribution of power that informs and results from those struggles. By power, I mean the ability to command (mobilize and dispose of) resources (human and material) within the institution as a hierarchical organization.[8] Such power is remarkably difficult to understand. The evolving corpus of sociological work devoted to institutionalized organizations does not agree on a model.[9] It does, however, yield at least one critically important insight: an organization's nominal hierarchy does not indicate its actual distribution of power. Authority in organizations derives from a more complex process in which formal structures interact with informal relationships among personnel and rules and norms that traverse the organization and link it to larger assemblages.

A look at Universal's evolving bicoastal hierarchy reveals a period of management turmoil and transition at its West Coast facility shortly before a new brand architecture was instituted in 1916. Relative stability arrived in November 1915 with the appointment of H. O. Davis as general manger of Universal City and second vice president of the company. When Davis enters film history at all, he tends to do so as an advocate of business efficiency and an enemy of director autonomy and the star system. Although surviving evidence is sketchy, it paints a different picture. Emphasis on efficiency, ambivalence toward stars, and concern with regulating the work of directors precede and postdate Davis's tenure. His efforts differed significantly in their particulars but not, fundamentally, in kind. In fact, changes to informal habits under Davis may well have mattered more than formal alterations of management structure. Surviving personal correspondence from the first vice president, Robert H. Cochrane, suggests that Davis's eventual dismissal (in the spring of 1917) resulted from President Carl Laemmle's resentment of his marginalization of Laemmle's friends at the studio. Whether we credit Cochrane's view or not, it seems clear that increases in the numbers of women directing in 1916 and 1917 owed something not only to new habits of production (evident in

the new brand architecture) but also to a revised distribution of power, in the form of new management at Universal City and a shift in the relationship between formal and informal distributions of authority. These changes created opportunity.

The cultural geography of Universal City explains why they created opportunities for women directors in particular. A corporate mythology organized Universal's West Coast facility. This myth received its first comprehensive articulation in a December 1913 *Universal Weekly* story, "Where Work Is Play and Play Is Work: Universal City, California, the Only Incorporated Moving Picture Town in the World, and Its Unique Features. 'Movie' Actresses Control Its Politics." In this imagination of the City, the playfulness and the interest of movie-making labor entailed a playful approach to gender norms. Universal developed this notion in planning and constructing a new Universal City, which officially opened on its current site in March 1915. The hallmark of this "chameleon city" was its mutability: the ability of workspace to also be a space of make-believe, a space of leisure, and, it was envisioned, a home.

In their work as filmmakers, Universalites frequently embraced such category confusion. In 1917, Ruth Ann Baldwin's feature '49–'17 went so far as to propose that the masculine authority to arrange space depends on the theatrical performance of that authority. Her film provides an allegory for the work of filmmaking at Universal; like numerous shorts that preceded it, the film indicates a keen awareness that because gender roles are, precisely, roles, one might as well have fun with them. A new certainty accompanied this celebration of variety, and it too is evident in Baldwin's film. By late 1917, Universal City looked less and less homelike, while, increasingly, movies reached resolution by envisioning home as a space apart from work. In that kind of place, Hollywood filmmakers insisted, persons should enjoy their roles as men or women, as opposed to having fun with them.

Universal's Names

Although the feat of naming scarcely registers as an issue in most of the social-scientific and humanist literature on institutions, those who give corporations names have seen clearly the connection between organizational identity and descriptive habit. The field of corporate-identity design did not establish itself as a profession distinct from management and public relations until late in the twentieth century.[1] As early as 1967, however, J. Boddewyn provided this enterprise with a theoretical statement. Writing in *Names,* the journal of the American Name Society, Boddewyn makes a case for the importance of naming by explaining the difference between personal and corporate names:

> Unlike individuals who may be recognized by their physical peculiarities, a corporation—said to be intangible, invisible and existing only in contemplation of law—is identified solely by its name. Since, in general, things are felt to be what they are called, the corporate name is an important element in the image projected by the firm, and it helps sell its products as well as its stocks and bonds. Symbols also make groups conscious of what they are, facilitating unity of purpose within the firm.[2]

Boddewyn exaggerates in claiming the name as a corporation's only means of identification—trademarks, logos, and corporate identification numbers do this work too. Yet the difference between name and number underscores his basic point. While the corporate number is a matter of public record, it serves to identify the company in relatively few contexts. In contrast, the name, like the logo but unlike the number, carries brand value and promotes group awareness precisely because it mobilizes the connotative as well as the denotative powers of language.

This play of connotation and denotation leads Boddewyn to state his case with noteworthy circumspection. The corporation is "said to be intangible," although presumably everyone knows it to be made up of people, places, and objects existing concretely in space and time. Similarly, in noting that things are "felt to be what they are called," Boddewyn hints that such feelings might be misleading. Finally, in explaining that the symbol's ability to identify a group "facilitates unity of purpose" for that group, he suggests that common purpose is a problem above and beyond the unity identified by the name: the unity, in other words, might be merely nominal. In all three ways, the name's power to reference both depends on its interpretation and is potentially undermined by it.

Given these implied problems, Boddewyn in effect proposes corporate naming as the project of: (1) forging an abstract unity out of diverse concrete elements, (2) endowing that unity with characteristics positively valued by a public, and (3) helping the diverse elements comprised within it act in concert. Although almost any name might accomplish the first objective (especially from a legal point of view), the second and third plainly require more finesse because they attempt to anticipate and direct the interpretations of others. The surest—indeed, the only—way to anticipate interpretation is to appeal to preexisting habits of interpretation. The namer does not interpret the institution by means of a name; the name interprets the institution by means of its namer. Such interpretations affect how work is organized within institutions. A consideration of Universal's names revels this process in operation.

According to the chronicler I. G. Edmonds, Carl Laemmle took the inspiration for the company's name from a passing dray wagon of New York City's Universal Piping Company.[3] Edmonds does not record other possibilities for the name, but there are reasons why Laemmle's new partners might have found his suggestion appropriate. For one, the name would have connoted an enterprise derived from the struggle of "the independents" against the oligopoly of the Motion Picture Patents Company (MPPC) and yet organized on a scale capable of subordinating that rival. The members of the MPPC, which controlled the young industry via a patents pool, were called by the names of their founders (Edison, Lubin, Méliès, Pathé) or by terms evoking motion-picture technology (Vitagraph, American Mutascope and Biograph). Some combined the two strategies (Selig Polyscope, Kleine Optical).[4] While a few of the independent companies that defied "the Trust" had similar names (Thanhouser, Powers), members of this group more typically adopted thematic monikers suggestive of autonomy or splendor. Laemmle's Independent Motion Picture Company

went by its scrappier acronym IMP, for example, and contemporaries included Centaur, Yankee, Champion, Rex, Majestic, Solax, and Lux. The name Universal continued this line rather than the patronymic one.

Laemmle's partners might also have judged the name suitable because it made sense of an organization that would, like the MPPC, encompass a "universe" of smaller firms that retained brand identity within it. The Universal Film Manufacturing Company filed its certificate of incorporation with New York's secretary of state on April 29, 1912, but the corporate history conventionally begins on June 8, 1912, with the merger of IMP, the Powers Motion Picture Company (Pat Powers), Rex Motion Picture Company (William Swanson), Champion Film Company (Mark Dintenfass), Nestor Film Company (David Horsley), and New York Motion Picture Company (Charles Baumann and Adam Kessel). Other participants in the deal almost certainly included Charles Jourjon, the head of the American subsidiary of the French Éclair company, and the distributor of Eastman Kodak film stock, Jules Brulatour, who was quickly forced to drop out by George Eastman.[5] The firm's principals had been involved in the Motion Picture Distributing Sales Company, established in the spring of 1910 to orchestrate distribution for independent manufacturers in circumvention of the MPPC.[6] The Sales Company neither purchased exchanges (local rental-distribution offices) nor went into the business of production. Rather, it served as an intermediary between independent producers and exchanges and employed legal counsel on their behalf. According to David Horsley's brother William, it charged its members a flat fee of five dollars per reel at a time when reels sold to exchanges for one hundred dollars.[7] As a firm that owned and operated production facilities as well as exchanges, Universal was an entirely different beast. Nonetheless, the habit of selling films by brand name persisted within it.

Universal continued to market films by subsidiary brands throughout the decade. It preserved the names of companies that merged to form it (or were later acquired by it) and generated new names to distinguish particular product ranges. In its first years of existence, Universal also served as a distributor for brands it did not itself produce: French and American-made Éclairs, for example, as well as the Italian brands Ambrosio, Itala, and Milano.[8] The somewhat awkward status of the name Universal, which designated a brand in its own right as well as a distributor for some brands and a corporate parent for others, suggests the novelty of the organizational feat the company performed. Its names pointed backward to a time when producers and distributors were separate business entities and forward to an era in which they would be one

and the same. Nomenclature changes helped conduct this industrial transformation insofar as they provided Universalites a way to identify themselves and their product. In addition to indicating how Universal addressed a market, brand names also indicate how it organized production. This is particularly clear in the case of the formerly independent brands merged under Universal's corporate rubric. To various degrees at various points in Universal's early history, a brand named an assemblage of properties and personnel as well as a set of films.

Brand Sales

Regular advertisements and notices to exhibitors reinforced the sense that "Universal" was an umbrella for a number of brands. On January 8, 1916, for example, a reader opening the trade paper *Moving Picture World* to the section detailing releases for the week would have found nine single-reel films listed under "Universal Film Mfg. Company": an installment of Universal's newsreel, the *Animated Weekly,* a Laemmle drama, a Rex drama, two Powers actualities on a single reel, the fourth installment of the Powers actuality series *Uncle Sam at Work,* a Nestor "knockabout number," a Victor drama, and two L-KO comedies (an acronym for "Laughter Knock-Out," L-KO was pronounced "L-Co.," as in "company").[9] A separate list of eight two- and three-reel films follows under the heading "Universal Film Mfg. Company Specials." Here the potential exhibitor finds another L-KO comedy, the fifth episode of the *Graft* serial (a Universal Special), a Gold Seal detective story, a Victor drama, a Big U action film, two Rex dramas (one of them directed by Cleo Madison), and a Bison Western. Readers of Universal's house organ, then called *Moving Picture Weekly,* would have seen most of these same films (the two papers began the week on different days) arranged as a weekly program—that is, preorganized for any exhibitor who could be convinced to show Universal films exclusively.[10]

Such lists depicted Universal as the entity that organized an array of brands, each brand loosely associated with a genre such that they could be combined in a "balanced program" that changed daily. This was not the company's only way of addressing a market. In contrast, advertisements for the Bluebird brand of feature films released beginning in 1916 provided no discernible link to Universal, except perhaps through the use of its New York address.[11] Announcements of the brand informed exhibitors that it would distribute

"the finest features yet made," that these fine features would be produced by Universal players on the Universal lot, but, contradictorily, that "the only point at which [Universal and Bluebird] touch is through [Bluebird general manager] Mr. Hoffman." Hoffman was also at the time general manager of Universal's exchanges. "Bluebird stands for happiness," Hoffman explained, "and certainly Bluebird productions will be the advance agent for happiness to any exhibitor who is long-headed enough to grasp the opportunity which they present."[12] Although publicity initially presented distribution through Universal exchanges as an economic advantage for Bluebirds, Universal quickly set up a semiautonomous system of branch offices to distribute these films. The impulse was to develop a separate brand identity for the Bluebirds, something it did neither with the Broadway-Universal features nor, to the same degree, with the Red Feather and Butterfly lines that succeeded them. The prestigious Jewel features were a different case again. Universal released no more than a dozen titles per year under this brand, which continued the type of marquee product Universal had earlier distributed on a "states' rights" basis. Universal continued the habit of marketing these films primarily by association with their star performers and/or directors, although it did set up a short-lived system of Jewel exchanges, apparently on the Bluebird model, in 1917.[13]

Before examining what it meant for Universal as the umbrella term for various brands of shorts to coexist with Universal as the name for, or concealed behind, brands of feature films, it bears noting that in foreign markets Universal's films could find themselves effectively rebranded. Between 1913 and 1920, Universal distributed shorts and serials in the United Kingdom through the Trans-Atlantic Film Company. The London firm's similar logo and exclusive relationship with Universal effectively linked the two brands, but Trans-Atlantic functioned as the commonplace name so that, for example, the 1917 *Year Book* of the British trade paper *Kinematograph* could reference happenings at the "Trans-Atlantic Film Company's studios at Universal City."[14] London in this period served as a major market for selling distribution rights to various territories around the world, and, in addition to providing Universal a British distributor, Trans-Atlantic also functioned as its agent in this capacity. In January 1916, for example, Trans-Atlantic announced that it had sold exclusive rights to Bluebird films to the British distribution arm of the French company Gaumont. Four months later came an announcement that American Films was the sole agent.[15] This sort of transposition from Universal to Bluebird to Trans-Atlantic to Gaumont to American Films would have challenged

exhibitors of Bluebirds to make the connection back to Universal.[16] Universal's connection with Trans-Atlantic resulted partly from the fact that a "Universal Film Company" was already registered in the United Kingdom when the U.S. firm formed in 1912.[17] Trans-Atlantic's principals reclaimed the name Universal with the dissolution of the original British firm in 1915, but their proprietorship of it presented the same problem again when Universal's relationship with Trans-Atlantic broke down in 1920.[18] The fate of Universal's name in the United Kingdom thus offers a powerful reminder of the play of contingency that shadows corporate naming strategy. In this case, a legal accident required Universal to reimagine itself as Trans-Atlantic overseas. Similarly, the creation of Bluebird as a separate, subsidiary brand allowed Universal to participate in the industry-wide trend that inaugurated the feature-film era even as it specified the particular form such participation would take for Universal.

By 1920, the kind of shorts program Universal advertised in 1916 had been obsolete for at least two years, and the typical film program consisted of a dramatic feature preceded by short comedy, newsreel, and scenic or travelogue material. Universal is often thought to have trailed the industry in making this shift, and evidence supports that conclusion.[19] Because brand names organize sales practices at the institutional scale, however, they provide a more complex and precise indication of what the new emphasis on features entailed. In truth, Universal was an early adopter of the longer film format and undertook several distinct experiments in marketing it. From its inception, the company promoted a limited number of expensive feature films as unique individual titles apart from its shorts program. As feature-film production increased, Universal treated distinct lines of features as brands, which it distinguished primarily according to standards of quality rather than by the loosely generic schema that prevailed in shorts. Jewels were the most expensive and prestigious, followed by Bluebirds, trailed by Butterflies and Red Feathers. If one considers the proportion of shorts to features expressed in the average reel length of Universal titles, the creation of the Bluebird and Red Feather brands in early 1916 (step 1) appears to have been nearly as consequential as the elimination of several brands of short dramas in late 1917 (step 2), followed by the creation of new brands of short comedies and Westerns early the next year (step 3). Step 1 increased average reel length by 34 percent; step 2 increased it by 42 percent; step 3 brought it back down by 25 percent. What must have been unclear to Universal in these years was not whether it should invest in features (it did so) but how it should market them in relation to the large

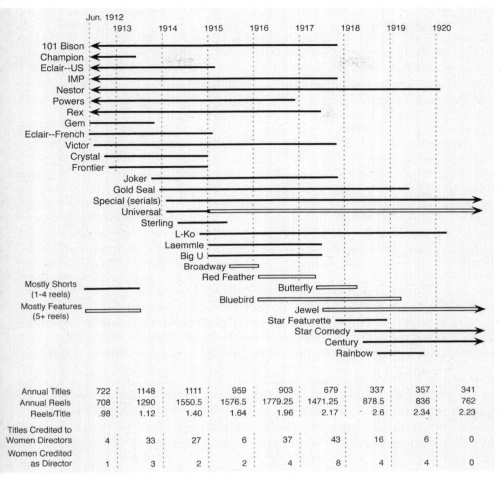

	1913	1914	1915	1916	1917	1918	1919	1920	
Annual Titles	722	1148	1111	959	903	679	337	357	341
Annual Reels	708	1290	1550.5	1576.5	1779.25	1471.25	878.5	836	762
Reels/Title	.98	1.12	1.40	1.64	1.96	2.17	2.6	2.34	2.23
Titles Credited to Women Directors	4	33	27	6	37	43	16	6	0
Women Credited as Director	1	3	2	2	4	8	4	4	0

Major brands distributed by Universal, 1912–1920 (brands lasting longer than twelve months and releasing more than twelve titles).

volume of short material it was also producing. Crucially, the increase in the proportion of shorts in 1918 indicates a general change in exhibition format: rather than bundling shorts together as a variety program, short Westerns and comedies now typically preceded a feature-length drama.[20]

To grasp what was at stake in these decisions, it is necessary to understand the two basic sales strategies available to film producers in the mid-1910s. According to one model, a manufacturer sold or leased titles to exchanges at a fixed price per foot or reel. Exchanges then rented to exhibitors.[21] In

Universal's case, these exchanges were for the most part subsidiary companies renting to independent owners of "neighborhood theaters."[22] Success depended on securing the repeat business of the theater owners, who expected to offer a program of at least four new short titles each day. The manufacturer therefore aimed to release twenty-eight films of consistent quality per week, lest it lose steady customers.

In the abstract, the economics of this arrangement were reasonably straightforward. An unpublished studio history, probably from 1916, estimates production cost (including one positive print) at between $1,000 and $1,500 per "title" (by which it likely means "reel"), and the cost of up to thirty additional positives at between thirty and forty dollars per reel.[23] This works out to a maximum production cost of $2,700 for thirty prints of a one-reel film. If Universal "sold" all thirty of these prints to its exchanges at one hundred dollars, its manufacturing branch would net three hundred dollars (an 11 percent return, exclusive of overhead costs), provided the subsidiary exchange could recoup one hundred dollars per print in rentals. In this approach, several significant variables affected profit: the cost of producing the film negative (the master from which subsequent positive copies would be made), the number of prints struck, overhead cost, and local rental revenues. The *Weekly* reported in 1913 that "a 20 percent profit on a reel that has been shown 50 times is considered good business."[24] In any event, this approach depended upon a voluminous production accounted primarily in reels. Measuring production in this way made it easy to aggregate risk—so long as a certain number of reels kept moving, individual titles could fare more or less well without substantially affecting the bottom line. This must have seemed an advantage when compared with the second strategy.

The alternative strategy adapted the "road show" idea from the vaudeville circuit. A central booking office—Universal's Feature Booking Department—attempted to engineer the success of prestige titles in big-city theaters and then, on the basis of that success, take the show on the road, first booking exhibition venues directly, and then selling "states' rights" (the right to exhibit the film in a particular geographical area) to exchanges. Depending on the film, the "road" could be long or very short—states' rights might be marketed simultaneously with the premier or after the film had completed a more substantial tour.[25] The relevant sales unit on this model is not the foot or reel but the title.

Although Universal handled few films in this manner in the 1910s, it seems

to have developed an effective apparatus for exploiting them. The studio claimed *Paul J. Rainey's African Hunt* as its first success with this approach, doubtlessly because of Laemmle's association with it, despite the fact that its initial release on April 14, 1912, precedes Universal's incorporation. *Traffic in Souls* (1913) was the next film to be treated as a special feature, and Universal also apparently handled the 1914 release of the Williamson Brothers' submarine expedition films in this way. By mid-November 1916, there were a total of seven films in the Feature Booking Department's merchandise inventory: *Neptune's Daughter* (1914), *Damon and Pythias* (1914), *Uncle Sam at Work* (1915), *Pavlowa* (a.k.a. *Dumb Girl of Portici*, 1915), *Where Are My Children?* (1916), *Idle Wives* (1916), and *Twenty Thousand Leagues under the Sea* (1916). Universal carried this inventory on the books to depreciate it, but values for the most recent releases probably indicate negative cost. Universal was just beginning to exploit *Idle Wives*, listed at $19,608.54, or over $2,800 per reel, and the eight-reel *Twenty Thousand Leagues*, listed at $162,453.87, or over $20,300 per reel. The books indicate a net profit for *Idle Wives* of nearly fifty-one thousand dollars after about six weeks in release and a net loss of nearly three thousand dollars for the Jules Verne adaptation, which had shown in Chicago but would not play more broadly for another month.[26] The company committed substantial resources to Feature Booking Department films on the expectation that it might reap correspondingly large profits, provided individual titles were well marketed and successful with audiences.

Although the Feature Booking Department handled nonfiction material (such as the Williamson submarine pictures and *Uncle Sam at Work*), it clearly favored what we now consider to be the feature-length fiction film. Notably, Universal entrusted Lois Weber with these films more often than any other director: *Dumb Girl of Portici, Where Are My Children?,* and *Idle Wives* are all Weber titles. As we shall see in the second part of the book, Weber's successes must have loomed large in corporate interpretations of its marketplace, but her Special Features cannot really be considered the prototypes for the variety of films made by Universal's other women directors. To understand the group phenomenon, as distinct from individual careers, requires us to take in the whole terrain of production.

Beginning in the summer of 1915, the vast majority of Universal's longer films were not treated as road shows but rather released via exchanges. The Broadway Universal Features were the company's first experiment along these lines. In August, the *Weekly* reported that since they "have been added to the

Universal program there have been many problems which need [the exchange manager] Mr. Hoffman's personal attention." While the problems were not precisely specified, they were said to involve publicity for the features. Only a few months later, the company announced Bluebird as a brand that would be distributed independently from the regular program.[27]

Consistent with the predominance of the volume-driven, reel-based sales model for the variety program at this point in Universal's history, it was not particular films so much as entire lines of films that succeeded or flopped. With the exception of the Feature Booking Department titles, the parent company's year-end report accounts for sales by brand and not by title. This is not surprising, given the number of titles—at least nine hundred fiction films in 1916 alone—but it underscores the extent to which brand names organized Universal's understanding of its business. Bluebird tops the list of 1916 U.S. and Canadian brand sales at $624,043.69, with an additional $40,586.10 in "foreign sales." Red Feather features and Universal Special serials each sold in the neighborhood of $450,000, and almost all the remaining brands (including the Universal *Animated Weekly* newsreel) accounted for between one hundred thousand and two hundred thousand dollars each in the United States and Canada. It bears emphasizing that these "sales" figures do not indicate rental or box-office income, nor do they equal profits; they represent payments from distributors, most of which were also Universal subsidiaries. Even so, the figures make plain that Universal invested substantially in the feature-film brands, which accounted for one-third of total U.S. and Canadian brand sales ($1,068,250.69 of $3,202,760.76) in 1916. If, however, sets of feature films entered the balance sheet as just another brand name, a closer look reveals profound differences between the actual practices organized by "Bluebird" and operations conducted under such rubrics as "Rex" or "Nestor."

Bluebird annual reports provide a more detailed accounting of the exchange end of the business than does the corresponding parent-company report. They reveal income and costs for each of the nineteen Bluebird branches, as well as costs and rental-income figures by title. This way of tracking data suggests that although Universal's executives intended Bluebirds to be program-like in the regularity and logistics of their distribution, they also understood their values in terms more familiar to the Feature Booking Department. Here, too, the relevant sales unit was not the reel but the title, the value of which could be reckoned in terms of longevity as well as initial appeal. Bluebird released approximately one five-reel titles per week in 1916, its

first year. Universal spent between fourteen thousand and sixteen thousand dollars to make about half of these films and between twenty thousand and twenty-two thousand dollars to make the other half. The low figure works out to about three thousand dollars per reel, or roughly twice as much as it would expect to spend on the most expensive single-reel film.[28] Accounting apportioned these negative costs (as "sales") and general office expenses to the Bluebird branches. Partly in consequence, Bluebird as a whole showed a net loss of $33,278.90 in 1916, while its parent, Universal, listed a trading profit of $1,039,600.58.[29] It is possible to imagine several reasons why Universal might have arranged its accounting in this way, and it would be a mistake to read too much into the profit-and-loss statement for Bluebirds in their first year. More significantly, the kind of information recorded indicates central corporate concerns as Universal attempted to adapt brand marketing to feature films.

The books are arranged such that one might easily distinguish a Bluebird hit, such as Lois Weber's *Shoes,* from less successful films such as *The Three Godfathers* (directed by Edward LeSaint and starring Harry Carey). Separate columns record the number of bookings for each title as well as the average rental (gross rentals divided by bookings). They also distinguish the cost of producing the film negative from the cost of producing promotional materials for each film and the general operating expenses (overhead) apportioned to it. Overall, the numbers would have shown executives that a Bluebird, particularly one made on a tighter budget, could expect to recoup its completed negative cost after about six months, but only exceptional films could expect to turn a profit after a share of operating expenses had been included. In showing that negative and overhead cost mattered so much to the Bluebird bottom line, such statements likely provided an argument in favor of continuing to promote the shorts program, which better distributed those costs.

Perhaps more importantly, in making clear that some feature films had longer "legs" and could command higher rental prices than others, this type of report probably inspired a hermeneutic at odds with Universal's interest in selling "Bluebird" as a mark of quality. Efforts to explain, reproduce, and market particular characteristics that made some Bluebirds "better" than others would have been as likely to militate against brand identity as to advance it. In this contradiction, the seeds of a new type of interpretation were sown. Before giving rise to the interpretative strategies that made the brand obsolete, however, Bluebird features created certain opportunities for filmmakers.

The Brand Nexus

Considered from the point of view of Universal's executives, brands not only addressed a market of exhibitors and audiences but also linked that market to production facilities and teams of creative personnel. Universal's inaugural corporate kerfuffle reveals the agglomeration of material properties and productive forces conjoined by brands. Within weeks of the June 1912 merger, a legendary struggle for control of the company erupted among the partners. Laemmle managed to get himself elected president of the young corporation; in consequence, Kessel and Bauman sought to withdraw their New York Motion Picture Company (NYMP) assets.

The journalist turned historian Terry Ramsaye provides the most colorful of several contradictory accounts of the ensuing struggle. He describes a "pitched battle" for physical possession of the NYMP's West Nineteenth Street studio in New York City and maintains that Thomas Ince defended the company's Santa Monica studio with a Civil War cannon and a Colt .45. "A clash of arms was avoided," confides Ramsaye, "or the canyon in Santa Monica would have been running deep with gore."[30] Fred Balshofer's less sanguine version maintains that Jim Brooks, the manager of the Miller Brothers' 101 Ranch troupe, "had his Indians carrying army muskets and jumping and hopping in an Indian war dance."[31] He also adds a struggle to replace the locks on the Edendale (Los Angeles) facility used by the NYMP's Keystone group.

Regardless of what actually transpired during the corporate property dispute, the matter was resolved by a court-ordered settlement in October that allowed the NYMP Company to withdraw almost all of its assets from Universal. It kept its production facilities and personnel, including the director, Ince, and the 101 Ranch hands responsible for its Wild West pictures, which it continued to distribute under a new "Broncho" brand. Universal retained use of the 101 Bison name and trademark. Laemmle could have kept the name Keystone as well, but apparently he rejected it as tainted by a scandal involving four actors, a sixteen-year-old actress, and a flight to Tijuana, Mexico.[32] In addition to pointing to struggles for personal advantage, then, the episode indicates that brand names could retain business value (and liability) apart from the people and places with which they had been associated.

It also demonstrates that such associations were habitual. In this context, the term "company" retained a connotation given it by the theater. It meant a team of creative personnel working consistently together in particular places under a unique name.

Beyond the oft-described clash of executives, the NYMP-Universal dispute indicates the range of practical challenges the company must have faced when integrating its diverse constituents into a new whole. There were difficulties, for example, arising from the fact that each of the merged companies brought real and tangible properties along with it. Champion and Nestor each had production facilities in New Jersey, for example, and Nestor had an additional studio at Sunset and Gower in Hollywood. Powers produced in Mount Vernon, New York. Most of the firms kept New York City offices, and IMP and Rex had production facilities there as well.[33]

The move to consolidate business operations began in the summer of 1912 with the acquisition of offices in the Mecca Building at 1600 Broadway in New York, where Universal occupied the entire third floor.[34] The company also leased the Oak Crest Ranch on Cahuenga Pass above Hollywood, where it officially opened the first Universal City in May 1913.[35] By September, the cashier Claude McGowan reported that Universal had about two thousand employees on the West Coast and four hundred on the East.[36] Universal purchased 230 acres of the Taylor Ranch next door to its Cahuenga Pass facility and officially opened a much grander Universal City on March 15, 1915.[37] At around the same time as construction began in California, Universal began building a large indoor facility on four acres in Leonia Heights, Fort Lee, New Jersey, with the idea of consolidating East Coast production there. In June 1916, however, the company had moved almost all of its production to the West Coast and leased the Fort Lee studio to a series of other producers. Despite the shift in production throughout the 1910s, Universal maintained its main laboratory facilities in New Jersey.[38]

As geographical counterparts to the organization of diverse brands under the Universal name, these changes indicated the centripetal movements of business operations toward the Mecca Building and of production toward Universal City. In May 1918, Universal announced that it would also consolidate the distribution of its product, including Bluebirds and Jewels, into a single system of exchanges to be called Universal Film Exchanges, Inc., a wholly owned subsidiary of Universal Film Manufacturing Company. At that point, Universal Film Exchanges had twenty-nine branches in North America and twenty additional branches abroad.[39]

As "Universal" acquired increasing scope and solidity, the theatrical idea of a company persisted. The unusually long career of the comedy team of Lee Moran and Eddie Lyons provides an illuminating example of the durability of

the approach. Beginning in 1912 under the direction of Al Christie, the duo became almost synonymous with the Nestor brand (which did include other producing groups). When Christie left Universal in 1916, Moran and Lyons continued to make Nestors for a time with the director Louis W. Chaudet, but in March 1918 they began directing themselves in Star Comedies, a name that harkened back to the short-lived Star Featurette but now became identified with them exclusively. Supporting performers went with the package. Victoria Forde, for instance, appeared weekly with Moran and Lyons from March 1914 through September 1915; Edith Roberts joined them from January 1917 through February 1919. Although brands primarily releasing dramas did not generate comparably durable collaborations, the pattern is similar. Lois Weber and her husband Phillips Smalley, for example, were the leading directing-writing-acting team associated with Rex when it joined Universal, and they continued to release one film a week under that brand through September 1914. From January through October 1914, Rex also released one film a week directed by and starring Robert Z. Leonard and costarring Betty Schade, Hazel Buckam, or Ella Hall. In the fall, Joseph De Grasse began directing, and Ida May Park began writing the scenarios for a Rex company featuring Pauline Bush and Lon Chaney.[40] There were several other, shorter-lived Rex combinations. In sum, brand-company organization allowed mobility and recombination but favored stable sets of personnel.

The fact that brand marketing historically preceded the development of the star system should not lead us to conclude that brands and stars pointed to opposing marketing strategies.[41] As the case of Moran and Lyons indicates, the two approaches coexisted. The brand name and the star name could be one and the same, as was the case with the Sterling comedies that featured the former Keystone star Ford Sterling.[42] Nonetheless, precisely because the brand rubric encompassed supporting players and behind-the-camera personnel, it mattered differently for the management hierarchy than evolving star personae did. Whereas the star system allowed executives to predict that particular performers would draw a certain audience, the brand name amounted to an organizational rubric allowing them to anticipate the collaborative work of a diverse filmmaking team. Although Universal did move particular titles from brand to brand to balance the mix of its shorts program or to preserve a quality standard in its feature offerings, habit favored clustering creative personnel in association with a brand name. Credits make clear, moreover, that brand-company organization conserved the tradition of "doubling in brass"

from its theatrical forebears and encouraged individuals to take on multiple on- and offscreen roles in production—to move back and forth, for example, from acting to writing or directing. As Karen Mahar explains, this created opportunities for women to become directors. Moreover, the correlation between the numbers of women directing and certain changes to Universal's brand structure underscores her point that this opportunity-generating mechanism was only one of several factors.[43]

What replaced brand-company organization by the end of the decade was not the star system, the evolution of which overlapped with and was even nurtured by the brand-company model, but rather a more rigid division of labor and a production process more clearly geared toward distinguishing films by genre.[44] Whereas the shorts program established a loose connection among brands and genres—such that a Nestor would likely be a comedy and a Bison a Western—Bluebirds gave rise to the puzzle of distinguishing different sorts of dramatic feature films. So long as the shorts program prevailed, one could imagine brand, genre, and star as rough equivalents, but by the end of 1919, when Universal released all its features as either "Universals" or as more prestigious "Jewels," differentiation by the independent variables of genre and star within the brand had became the rule.

At their inception, however, Bluebirds extended the habit of associating particular companies with brands, mutatis mutandis, to feature-length films. Among the fifty-four Bluebirds released in 1916, we find six titles from De Grasse and Park, all starring Chaney and Louise Lovely; seven titles from Weber and Smalley, three starring Mary MacLaren and three featuring Marie Walcamp; five titles directed by and starring Rupert Julian, four of them written by Elliot J. Clawson and all but one featuring Francelia Billington; five directed by Robert Z. Leonard, three written by him, and three starring Ella Hall; three titles each written and directed by Rex Ingram and Lynn Reynolds with recurring casts; and five titles starring J. Warren Kerrigan opposite either Lois Wilson or Louise Lovely with Harry Carter and Maude George in supporting roles, two of these directed by Otis Turner and three by Jack Conway. Of the fifty titles, perhaps fifteen could be considered one-offs, but the majority reveal the company idea at work, with the expectation that each loosely defined unit would make between three and six features in a year.

At mid-decade, then, the brand nexus indicates an evolving production situation in which several kinds of changes were happening simultaneously. Universal was in the process of creating a corporate identity out of pieces

inherited from predecessor companies, determining how best to enter the emerging market for feature films, attempting to match teams of filmmakers with particular projects in ways that would allow it to anticipate and reproduce success, and developing a more rigid division of filmmaking labor from the more flexible theatrical model. Because brand names index all of these related changes, a look at credits by brand reveals something of the particular conditions allowing women directors to flourish at the studio.

Four interesting patterns emerge. First, women directors were concentrated in the feature-film brands, and particularly in Bluebirds. Between 1916 and 1919, Bluebird credited women with directing 12 percent of its titles, whereas Universal as a whole credited women with directing only 4 percent of its total output. Of women directors credited with more than one title, only two, Lule Warrenton and Ruth Stonehouse, made no features at all. Second, women directors were much more strongly associated with short dramas than with short comedy brands or serials. Of 112 shorts credited to women directors, only three were released under brands identified exclusively with comedies: Grace Cunard and Stonehouse directed one Joker each, and Stonehouse also directed a Star Comedy.[45] Cunard is the only woman credited with directing serial installments. Third, among the shorts brands, Rex accounts for by far the highest concentration of titles directed by women. This is due largely to the prolific Weber, but Madison and Baldwin also directed Rex titles, and Park, although credited as screenwriter, probably assisted in the direction of Rex titles credited to her husband, De Grasse. Fourth, everybody started in shorts. Although Park's and Elsie Jane Wilson's directing credits begin and end with feature-film titles, Park and Wilson came to features with well-established track records in shorts (as screenwriter and actress, respectively) that almost certainly included directing experience.[46] Credits for some women—Madison and Baldwin, for example, who made two features out of a dozen titles each— suggest that they never fully made the transition to features. But even the great Weber turned out a few one-reelers between features in 1917. Thus, it is reasonable to conclude that the coexistence of short drama brands alongside features, and especially Bluebirds as a distinct approach to marketing features, generated opportunities for women directors at Universal.

Universal's Organization

Universal's names interpreted its constituent parts for its personnel, its customers, and its competitors. In this way, they indicate something of how the company organized production internally as well as how it addressed the competitive field in which it participated. Changes of nomenclature indicate changes to the institution. In the liquidation of the brands that formed Universal and the generation of new ones, we see the passing of contests among the original partners and the emergence of a new struggle to stay abreast of a wider industrial shift away from a shorts program toward a program emphasizing the feature film. Universal's particular manner of negotiating that change created opportunities for women directors.

Universal's brand architecture also indicates a great deal of volatility. Fully half of the thirty-two major brands produced and distributed by Universal in this period lasted less than three years. In the rise and fall of various brand names, the distribution of power within the company changed. Hierarchies mutated as employees were hired, promoted, reassigned, and let go. Although changes to the nomenclature system register shifting interpretations of how to address the marketplace and organize a workforce, they remain silent on questions of power. As outcomes of interpretative contests, they explain neither how the authority to interpret was secured nor the distribution of authority that resulted from particular interpretations.

Whereas the consideration of institutional names has been a pursuit primarily of those specialists responsible for the work of naming, the problem of institutional authority has preoccupied sociologists since the beginnings of the discipline. The study of what social scientists call "institutionalized organizations" has typically begun by considering their functions within a

social setting and their mechanisms for mobilizing various sorts of resources (human, technological, geographical, financial) in service of particular aims. According to Max Weber's influential definition, formal organizations may be distinguished from ad hoc assemblages, called by Weber "enterprises," and much larger associations, typically called "societies," by identifying an ongoing division of labor oriented toward rationally achieving particular ends.[1] Not controversial in itself, this way of defining a formal organization has presented two hefty problems: first, describing the relation between formal organizations and other sorts of organizations—such as enterprises and societies—with which they coexist; second, describing the relation between the ends-orientation of formal organizations and the processes meant to accomplish those ends.

The English term "organization" suggests answers to both questions, and it is worth noting that the word's usage changed historically in tandem with that of "institution." In the fifteenth and sixteenth centuries, according to the *Oxford English Dictionary*, "organization" was a biological term signifying "the development or coordination of parts (of the body, a body system, cell, etc.) in order to carry out vital functions." Since the eighteenth century, "organization" has also defined a "body of people with a particular purpose, as a business, government department, charity, etc." This change made it possible to use "organization" and "institution" as synonyms, although they differ in their connotations: "organization" conveys the sense of arranging vital parts, while "institution" reflects the feat of establishing and legitimating. The former suggests an ongoing process, and the latter, a punctual event. As a characterization of processes, "organization" encourages the adjustment of scales, so that one can imagine particular institutions as "organs" within a larger social body and also as "organisms" with their own functioning component parts. The term also tempts us to think analogically, as if institutions were societies in microcosm. Moreover, an organizer is implied by "organization." The ancient biological connotations of the term hint at a metaphysical entity such as God or Nature.

If social "organizations" have yet to shrug off the noun's history of biological usage and the implication that social parts will serve the whole in the same way that organs come to life within a body, this is partly because certain founding figures of sociology, such as Emile Durkheim, make that comparison explicit.[2] Others, like Weber, reject the premise that each element of a society necessarily serves a function within the whole and seek to contain

this implication of "organization" or else avoid the term. When it comes to formal organizations, however, the implication seems particularly appropriate: an organizational chart, for example, will reveal the nominal coordination of parts as they function within an ordered whole. As James G. March and Herbert Alexander Simon put it in their foundational 1957 cognitive approach to behavior in organizations: "Organizations . . . are the largest assemblages in our society that have anything resembling a central coordinative system."[3] March and Simon immediately qualify the metaphor, however, by noting that the powers of this coordinative system cannot match those of our own central nervous systems precisely because the people within it are not reducible to the functional "organs" envisioned by the formal structure.

Probably everyone who has worked within a reasonably large organization has experienced a difference between the hierarchy indicated by its organizational chart and how decisions are "really" made. During the 1940s, Columbia University led the way in reminding sociology that bureaucracies never work the way they are meant to. In "Bureaucratic Structure and Personality," Robert K. Merton starts from Weber's definitions, grouping corporations and government bureaus alike under the heading "bureaucracy." He argues that bureaucratic structure trains people to overconform to its rules and procedures, which by force of habit stop looking like means to particular ends and become values in themselves. Devout company men find it difficult to adapt when confronted by "conditions not clearly envisaged by those who drew up the general rules."[4] In such circumstances, Merton proposes, the very mechanisms designed to ensure efficient operation are guaranteed to yield inefficiency, if not gross incompetence.

Merton's student Philip Selznick developed this perspective and revealed the unanticipated consequences of rational organization to be the quintessence of institutional life. Selznick notes that the formal structures meant to ensure the smooth accomplishment of institutional ends "*never* succeed in conquering the non-rational dimensions of organizational behavior" because individual staff members have affiliations that extend outside the organization as well as allegiances within it. He therefore proposes that we consider organizations from two points of view: they are an "economy," a functional system for managing scarce resources efficiently and effectively, as well as an "adaptive social structure" involving persuasion and contests over legitimacy. From the latter point of view, he suggests, it is crucial to observe that "the *state of the system* emerges as a significant point of analysis" for those who

work within an organization. "A proper understanding of the organizational process must make it possible to interpret changes in the formal system—new appointments or rules or reorganizations—in their relation to the informal and unavowed ties of friendship, class loyalty, power cliques, or external commitment. This is what it means 'to know the score.'" Although the formulae by which "the score" is tabulated might be at odds with the institution's official procedures, the process of knowing it is not necessarily dysfunctional after the fashion of Merton's "overconformity." Indeed, such interpretations enable the countless little adjustments necessary to maintain the institution as an "adaptive social structure." Where Merton depicts organizations as habituating their most devoted functionaries to act as saboteurs, Selzinck's argument allows us to see that contradiction as an extreme consequence of a constitutive tension between the institution's official mission and how staff members interpret their interactions with one another.

For Selznick, that tension brings the institution to life: "The organic, emergent character of the formal organization considered as cooperative system must be recognized," he writes. "The organization reaches decisions, takes action, and makes adjustments."[5] In this formulation, Selznick draws on the biological connotations of the term in describing the systemic interaction of different parts, but he undercuts the idea that such a system is organized in advance. The problem of characterizing institutional elements thus looks less like one of relating organs to a body and more like describing the arrangement of stars in constellations: they constitute provisional wholes that might be broken up and seen anew from a different vantage, whenever a new interpretation of the state of the system holds sway. The organization is "emergent" until it decides, acts, or adjusts. As such, its rationality may only be described after the fact. Although subsequent work has developed, reframed, and in key particulars departed from Selznick's analysis, it has not improved on the clarity with which he presents organizational rationality as post hoc.

Ownership, Control, and Bicoastal Organization

With a few significant exceptions, histories of the early U.S. film industry in general and Universal in particular identify corporate decisions with those of the chief executive.[6] Universal, the story goes, did what Uncle Carl thought it should. A close look at the company as a whole suggests a different picture.

In truth, the basic facts of institutional life constrained Laemmle's—indeed, anyone's—ability to command daily operations.

Laemmle held the position of president from June 1912 until he retired in April 1936. His longevity testifies to his personal effectiveness, but it also owes a good deal to his partnership with the advertising wizard Robert H. Cochrane, who served as vice president from 1915 to 1936 and thereafter became president of a reorganized Universal.[7] During the company's first two years, Laemmle's presidency cannot have seemed secure. In addition to the fracas with Kessel and Bauman, headline-catching disputes among the original incorporators included an episode involving the defenestration of the account books in the summer of 1913.[8] By January 1915, however, William Swanson, David Horsely, and Mark Dintenfass had all been bought out, and the remaining stockholders arrived at a stable configuration of corporate officers with Laemmle as president, Cochrane as vice president, and their rival Patrick A. Powers as treasurer.

A snapshot of Universal's stockholders taken at the close of business on May 19, 1916, makes plain that Laemmle's presidency depended on his ability to command a voting block. Although he owned a significant majority of the preferred stock, preferred stock did not vote.[9] Holdings of the voting common stock were more evenly divided: twenty-two individuals held a total of 8,823 shares; Laemmle owned 3,301, and Powers owned 3,362 (6,663 shares combined). Either man could prevail by swinging other shareholders, but Laemmle could be sure to retain the top job so long as Cochrane remained loyal, since Cochrane and Recha Laemmle, Carl's wife, were the next largest stockholders with 614 shares each. (Powers finally sold out to Laemmle and Cochrane in 1920.[10]) Although Cochrane owned a comparatively small share of the company and never received the quantity of public attention that Laemmle and Powers did, anyone in a position to count shares would know that he had considerable leverage.

If the relationship between ownership and the corporate presidency was fraught, the relation of ownership to daily control was even more so. The company was simply too big to allow its owner-officers to supervise closely all of its operations. Laemmle and Cochrane cultivated salaried executives such as Joe Brandt, who was promoted in 1915 from being Laemmle's personal secretary to manage the home office and remained a senior executive with Universal until 1919, when he left to form the National Film Corporation.[11] Only a handful of Universal's top managers lasted so long. While the scope

and scale of Universal operations clearly required a substantial administrative apparatus, frequent changes to the arrangement and staffing of its organizational chart indicate uncertainty about what form such an apparatus should take and how exactly it should function.

A major challenge of coordination stemmed from the firm's bicoastal organization. The 1920 *Motion Picture News Studio Directory and Trade Annual* lists fourteen department heads who supervised, from New York, the system of fifty-three "branches" (exchanges) in the United States and Canada, as well as such functions as purchasing, advertising, posters, press books, and publicity. The Mecca Building also housed a "special exploitation representative" and the offices of Paul Gulik, the editor-in-chief of *Moving Picture Weekly*. Although New York ran a unit making industrial and educational films, production was primarily a West Coast affair. Universal City had its own large and substantially independent bureaucracy. The 1920 *Studio Directory* (based on 1919 information) lists eight department heads at Universal City, and it indicates only two points of formal overlap between East and West Coast organizations: the general manager Tarkington Baker and the scenario editor Percy Heath. A 1916 article in the *New York Dramatic Mirror* describes twelve Universal City departments: productions, engagements, scenario, laboratory, technical, photographic, staff and prop, back ranch, screen editor, engaging of extras, cashier, and purchasing.[12] At that point, only the studio head, who was also second vice president, formally connected California to New York. In short, in its official structure the firm developed parallel East and West Coast hierarchies joined by key positions at the top.

Universal City leadership changed with notable frequency during the 1910s. Periods of relatively stable management are punctuated by periods when existing sources leave it unclear exactly who was in charge. In late June 1913, Isadore Bernstein replaced A. M. Kennedy as manager of Universal's Pacific Coast Studios (comprising at that point a studio at Sunset and Gower and the first version of Universal City).[13] Formerly a newspaper editor and director of a school for boys, Bernstein had been general manager of Monopol Film Company. He oversaw the building of the second Universal City, resigning soon after it officially opened in March 1915.[14]

A brief transitional period followed. The *Weekly* reported in April that George Magie had traveled west to install a new arrangement: as the studio's general manager he would oversee five business managers. In its cursory description of their roles, the article indicates that they would have duties somewhat

like those of the executive producer (Magie) and line producers (the five) that would later become industry standard.[15] In October, it was reported that George Kann, corporate secretary and assistant treasurer, had been promoted to business manager of Universal City.[16] At that point, Henry McRae was likely serving as the studio's director general.[17]

In late November 1915, H. O. Davis assumed the position of studio head as second vice president of Universal and general manager of Universal City. The former manager of a cattle ranch, Davis had likely come to Universal's attention through his work as manager of the San Diego Exposition, which cross-promoted itself with tours of Universal City.[18] He lasted about as long as Bernstein did. In May 1917, the *New York Dramatic Mirror* reported that Laemmle was "at the head of activities at Universal City," and a month later it was announced that Davis had been elected vice president and general manager at Triangle.[19] Henry McRae was again "at the helm."[20]

Available sources do not provide a clear picture of what happened next. Harry Kline was transferred from the New York office to become "production manager" in mid-May 1919, at which point the former head of the publicity department, Tarkington Baker, may have already been "general manager" at the studio.[21] In late February 1920, the *Los Angeles Times* reported that Baker had been promoted to "general manager, director-general, and supervisor of productions," but in mid-April the *New York Times* reported his resignation.[22] In early June, the *Los Angeles Times* reported that Universal City would be under a "commission form of government" with Bernstein back as manager of production, Louis A. Loeb as financial manager, and Laemmle's former personal secretary Irving Thalberg as his "personal representative."[23] The 1921 *Studio Directory* and an internal 1920 telephone directory of Universal City list Thalberg as "general manager" and Harry Shenck as "production manager."[24]

Three factors contributed to this pattern of rapidly changing management. First, the labor market was generally volatile. Although it would be difficult to provide a reliable index against which to measure changes at Universal, the trade press and biographical accounts of the early film industry leave the impression that managers moved frequently from job to job and firm to firm.

Second, the changing title of Universal City's top executive and the various backgrounds of the persons hired suggest that the company had difficulty defining the job as well as the necessary qualifications for it. There was no doubt that executives would be men, but there was some doubt about the kind of men they should be. The uncertainty makes sense, given that the

role of studio head had yet to be fully distinguished within the industrial division of labor more broadly. The legend that has grown up around the "boy prince" Irving Thalberg credits him with defining that role at Universal against the customary prerogatives of the studio's old hands and directors. The historical record makes clear, however, that Isadore Bernstein and H. O. Davis shaped the position decisively years before Thalberg's arrival. Defining "studio head" proceeded in fits and starts, in other words, rather than in a burst of youthful organizational genius. As we shall see, this process had everything to do with changes to the cultural geography of production.

Third, and probably most significantly, New York's interpretations of how work was going on "the coast" must have spurred management changes. Given that Universal's business model was itself in flux in these years (as witnessed by its changing brand architecture), those interpretations required more than a look at the bottom line. They must have entailed all manner of judgments about who in distant Hollywood could provide trustworthy information about work on the lot and who, there and in the home office, could best forecast the future of the rapidly evolving industry.

For all these reasons, relatively frequent changes among Universal City's senior management emphasize the difficulty of "knowing the score" from moment to moment as well as the importance of knowing it, given the likelihood that new interpretations could result in substantial changes on the lot.

H. O. Davis (1915–17)

Fully half of the Universal women were promoted to director under Davis. This coincidence may or may not have had anything do to with his attitude toward women, but it almost certainly had something to do with how he understood the job of director. The cattle baron turned movie producer became notorious for rationalizing production at Universal City, and his emphasis on efficiency was likely opportunity-creating for women. It is also the case, however, that Universal City cannot have actually worked as Davis envisioned it should. Surviving correspondence from Davis to Laemmle and between Cochrane and the Universal attorney Siegfried Hartman provides a rare look behind the studio's public-relations curtain and a concrete example of the interaction of formal and informal organization described by Selznick. This correspondence clarifies why corporate decisions are, in fact, corporate and suggests that uncertainties regarding the informal distribution of power may have been as important as formal policies in creating opportunities for women to direct.

On March 15, 1917, only two months before announcements of Davis's departure, Cochrane sent Hartman a three-page typewritten letter characterizing Laemmle's six-week visit to the West Coast as a total disaster. The vice president cautions the attorney that Laemmle is likely to stir up trouble on his return to New York and requests his help in protecting Universal's president from himself. Instead of dealing forthrightly with "Mrs. Smalley" (Lois Weber) regarding a contract dispute, Cochrane reports that Laemmle had been preoccupied with finding information damaging to Davis. Spurred on by relatives and his longtime associates Julius and Abie Stern, he had sought out directors and actors dismissed by Davis and openly criticized working conditions on the lot in interviews with current employees. The results, according to Cochrane, approached "chaos." Moreover, he tells Hartman, Bluebird directors had wanted to go to Laemmle and threaten mass resignation unless he listened to their favorable report on Davis. Cochrane apparently thwarted this plan for fear it would have exacerbated the difficulty. In this way, the vice president presents himself as uniquely capable of moderating the dispute.

But he is also clearly a Davis partisan. Cochrane explains that he has extracted Davis's promise to stick with the company until he determines the situation to be "hopeless" and confides to Hartman that he does not know how Davis has managed to tolerate it. Reading between the lines, it seems that Cochrane might have identified with Davis in feeling abused. He reports that Laemmle tried to trick him into selling his shares of Universal stock, that the president had been inflating his own reputation at Cochrane's expense, and that he had cultivated a paranoid belief that Cochrane sought to circumvent him in the management of the firm. The letter gives some evidence for this last contention, since it shows Cochrane scheming with Hartman about how to constrain the boss, an alliance cemented by a series of telegrams in which the two contrive to delay Laemmle from taking action so that Cochrane might clean up the mess in California and return to the home office.

In this regard, Cochrane does not tell the whole story when he urges Hartman to understand the roots of the problem in psychological terms as stemming from Laemmle's "bitter jealousy" of Davis and his resentment that the West Coast employees do not "make a great deal of him." The size and fragility of Laemmle's ego notwithstanding, the letter paints a broader picture. In it, the contending interests and interpretations of former employees, current Bluebird directors, Hartman, Davis, Cochrane, and the Stern brothers all play a role in setting Universal's president at odds with the company's senior executives.[25]

A key point of tension has to do with Laemmle's influence over the book-

keeper, H. R. Hough. All participants in this dispute seem eager for the books to provide an accurate assessment of production at Universal City, but accounting's authority as a neutral arbiter was in question. Cochrane informs Hartman that Laemmle had spent a lot of time trying to get Hough to represent the figures in a way that would emphasize business defects and overlook successes. Telegramming Cochrane on Laemmle's return to New York, Hartman reports that the president was "extraordinarily aroused" by misleading facts and figures that he had been unable to correct. He particularly wanted Cochrane's help in explaining the Hollywood studio's increased weekly expenditures. Cochrane replies that the misleading numbers had been refuted in Laemmle's presence and promises to provide "honest figures certified by Laemmle's own men." These numbers, he asserts, will point to enormous savings on the coast that had made operations more efficient while preventing a shortage of release prints.[26]

Laemmle's failings are on display here, but the recitation of them underscores three familiar institutional ideals: the numbers should have autonomous truth value derived from the disciplinary integrity of those who produce them (such that "Laemmle's own men" might generate numbers at odds with his preferred interpretation); the chief executive should have mastery over the figures but should not interfere in their production; and to translate into future action, the accounts would have to be interpreted.[27] If weekly expenditures had increased, that is, it was not self-evident what that increase would mean for the future of the enterprise: it might portend mismanagement or promise corresponding increases in income. An institutional context where such a difference between generating the numbers and interpreting them holds sway necessarily distributes power within its hierarchy, and Cochrane's complaint might be understood to turn on his conviction that Laemmle had rejected that principle.

In a March 23 letter, Davis responds point by point to notes apparently left by Laemmle prior to his departure for New York. He adopts the tone of a loyal subordinate eager to clear up misunderstandings, but he employs it archly, with exaggerated emphasis. Davis contends that he has never objected to independent auditing. He adds that Hough, newly tasked to report directly to New York, will face no interference or difficulties—provided he limits himself to his auditing task. The letter concludes by asking Laemmle to explain exactly what types of pictures New York wants made on a newly mandated operating budget of thirty-five thousand dollars per week. Davis lists the approximate costs of each type of film, explains that production cuts will be necessary,

and pointedly reminds Laemmle of their joint decision (with Cochrane) to discontinue one- and two-reel dramas (which had been the cheapest films to make) because "the exchange men say they are a drag on the market."[28] Here too the implication is that Laemmle has lost his grip on the economics of production and is meddling in affairs he does not understand. Davis's explicit request that Laemmle define the production schedule is equally noteworthy, however, because it underscores that any effort to judge whether costs are too high would have to interpret those costs in light of assumptions outside the bookkeeper's purview. Crucially, such judgments would need to anticipate a changing market for shorts and features.

In addition to revealing the pivotal and contested role of accounting, this executive-level correspondence also indicates what Selznick would describe as a tension between official hierarchy and the "cooperative social structure." Laemmle and Cochrane evidently held opposing interpretations of Davis's management skills. Cochrane, Davis, and Hartman collaborated to check Laemmle's authority within the firm. The Stern brothers, if Cochrane's account is accurate, apparently traded on their family connection and long association with Laemmle to undermine Davis's position, and possibly Cochrane's as well. Abe Stern was Laemmle's brother-in-law, and Julius had worked for the Laemmle Film Service nearly from its beginning in 1906.[29] Julius may have had a specific axe to grind in 1917, as he had been in charge of Universal's studio in Leonia before the company abandoned it to concentrate production on the Coast. At the time, this move was publicly attributed to the efficiencies of Davis's administration.[30] Although surviving records do not indicate whether Davis resigned, as Cochrane feared he might, or was fired, as seems likely to have been Laemmle's inclination, this correspondence makes clear that the impasse stemmed from the fact that, for reasons professional and personal, the nominal hierarchy of the firm was crisscrossed by factional interests such that various parties could not take others' assertions of the corporate good at face value.

An exemplary statement in this regard is Davis's response to Laemmle's report of a rumor that Davis would discharge McRae as soon as the president left town. Disclaiming any knowledge of the rumor, Davis avows that if Laemmle wants to continue McRae at the highest director's salary on the lot (three hundred dollars a week), he has no objection. However, he feels that he should not be expected to assume responsibility for the cost or quality of McRae's films. To underscore the point (and twist the knife), he mentions that

Universal has numerous better directors who are paid much less. In addition to revealing an ambiguity over who would normally have had the authority to hire and fire directors (is Laemmle "taking back" a power formerly delegated to Davis?), the rebuttal actually lends credence to the rumor. Davis implies that McRae is not worth three hundred dollars a week and that Laemmle is a hypocrite for emphasizing cost controls while favoring him. Moreover, Davis's hostility to McRae is easily understood as self-interested, since it can have escaped no one's notice that McRae preceded Davis in the job of general manager and would therefore be a likely candidate to succeed him. Nonetheless, it is possible that Davis was right. The few surviving samples of McRae's directorial work do not in retrospect seem particularly accomplished, and Davis, much closer to the actual work of production than Laemmle, was in a better position to relate directorial quality to cost. If Davis was right, then McRae's salary defied business sense. Even so, Davis's deference to hierarchy, however ironic, combined with Laemmle's interest in McRae, however motivated, meant that McRae lasted two months to become, once again, interim studio head. If Davis was wrong, and McRae was an accomplished director in addition to being a Laemmle favorite, then it would seem that Davis's administration had been working against Universal's business interests, just as Laemmle apparently feared.

The crucial point is this: there was no Archimedean point within the firm from which to make this judgment. The account books could not have provided one; every answer to the question of Davis's or McRae's competence would have entailed an assertion of loyalty to one faction or another; no position could claim disinterest. Davis's enthusiasm for the development of formal organization lends credence to Cochrane's perception of Laemmle's jealousy. It also gives a more reasonable complexion to the president's concern that he was in danger of losing the loyalty of his employees—and particularly of the Bluebird directors who, Cochrane avers, wanted to come to Davis's defense. It was not merely a question of which people would prevail but of which faction would set the standards of cost and quality for the organization. Whether Davis decided to resign or Laemmle decided to fire him, the decision to replace Davis with McRae was, properly speaking, Universal's. Post-hoc, we can see that it resulted from a tension between the formal organization and the differently motivated interpretations of how well that organization worked from competing factions within the firm.

Because Universal women directors were relatively concentrated in the

production of Bluebirds, because Cochrane insinuates that Bluebird directors were Davis partisans, and because Cochrane specifically mentions a dispute involving Weber (then the company's most profitable director), this factional contest concerned the Universal women in both senses of the word: it likely worried them personally as well as affected their working conditions as employees. Equally clear, however, is that the organization's decision to replace Davis with McRae was not a decision about whether women should or should not direct. In fact, many of the women promoted to the director's chair under Davis continued to work under McRae. The dispute with Weber ended in her favor: she won support for her own largely autonomous studio, which continued to release through Universal. The decisive changes in employment prospects for women directors did not come until later and had little to do with the question of who ran Universal City.

The dispute captured in the Cochrane-Hartman correspondence is more interesting for what it reveals about why women directed at Universal in the first place. Davis was plainly a strong manager whose tenure realigned informal allegiances within the organization in addition to altering formal structures. Simply put, Davis's management must have seriously disrupted the informal networks that had connected Laemmle with West Coast operations through McRae. Although nothing in this correspondence explains why shaking things up in this way would have been good for women directors specifically, it does indicate substantial changes in the habit by which one "knew the score." Habit change creates possibility.

Changes to the informal distribution of power were not, however, the only sorts of changes afoot. By 1917 Davis was notorious for his opposition to the star system and his advocacy of "efficiency" in production. In practice, efficiency meant annexing techniques of cost accounting and scheduling to the continuity script such that work could be subdivided into specialties, evaluated against standards of productivity and expense, and hierarchically managed, so that, for example, the work of planning various filmmaking activities was separated from the bodies who performed those activities.[31] Davis did not introduce this type of management at Universal. Accounts of Universal's business operations boasted the scope and efficiency of its cost-accounting and production-tracking systems as early as 1913.[32] Early in 1914, the *Universal Weekly* staged a visit to the West Coast facilities that discovered "some thirty bookkeepers scratching in unison" and found the studio manager Isadore Bernstein declaring, "'There is not a single picture ever made at this

studio that we can't tell you to a penny how much it cost to make.'"[33] If Davis did not pioneer efficiency-minded central management at Universal, however, he did significantly strengthen it.

In May 1917, Davis described for readers of the fan magazine *Photoplay* how he envisioned Universal's formal organization. The studio manager tracks a hypothetical movie from script to screen. It is worth following this article at some length, for its aspirations as well as for what it reveals about the logistics of production during Universal's best year for women directors.

Davis begins by explaining that Universal reads five thousand or so manuscripts a month, "from amateurs as well as more or less well-known authors" plus current magazine fiction. The scenario department compiles reviews and synopses of these works; the scenario editor reads and rejects "at least 95 percent."[34] The remaining 5 percent go to a second reader, and on the basis of the two reports the scenario editor makes recommendations for purchase to the production manager, "who has a reading staff of his own, trained to read manuscripts not only from the story standpoint but from the production standpoint." "From the production standpoint" means, in large part, "considering the money." The production manager's staff attaches an estimate of costs to its recommendations. Stories approved by the production manager, Davis explains, "form our source of supply, together with the output of special writers who are writing scenarios on particular subjects."

Next, the production office matches scenarios with a director. It looks ahead in its "daily or hourly record of all the directors on the plant" to discover who will be available. The production manager requests from the scenario department "several stories of the particular type that this director is best fitted for" and, after vetting them, passes them to the director for selection. The director's choice goes to a continuity writer who develops a script after a "conference with the editor of the department, the director, and the manager of production." After approval by the scenario editor, the continuity script heads to the production office, which checks it "for possible faults from a production standpoint and then turns it over to the director," who has several days to make suggestions, which may in turn require rewrites. "After the perfect script is completed," Davis asserts, "it is again sent to the production office, where an estimator [again] estimates the cost of production."

Up to this point, Davis has described a process organized almost exclusively for and through the scenario, but this new cost estimate gives the film a second life as a budget entity: "The estimate is sent to the executive office

with a request for an appropriation, which, unless there is some good reason to the contrary, is granted, and the production department is given authority to expend the amount of money appropriated for this particular picture." The work in progress becomes not only a film but also a means of allocating money to different departments. Davis includes a sample estimate sheet that divides the budget for a five-reel film having ten sets, twenty-one locations, and 306 scenes into items for overhead costs, salaries, extras, laboratory, negative, sets, rentals (props itemized in a separate column), story, lunches, and locations (total: $6,026).

Once such an estimate has been approved, the director "takes his script to the specification and set man in the production office." Scene plots and drawings for special sets are created. "The librarian selects plates and books accurately describing the architecture, customs, and costumes" to inform the production of period pictures. After the director approves plots and drawings, the production office sends them to the technical department "with the date and hour on each plot, specifying when it is wanted." The director then casts the picture "in conference with the head of the casting department and the manager of production." Here, in its evident hostility to the star system, Davis's account departs polemically from the impression conveyed by Universal's own credits and advertisements.[35] Noting that "we carry about 300 actors and actresses of various types on the payroll and in stock at all times," he maintains that "actors are cast *for the picture,* without any regard for alleged stars. If there is a maid in the picture, we insist upon her being a good maid. An actress who plays a maid in one picture may play a lead in the next and vice versa."

Davis then envisions a process in which the director has nothing to do but "tell his story." Explicitly answering the objection that systematization undermines artistic authority and creativity, Davis explains how this division of labor serves the creative process. The director shows up to find the set constructed and dressed, with cameraman and cast at the ready. The laboratory head, "in supreme command of all the camera men," is there to approve the light. "From this time on the production office will keep two or three sets ahead of him all the time, so as not to interrupt the continuity of his work. The assistant director reports to the production office twice a day the number of scenes 'shot,' so that the office is kept in constant touch with the work," allowing the head of the laboratory and electrical engineer also to work ahead. At the end of the day, the laboratory develops and prints the

film to be run for the director's approval the next morning. If "O.K.," the print goes to the "film editorial department" to be "assembled in rough continuity as the work progresses, the film editor also having a copy of the script and a cutter assigned to this particular story." Upon completion of filming, the editor, cutter, and director consult on the final cut, over which the director and editor together have approval.

It should be apparent that the question of whether central supervision promotes or discourages aesthetic achievement disguises a workplace struggle over power, registered here in the attention to who approves what when. Directors who had worked for Universal before Davis may have considered themselves losers in this struggle. Thanks to the film historian Janet Staiger, we see Davis, along with Thomas Ince, as an architect of the central producer system that, beginning around 1914, replaced "director-unit" organization, in which the director had broad responsibility for the totality of a film's production and might also the write the scenario (or significantly modify it during production), act one of the leading parts, or both. In the new system, Staiger explains, the continuity script served as the central mechanism through which supervisors above the director orchestrated production and sought to balance creative and economic imperatives.[36]

Davis almost certainly institutionalized something like the system he describes. *Motography,* for example, credited him with reducing the production schedule for a five-reel film to about eighteen days, down from six to eight weeks.[37] Such changes doubtlessly proved consequential for the director's work. Nonetheless, they cannot have succeeded in completely displacing earlier work habits, nor were they able to counter other industrial trends, such as the star system, in which the institution had a stake.

A closer look makes clear that the shift from one system to another did not come about all at once or through the efforts of talented individuals. Rather, managers like Davis built on and altered organizational habits that preceded them with effects that took some time to ramify through the organization. For example, Universal did not distinguish "director" from "producer" consistently before the end of the decade. Its house organ used the terms interchangeably through at least 1918, although with a slight difference in connotation that suggested a survival of the "director-unit" model: "producer" or "producing director" indicated supervision of a relatively stable company. For instance, *Moving Picture Weekly* gave notice in 1917 that "Miss Baldwin is a 'regular,' with

a company of her own, and a rating as a producer for the Universal program; while Miss Stonehouse just takes an occasional flier into direction, in the intervals of starring for somebody else."[38] Moreover, the habit of "company" organization described in the previous chapter militated against the open-casting and central-staffing models Davis envisions. Although Davis was powerful, his choices cannot have entirely determined Universal's decisions.

With respect to the evolution of the central producer system, the case of Universal also clarifies the importance of cost accounting as the continuity script's partner. Cost accounting does not only track expenditures; it also manages people by defining a standard against which their performance can be measured. To say what a particular story should cost to produce, for example, the production department had to know the normal cost for films with comparable casts, numbers of sets and locations, special props, and so on.

This is known as "standard costing," a technology that proliferated in business enterprises and state bureaucracies on both sides of the Atlantic, but with particular vigor in the United States, between 1910 and 1930.[39] According to the historians Peter Miller and Ted O'Leary, this kind of cost accounting "supplemented the traditional concerns of accounting with the fidelity or honesty of the person" by making individuals and collectives "accountable by reference to prescribed standards of performance."[40] Accounting standards did not merely judge the integrity of past conduct; they disciplined further conduct insofar as individuals became aware that deviating from those standards would prove consequential. Cost accounting thereby became a widespread form of governance.

It seems likely that Universal employed some form of standard costing under Bernstein, although the details are unclear. Certainly a system for tracking costs existed. Consonant with Staiger's findings, however, it seems that in 1914 directors had substantial authority to manage production budgets.[41] In any case, Davis's system clearly envisioned a highly developed and extensive application of the art. Indeed, the "daily or hourly record" of production bespeaks the supervision characteristic of disciplinary systems. Budget reports, strict timetables, and daily review of work, reckoned against standard expectations, encourage self-discipline in employees and support a specialized division of labor in which writers write, directors direct, the laboratory head supervises cinematography, and actors good at playing maids play maids. Davis maintains that such specialization enhanced quality as well as predictability,

and this may have been the case. Unquestionably, however, the system limited the director's discretion by subordinating it to the procedure organized by the continuity script and supervised by accountants.

Some directors resisted these new rules. Although Cochrane does not reveal precisely what Weber's concerns were, that the solution involved establishing her own studio and that she publicly avowed a desire to personally control all aspects of production suggest that the controls imposed by Davis's system were an issue. Moreover, Davis's management apparently alienated Grace Cunard and Francis Ford, the company's major serial producers, in the spring of 1916. The team walked off the set, delaying production of *Peg o' the Ring*, requiring the mediation of Laemmle, and resulting in an agreement that returned them to production not at Davis's Universal City but at the L-KO studio (at Sunset and Gower), managed by the Stern brothers.[42] Nonetheless, it is possible to credit Cochrane's report of the Bluebird directors' enthusiasm for the Davis adminis-tration for precisely the reasons Davis gives. The director retained substantial authority over all aspects of production except budgeting. Coordination and specialization made the director's job easier. The structure laid out normative expectations. And, finally, it was likely that work that met or exceeded those expectations would be noticed and approved by senior managers.

What sense, then, do we make of the fact that Davis's organizational zeal coincides with the promotion of significant numbers of women actors and screenwriters to the director's chair? If the disruption of habit that accompa-nied new studio leadership in 1915 created possibilities for women directors, how did new procedures take advantage of those possibilities such that more women directed in 1917 than any other year? The sociology devoted to the problem of occupational sex segregation in general suggests an intriguing hypothesis. It points out that self-consciously meritocratic forms of workplace discipline encourage integration.

According to one influential line of reasoning, gatekeepers exclude women from particular occupations not because they cannot compete with their male counterparts but because they are not given the opportunity to do so. While acknowledging blatant discrimination, this approach emphasizes the infor-mal social habits that operate within and across organizations to reinforce occupational segregation by sex. These include the attribution of gender to particular jobs, the attribution, in advance, of gendered traits to individual persons, the tendency of employers to hire people like themselves, and the reliance on informal personal networks rather than open competition when

H. O. Davis, n.d.
Author's collection.

filling positions. Such factors not only inform an employer's choices but can also lead workers to self-select gender-typical occupations.

Organizational changes can counter these habits. For example, performance-based evaluations and open advertising for positions encourage integration and, it is argued, undermine the stereotypes that perpetuate segregation. This basic model informs equal-opportunity and affirmative-action programs, and its practical application arguably reduced the index of occupational sex segregation in the United States from around 70 percent in 1970 to just over 50 percent in 2000.[43]

Following this reasoning, one might speculate that Davis's system encour-aged integration of the director's chair by making expectations of quality, schedule, and budget explicit and by rewarding those who met or exceeded them, regardless of sex.[44] Such speculation has the virtue of upsetting one of criticism's more romantic habits. Artistry, critics reflexively assert, has no love of business. Cast the artist as a woman, and the corporation plays the part of her male oppressor. The hypothesis that systematization benefited women directors requires us to regard more critically the supposed antimony of art and commerce and the personification of the corporation as a bad man.

We should take seriously the proposition that Universal promoted women not out of a guilty conscience, nor in a spontaneous eruption of paternal

generosity, nor even because the women cannily outfoxed it, but because the organization judged them to be good at their jobs. Alongside the possibility-creating disruption of informal networks that had allowed Universalites to "know the score" before Davis showed up on the lot, one might therefore set organizational mechanisms that allowed women to succeed on their merits. While such mechanisms may have raised the hackles of individual stars like Weber and Cunard, they appear to have advantaged women as a group.

This hypothesis, however, presents its own problem—namely, that of determining how the organization brought the job of "director" and the category of "woman" into this particular alignment. A comparison of the key positions reveals this to be a crucial issue. If it were simply a matter of rational performance-based criteria promoting equal opportunity and thus integration, one might expect systematization to have opened to women such jobs as production manager, cinematographer, and carpenter. This did not occur. Of those jobs mentioned by Davis in his review of the production process, only the occupations of actor, scenario writer, and director were significantly integrated by sex.[45] Universal employed only one woman as department head during Davis's tenure: Eugenie Magnus Ingleton ran the scenario department with Eugene B. Lewis in late 1916, when five of fourteen staff writers were women.[46]

Bucking the industry-wide trend detailed by Karen Mahar, the position of director at Universal was unique in undergoing two changes simultaneously: it became more open to women and more clearly defined as a specialized kind of middle management. To account for this distinctive interpretation, the time has come to shift attention away from Universal's names and organization toward a consideration of its interpretation of gender. It is time to ask what Universal thought a woman was. Universal asked itself this question, it turns out, via corporate geography. Before we can rejoin managers and creative personnel at Universal City in 1915, this connection between gender and spatial arrangement wants explanation.

Universal City

A December 1913 *Universal Weekly* headline proclaimed the company's West Coast facility a place "Where Work Is Play and Play Is Work," and a subhead amplified, "Universal City, California, the Only Incorporated Moving Picture Town in the World, and Its Unique Features; 'Movie' Actresses Control Its Politics." True to its headline, the article links and balances three pairs of terms that would likely appear contradictory if not made reciprocally confirming: "work" and "play," "business organization" and "municipal government," "actresses" and "authority." This rhetorical feat established an interpretative paradigm, and for the next several years, popular and industrial press coverage continued to explain Universal City in more or less these terms. But the balancing act was not merely rhetorical. Planners built it into a new version of Universal City, which had its gala opening on March 15, 1915. This "chameleon city" embodied in timber, steel, and concrete the proposition that work and play are opposites that can nonetheless be reconciled.[1]

While continuing to promote fun, the new Universal City allowed the company to increase the quantity of production, centralize its supervision, and concentrate it on the West Coast. Early descriptions extended the rhetoric of the 1913 article in imagining that the city embodied the efficiency of the most up-to-date office building without ceasing to be an infinitely mutable wonderland. In effect, the city sought to reconcile in its spatial arrangement competing and potentially contradictory conceptions of power. On the one hand, it embodied a functionalist conception: the city as a vast machine under central supervision. On the other hand, it enacted a theatrical conception in which authority derives from public performance. Built into corporate space, the tension between these two models of authority encouraged experimenta-

tion with gender in the arrangement of work. This was among the key reasons why the number of women Universal credited as directors doubled from two to four in 1916 and doubled again to eight the following year.

As a "city," Universal's studio also necessarily invoked a third sphere of activity, distinct from either work or play and associated with its own manner of distributing and gendering power: home. Home proved resistant to incorporation within a dialectic of work and play. While it may be true, as Gaston Bachelard claims, that all built space has a homelike quality, Universal instituted the opposite contention.[2] Whereas planners and promoters had originally envisioned that the city would encompass the homes of its employees, by decade's end it was clear that they would commute. This habit limited the opportunities urban playfulness had created for women. It begged explanation in terms of the old ideology of separate spheres that imagined women as naturally suited to the supervision of domestic functions—intimacy and moral cultivation along with the aesthetic and pragmatic work of keeping house—and men as better fit for the dispassionate administration of businesses and bureaus. In fact, the "return" to this habit did not reprise the nineteenth-century norm so much as insist that a new norm could be understood in its familiar terms.

This process of updating by appearing to recycle has been well studied at the scale of U.S. national culture, and a number of social and culture histories explain cinema's contribution to it. Perhaps most clearly, Progressive Era cinema helped reconfigure the nineteenth-century distinction between a feminized domestic sphere and the masculine spheres of business and politics through its promotion of new sexual thrills and a concomitant reconfiguration of the rules of romance. The safety and mobility of young women outside the home particularly concerned audiences, filmmakers, and those who would regulate them. A spate of controversial white-slavery films, for example, established the city as a scene of predation for the unwary but also reiterated that it could be an arena of true love for the fortunate and the alert. For every hapless immigrant lured into a house of ill repute, the movies prepared a plucky stenographer to meet cute and marry well. In part to regulate the difference between romance and ruin, but taking a much broader view of social vice, cinema adapted contemporary discourses of uplift that extended the logic of domestic supervision outside the home and professionalized it. By inclination, movies favored moral and individual solutions to social problems over explicitly political ones. Accordingly, they greeted suffrage campaigns with

ambivalence: comedy was a favored mode. Finally, while historians argue over what films contributed to the ethos of a rising new middle class of salaried mental workers, all agree that they promoted consumerism and established the ideal consumer as a woman. By giving romance a public dimension and allowing it to penetrate the workplace, by extending the purview of domestic care, and by celebrating feminized consumption, 1910s cinema overhauled the nineteenth-century ideology of middle-class domesticity.[3]

Amidst the profusion of concern about cinema's effect on U.S. culture during this pivotal moment of urban modernity, it has been easy to overlook that filmmakers also confronted changing norms as employees. In their large, mixed-sex workplaces, filmmakers must have worried about the unwelcome advances of coworkers, even as they conducted workplace romances. They were, of necessity, aware of their participation in public arguments about their products' uplifting or demoralizing influence, and they doubtlessly held various political opinions on such questions as suffrage. If they sought upward mobility in classic American fashion, they nonetheless sought it in a new, nontraditional industry that was rapidly being organized along the most modern of corporate lines. And while film workers who could afford to do so apparently embraced the consumer lifestyle with enthusiasm, they must also have felt its disciplinary force. Women actors and directors in particular must have perceived their taste in clothes, homes, and automobiles to have been under constant surveillance by fan magazines and the popular press, which regularly ran articles on what they wore and how they lived. By developing key themes of filmmaking in the period, Universal's filmmakers perhaps hoped to explain their working circumstances to themselves.

The explanation they offered ultimately undermined the more intriguing possibilities of the place where they worked. Initially, Universal imagined its city as workplace, spectacle, polity, and home. Through the end of 1917, makers of short dramas and comedies capitalized on this conflation of categories to articulate gender with work in novel ways. Cleo Madison's 1916 two-reel *Her Defiance,* for example, locates a version of the family home in an office build-ing, while her one-reel *Eleanor's Catch* (1916) makes domestic space a location for undercover detective work. In *Dolly's Scoop* (directed by Joseph De Grasse from an Ida May Park screenplay, also in 1916), a woman reporter saves her editor's marriage, reforms her newspaper, and finds romance in the newsroom. In a similar vein, diverse films used cross-dressing to present bodies understood as female performing practices understood as masculine. A random selection

of examples from 1914 includes the Imp Comedy *Papa's Darling*, the serial *The Black Box*, and Grace Cunard and Francis Ford's *The Return of the Twin's Double*, an installment in the 101 Bison *My Lady Raffles* series of crime-dramas. The device continued into feature films such as the 1917 Bluebird *The Boy-Girl* and Elsie Jane Wilson's 1918 Bluebird *The Dream Lady*.[4]

Increasingly, however, the force of habit militated against such experimentation. It favored segregating "home" from "workplace" and reestablishing feminine authority over the former as the logical counterpart to masculine authority over the latter. As we shall see in part 2, the elimination of the short drama and the increasing importance of generic distinctions among feature films made women directors collaborators in promoting such a conception of home's difference from the workplace. Eventually, Universal City itself was remade in this image. Commentators reconceived its playful embrace of contradiction, once seen as emblematic of its progressive character, as a part of the industry's slightly disreputable past.

Thus, institutional geography encouraged the phenomenon of the Universal women directors and materialized a contradiction that foreclosed it. To understand geography in this way affirms what Universal City has in common

Grace Cunard in *Return of the Twin's Double*, 1914. Courtesy Robert S. Birchard Collection.

with all modern social spaces. It owes its existence to representation and determines representations that depart from its initial plan.

As Henri Lefebvre explains, modern persons almost never encounter a space that some sort of map or plan has not organized in advance. Yet such maps are not identical with the territory. Lefebvre distinguishes two sorts of relationships between representation and space. By "representations of space," he refers to "conceptualized space, the space of scientists, planners, urbanists, technocratic subdividers, and social engineers, as of a certain type of artists with a scientific bent." "Representational space," in contrast, means space as "directly *lived* through its associated images and symbols, and hence the space of 'inhabitants' and 'users,' but also of some artists and perhaps those, such as a few writers and philosophers, who *describe* and aspire to do no more than describe."

The difference between representations that seek to order spaces and those that aim to describe them provides Lefebvre with a means of explaining how changes to spatial organization might occur. Planners have difficulty envisioning substantive change because they "identify what is lived and what is perceived with what is conceived." Describers, in contrast, show up the difference between the plan and what it means to inhabit it and thereby make available "the dominated—and hence passively experienced—space which the imagination seeks to change and appropriate." Like the worn pathways that crisscross lawns in mute defiance of sanctioned sidewalks, this "representational space" testifies to the survival of experience that planners deny and attempt to "vanquish"—typically in the name of progress. By definition, representational space cannot itself be the space of an alternative plan. But it might inspire one. Lefebvre sees the two sorts of space as dialectically related in the category of "spatial practice," which sublates plan and description, conception and perception.[5] Among other features, the practice of reworking representations of space can chart the way to revising authority over them.

Work, Play, and Politics: Universal City and Corporate Myth to 1915

Although not the first film manufacturer to style its plant as a sort of city, Universal stands out for its dedication to that vision. At the time of Universal's genesis in the spring of 1912, Los Angeles was not yet the movie capital it would become by decade's end. Major manufacturers scattered plants across the

country, with significant concentrations in New York City; Fort Lee, New Jersey; Chicago; and Jacksonville, Florida. In North Philadelphia, Siegmund Lubin in 1909 established a studio the local press called "Lubinville." Three years later, he purchased a 350–acre estate across the Schuylkill River in Betzwood to create a grander and more townlike facility.[6] On the West Coast, the New York Motion Picture Company's Inceville (named after the director Thomas Ince) comprised eighteen thousand acres of canyon land north of Santa Monica where Sunset Boulevard runs into the Pacific. This tract might well have been Universal's had legal wrangling with its erstwhile partner gone differently.[7] As it was, Universal inherited the Nestor studio at the corner of Sunset and Gower in Hollywood and soon began constructing a much larger facility across the street. In mid-May 1913, the company rhetorically surpassed Lubin's and Ince's "villes" by formally opening the first Universal City on a large parcel leased from the Oak Crest Ranch along the northeastern edge of Cahuenga Pass. The City's predecessors were townlike in size; they comprised a variety of functionally distinct structures, and they housed at least some employees as residents. Inceville had the character of a Western camp; the 101 Bison Ranch Hands wintered there between runs of their Wild West show.[8] Lubin envisioned the Betzwood facility as a self-sufficient company town modeled on the Krupp works of his native Germany.[9] Universal drew inspiration from both prototypes, but it took the idea a step further when it gave its "city" a government.

It comes as no surprise that an institution establishing itself as a "city" would light on the possibility that its polis might constitute a polity. That formulation, however, logically opened the question of how a polity's powers would relate to those of corporate management. How, in other words, would the city qua city relate to the city qua office and production plant? Early on, that question converged with the arguably more fundamental issue of what it meant to be in the business of entertainment. What did it mean to work at fun? Insofar as it provided an occasion for consideration of such matters, Universal City allowed the film-manufacturing concern to explain itself to itself—not in the sense of providing something akin to therapeutic self-knowledge, but rather in the sense of reconciling what would otherwise seem to be contradictory aspects of its endeavor.

A corporate myth congealed around the Universal City elections of May 1913. Planners of the publicity stunt must have been delighted when major Los Angeles papers picked up the story that Universalites had elected women to key offices. "Woman Police Chief," headlined the *Los Angeles Times,* which

went on to list eight women elected in a total of twenty-eight races, including Laura Oakley as police chief. The *Times* reported that A. M. Kennedy had defeated Lois Weber in the mayor's race by a scant fifteen votes. On the strength of that margin, a front-page story in the *Los Angeles Examiner* declared: "Film City Actors Drop Masks at Election; Woman's Slate Smashed; Elect Man Mayor." Universal's publicists must have been doubly pleased to find the *Times* repeating the company line that Universal City was "the only city in the world used exclusively for the production of motion pictures" and to read in the *Examiner* that the city was "soon to be incorporated."[10]

While later stories make clear that the event had been orchestrated for purposes of promotion, the degree to which the company engineered the election of particular candidates will likely never be known. Universal could have anticipated that women officials would grab headlines. Suffrage campaigns were in full swing nationwide, and male voters had approved voting rights for California women by state referendum less than two years earlier. *Los Angeles Times* coverage of opening-day ceremonies, which preceded the election by more than a week, made suffragettes part of a well-rounded entertainment program: "From barbeque to rodeo the programme was replete with sensations, not a few of which were women, and others of which were an explosion, a suffragette's speech, a three-round boxing mill, and the number of society people who motored to the mesa from all parts of Southern California."[11] The *Fort Wayne [Ind.] Journal-Gazette* gave the contest a more menacing connotation when it reported, "The women are threatening to resort to methods of sabotage as practiced in London and Paris by militant politicals. They promise to spoil thousands of feet of film unless the men will treat their movement with more dignity and agree to give them their support."[12] The contrast between the militants of the *Fort Wayne Journal-Gazette* and the orators sandwiched in between an explosion and a boxing match by the *Los Angeles Times* underscores the fact that no matter how one construed them, Universal's suffragettes made newsworthy spectacles.

If the company did in the end rig its election, participants in it appear to have played their parts with exceptional conviction. The *Examiner* marveled that "the actresses—mimics by training and occupation—forgot. It was all real to them, and a red hot contest came for every office." Detailed vote counts published in the two papers suggest that some sort of balloting did take place, and it is possible that the company ran a legitimate election in hopes of securing the city's legal incorporation. Although it later mislead-

ingly announced incorporation as a fait accompli, the scheme would have run afoul of residency requirements in California law.[13] Whatever the initial plan, the election did not confer legal authority in the manner the papers suggested. It did, however, have all the symbolic properties of such contests and established that actresses could win public office. More than the oddity of a motion-picture city, this made headlines.

Months later (December 27, 1913), "Where Work Is Play and Play Is Work" rewrote the election to bring Universal City under the yoke of a plan.[14] The story begins by likening the work of filmmaking to child's play and describes Universal City as a "Land of Make-Believe." It imagines a reader who "used to envy Humpty-Dumpty and Columbine . . . as they jumped blithely out of their little painted houses, and scurried away beneath the arching branches of the painted forests." But the reader-child's fantasy abruptly collides with the regularity, scope, and responsibility of a grown-up town: "Did you know that out in the California hills there is a regularly incorporated town, wherein two thousand people daily play amid make-believe surroundings, and that this play is their serious life work, carrying a message of uplift to millions of human beings?" The *Weekly* does not fail to throw an elbow at pro-censorship rhetoric by implying a connection between the childlike, and therefore presumably innocent, character of fantasyland and its uplifting message to millions. The nature of Universal City itself, however, rather than disputes over morality, is the *Weekly's* central concern.

To this end, the house organ equates child's play not with innocence but with mutability. The make-believe town "takes on the appearance of an Oriental city, again it is a Spanish garrison, still again an Indian Pueblo . . . a frontier settlement, or an army post in the old frontier days." At the same time, however, the town has a more serious and grown-up aspect in that it encompasses "permanent buildings . . . for a variety of useful purposes." The oxymoron of a location designed for playful work and worklike play becomes concretely descriptive of complementary relationship between changeable and permanent structures.

The relationship between the City and its people provides another sort of puzzle. The *Weekly* employs three distinct terms for Universalites. First, it describes the "inhabitants of Universal City" as part of the scenery. They constitute a great variety of "nationalities and types": "Whole bands of red Indians; regiments of soldiery, both cavalry and foot; cowboys, Mexicans, Filipinos, [N]egroes, Orientals, and every nationality among the Aryan and

Semitic races." Declaring the City a "cosmopolis in the truest sense of the word," the house organ proceeds to list the contents of the zoo ("lions, tigers, leopards, elephants, camels, pythons and boa constrictors, jackals, hyenas, chimpanzees, gorillas, ourangs and other jungle beasts"). "Inhabitants" encompasses people and animals. It indicates a catalog of properties, aspects of the mutable city, which the reader imagines to be useful in the production of various onscreen worlds.

There was no escaping the fact, however, that as workers the City's inhabitants made those worlds possible. Indeed, they perpetually remade the City itself in its guise as a movie set. The article finds two principal ways to describe this second sort of relationship between people and city space. It indicates supervisory power by identifying key personnel and their titles (e.g., general manager Isadore Bernstein, animal trainer Henry Sanders). It also describes facilities in terms of their functions within a division of labor (e.g, tailoring shop, furniture factory). Where "inhabitants" blend into the scenery, "workers" oversee the grownup town and occupy the more permanent structures that reproduce the land of make-believe.

The two characterizations are not logically compatible and present a difficulty when it comes to understanding what it means for the "inhabitants" of this company town to also be "workers"—to produce the very scenery of which they are a part. Moreover, neither compellingly accounts for the most famous of the City's people, its picture players. Unlike "workers," players neither occupy particular permanent buildings nor have a specific management role: the entire City is imagined as their domain. Yet players cannot be cataloged as inhabitants, since unlike that list of types, and like workers, they do not simply appear within but also labor to make fantasy worlds. As performers of different roles, finally, players figure a more complex subjectivity than either inhabitants, rhetorically reduced to appearances, or workers, rhetorically reduced to job functions. The player introduces the problem of duplicity.

By suggesting that all Universalites might possess the duplicitous qualities of the photo-player, the *Weekly* explains how they can be both inhabitants of the mutable city and workers amidst its permanent structures. Universalites play politics. The *Weekly's* discussion of the May election begins:

> It was in a spirit of jest that the movie actresses of Universal City took up the matter of suffrage. Most of them were from the East, and were keenly enthusiastic about exercising their rights of suffrage, recently conferred by

the California State Legislature. When the proposition to incorporate Universal City was first broached, some of the actresses thought it would be good fun to put a 'Suffragette' ticket in the field.

First jesters, then "keenly enthusiastic" and apparently in earnest, then finally having "good fun," the women candidates make it difficult to tell the difference between a real contest over power and a lark. The *Weekly* perhaps strives for clarity in providing more forthright male opponents. "Democratic and Progressive parties put out opposing male tickets," one learns, but "the novelty of the fight, and the inherent chivalry of the men of Universal City, from the beginning presaged the triumph of the women." With the hint that men let the women win, the reader is encouraged to interpret the election according to a battle-of-the-sexes plot in which victory amounts to a joke on the less self-conscious, if triumphant, women. Yet insofar as this interpretation makes the women dupes, it also makes the men "players." Their act of "chivalry" does not entail withdrawing from the contest but rather misleading the women into thinking that they really won.

Those with lingering doubts over who bested whom could find firmer ground in the discussion of the mayor's race. The *Weekly's* account expunges from earlier coverage A. M. Kennedy, who had been replaced as general manager by Isadore Bernstein earlier that year, and it revises the vote count. Here Bernstein, not Kennedy, won the mayor's seat by fourteen, not fifteen, votes over Weber, who demanded a recount. While Weber's "agitation was pending," the paper explains, "business changes demanded the resignation of the masculine Mayor. To fill the vacancy the Board of Aldermen . . . appointed Miss Weber to the vacancy, and she is now at the helm." This rendition of the contest gives it a different complexion along with a different outcome. Weber's candidacy raises the question not only of female authority but also of the relationship between municipal leadership and business management. Her appointment equates municipal authority with the feminine authority of players even as the necessity for that appointment subordinates player politics to the "business changes" that demand it.

Establishing political play as the feminine counterpart to masculine business administration, the *Weekly* once again explains how Universal City can be a place where work is play and play, work. Bernstein is portrayed as the sort of man who knows to stop playing when work demands it. As mayor, however, Weber presents an authority defined by its ability to perform one role after another. The article treats Weber as a bona fide official and suggests that the

actresses' political roles are, like onscreen parts, directed toward an audience for profit. The *Weekly* assures readers that the city's administration includes "some of the brainiest as well as the most beautiful women in America." It pronounces them "ladies of culture and high ideals" and adapts the Progressive rhetoric of "civic housekeeping" to construe the entire City as a kind of sociological test-case: "Their experiment in municipal housekeeping will be watched with interest both by students of civics and economics, as well as moving picture fans generally." While no evidence indicates that Universal City's government attracted the attention of political scientists or economists, it certainly did interest "moving picture fans generally." The article's final paragraph explains that hundreds of tourists visited the city every week and that one dollar would suffice to board a "'rubber-neck' auto-bus service" from central Los Angeles. Politics, domesticity, and professional discipline are exuberantly conflated with feminized performance. Whereas Weber exemplifies authority conceived as an endless succession of roles and relations, Bernstein's authority is defined by his ability to exempt himself from playacting. In this way, masculine authority sets a conceptual limit on play. It provides play a defining "outside" in the reality of business and its demands.

Just as the *Weekly* reconciles the potentially contradictory spaces of work and play by finding a complementary relationship between permanent and changeable structures, it reconciles Universalites to that geography through a chiasmus that makes work the necessary masculine counterpart to feminine performance. In the process, it endows Universal City with a plan: work is to play as permanence is to mutability, as front-office management is to back-lot politics, as business administration is to commanding an audience, as masculine is to feminine. Male and female Universalites alike might have experienced a contradiction between their roles as workers within a business hierarchy and as inhabitants of a land of make-believe. Nonetheless, the mythic player made that distinction intelligible as a complementary relation akin to the supposedly natural difference between men and women.[15] The particular gender norms at issue, however, are markedly new, as evidenced by the *Weekly's* whimsical appropriation of suffrage and civic-housekeeping rhetoric to cast its city in a decidedly Progressive light. In this mythology, the fun of modernizing gender confirms sound business administration.

The myth elaborated in "Where Work Is Play" informed construction of the new Universal City, but before noticing how it did so, it pays to observe how thoroughly the contradictions it imaginatively resolved saturated the

company's self-descriptions during the period that led to its construction. A dialectic of work and play informed Universal's representations not only of good management and interesting actresses but also of the difference between East Coast and West, the nature of studio work, and the relationship between Universalites and neighboring Angelinos. It animated Universal's films as well.

Consider two routine news items published by the *Universal Weekly* on February 28, 1914. The magazine reprinted a letter from the Assistant Department of Labor Commissioner for California praising the moral and sanitary conditions at the Hollywood studios and calling "ideal" the "arrangements made for taking care of the women and children." Immediately below this staunchly patriarchal praise, the *Weekly* called attention to "Three More Accidents at Pacific Coast Studios," the most interesting of which is surely the grizzly-bear attack. During the production of Francis Ford and Grace Cunard's *Washington at Valley Forge,* the paper explains, an unnamed young woman had been feeding a performing bear by hand. (Why dramatization of Washington's heroic moment required the grizzly is not made clear.) When she stopped, the bear, "without any provocation," seized in its mouth the hand of the actor portraying the president (Pedro Leon). The animal released the mangled appendage only after a severe beating.[16] However much the company's management craved the sanction of California officialdom for insuring the safety of "women and children," it also delighted in the fact that its city was not a workplace like any other, a fact that could be measured, in part, by the risky things it asked women to do to. With some irony but no explanation, this juxtaposition of these news items implies that responsible management employs young women to hand-feed mercurial grizzly bears.

Reports in the house organ indicate that the West Coast differed from the East in this respect. From late June through early November 1913, the paper ran a series of nineteen articles in which an unnamed and presumably fictional Western exhibitor described his visit to the New York offices. In January 1914, it ran a four-part series that reversed the formula and had an Eastern exhibitor visit the West Coast facilities. In each series, the reader's wide-eyed surrogate surveys different aspects of an organization impressive in magnitude and efficiency, but California unquestionably presents a more delightfully unsettling spectacle.

The home office first impresses the Western visitor through the number of its phone lines: ten trunk lines and fifty extensions handled with astonishing self-control by Miss Lillian Clair McGuinness.[17] He is equally struck by

the "one-hundred percent efficiency" of the accounting system supervised by Harry Caulfield, finds the stenographic department remarkable for its "galaxy of pretty girls and the speed with which they operate their machines," and marvels at the four unnamed boys who file three thousand pieces of paper daily.[18] The scenario department under Calder Johnstone amazes him with its capacity to handle one thousand scripts per week. Similarly astounding are the ability of the Foreign Department head Mark M. Dintenfass to predict which films will sell abroad; the sophistication of William Sistrom's purchasing system, capable of acquiring some five hundred articles weekly, in addition to a million feet of raw film stock; the cashier Claude H. MacGowan's supervision of cash payroll for four hundred Eastern and two thousand Western employees; and so on. The culmination of the visit features the office of "the littlest giant in the world," President Carl Laemmle himself.[19]

In each installment, the Western exhibitor interviews a different department head and admires his competence and scope of responsibility. With the sole exception of the unnamed head stenographer, these managers are all men, and "attractive young ladies" play the parts of their helpers.[20] The capabilities of Universal's personnel often astonish the exhibitor, but nothing about the plan of its "homelike" office or its gendered division of labor particularly unsettles him.

The Easterner's trip to California follows the same basic pattern, but half the time the visitor does not know what he is seeing or to whom he is speaking. The series begins as if through a chance encounter with the actor-director Phillips Smalley in a Los Angeles hotel, which yields an impromptu invitation to see the plant. Upon arrival at the Hollywood studio, the Easterner encounters "a maze which I would be at a loss to describe, either as of automobiles or of human beings." He recognizes Isadore Bernstein's managerial bearing but cannot place the man himself. He mistakes the librarian, Lois Weber's sister, for the famous director.[21] When he finally does meet the director Weber, he encounters "a tall, striking, stately brunette" with "flashing grey-green eyes and a superb figure" who is "wonderfully gowned in an evening costume" at the incongruous hour of 8:30 in the morning. She sets down a "golden box" from which slithers "a silver snake about eight feet long, followed by three white mice." Leaving the fate of the escapees unclear, the visitor shifts his attention to Weber's talents. He writes: "It is easy now to understand how and why Miss Weber had been elected mayor, having, as she evidently has, an executive and administrative ability."[22] While wonders of magnitude abound—the size

of the stages, the lavishness of the dressing rooms, the "22,000" acres of "the ranch" (i.e., the first Universal City)—the Easterner is repeatedly gobsmacked by the fact that persons and things are not what they at first appear to be. At the ranch, he discovers, "Indians, wild and otherwise . . . can get ice cream whenever they want it." The roar of cannon and "a horde of wild infantry men in eager pursuit" turn out not to belong to an action film but to a Christie comedy.[23] Presumably Universal's East Coast production facilities could have offered kindred spectacles, but the company did not make a ritual of reporting on them. In contrast, the trip west seems a sort of pilgrimage in the *Weekly's* pages, one that entailed marveling at its theatrics and, not infrequently, being caught up in the show. On one of her trips west, for instance, Mrs. Laemmle herself maneuvered for a better view of the action and found herself an extra in the comedy *When the Girls Joined the Force.*[24]

If, from the point of view of New York, all of California could seem to be a land of make-believe, one could nonetheless find the businesslike aspects of the home office there. The Eastern exhibitor notes the awesome record-keeping prowess of Bernstein's accounting department, for example, in much the same spirit as the Western visitor praises operations in New York.[25] As early as July 1913, Universal's general manager, J. C. Graham, reported of West Coast operations: "We now have a systematized organization out there which will give us excellent results." Describing his impressions from a week-long trip the previous December, Graham presents the Hollywood Studio and Universal City ("the ranch") as aspects of a single plant. The Hollywood facility housed central management as well as departments devoted to such matters as auditing, scenarios, extras booking, purchasing, laboratory work, and stage management (including carpenters and scenic artists). The ranch, supervised by its own foreman, had quarters for cavalry, Indians, and cowboys, large prop rooms, and a zoo for Westerns and spectacular pictures. In a nod to the factory-town prototype, it also included a vegetable farm to supply its "model dining room." Initially conceived as a necessity for employees given the relative isolation of Universal City, the commissary proved self-supporting due to the many tourists who patronized it. Here Graham introduces a perennial theme: the city's isolation as a self-sufficient, utopian workplace turns out to make excellent business sense within a larger market. The plant was, as Graham puts it, "one of the things to see when you go to Los Angeles." It established Universal City as a fixture of the local economy, but it also construed its spectacular employees as separate from ordinary Angelinos. Noting the strength

of California nativism, Graham contends that Universal has been "virtually adopted by Los Angeles as its own," but he still depicts the photo-players as a society apart. Other accounts attribute this separation toward local hostility. In late summer 1914, for example, Isadore Bernstein railed at Hollywood Presbyterians for their un-Christian attitude toward movie people.[26]

For its part, management aimed to cultivate a sense of social solidarity among employees. Graham describes a series of informal "weekly conferences and meetings" in which directors, "camera men," and "scenario men" by turns "discuss the subjects which come up in their work and make what suggestions seem proper to the local manager." He also mentions "local dances, which are held on the various stages in the studios." These are "a means of making life at Universal City more pleasant, and bind the various employees together in their loyalty to the company and their co-operation with each other." Just as the flood of tourists made the work of putting on a show itself a show, here leisure looks like an extension of work relations. Indeed, Graham's report would seem to place the accent entirely on business—if not for his evident delight in Universal's recently acquired pirate ship, the first, he hopes, of an eventual fleet. "All in all," the executive concludes, "the trip was a revelation to me of the possibilities which exist for us in California."[27]

And what, after all, could suit a land of possibility better than a woman police chief? Laura Oakley's election to that position suggested at once an overturning of the norm and a situation safe enough to risk it. A tall woman with what one reporter described as "ungainly arms and two large feet," Oakley was a comedian with a Nestor company at the time she took office. She had, for example, portrayed a "cowgirl Cinderella" in the film of that title released the previous November. While some papers were eager to see her new role as another comedic performance, however, many others described her as playing it straight. "Miss Oakley," one wrote, "is sincere in her desire to accomplish something in a position given to no other woman in the world and feels a keen pride in the honor that is hers." Another quoted her 1913 acceptance speech to fellow Universalites:

> I ask the co-operation of all of you. I am sure we all feel the highest regard for our little city and want to do everything in our power to see it advance. The moral tone of a city I regard as its chief asset. There is only one thing to do to keep up the standard of morality, and that is to enforce the laws. I want to impress on you that I have taken the office of chief of police with the one aim of doing my duty, and I assure you that I will carry out the law

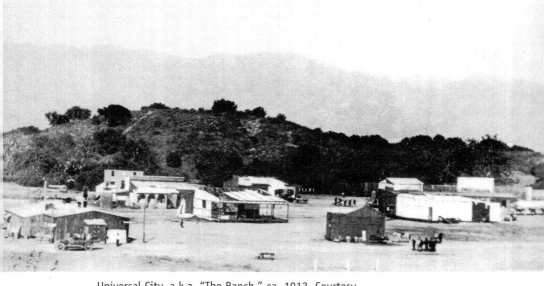

Universal City, a.k.a. "The Ranch," ca. 1913. Courtesy
Margaret Herrick Library, Academy of Motion Picture
Arts and Sciences.

President Carl Laemmle opens Universal City with Police
Chief Laura Oakley in the background, 1915. Courtesy
Robert S. Birchard Collection.

to the letter, no matter who may be hit. The honor that my election gives is the greatest that has been accorded me and I cannot show my appreciation in a better way than by doing my duty at all times.[28]

In May 1914, the *Weekly* reported that Mayor Weber had appointed another Nestor comedian, Stella Adams, to replace Oakley.[29] In August of that year, however, it restored Oakley to the role, reporting that the Los Angeles city clerk had sworn her in as "Officer 99."[30] An official certificate from the Los Angeles chief of police indicates her one-year appointment to the office of "special policeman" without pay beginning on March 16, 1915.[31] Universal supplied her with a gold badge, an official uniform, and a police force; she commanded male deputies. In sum, the historical record reveals Universal City's police chief to have been at once a publicity stunt and a legally appointed officer, a comedian and an earnest pioneer, a character type readily replaceable by management and a commander who defined the role. "Possibility" is an apt adjective for such a situation, which seemed poised to resolve itself into one of two starkly different actualities.

Far from finding such ambiguity intolerable, Universal made movies about it. In *Her First Arrest* (Powers, 1914), for example, Oakley portrays a candidate for police chief who bests her fiancé, the incumbent, in an election.[32] According to a synopsis, the short comedy resolves itself when Oakley arrests her intended, mistaking him for a thief. Upon discovering the truth, she marries him. Although difficult to appraise in the absence of any surviving print, the comedy was clearly meant to turn on a series of inversions and misrecognitions. The situation places a woman in a traditionally male role and makes her incompetent at it. Supposed to find items, she loses them, and instead of crooks she arrests her helper. The synopsis does not, however, suggest that she will have to abandon her elected position to right this topsy-turvy world. Instead it seems that Oakley's character, like Oakley herself, will have both a husband and a career. This resolution invites an interpretation in which the film's central problem is first and foremost romantic. It only satisfactorily resolves that problem, however, if one can also embrace a playful approach to gender in the workplace.

Like other film companies, Universal insisted on a form of the romantic couple that presupposed the difference between men and women to be all-important. Such partners constituted halves of a whole, and their union connoted at once personal fulfillment and social stability. In practice, however, the insistent repetition of this formula also entailed awareness of masculinity

and femininity as performances and thus as unstable and contingent. This is nowhere more evident than in the contemporary profusion of cross-dressing films. Dressing up as a woman to get the girl was a staple trope, for instance, of the Eddie Lyons and Lee Moran comedies.[33] But cross-dressing was not always comedic. In the fourth installment of the *Black Box* serial, Laura Oakley, playing Laura, assistant to the detective Sanford Quest, goes undercover as a man.[34] Grace Cunard, as the master thief Lady Raffles, dons gentleman's garb in *Return of the Twin's Double* to match wits with Francis Ford's Detective Kelly. Such experiments always have the potential to shift gender norms by calling attention to the difference between the performances we take for granted as male and female and the bodies that perform them. The standard romantic resolution collapses the difference thereby opened when the bodies acting the parts of men and women seem identical with those parts once more.[35] Judging by the surviving evidence, Universal did not resist this resolution, nor was it exceptional in its willingness to experiment with gender roles before securing it—certainly other manufacturers did so. Universal's uniqueness resided in the articulation of such onscreen gender experiments with similar behind-the-camera experiments via the spatial practice of Universal City.

Spatial Practice after 1915: The New Universal City

At the same time as Universal elaborated a mythos that made a playful approach to gender norms central to its business model, it planned, built, and opened a new Universal City and appointed H. O. Davis to run it. The expanded scale of operations and Davis's business background intensified the emphasis on efficiency and central monitoring. The proportion of feature films increased, and so did the numbers of women directing.

The previous chapters propose several partial explanations for these coincidences. The increased production concentrated at Universal City soon included feature-film brands along with the variety program, and this brand structure changed with relative rapidity. While the formulae for success were shifting and uncertain, the risk of failure was nonetheless distributed across a large volume of titles. At the same time, the "company" persisted as a habitual way of grouping filmmakers. All of this encouraged Universal to try familiar personnel in new roles. The change in studio leadership, moreover, must have unsettled informal as well as formal organizational habits. Following Selznick, this would have caused Universalites to recalculate "the

score"—to reappraise their understanding of how authority was distributed within the organization.

When, finally, Davis began implementing cost-accounting and efficiency mechanisms, these likely encouraged performance evaluations based on a director's work rather than her or his person. Davis's production model envisioned the director as the principal coordinator of any given film, but also as clearly subordinate to the executives who planned production and managed money. This approach made it possible to treat the director's work as a statistical abstraction and thus to distinguish his or her body from his or her skills. But that feat, even when seen in combination with the above-mentioned factors, does not clarify why the job of director differed from other occupations in becoming more integrated while simultaneously being more clearly defined as middle management. To explain that, we need to grasp how a director's body remained connected with her or his skills, how the categories of "women," "men," "masculine," and "feminine" operated locally to explain and identify persons as well as occupations. As a rhetorical and a built environment, Universal City made those connections.

Linking work and play, the corporate mythos of Universal City valued women who publicly played authoritative parts. It also imagined that a sober, efficient, and less visible business administration should provide the necessary counterweight to their performative exuberance. This mythos supplied the planning principle for the construction of the new facility. As built space, it regulated the movements and interactions of Universalites and gendered working relationships in a distinctive way.

Feminist geography explains that physical mobility entails occupational mobility, and vice versa. Where space is strictly divided into male and female zones, activities within those zones tend to be strongly gendered, which reinforces the importance of sexual difference and naturalizes a gendered division of labor.[36] Because the unfamiliar is typically held to be more risky than the known, moreover, limitations on physical movement tend to decrease occupational opportunities, just as the ability to move across zones increases them. The cognate occupations from which women moved into the director's chair—screenwriter and actress—tended, like the work of directing, to encourage physical mobility across zones of production. (In this period, screenwriters often joined directors on set.[37]) These occupations entailed movement between very different zones. In administrative areas, as the above description of Universal's New York offices indicates, hierarchical organization

was clearly gendered. On much of the lot, in contrast, authority depended on its public performance, personnel intermingled, and gender experimentation was encouraged.

On March 31, 1914, Universal purchased 230 acres neighboring its ranch facility for $155,000 and almost immediately began construction of a new Universal City.[38] "No communistic or socialistic colony has been planned on a more practical, economic basis," the *Weekly* assured readers in September. "This is not a philanthropic project, but a money-making industrial undertaking." The paper made clear the extent of the company's organizational aspirations: "It all hinges on the fact that taking motion pictures is taking pictures of men, women, cows, dogs, houses, locomotives, deserts and hills. Instead of renting [these properties], why not own them? Make the cow pose for the camera, then sell the picture and sell the milk, the beef and the hide." Despite, or perhaps because of, its zeal not to let so much as a single hoof escape the profit motive, Universal took obvious delight in the limitless transformations its new "fairyland" might undergo.[39]

The *Weekly* continued its coverage with the revelation that "the entire complexion and appearance of Universal City can be changed in three days to conform to any nationality, style of architecture, color scheme, or state of preservation." The article extols the "chameleon city's" ability to approximate Troy, Athens, Rome, Paris, London, or New York "for motion picture purposes." It proclaims: "There is not a building in the entire city limits of Universal City which could not be changed overnight into something radically different and changed back again with equal facility."[40] The range of examples cited does indeed appear exhaustive. The utility shop, one learns, might become a soldier's barracks, thieves' den, or ranch house. The administration building has been "built with a different face on every quarter." Roads and bridges vary in width and surface and may be transformed to render different periods and places. There are "cottages and villas of all description, containing all numbers and combinations of rooms" that the company intends to rent to employees at below-market rates. In this city, "built for utility and pleasure combined," recreational facilities will include swimming pools, a Turkish bath, bowling alleys, tennis courts, and "a quarter mile race track with concrete grandstand and stadium in the most approved University style," which might one day double "the Coliseum at Rome," the "Olympic stadium in Greece," "the Polo Grounds in New York City," "an Indian Durbar," or "a golf link."[41] According to this scheme, the most ludic concatenations would also be the most practical.

The wildest scenes imagination could devise would stare instrumental reason in the face.

They would confront each other, however, across a substantial amount of open space. A large wall map, drawn by M. Quadrelli probably from the architects' plans in 1914, reveals that planners aimed to segregate the chameleon city's most playful aspects from its supervisory functions. They thereby created a geography that continues to define the city in its early-twenty-first-century manifestation.[42] At the western edge of the property, the main lot begins with a row of substantial buildings fronting onto Lankershim Boulevard. Here are drawn, from south to north, the main hospital, five large structures labeled "living quarters," a drug store, barber shop, main restaurant, and the administration building. This last is set back from the road behind a garden and is neighbored to the south by the post office and city entrance. North of the administration building are the laboratory, purchasing and city building, and extras' dressing rooms. Behind those dressing rooms, along the northern property line defined by the Los Angeles River, one finds the garage and the scenic department. South of this, across a large "operating ground," the vast main stage opens to the north and is backed on the south side by a large building that includes the main dressing rooms. Farther south, Universal Avenue separates the stage area from a schoolhouse, additional "living quarters," clubhouse, tennis courts, nursery, and hothouse. Housing and recreational facilities thus constitute a neighborhood of sorts adjacent to, but distinct from, the filmmaking facilities, which occupy approximately three quarters of the total area.

From the main lot, Laemmle Boulevard heads east, arcs north to skirt a scenically convenient bit of the Santa Monica range, and arrives approximately one-half mile later at the back ranch. Here the buildings appear much less grand. On the north side of the boulevard, Quadrelli has drawn a Western stage, scenic department, arsenal, zoo, corral, and sawmill. On the south are depicted the Western restaurant, cowboys' bunkhouse, four buildings labeled "living quarters," and the cavalry bunkhouse. Large open areas of "operating ground" surround the ranch. Dotted within them one finds Chinatown, an Indian village, a fort, and a "Wyoming village." The playful qualities of work are particularly evident here. The Western theme of the timber-clad ranch structures suggests that even those buildings with permanent functions might be expected to double as sets, and the expansive surrounding "operating ground" indicates a kind of blank canvas, an unspecified space in which photoplayers

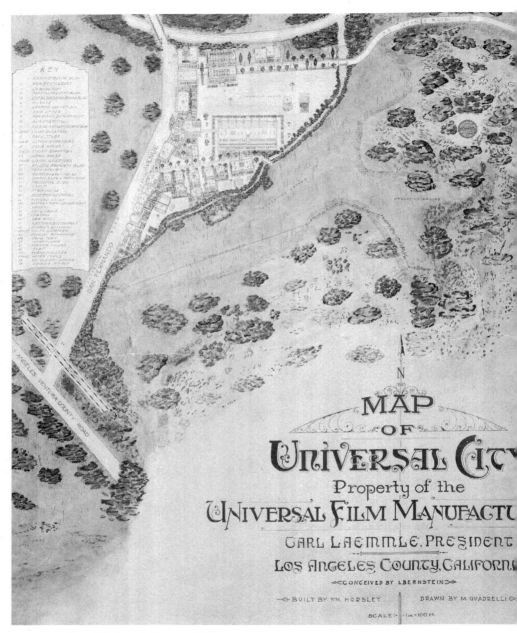

KEY

Map of Universal City, ca. 1914.
Courtesy Margaret Herrick Library, Academy
of Motion Picture Arts and Sciences.

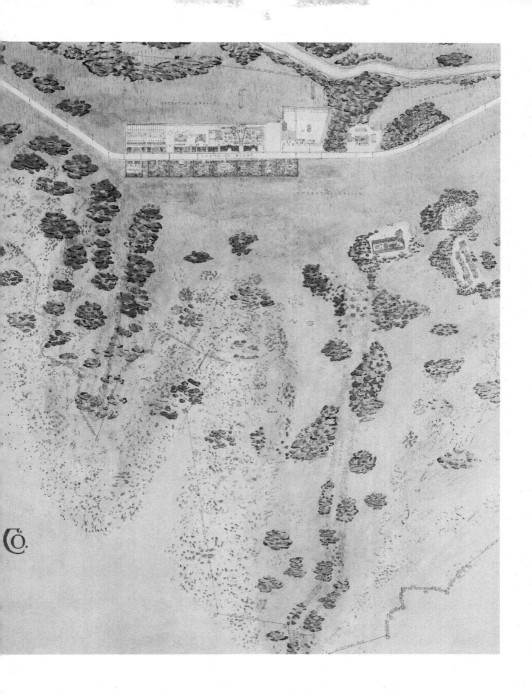

might construct all manner of mock hamlets. Finally, the distinction between living space and performance space is much less clear here than it is on the main lot. Like the "inhabitants" of the 1913 story, the ranch hands bunking here could be expected to live their onscreen cowboy roles.

True to plan, the architects S. Tilden Norton and Frederick Wallis provided the main lot with gleaming white stucco buildings in a modern update of California mission style. They had been inspired, perhaps, by the Selig Polyscope Company, which had earlier enclosed its city-block-sized Edendale studio with a wall and gate modeled on those of the Mission San Gabriel.[43] Whatever the inspiration, the architectural choice suggested solidity, durable local heritage, and territorial power. Accordingly, Norton and Wallis perched the general manager's office on top of the administration building and gave it windows from which the entire main lot could be overseen. By contrast, the accumulation of exotic sets at the other end of Laemmle Boulevard, shielded from those windows by distance and the intervening hill, must have seemed to embody the city's shape-shifting potential. In practice, of course, neither zone was a pure instance of its type. The back ranch had its own manager's office, just as the main lot had its own stages and operating ground, and the built city differed in key respects from the map. Nonetheless, in its early years, Universalites likely experienced the studio as approximating its publicly stated ideal as a self-sufficient city where people would live, work, and play.

Isolation was one factor. In fact, Universal City is closer to Hollywood than Hollywood is to central Los Angeles. Universalites who did not drive their cars or take the bus could ride Pacific Electric's "Red Car" trolley from central Los Angeles in perhaps forty minutes or travel from the Hollywood stop (at Highland and Hollywood Boulevard) in perhaps ten.[44] Despite its relative proximity, however, Universal City's topographical separation from Hollywood by the Santa Monica Range creates a strong sense of geographical difference, and the low population density of surrounding rural Lankershim (now North Hollywood) would in the 1910s have contributed to a perception of Universal City as a space apart, a sense that can only have been strengthened by the completion of a wall enclosing the city shortly before its public grand opening in March 1915.[45]

Within their enclosure, Universalites spent daylight hours working closely together. Although intense rains in the fall of 1914 had prompted city planners to transform the garage into an indoor electric studio, almost all of Universal City's production occurred on large outdoor stages roofed with muslin diffusers

Universal City main administration building and gardens, 1916.
Courtesy Margaret Herrick Library, Academy of Motion Picture Arts and Sciences.

Back Ranch, Universal City, 1916. Courtesy Margaret Herrick Library,
Academy of Motion Picture Arts and Sciences.

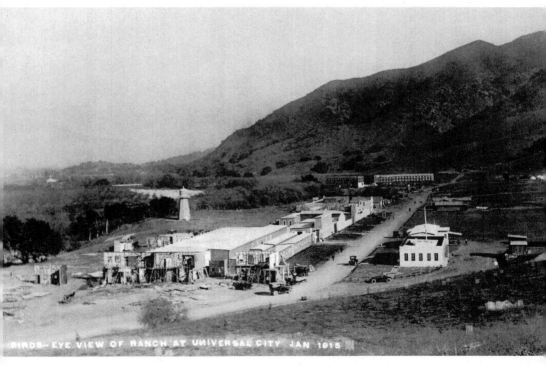

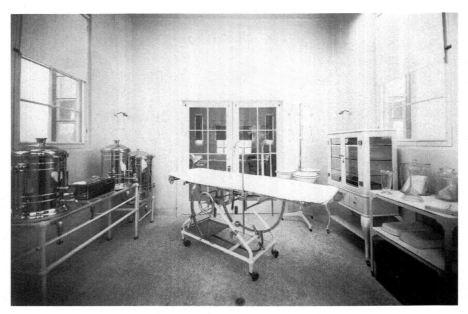

Hospital, Universal City, ca. 1915.
Courtesy UCLA Special Collections.

to filter the California sunlight. The intensive production schedule pressured filmmakers to use every possible sunlit hour, and the plant's design facilitated this. Where the first Universal City had one restaurant, its successor had two. For child actors, the city provided a school.[46] A substantial hospital treated the frequent injuries of early film work.

In addition to keeping employees on the job, such facilities had community-building functions. Restaurants offered opportunities to build informal relationships over meals. The school provided not only education but also day care. Both sorts of facilities built into corporate space functions traditionally belonging to the domestic sphere. Moreover, spaces that might be expected to have reinforced sexual difference were notably proximate to one another. For example, a 1915 photo shows a woman casually waiting outside what was apparently the men's side of the main dressing rooms.

This is not to say that Universal City lacked clearly gendered spaces. The laboratory, for example, was the base of operations for the all-male cinematographers, and the interior of the administration building likely resembled the organization of New York's Mecca building, with separate office spaces for

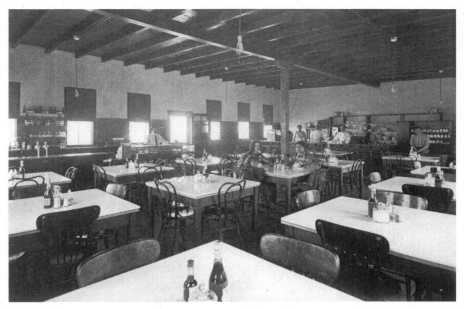

Western restaurant, Universal City, ca. 1915. Courtesy UCLA Special Collections.

Dressing rooms, Universal City, 1916. Courtesy Margaret Herrick Library, Academy of Motion Picture Arts and Sciences.

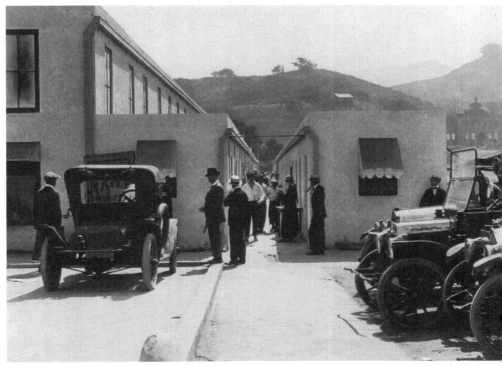

male managers and female clerical workers. The gendered character of these occupational spaces serves to underscore their difference from others, like the dressing rooms, restaurants, and stages.

As feminist geography would predict, occupational and spatial mobility entailed one another. Those occupations most integrated by gender (actor, screenwriter, and director) were also the easiest to move among (actors wrote and directed, writers directed, directors wrote, and so on). While cameramen went everywhere the company did while the film was being produced, for example, they did not follow the script from office to office in preproduction, as the director did. And whereas the laboratory must have seemed an all-male preserve, the scenario writer's office under the joint direction (in 1916 and 1917) of Eugene Lewis and Eugenie Magnus Ingleton was a mixed-sex enclave within the central administration building.[47] While the city's arrangement overall encouraged men and women to work closely with one another for sustained periods of time, the degree of integration varied from occupation to occupation roughly according to degree of mobility across differently gendered spaces, including mixed-sex ones.

The city was built to encourage informal bonds among its employees. As planned, this blurred the difference between professional life and personal life. While rhetoric describing coworkers as "family" is common in large organizations, Universal meant it more literally than most. Here again the urban metaphor was key. The *Weekly,* for example, habitually described children born to Universal employees as additions to the city's population.[48] On December 21, 1914, the new city celebrated the birth of its first child to Mr. and Mrs. Charles Oelze, respectively the city's cavalry commander and a former nurse at its hospital. Little Carl Bernie Oelze, presumably named after the company's president and the city's general manager (Isadore "Bernie" Bernstein), had been born in a bungalow on the lot.[49] In the fall of 1916, *Motography* reported that "another Universal baby has been named after Lois Weber" by her father, Al Zeigler, Weber's cinematographer, and the *Weekly* reported that three more babies had been "added to the ranks of Universal City." The Joker comedian Milburn Moranti had a daughter, and so did Laura Oakley and her husband, the cameraman Milton Moore. The leading juvenile Jack Mulhall had a son.[50] Unlike young Oelze, these children probably did not live on the lot, but they may well have spent considerable time there.

Nepotism provides another index of Universal City's familial quality. Historians have often noted "Uncle" Carl Laemmle's tendency to give jobs to

relatives, but in truth the practice was widespread. The actor/directors Cleo Madison, Grace Cunard, Francis Ford, and Lois Weber all found siblings work at Universal.

More significantly, Univeralites married each other. Some couples, like Lois Weber and Phillips Smalley, Ida May Park and Joseph De Grasse, Elsie Jane Wilson and Rupert Julian, and the actors Carter and Flora Parker De Haven, were already married when they started with the company. Others met their spouses on the lot: Oakley and Milton Moore, Cunard and the actor Joseph Moore, Ruth Ann Baldwin and the actor Leo Pierson, the actor-director Robert Z. Leonard and the actress Mae Murray, the director Jacques Jaccard and the actress Helen Leslie, the ingénue Peggy Custer and her cameraman husband, the actors Betty Schade and Ernest Shields, the leading lady Eileen "Babe" Sedgwick and the assistant director Justin McCloskey—to name a few.[51] Of the eleven Universal women directors, seven either came to the company with their husbands or married other Universal personnel.

It seems that endogamy was policed. In 1915, Laura Oakley told the Chicago newspaperwoman Kitty Kelly that she had taken the job of police chief "in order to weed out the undesirable girls who had flocked in as extras. It was really social work and was conducted in that way."[52] In another report, Gertrude Price explained that "all of the girls who apply for positions come under [Oakley's] surveillance" and that the police chief quickly sorts those who want to work from those who simply want to ogle the leading men.[53] Given Universal's public celebration of its couples, this cannot have been a matter of ruling out workplace romance so much as of deciding who would qualify.

Although there is no record of swimming pools, the Turkish bath, the bowling alley, or tennis courts having actually been constructed at Universal City, there is evidence that Universalites spent leisure time together, although again the relation between publicized leisure activities and their work roles as performers is not entirely clear. Descriptions of company parties, balls, and dances, for example, suggest that such functions were as much obligatory as fun.[54] A photograph of the Universal City baseball team gives the impression that the players meant business—Laemmle, for once, foregoes his avuncular demeanor in favor of a steely glare. Unfortunately, I know of no comparable photo of the women's team, reportedly organized in December 1915 by the actress Ida Schnall. Schnall had been captain of the New York Female Giants before landing a role in *Undine*.[55]

Universalites continued to play at politics, and the new city was even

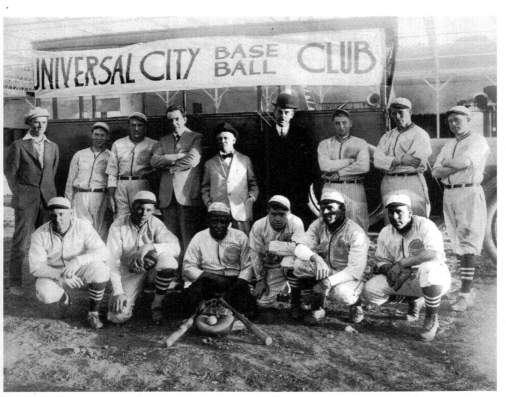

Universal City Baseball Club, 1915; Carl Laemmle, top row, center. Courtesy
Margaret Herrick Library, Academy of Motion Picture Arts and Sciences.

Aftermath of the staged flood, Universal City, 1915. Courtesy
Robert S. Birchard Collection.

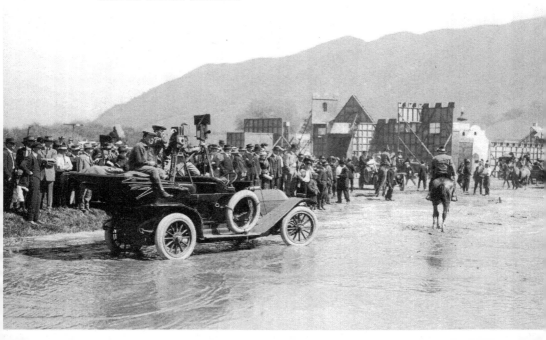

more a tourist spectacle than the old one. The *Weekly* reported municipal elections at odd intervals through the end of 1916. The actor Herbert Rawlinson apparently replaced Weber as mayor and retained the office against challenges from J. Warren Kerrigan and Ben Wilson.[56] For the new city's grand opening on March 15, 1915, Universal orchestrated a major national advertising campaign. A cross-country train trip for executives and reporters ended in three days of festivities that included a "bevy of poppy girls" who pelted visiting dignitaries with flowers, followed by Police Chief Oakley's presentation to Carl Laemmle of the golden key to the city, musical fanfares, a flood scene, a battle scene, the staging of a courtroom farce, a mock airplane battle that ended tragically in the real death of the aviator Frank Stites, a rodeo, and a dinner and dance at Nat Goodwin's café.[57] Clearly a major production, these opening ceremonies forecast that to accommodate visitors would be a substantial administrative task.

By September, the director general Henry McRae had constructed a visitors' gallery to accommodate crowds the *Weekly* estimated at four thousand per day. Part of the traffic could be attributed to the fact that Universal cross-promoted its city with the Panama-California Exposition in San Diego and the Panama Pacific International Exposition in San Francisco—artificial cities in their own right built to display industrial, cultural, and agricultural wonders. If Universal City resembled the expositions as a tourist destination, however, the fact that people worked to produce spectacles there posed unique challenges. The visitors' gallery had been designed, in part, to segregate spectators who had interrupted filming by "shouting advice" to the players.[58]

The relation between work and play must have seemed more urgently in need of management than ever before. According to the mythology of 1913, business management could be understood as the masculine counterpart to feminine theatrics. As we have seen, however, Universal executives traveling West were typically captivated by the boyish roles on offer in the land of make-believe, such that the most sober of auditors might return East imagining himself captain of a pirate fleet. Feminized theatricality thus perpetually threatened (or promised) to reveal the theatricality of all gendered performances, or that least all of those that were any fun. A nominally masculine rationality did not make "femininity" its other so much as gender play in general. Good business judgment encouraged but regulated performances of masculinity and femininity alike.

The Administration Building and Back Ranch, the antipodes of Universal City,

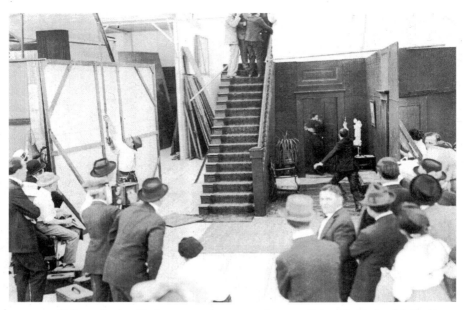

Visitors viewing filming at opening, 1915. Courtesy Robert S. Birchard Collection.

provided ideal placements for these countervailing practices of masculinity: at one pole, the invisible paper pusher; at the other, the spectacular athleticism of cowboys and serial queens. In truth, the distinction was easier to embody in architecture than in persons. Freed from the office, administration too entailed ritualized gender performances. After being pelted by poppy girls on Universal City's opening day, "exchangemen and producing directors" were invited to enjoy a "stag dinner" on the night of the seventeenth.[59] Presumably they had fun acting like men. Similarly, the general manager's office added to its supervisory windows a balcony on which he could step forth to address the Universalites. The architectural feature imagines a spectacular, as opposed to disciplinary, power, as if the manager might be compelled on occasion to enact the part of a sovereign. (The balcony is visible at the left in the image on page 77.) Distinguishing the masculinity of administration from the masculinity of men (and sometimes women), Universal City's arrangement implicitly asked which sort of masculinity would qualify men to hold power.

In fact, the early management of Universal City bounced back and forth between two masculine types. Bernstein, general manager when the new Universal City was designed and built, is described in the trade press as exceptionally

well liked, energetic, and small. When he left New York to take up management of Universal's West Coast operations in June 1913, the *Moving Picture World* gushed: "We are going to miss Isadore here in New York, because his energetic personality has always been refreshing and because he is such good company. . . . We congratulate the Western Universal forces upon receiving into their midst a fine little gentleman with a heart as big as all outdoors."[60] Whatever Bernstein's virtues, "a fine little gentleman" cannot have been a paradigmatically manly one.

Henry McRae hit closer to the mark. A 1914 profile described him as "aged 35, weight 195, smile .45 caliber, capacity for work unlimited. . . . He eats, sleeps, dreams, and acts thrills." It then explains how he blew up a chunk of Hawaii to re-create a volcano.[61] A durable director of serials, Westerns, and animal pictures, McRae held the position of interim studio manager after Bernstein

Universal City, 1916, showing administration building (left) and main stages (right). Courtesy Margaret Herrick Library, Academy of Motion Picture Arts and Sciences.

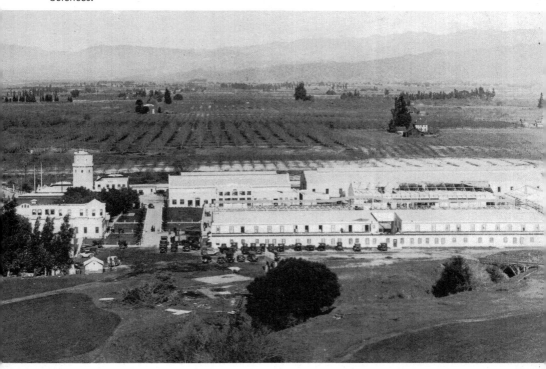

Carl Laemmle speaks at Universal City opening, flanked by Isadore Bernstein (left), Pat Powers (right), and R. H. Cochrane (far right). Courtesy Robert S. Birchard Collection.

Henry McRae directs F. B. Silverwood, with Major Henry Holden Sheen at the camera, 1917. Courtesy PictureHistory.

and was later made "production manager" after H. O. Davis's departure. As for Davis, a 1916 profile by Mabel Condon described him as "inconspicuous" but powerful. Like Bernstein, he was a man of slight stature who had an extensive business background, albeit one that included cattle-ranch administration.[62] Different though they were, reconciling the versions of manliness embodied by Universal City's management proved easier than reconciling the work of gender play with its commitment to home.

The Problem of Home

The job of director was less clearly gendered at Universal in large part because its studio was conceived and built as a sort of laboratory for gender experimentation. In its spatial arrangement, the workplace encouraged playfulness regarding gender roles while at the same time fostering informal networks and certain types of professional collaborations. These factors combined with others to integrate the director's chair. As lived, however, Universal City must have contradicted its plan in one major respect: it did not encompass its workers' homes.

The map itself envisioned nothing close to the facilities for the "comfort of the upwards of 15,000" inhabitants boasted by the *Weekly* in 1914. It limited itself to seventeen buildings marked as "living quarters," plus a cavalry bunkhouse.[63] Where the map shows a grand neighborhood of homes and recreational facilities south of Universal Avenue, moreover, a 1916 photo reveals a cluster of small buildings, only a few of which seem possible residences. A parking lot stands where the clubhouse would have been. A 1919 fire-insurance map indicates eleven timber-frame "dwellings" scattered about the lot, most of them tiny. In 1920, Carl Laemmle relocated his brother Joseph from New York to a bungalow on the lot, for health reasons.[64] Joseph's daughter Rebecca (Carla) recalled years later, "We were the only ones that lived there, of the family. Originally, the Chief of Police and the fire chief lived there, and then they moved to some other place. And there was a little hospital with a resident nurse who lived there. And then there was a Norwegian gardener that lived in a little house."[65] With the exception of the Joseph Laemmle's family, it seems, Universalites who lived in the city did the work of maintaining it.

In 1915, one article estimated that 80 percent of Universalites drove their cars to work, an indication, according to its author, of their prosperity.[66] Considering the source—the Universal publicist H. H. Van Loan—the estimate

is almost certainly inflated. Nonetheless, that automobile ownership equaled prosperity is undeniable. Press devoted to the cars of directors and stars established the automobile as a status symbol. Extras took the jitney to work. Thus, they moved in different circles.[67] In June 1917, the *Weekly* twittered at an anonymous extra girl who happened to sit by Ruth Stonehouse in the jitney one morning when the star's car was in for repairs. Failing to recognize Stonehouse, the extra proceeded to give all manner of advice about how to succeed in the movies.[68] The joke was on the extra, who understood all too well that not having a car placed one in a different class but failed to allow for a temporary suspension of the protocol.

The separation of home from lot thus undermined the communitarian quality of Universal City and underscored distinctions of occupational status and social class. Similarly, the separation of home and work supported an argument that motion-picture acting, in contrast to theater work, might be a normatively middle-class occupation.[69] As Oakley explained to Kelly: "It is so good for us to be settled and have homes. We are all so much better off with our day work, out in the open air mostly, that leaves us too tired at night to want to go flying around to cafés, preferring rather to go to our quiet homes and rest."[70] While the "world's first" woman police chief doubtlessly exaggerates in implying that movie work consigned all playfulness to the daylight hours, it is notable that she reprises a hallmark of bourgeois ideology in her advocacy of home qua private household as a respite from work. Precisely because it allowed a space apart from work and "cafés," this sort of home made one a better person. Traditionally, the middle-class woman supervised the house, and her husband returned to it. Oakley's version differs. While the photoplayer who piloted her automobile from bungalow to back lot might resemble that old-fashioned lady in certain respects, she was clearly unlike her in others. Explaining the similarity and the difference was among the jobs cinema set itself. The explanation Universal's filmmakers offered eventually required the reconception of Universal City itself.

Lefebrve indicates that artworks might supply either "representations of space" or "representational spaces," depending on whether they aspire to idealize a plan or to describe lived experience. In truth, the situation is more complex in that artworks might do both at once. The director Ruth Ann Baldwin's *'49–'17*, for instance, can be regarded both as asserting a conservative, even reactionary, distinction between home and work in its conclusion

Joseph W. Girard
in '49–'17, 1917,
frame enlargement.

and as describing that very resolution as a normative convention mandated by corporate filmmaking. The film's ending invites viewers both to idealize domestic space and to recognize the happy home as a theatrical cliché.

To arrive at this conclusion, the Western parody offers an allegorical description of work life at Universal City and caricatures the two types of men who managed it. At the same time, its narrative works to define their masculinities as complementary in their guardianship of women and homes. Considered as "representational," the spaces of Baldwin's 1917 film describe the playful attitude toward gender and filmmaking that flourished on Universal's shorts program and that then characterized the spatial practice of Universal City in general. Considered as "representations," her film's spaces help plan a generic pattern we now identify with the feature-length Western and a spatial practice that located home outside Universal City's boarders.

The film begins in the big city, where an aging miner-forty-niner, Judge Brand, enlists the help of his secretary, Tom Robins, to re-create Nugget Notch, the California mining camp of his youth. Baldwin introduces this nostalgia plot by transforming the lid of the judge's old trunk into a movie screen onto which his dreams of the past are projected. This film within the film seems to have captured and preserved a past in the way a memory might, but in its display of technical virtuosity it also flaunts cinema's ability to

produce fantasy worlds. Through the juxtaposition of these cinematic powers, '49–'17 offers a spontaneous theory of what movie magic is all about: the ability to present a verisimilar wish. But interestingly, this permutation of that not-uncommon theory establishes the judge (Joseph Girard) as the subject-spectator of the film within the film and also its producer. He gives the job of casting and executing his nostalgic fantasy to Tom (Leo Pierson), who becomes the director to his producer.

The secretary dutifully heads west and retains a down-on-its-luck theatrical troupe. Tom's supervisory role, however, is soon complicated by the fact that, like the judge, he himself plays a part in the reenactment. Masking his true position as the judge's agent, he has the troupe's nominal manager, Castle, introduce him as a new addition to the company. Thereafter, he plays the tenderfoot. Thus the film piles up performances in dizzying fashion, so that we have Joseph Girard playing a miner-forty-niner playing a judge playing a producer playing a miner in a show for which he is also the main audience member, and Leo Pierson playing a personal secretary playing a director playing an actor playing the tenderfoot in a Western drama in which he will eventually get the girl. Given this performative excess, ordinary moviegoers of 1917 might not have fastened on the interpretation in which judge and secretary allegorize a film producer and director. That same multiplication of roles would have made such an interpretation almost inescapable for the filmmakers themselves. They were, after all, in the business of playing different parts and not infrequently moved from onscreen to behind-the-camera roles.

The stout judge embodies a version of manliness at once commanding and juvenile in its exuberance. Indeed, the Westerner's macho competence seems at times to verge on delusion. When the judge arrives at the re-created Nugget Notch, for example, his pistol play has the worried theatrical troupe diving for cover. Meanwhile, the wiry, fine-featured secretary played by Leo Pierson seems "wise" in the urban sense, taking advantage of an opportunity to recruit Castle's struggling troupe on the cheap and immediately detecting the villainy of Gentleman Jim Rayner (Jean Hersholt), who is also his rival for young Miss Peggy Bobbett (Donna Drew). The mustachioed Hersholt glowers at Pierson from beneath the brim of his black hat, while, in the reverse shot, the smile Pierson had for Drew gives way to grim determination as he stares down the gambler.

The exaggerated role-playing works out in generically familiar fashion. What starts out looking like a hierarchical relationship of employer to secretary

Joseph W. Girard, Donna Drew, and Leo Pierson in '49–'17, 1917, frame enlargement.

ends up looking more like a relationship of father to son, in which the urban youth reaches maturity through exposure to the elder's "Western" skills and values. Pierson's character learns to handle himself in chaps, discovers his own gold mine, and helps the judge rescue the girl and drive off the villain, who in the end breaks his neck in an hilariously unmotivated horse accident.

Flashbacks and intertitles tie up the backstory, in which it turns out that the judge detected Raynor's scheme early on and merely waited for matters to come to a head. The revelation is complicated by a subplot in which we are led to believe that Peggy might be the long lost daughter of Brand's former mining partner (and romantic rival) and therefore heir to half of his fortune, but this turns out to be a ruse of the villainous Raynor. With the revelation of Brand's true mastery of the show, the clarification of Peggy's patrimony, and the death of Hersholt's character, Nugget Notch is transformed from a theatrical set to a home for Pierson and Drew. Flanked by the fatherly judge, they occupy the conventional space of safety that, through repetition, acquired the force of resolution in U.S. feature filmmaking. Framed together in a tight composition, Judge Brand, Peggy Bobbett, and Tom Robins are safe at last inside a stone cabin. When the older man begs a kiss from young Bobbett, her daughterly peck on the cheek points the way to the substantial smooch she plants on Tom as the judge looks on approvingly.

This resolution is emphatically conservative in its representation of the

woman as a rescue object, domestic helpmate, and prize symbolically conveyed from father to son. Unless one reads the film ironically, one cannot possibly understand why the studio that produced it would also be promoting women directors. The irony is not so much that Baldwin, an energetic professional woman, delivers a passive domestic heroine in the form of actress-turned-homemaker Peggy Bobbett. Rather, an irony more relevant to studio production lies in the theatrical quality of the conclusion that is supposed to end playacting within the plot.

The show both ends and continues. The allegory with filmmaking breaks down as the judge shifts roles from theatrical producer to lawgiver, but that shift gives us, precisely, a filmmaking convention: the Hollywood happy ending. Considered as a description of filmmaking at Universal City, Baldwin's film presents us with a cultural geography obsessed with the work of putting on shows. The authority to direct the show is plainly masculine, but masculinity is uncertainly poised between indoor and outdoor values and competences, a potential contradiction reconcilable through the insight that indoor men can learn to play outdoor parts. This work of putting on shows has as its objective, according to Baldwin's presentation, the production of roles that do not appear to be roles because they indicate a particular spatial configuration we have learned to recognize as home. By force of habit, viewers are inclined to see this space of innocence as a place where characters are finally most themselves. The parts they play here mimic the status of nature, in other words, and nature looks like a young man and woman in love, blessed by a benevolent and powerful father. The mimicry itself is only discernible if we are attuned to this difference: as a representation of space, home abolishes theater; as a representational space, '49–'17's cabin continues it.

Home presents a very different problem in the sort of film '49–'17 gently parodies. Two months before it released '49–'17, Universal released the director John (then Jack) Ford's first Western feature. The Maine native had teamed with Universal's New York cowboy Harry Carey to make *Straight Shooting*. Carey plays Cheyenne Harry, an outlaw hired by ranchers to expel a family of farmers from the range. Disgusted by his employer's underhanded tactics, Harry switches sides and, in a rendition of the surrounded-cabin scenario, defends father and daughter against the ranchers' onslaught. Like Baldwin's film, Ford's demonstrates an awareness of convention and an eagerness to have fun with it. Rescue for the besieged cabin comes not from the cavalry but from a gang of outlaws led by Cheyenne Harry's friend Black-Eyed Pete,

an iconic bad man who does a good deed and turns out to have a secret passion for jam. Like *'49–'17*, *Straight Shooting* assumes a viewer fully prepared to delight in the inversion of generic convention. It nonetheless declines to explore what it means for Cheyenne Harry's manliness to be a performance. The dénouement hinges on whether the reformed Carey will ride off into the sunset or pair up with the daughter (played by Molly Malone) and be domesticated within the home. Mise-en-scène conveys the choice by repeatedly framing the halves of this potential couple in doorways: she inside, he outside. In the end, the film compromises by uniting them in a woody clearing, and they solemnize their union with a kiss in the light of the setting sun. Here we have a story confident in its ability to locate true manhood out of doors and ambivalent about the domesticity romance seems inevitably to entail. Precisely because this man is true, he is worth bringing indoors. Because he is needed to secure the home from outsiders, however, he can never really be comfortable inside. *Straight Shooting* does not deliver the ending of *Shane* (1953) or *The Searchers* (1956), and it has a much lighter touch than those midcentury classics. Nonetheless, it arrives at a configuration similar to the one they make familiar: law, home, and community owe their very existence to the lawless men they must exclude.

Considered in its descriptive aspect, Baldwin's film interprets such a structure as a relation not of community to outlawry but of domesticity to work/play. Performances of western masculinity, it points out, empower eastern actors like Carey and Ford. Home does not establish a rule of law so much as it puts an end to the plot's playful transformations. Home is equally the aim of outdoor fun and its resolution, equally the goal of movie making and the end of the workday. To keep the fun times rolling, men must resist going home.

In describing male authority as a basically theatrical exercise, *'49–'17* adapts the conception of city space that in 1913 had celebrated actress politicians and inspired the planning and construction of the new chameleon city. So long as the role-playing qualities of the director's job were apparent, such a description made sense of Baldwin's migration from the screenwriter's seat to the director's chair. That Baldwin herself embraced the role of director as a kind of gender play is suggested by descriptions of the "masculine costume" of work shirt and puttees she wore while apprenticed to Lynn Reynolds on the north-woods drama *End of the Rainbow*.[71] Shooting on location amidst the great California redwoods, Baldwin might well have imagined herself as playing the part of tenderfoot to Reynolds's judge. Baldwin-the-director allegorically

inhabits the representational spaces of '49–'17 by playing a masculine part—just like the male directors do.

Should she be required to play a feminine part, however, the film's overarching distinction between masculine theatrics and feminine domesticity leaves the director out of work. Considered as a representation of space, the descriptive playfulness of '49–'17 yields to a programmatic distinction between home, understood as a space of safety arranged around a woman, and the masculine antics that secure it. That distinction confirms *Straight Shooting's* plan.

If Ford's film seems a more familiar instance of the genre, this is not so much because it epitomized the Western in 1917 but because it more strongly modeled subsequent practice. As much as it invites comparison with Ford's feature, Baldwin's film, with its juxtaposition of contemporary and historical settings, self-conscious nostalgia, playful approach to stock characters, melodramatic reversals, and episodic plot, also recalls the profusion of Western films that had been appearing for the previous five years as part of Universal's shorts program.

The Guilty One, a two-reel Bison Western directed by Cleo Madison and William Mong in late summer 1916, provides a sense of the range of possibilities available in the format. Madison portrays the adventuresome daughter of a stagecoach driver who, when her fiancé is beaten by thieves and falsely accused of a robbery, tracks down the real perpetrators and exonerates him. She both rides to his rescue and ends up in his arms.[72] Far from being atypical, *The Guilty One* participates in an early subgenre of the Western shorts featuring "cowboy girl" protagonists who often share traits with the "girl detectives" who turn up in short mysteries and serials.[73] Part 2 of this book demonstrates how the institutional practice of genre, as it developed in and through the switch from the shorts program to a production model emphasizing the feature film, limited the range of experimentation with gender and required women directors to act feminine parts—a step that insured their marginalization.

Universal's filmmaking on the cusp of this change is exemplified by '49–'17, and the film exposes with particular clarity a contradiction at the core of Universal City: it both included home and excluded it. The film reveals Universal City as a heterotopia on the brink of collapse.[74] The working environment had been open to an imaginative play that made it homelike—not necessarily what one customarily thought of as home, but like it in certain aspects. This would soon give way to a hardened distinction between real space and idealized domesticity. A house organized around the particular

sort of romantic couple imagined to provide the nucleus of the nuclear family looked increasingly like the expected ending to every movie story. The more it did so, the more this version of home seemed the raison d'etre of cinematic performance. Accordingly, the work of making it seemed less susceptible to playful modification.

Because Universal's films made a particular version of home a central pre-occupation, one can conceive the studio as attempting to export and install beyond its borders an idealized space it could not, or would not, include within them. For the commuters on Universal's lot, this home was a kind of space they worked to represent. If they attempted to live it, they did so elsewhere. This new imaginative geography dissolved the mythology of 1913. The notion that Universal City would be a magical place where people would live, work, and play lost its ability to organize spatial practice. In place of the working woman as a mayor or police chief, the new configuration envisioned her as a commuter; if she worked at the office, she would also be expected to work at home as a wife and mother, a maintainer of impossibly clean, safe, and caring domestic spaces rather than an organizer of make-believe cities.

In 1917, Universal credited more women as director than it ever had or would again, and Universal City was about to become a different kind of place. Conflict among top executives spilled over onto the lot that spring, produc-ing factions and straining working relationships. The U.S. entry into World War I also made a difference. (Congress declared war in April and introduced conscription in May.) Although women directors did not replace men called to war, *Moving Picture Weekly* began a series of stories that described women as doing men's jobs out of temporary necessity rather than an experimental sense of play. The economics of war affected work life at Universal in ways large and small.[75] In October, a tax on entertainments to fund war efforts provided Universal the pretext it needed to discontinue its obsolete shorts program and begin layoffs.[76] In January 1918, *Variety* reported that 1,500 of 2,100 regular Universal City employees had been let go. The company sought renters for its underused facilities, promoting Universal City as big enough to house the entirety of U.S. motion-picture production.[77] Ida May Park, Lois Weber, and Elsie Jane Wilson continued to direct, but there were no new women in the pipeline behind them. Universal City was a land of possibility no longer.

At least two Universal veterans found ways to continue the playful suspen-sion of roles and boundaries that characterized the city's earliest manifestation, but they had to do so elsewhere. In June 1917, with Universal's support, Lois

Weber established her own studio on a rented estate off Sunset Boulevard. Shelley Stamp notes that celebrity profiles of Weber differ from the norm in that "rather than domesticating a notable professional woman, they blurred the boundaries between work life and home life."[78] Descriptions of her studio continue this pattern. *Photoplay* reported that Weber called it "My 'Old Homestead.'"[79] *Moving Picture Magazine* noted that nothing about it "suggests business" and recorded Weber's hatred of the word "efficiency," noting her "pity" for "women so efficient they can only be housekeepers and never approach home-making."[80] Yet Weber insisted that she intended the enterprise to be profitable, and the studio was said to include "sixteen dressing rooms; administrative offices, scenic and property rooms; in fact, everything pertaining to an up-to-date and well-equipped modern picture plant."[81]

Meanwhile, Harry Carey lit out for the territory. He purchased a remote ranch in San Francisquito Canyon—one used, in fact, as a location in *Straight Shooting*—which he maintained as a working farm. It later developed into a movie colony of sorts as well as a tourist attraction, the Harry Carey Trading Post, featuring "The Only Navajo Indians off the Reservation."[82] Both enterprises embraced in different ways the blurring of the boundaries between work and play, business and home, that had in spatial practice created opportunities for women directors at Universal. The one aligns Weber with homemaking, and the other aligns Carey with primitivism. In this they reveal how the particular parts required of and, to different degrees, embraced by these performers reinforced the very gender distinctions their performances theatricalized and thereby opened to variation.

By 1924, the attitude that once defined Universal City as cutting edge had established it as a relic. "'The U' . . . can't live down its past," wrote Sally Steele in *Motion Picture Magazine:*

> Art struggles valiantly with Hokum here, but the gypsy-like atmosphere of the carnival reigns. There was a day when one could tour Universal City, and see all its wonders, including stars and trained animals, for the nominal admission price of twenty-five cents. Those days are gone, but the tinselly flash of them oddly remains. Even now the studio cafeteria at the roadside carries an arresting sign, calculated to gather in the shekels of the movie-curious. "Eat Here—Dine with the Stars," it invites.[83]

In 1915, a comparable commentator boasted of the very pleasure Steele dismisses as jejune:

By a special dispensation, the Spectator and his entourage sat at one of the tables reserved, so the sign read, "For Directors and Leads Only." Half the lunchers were in their make-up, and a more conglomerate, interesting crowd the Spectator never ate with. Here was a table of ladies in full evening dress—black lace, low neck—eating beans with a couple of cowboys. The Pride of the Harem appeared in all her glory of shimmering satin and pearls, with her a very tall and melancholy-eyed grand vizier. The sultan was close by—very old, with long white hair, fierce eyes, armed and jeweled to the teeth. The criminal of the sleeping-car scene, his sinister look laid by with his handcuffs, slapped an old black-capped Fagin on the back and sat down beside him. And Fagin did not have time to finish his coffee when the call came, "Ghetto scene, all out!"[84]

The sign in 1915, "For Directors and Leads Only," announces a distinction immediately violated by our observer. This distinction further dissolves into a conglomeration of players defined almost entirely by the parts they happen not to be performing. The sign in 1924, "Eat Here—Dine with the Stars," suggests an inclusiveness that amounts to a scam. As Steele points out, Universal had at that time no stars of note. She concludes with a zinger that has the ring of an epitaph, pronouncing the U "[a] picturesque gypsy who tries at times to be a perfect lady, by wearing an ermine wrap." A decade earlier, playing dress-up was cause for celebration as the very essence of the chameleon city. Now it looked like a woman's pathetic attempt to rise above her station.

PART TWO

Impossibility

In February 1919, Carl Laemmle proclaimed Universal to have come "back from hell."[1] Thanks to investment in quality features, he maintained, the company had rebounded from the collapse of its shorts program and from the twin economic blows of the 1917 wartime tax on entertainments and the influenza pandemic of 1918. Historians are less sanguine. Consensus has it that the former giant continued to struggle in an industry increasingly dominated by vertically integrated firms.[2] Even understood as the expression of a wish, however, Laemmle's pronouncement presents a paradox: Universal bet that women would lead it from purgatory at the same time as it excluded them from the march. Marketing and credits reveal that the company considered Ida May Park, Lois Weber, and Elsie Jane Wilson to be among its most reliable producers. Most of the men directing for Universal made titles of a less prestigious sort and worked less often than these three women. Yet despite Universal's evident admiration for them, the company was in the process of limiting directing opportunities for women as a group: it credited roughly twice as many women in 1917 as in 1918. This contradiction indicates uncertainty about how gender should factor in corporate interpretations of what constitutes a successful director and a profitably reproducible type of film.

Accordingly, the three chapters in part 2 describe the play of uncertainty and conviction at work as Universal limited the types of films women would direct. Chapter 4 considers genre as an institutional process in which interpretations of content interact with staffing decisions. For Universal, at least, this process developed in tandem with the shift from the variety program to the feature film. Beginning in 1915, it took several years to complete. During these transitional years, serial action films were a Universal staple, and chapter

5 shows how the practice of genre worked to exclude women directors from these films. A longer chapter concludes this part by tracing in some detail the process that made Universal feel certain that women would be good at directing only particular sorts of feature-length dramas.

Uncertainty, one might point out, is a less flattering name for possibility, and the uncertainty was institutional. As individuals, Universal executives and filmmakers may well have been as confident of the way "back from hell" as Laemmle makes it appear. Nonetheless, awkwardness, hesitancy, and confusion are evident in patterns of choices about who would direct what films and how those films would be marketed. Although the historical record does not establish how such selections were made, it is clear that multiple actors made them within an evolving organizational hierarchy. Universal's constituents may or may not have worried over future prospects for women directors in general. They could not, as individuals, have revised the gendered division of labor. The organization constrained them, favoring certain types of choices while limiting others. At the same time, as constituents of the organization, they participated in the process of setting and revising such limits in response to interpretations of the marketplace and of the material and intellectual resources at hand. By 1920, the confluence of decision makers and decision making had set a new limit: as a general rule, from this year forward women no longer directed for the company.[3]

In 1918 and 1919, Universal credited twenty-two releases to women. Two were one-offs. A comedy short directed by Ruth Stonehouse had almost certainly been pulled from the company's backlog of unreleased films. Wilfred Lucas and Bess Meredyth, typically credited as director and screenwriter, respectively, for once shared the credit for directing a civil-war drama. Of the remaining twenty titles, Elsie Jane Wilson directed six. Ida May Park and Lois Weber—working from her own, largely independent studio—directed seven each, although one of Weber's, *Scandal Mongers,* was a rereleased 1915 film.

Quite unlike the output of women directors as a group before 1918, these films constitute a discernable type. Although they can be described in ways that make them seem various, in truth they resemble one another much more closely than the films directed by Cleo Madison and Weber in 1916, or by Weber, Ruth Ann Baldwin, and E. Magnus Ingleton in 1917. All were feature length (five reels or more) and starred one of Universal's most popular female leads. All but two were released as "Jewels" or "Special Attractions"—the marquee brands. Advertising mentioned their directors' names and proclaimed them "women."

Not infrequently, publicity for these films suggested that women directors would make the sorts of films in which other women might be interested. While this proposition might seem obvious, it nonetheless amounted to a new emphasis in Universal's marketing. The company hoped that a successful interpretation of who "women" were would allow it to understand audiences and organize their desires, and it began to arrange production on that basis.

In general, the films are about marrying well. They represent that task as complicated by, first, the need to mobilize sex appeal while maintaining sexual propriety and, second, the difficulty of distinguishing sincere devotion from merely material or purely erotic desire. Advertising for these films deployed adjectives such as "frank," "risky," "intimate," and "daringly French." It sometimes counterbalanced such intimations of raciness with assurances that the films are also "sweet" and "wholesome." Several plots involve women who narrowly avoid "the crimson alternative" (being kept by a man outside of marriage) or who are misperceived by others as having succumbed to that state. Imposture, disguise, and misrecognition are common motifs, as is a thematic opposition of city and country. Many of the films depict "society"—that is, high society—and thereby allow for the display of fashions, which marketing never failed to present as a selling point for women patrons. (For men, the corresponding selling point was thought to be the "beautiful" or "lovely" women who wore the fashions.[4]) Advertising explicitly labeled several of the films "society dramas," a term carried over from shorts that pitched the moral dangers of high society against its material lures. A few of the films were called "comedy-dramas," a contemporary category looser than but similar to later romantic comedy. At least two were described as "sociological experiments" but nonetheless differed in orientation from earlier features, such as Weber's 1916 *Shoes,* also characterized in that manner. Critics have proposed that many women-directed films of this period might fall into the genre of the social-problem film. Notably, this was not a label employed by Universal. It does not well capture what the twenty features of 1918 and 1919 had in common and can obscure important changes in Universal's understanding of its women directors.[5]

The historian Karen Mahar proposes that an industry-wide shift in emphasis from the problem of achieving cultural legitimacy for the movies to the problem of business legitimacy "ultimately marginalized the woman filmmaker."[6] In her account, Weber's 1915 hit *Hypocrites* emblematizes a moment when the social-problem film could legitimate the movies in general

by extending Progressive Era discourses of uplift. Like Weber's film, these discourses often drew strength for their social arguments from association with the presumed moral authority of the white middle-class woman. That same year, however, the U.S. Supreme Court declared movies "a business pure and simple," depriving them of protection under the First Amendment and establishing their destiny as entertainments rather than as explicitly social or political interventions.[7] Accordingly, Mahar sees 1916 as the beginning of the end of the moment when the project of "uplift" could legitimate filmmaking along with women directors. Interest waned in Weber's uplifting voice, and corporate filmmakers pinned their stars to the sexy entertainment cinema emblematized by Cecil B. DeMille.

While the long, broad trend described by Mahar is discernable at the institutional scale, its relation to the gendered division of labor looks different when considered institutionally. At Universal, Weber's womanliness did not associate her with a type of feature film that other women might direct until after 1917. That type of film looked more like DeMille's contemporary output than Weber's exemplary films of 1915 and 1916. The rise of entertainment cinema did not strip women directors of an authority they once had as women, that is, but rather banished women by constituting them as such, by imposing a unity on the category "woman" it had not theretofore possessed.

In 1918, Universal's publicists began explicitly and implicitly to associate films with one another on the principle that they were directed by and for women. It cannot have been clear, however, what distinguished these films as a group from films directed by Universal men. Obsession with "the crimson alternative" and the related problems of forced, fake, or otherwise bad marriages characterized Universal's Jewels and Special Attractions in general, as did the contrast between rural and urban life, class differences, and the evergreen question of marriage prospects for actresses, dance-hall girls, stenographers, and models. Moreover, individual titles are more easily categorized in other ways than as "women's films."

Stars, for example, more clearly group films into sets. One series starring Dorothy Phillips begins with the 1917 hit *Hell Morgan's Girl,* directed by Joseph De Grasse from a screenplay by Park. Phillips plays the daughter of a Barbary Coast dance-hall owner who reforms a millionaire's dissipated son. She played a similar part later that year in *Pay Me!,* directed by De Grasse from a screenplay by Meredyth, which was compared in its turn to her early 1918 role in *The Grand Passion,* directed by Park. Two other Park films, *Broadway Love* and

Risky Road, developed Phillips's star persona by casting her as a country girl who preserves her virtue in the big city and eventually marries well. Phillips continued in such parts after she stopped working with Park in mid-1918 to begin a series of pictures with her husband, the director Allen Holubar.

The few surviving examples of Universal features from this period suggest differences of style that could be attributed to the different social situations of men and women directors. If publicity took note of a director's style at all, however, that observation was far more likely to individuate her than to associate her with other women. Weber, for example, clearly stood apart as Universal's most celebrated director. While the company's pressmen occasionally accorded Park the status of "genius," Weber—"the Belasco of the screen"—was the only director they consistently promoted above the star, giving her supervision as a reason in itself for exhibitors to book a picture.[8] In sum, while it can be said that "women" tended to direct particular sorts of films for Universal in 1918 and 1919, and while it is possible to discern the company making efforts to market women-directed films as distinct, it cannot have been clear what exactly made them so.

It is far easier to determine the types of films women did not direct. Baggy though they are, such feature-film labels as "society-drama," "comedy-drama," or just plain "drama" delimit a more restricted range of films than men directed or than women had directed as little as a year earlier. Crucially, women no longer directed serials, which accounted for slightly more than a quarter of the individual titles and slightly less than a quarter of the total reels of film Universal released. They no longer directed short dramas, which had been all but eliminated along with the shorts program. Universal also scaled back production of "kid pictures," shorts and feature-length films with child protagonists, several of which had been directed by Stonehouse, Wilson, and Lule Warrenton. Never well represented among directors of short comedies, women no longer supervised these at all.[9] They did not direct animal pictures. Since these types of short films accounted for three-quarters of the fiction titles and over half of the fiction reels Universal released in these two years, the habit of assigning them exclusively to male directors effectively excluded women from the majority of directing positions at the studio.

While women did direct more than a quarter of the Jewels and Special Attractions, moreover, here too certain types of films proved off-limits. They did not direct Universal's biggest male stars, Harry Carey and Herbert Rawlinson. Nor—with the telling exceptions of one film each produced by Park

and Weber—did they direct the types of films in which these men tended to feature: Westerns and dramas of the more action-packed sort. And although no fewer than three men (De Grasse, Jack Dillon, and Tod Browning) directed a series of pictures featuring Priscilla Dean as a brazen, if ultimately redeemable, thief, women directors never treated this type of heroine in a Universal feature film, despite the fact that the character type arguably achieved its currency through a series of shorts and serials starring, written, and codirected by Grace Cunard.

The habit-changes afoot from 1917 through 1919 pose two substantial questions. First, when and how does the insistence on assigning gender to individuals come to trump other ways of seeing them, such that identification of a person as a woman determined perceptions of her capacity to direct? Second, how was a fit between genre categories and a gendered division of labor established and revised, such that women directed some sorts of films but not others, and then directed no pictures at all?

Although the first question might seem to be the more fundamental one, its answer actually depends on the second. We have seen how Universal City, in giving business organization life as spatial practice, encouraged experimentation with norms of gender and work. The habits of genre that developed after 1917 fixed gender within a division of labor at the same time as the spatial practice of Universal City changed. This is not to suggest that film genres somehow invented a distinction between men and women ex nihilo and then imposed it on work. Rather, they made sense of a contemporary situation in which gender seemed simultaneously natural and uncertainly related to social position. Such uncertainty played out, for example, in the conflation of political and domestic authority in the 1913 Universal City election of actress-officials to "experiment" with "municipal housekeeping." By 1918, playtime was over. "Home" had been pried away from studio politics and moved from an imaginary location within the workspace to an equally imaginary location outside its borders.

Films directed for Universal by women in 1918 and 1919 confirmed the removal of wives from the workplace. They represented episodes of work and other forays into the public arena as necessary to finding romance and restoring it. If they ended happily, however, they returned the woman to the domestic sphere and normalized monogamous relations with the husband she found there. In so doing, features by Park, Wilson, and Weber reproduced the conventional Hollywood ending. The emergent feature film had established

that ending as typical over the course of the previous three years. In the process, it declined to reproduce some of the alternatives that had flourished at Universal in that period. For millennia, criticism has liked to think of such feats of typification as addressed to audiences by artists who control them. Recent work on genre formation within culture industries, however, reveals filmmakers' interpretations of genre as immanent to the process of genre formation itself. This revision enables us to chart the institutional links between the development of onscreen conventions and a gendered division of labor.

Genre

A Category
of Institutional
Analysis

As an analytical category, genre explains how filmmaking institutions decide and what it means for them to have done so. This is a lesson that might be derived from reading recent approaches to film genres in tandem with a few key sociological studies of culture industries. Rick Altman's *Film/Genre* (1999) and Steve Neale's *Genre and Hollywood* (2000) consolidate a change in film studies' understanding of genre. Both provide an account of this intellectual turn, under way since the 1980s, and place it in the longer history of genre theory since Aristotle. Each rejects the proposition that genre is a fixed structure comprising a set of elements that delimits a corpus of works. In contrast, they understand genre as the effect of a classification process conducted by differently interested parties. Through a complex give and take, this process yields more or less stable groups of works, but it does not rule out the possibility that any given work might be categorized in multiple ways. Indeed, on this view, genres develop as much by recategorizing existing films as by making new ones.

By reorienting the term, these scholars challenge the proposition that mass-cultural genres constitute a ritual or ideological contract between the industry and its audience. As Altman notes, that thesis sustains a kind of magical thinking in which critics need only identify a generic pattern to conjure a sense of collaboration between industrial and audience desire.[1] Grasped as moments of relative stability in an ongoing process, genre's feats of audience mediation look less predetermined, although no less ideological.

Crucially, Altman and Neale insist on the significance of production-side mediation.[2] For Neale, industrial discourses establish "inter-texual relays" by labeling and grouping films, and for Altman, processes of classification and

reclassification presuppose that producers adopt "reading positions" partly based on such discourses.[3] "Reading position" designates a structure within which films can be intelligibly analyzed, interpreted, and "expressed as film-making conceived as an act of applied criticism."[4] The producer and the genre critic thus come to look like comparable sorts of interpreters, albeit with different aims and methods. Each strives to group films by identifying and comparing their significant traits, a task that, for producers, entails specify-ing and reproducing those features felt to be successful—that is, salable. Because they select new projects in accordance with their interpretations, Altman points out, producers effectively make and unmake genres through a continuous process of experimental sorting in which each new film amounts to an interpretation of the genre in which it participates.

On this view, a genre stabilizes when institutions across the industry adopt a comparable reading position and begin to make films accordingly. Within a given studio, the process of genre formation proceeds through a series of production cycles.[5] As commercial filmmakers work to apprehend a shifting market, they strive to identify what the successful types of films have been and to reproduce those successes. At the same time, however, they also strive to distinguish their product from that of competitors. They seek repetition with a difference, a goal achieved by reinterpreting past instances of a given genre or by collating films that would formerly have seemed generically distinct.

We have already seen why it makes sense to consider the studio itself, rather than particular personnel working within it, as the agent of such a process. Studio hierarchy disperses creative prerogative across a number of roles. At Universal, top executives and department heads held substantial authority within the creative process, but so too did directors and scenario writers. H. O. Davis's description of filmmaking at Universal City in 1917, for example, indicates a high degree of central control that nonetheless allowed for substantial give-and-take over what would appear onscreen (see chapter 1). In addition, the geographical separation of production (in Los Angeles) from marketing (in New York) meant that the work of assembling promotional materials was practically distinct from that of making films. As the first point of contact with any given title for audiences and exhibitors, advertising can shape interpretations. Insofar as a division of labor segregates the production of films from the production of advertising for them, however, that advertis-ing does not so much extend the work onscreen as provide an intertext for it.[6] Once we take the collective but internally fractured, hierarchical but col-

laborative character of mainstream filmmaking into account, it becomes clear that no one person can possibly set or singlehandedly revise the structure within which generic interpretation occurs.

By the same token, "the industry" cannot be regarded as the agent of the feats of applied criticism that make and remake genres for the simple reason that "the industry" does not write paychecks or release particular films. From the industrial point of view, genres provide a catalog of trends past, whereas from the studio's vantage they are contested categories, interpretations of which are central to the bid for future success.

To achieve that success requires filmmakers to anticipate what audiences might want, and critics have regarded genre as a means by which producers could make those desires more predictable. It is also a staffing mechanism. Post hoc interpretations of the relative strengths of key personnel proceed in tandem with those of the films on which they work. The process can yield strong equivalences, so that, for example, the mere mention of "Louise Brooks," "Alfred Hitchcock," "Stephen King," or "Arthur Freed" will suffice to generate clear expectations of genre. Dorothy Phillips's progress from dance-hall-owner's daughter to country girl on Broadway provides a more typical instance, in which the star's persona develops through sets of related but distinguishable types of films. Both sorts of examples point to a process in which a studio identifies an employee as a point of consistency. Once such identification has been made, to hire the person again is to adopt a preexisting reading position, even if the star or director or writer is to be employed in an effort to alter or defy expectations.

The sociologist Paul DiMaggio provides a crucial insight into why motion-picture staffing requires this type of post hoc interpretation. His 1977 explanation of "brokerage-administration" points out that the relation between professional skill and administrative hierarchy in cultural industries resembles craft production more closely than it does traditional industrial organization. As in craft administration, the culture industry's decision-makers "lack professional competence to build a finished product and must defer to specialists beneath them on the organizational chart." Nonetheless, brokers—for example, producers—face very different challenges than their craft-administrator counterparts: "They can never be certain exactly what professional competence is or who may be expected to possess it." It is not a matter of finding artisans capable of, for example, reliably cranking out so many hand-blown goblets of a certain quality, but of deciding who seems likely to produce next month's

hit. The only way to do this is "post hoc on the basis of success, or on the basis of reputation or track record."[7]

Sociology has linked this insight about how culture industries function to gender discrimination. In work by Denise D. Bielby and William T. Bielby, brokerage-administration teams up with genre to explain why women writers who work in film and television continue to be paid less and have fewer opportunities for employment over the course of their careers than men do. Because brokerage-administration emphasizes track record, because writers' contracts are short-term, because men are overrepresented in decision-making positions, and because practitioners perceive entertainment-for-profit to be risky business, such assumptions as "women can't write action pictures" typically stand untested. Gendered restrictions do not apply equally or in the same way to men, who, by force of habit, are perceived to be capable of writing in all genres. This decreases the employment opportunities available to women and makes them especially vulnerable to shifts in generic fashion.

Having reached this conclusion, however, the Bielbys identify a problem they find themselves at a loss to describe: namely, what gender discrimination has to do with generic content. "Mass-culture industries are sites where symbolic representations of gender are literally produced," they write, "and they provide new challenges to the way we understand gender inequality in organizations."[8] The difficulty lies in explaining, for example, how the representation of gender by action films gives rise to or sustains the assumption that women cannot write them. The Bielbys' account posits such a link, but it does not explain how it comes about and thrives.

The history of women directors at Universal provides a concrete example of how generic interpretation secures a gendered division of labor, but only if we keep the distinction between individual and organizational decisions in mind. In emphasizing the role of the broker qua gatekeeper, the Bielbys reveal how decisions about individual performance that are not based directly on gender can nonetheless add up to systemic gender discrimination. Gatekeepers do not match "women" to particular genres so much as they match individuals' track records with specific projects. Similarly, Altman shows that individual filmmakers do not invent genres so much as contribute to their evolution. Assumptions about "women" and "men" plainly inform both processes and are informed by them. Nonetheless, the choice to hire a particular individual for a particular job is of a different order than the decision to gender an entire occupation.

The institutional practice of genre that Altman describes arguably matured at the very moment Universal promoted and then abandoned its three most successful women directors. One can see genre-based decision making, but in a much less developed form, during the heyday of Universal's shorts program before 1915. In this period, producing directors and actors constituted relatively stable companies marketed under particular brands. Brands corresponded to broadly defined genres, so that, for example, an exhibitor booking a Joker, a Bison, and a Rex or Laemmle every Saturday could expect to show a comedy, a Western, and a drama. Discernible cycles often flourished within these broad categories, such that one can consider Indian pictures and "Cowboy Girl" pictures to be Western subgenres. Nonetheless, these subtypes too tended to be associated with particular brand names.[9] As early as 1913, Universal routinely connected performers' names with brand names in news items for exhibitors. A randomly selected 1913 issue of *Universal Weekly*, for instance, finds Eddie Lyons identified as "the popular Nestor juvenile comedian" and "petite Jean Acker" named as "a member of the Imp Stock Company" who is about to have her debut in legitimate theater.[10]

Publicity that differentiated individual titles through appeals to stars and genre displaced brand-name marketing after 1915. As Janet Staiger has argued, the change in advertising strategy was necessary for and contributory to a production model emphasizing the feature film.[11] The work of Altman and Neale helps explain why this was so.[12] Whereas a nexus linking key personnel with brand and genre existed during the program era, the comparative field assumed by the mature genre process did not. That process involves weighing a work in progress against prior films and attempting to distinguish it from other works in progress. An ideal outcome of this "producer's game" (Altman's term) is the formula-defining hit—such as *The Jazz Singer* (1927) or *Die Hard* (1988)—which distinguishes itself in the marketplace and lends itself to profitable repetition. In contrast, the program model emphasized regular output, variety, and technical competence over broad and durable public interest in individual titles. To keep the machine running required the production on budget and schedule of films good and various enough to ensure that exhibitors would remain loyal to the brand.

Variety within the program doubtlessly required attention to what had become clichéd and what remained open to variation. The very nature of the program model encouraged the establishment of generic reading positions capable of picking up such nuances of formula. Particularly in two- and

three-reel dramatic subjects, Universal's filmmakers evolved story types that can retrospectively be seen as precursors for most if not all of the types of features it produced at decade's end. As long as Universal was selling the program rather than the title, however, variety could be accounted a virtue in itself. Difference managed risk: given enough different titles meeting a technical standard, some could be counted upon to bring patrons back for another offering.

Features abolished such thinking. Risk management entailed predicting whether a particular title would be at least as successful as its predecessor, which required an interpretation of that precedent's relative success and an evaluation of how well a variation on its theme might do at the box office. While the program and features both required interpretive judgments about what made films "good" and what constituted variety, only the latter made generic thinking essential to the business of production.

The fate of the Bluebird brand indicates the nature of the change most clearly. Nineteen-fifteen often designates Year One of the feature-film era and all it entails, but the Bluebirds offer an important reminder of the unevenness and contingency of this shift. It really was not clear in 1915 what the feature-film era would turn out to be. Universal hoped in 1916 and 1917 to develop a loyalty to their new feature-film brand that would allow it to distribute risk across titles after the fashion of the program. Accordingly, it promoted Bluebirds as setting a quality standard and encouraged exhibitors to market the brand as such. For example, Universal urged theater owners to set a weekly "Bluebird day" and promised to supply a new feature every week to fill that slot. Unlike the daily-change program of shorts, however, Universal counted on Bluebirds to generate larger returns through longer runs and repeat bookings. Judging by the accounting information that survives, a few titles had to succeed in this way to justify the higher per-reel cost of feature-film production in general.[13] Yet to promote some Bluebirds over others (even if by implication) militated against the identity of the brand as a mark of consistent quality. Universal no doubt hoped that repeat bookings of successful Bluebirds would take screens away from competitors rather than from its own new releases, but it cannot have found it easy to contain the comparative logic that encouraged exhibitors as well as filmmakers to seek the next hit.

A look at Bluebird advertising shows a shift in emphasis from brand differentiation toward marketing attributes of individual titles. Beginning in 1916,

Bluebird advertising distinguished itself through its minimalism. Renouncing photographic reproduction of the performers' faces—or indeed any visual elements specific to the film—the Bluebird ad combined an iconic representation with text identifying the film. Typically, a line-drawn bluebird hovers in the upper right-hand corner of the page over the corner of a box within which are written the title, the names of key filmmakers (always the lead players, often the director and author of the source material, sometimes the screenwriter), and sometimes a very brief description. Whereas film-specific information predominates in terms of textual quantity, the brand name overwhelms it graphically as text and icon. For instance, a February 1916 ad for *Hop, the Devil's Brew*, repeats the name "Bluebird" five times in addition to the logo and slogan "The World's Finest Screen Productions."

Only the first word of the title is printed in a larger font than these insistent reminders of brand identity, and one squints to find the names of the leads and directors Lois Weber and Phillips Smalley. The smallest type

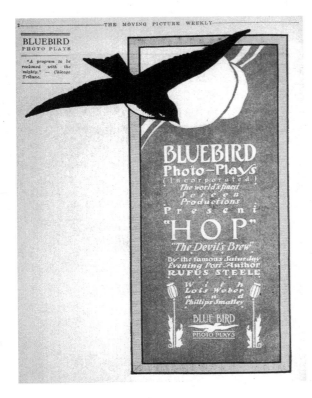

Advertisement for *Hop, the Devil's Brew,* January 1916. Courtesy Margaret Herrick Library, Academy of Motion Picture Arts and Sciences.

is reserved for the description of the film. This is the only indication, other than the title, of what it might be about: "A dramatic portrayal of the secret methods of the opium traffic . . . produced under the supervision of U.S. Government Officials."[14]

Bluebird layout differed from other Universal advertisements in consistency as well as design. Marketers did occasionally produce more abstract, line-drawn advertisements for other brands, but these typically included a pictorial element related to the film. In the same issue as the ad for *Hop,* for example, a target rakishly pieced by descending arrows illustrates Red Feather's *The Target.* While advertisements for Red Feather features did feature the brand logo (a single red feather), they inserted it in a variety of designs, some of which included photographs and sketches of the principal actors and settings of the film. In contrast, with minor variations, the initial Bluebird format repeated itself through the summer of 1917, when Bluebird advertisements featuring photographs of the lead performers began to appear.[15]

In October 1917, the *Weekly* featured the photographs of seven "Bluebird stars" on its cover along with a still from *The Man Trap,* a Bluebird release staring Herbert Rawlinson. By the end of 1917, the textual approach emphasizing brand identity had given way to industrially standard varieties of pictorial advertising. In this approach, star, title, and loosely generic comparisons with other films predominated over markers of brand. A typical Bluebird ad from late July 1918, for example, featured the name of the star, Carmel Myers, above and in letters as big as the title, *The Dream Lady.* (For an illustration of this type of ad, see page 165.) Set off from the background in a bubble, the text describes Myers as the "Bewitching . . . Heroine of *My Unmarried Wife* and many other popular Successes" and designates the screenplay's source material, "Margaret Widdemer's widely read novel *Why Not?*"[16] The background reproduces a still of Myers and the male lead Thomas Holding as well as a second image of Myers in a fairy princess outfit. A tiny text bubble in the bottom left corner explains in relatively small type that the film can be booked through a Bluebird exchange.

Along with this shift in the layout of the Bluebird display ad, the *Weekly* introduced a new "press sheet" format for marketing its features. Rather than embedding a film's key traits in a relatively long discursive synopsis, as it had with two- and three-reel dramas as well as features through 1917, from mid-1918 the *Weekly* provided exhibitors bulleted "selling points" alongside news

items that could be clipped for insertion in local papers. The press sheet for *The Dream Lady*, for instance, enumerates the following "Advertising Punches":

1. The star's drawing power.
2. A novel plot; a young girl setting herself up as a fortune-teller and thereby directing the destiny in love and fortune of those who seek her sage advice.
3. The appealing angle of a girl determined to make dreams come true.
4. A frank exposé of the dreams that beset most young girls, and in the end a realization of the greatest dream.
5. The popularity of a novel turned into a rattling good photoplay.

The *Weekly* provides other crucial information "At a Glance": a list of the star's previous hits; the names of the director (Elsie Jane Wilson), novelist (Widdemer), scenario writer (Fred Myton), and "all-star supporting cast"; the locale ("A small town. A fortune-teller's tent in the rear of a pretty girl's bungalow"); the time ("now"); and "thumb-nail theme." The display ad illustrates several of these traits: the contemporary setting, the fortune-teller theme, and Carmel Myers's participation in the film.[17] This press sheet does not indicate *The Dream Lady's* genre as strongly as, for example, the comparable sheet does for Wilson's *The Game's Up* (1919), which describes that film as "a rollicking comedy-drama bordering almost on the burlesque."[18] Nonetheless, the logic of generic sorting is evident in the comparison with other Myers films and in the emphasis on the novelty of plot combined with indications of the story's familiarity overall. Along with the revised Bluebird display ads, these press sheets provided exhibitors increasingly clear information about the types of films on offer. They selected and parsed particular traits as "selling points." Themes, settings, characters, and key personnel displaced the brand as separate but interdependent variables related by the filmmaking corporation in marketing individual films.

Speaking to the students of Harvard Business School on the subject of motion-picture advertising in 1927, Universal's vice president R. H. Cochrane explained that publicity for the movies was unlike that for other fields because "we may standardize 'brand' advertising, but each film presents a new problem." As a rule, he further asserted, the public was uninterested in movie brands. It cared for personalities instead.[19] By the end of the 1910s, promotion of the star was by far the most consistent feature of Universal advertising, as indeed it was throughout the industry.[20]

Discourse about stars in this period will seem hopelessly contradictory, however, unless one grasps that stardom functioned in tandem with other risk-management strategies, especially genre. The star had what the investment bankers Halsey, Stuart, and Company would later describe as "production, trademark, and insurance value."[21] In addition to contributing to the intrinsic value of the work, the star made returns more predictable by guaranteeing a certain audience. This justified what might otherwise seem irresponsible salaries. How much this "insurance" would be worth, and not whether there should be stars at all, was the question. Opposition to the star system was announced as an imperative behind the creation of the Bluebird brand, for example, yet publicists did not hesitate to name key performers, and by the summer of 1917 they had begun promoting them over the brand. Still, Universal persisted in its efforts to leverage the brand as "antistar." January 1918 saw it advising exhibitors to "Come to Bluebird and Quit Paying for the *Extravagant Star Salaries* That Have Damaged the Whole Picture Business."[22] Through the marketing of Bluebirds, one may deduce that the company wanted the insurance value of the star without paying a premium for it. This could only have increased its interest in generic interpretation, which is crucial to the formation of new, presumably cheaper, stars, insofar as the star's persona develops through its repetition across similar roles.

The deliquescence of brand advertising strengthened the connection between star and genre, but it also loosened the connection among filmmakers favored under the shorts program. Filmmaking personnel remained clumped but tended not to constitute durable companies in which actor, screenwriter, and director worked consistently together and might have exchanged occupational roles. In 1918, Wilson directed six films with five different scenario writers and three different leading ladies. Park, who wrote her own scenarios, made three pictures that year with Dorothy Phillips and William Stowell before switching to make three with MacLaren and Kenneth Harlan. Weber's team was the most consistent, as one might expect given that she had by this point established her own studio off the Universal lot (she continued to release through Universal). Nonetheless, it also registered a shift. She herself starred in *Scandal* (the 1915 film rereleased as *Scandal Mongers*), as she had in numerous titles she directed through mid-1917. She did not appear in her three other 1918 releases, all of which featured "Mrs. Charlie Chaplin," Mildred Harris. Of the men directing features as frequently in 1918 (Tod Browning, Elmer Clifton, Joseph De Grasse, John Ford, Douglas Gerrard, Rupert Julian,

and Robert Z. Leonard had at least four credits each), only Rupert Julian appeared in his films in a principal role. Just as star quality became a variable distinct from but related to genre, so too did the reputation of a director become distinct from, yet associated with, the stars with whom she or he worked and the types of films in which those stars appeared. "Track record" could no longer be reckoned in terms of the success of an entire company or brand over many months but instead had to be based on a scant handful of individual titles.

There was always the chance that the director would, like Weber, become a star—in the sense that his or her name would guarantee a certain public. The director's name, however, rarely had this prominence, and as the example of *The Dream Lady* indicates, it could go almost entirely unremarked in advertising. Nonetheless, the work of interpreting a director's track record resembled that involved in matching a star to a film. The director's skill could perhaps be abstracted from its instances more readily than the performer's persona. Even so, it could not be entirely divorced from those instances. There was no way to say what made a director "good" apart from an interpretation of individual titles, which occurred with an eye toward determining their reproducible traits.

To grasp the situation of Weber, Park, and Wilson in 1918 requires attention not only to how women directors were and were not matched with genres but to the evolution of generic thinking itself as an institutional project. As we shall see, efforts to associate women with certain types of screen dramas beginning in 1917 ended up contributing to a division of labor in which directors were men. Dramas, however, do not provide the best example of how the institutional imperative to think generically developed at Universal. Serials have that honor, and their evolution was more consequential for the gendered division of labor.

Serials

The Foreclosure
of Collaboration

Universal premiered the first episode of *Lucille Love, the Girl of Mystery*, in late April 1914. The studio doubtlessly hoped that this, its first, serial would allow Universal to catch up with Selig, which had hit with *The Adventures of Kathlyn* early in the year, and with Pathé-Eclectic, which had launched *Perils of Pauline* in late March.[1] It turned to the director-actor Francis Ford and the writer-director-actor Grace Cunard, a team that had reliably produced two and sometimes three shorts a month since joining Universal as a package in 1913. Even as they continued to crank out short films, Cunard and Ford made a total of four serials between 1914 and 1917, establishing themselves as Universal's most popular and reliable producers of the genre.

In their shorts, Cunard and Ford played a wide variety of roles, but their onscreen relationship in the serials was fairly consistent. It owes a direct debt to their popular *My Lady Raffles* series, which began to appear in March 1914 and continued at odd intervals over the next two years.[2] (A "series" featured recurring characters but, unlike a serial, completed a narrative in each installment.) In this series, Cunard plays a crook, and Ford, the detective who seeks to apprehend her. They are often united, however, in confronting a more profound villainy.[3] *Lucille Love* likewise transforms the stock characters of hero and heroine into adversaries who must occasionally collaborate: he is an enemy agent who steals secret government documents from her father, she, an amateur investigator. The subsequent Cunard-Ford serials developed this collaborative-competitive relationship in various ways, concluding with *The Purple Mask* (January–April 1917), which explicitly reprised the *My Lady Raffles* template, borrowing Ford's Detective Kelly from that series and re-

creating Cunard's Lady Raffles as Patsy Montez, the Purple Mask, who robs from the greedy to give to the needy.

The surviving fragments of *Lucille Love* and *The Purple Mask* show each partner to possess equally remarkable capabilities of disguise, movement, and command. For example, the final episode of *The Purple Mask,* "The Prisoner of Love," reaches resolution through a scenario of mutual of rescue. Cunard's Purple Mask foils a plot by "social revolutionists" to blow up secret-service agents. Injured in her rescue, she is captured, bound, folded into a dirty sack, and handed over to a gang of river pirates for disposal. Ford's Detective Kelly follows her trail. Moving from shore to rowboat to the pirates' hideout in a shack built on pilings over the water, he finally passes through a series of trap doors to the storeroom containing the sack. Kelly unties Cunard's character and for the first time sees her in her Purple Mask costume, but unmasked—a clear signal that the serial's succession of disguises has come to an end. To cover her escape, he takes her place in the sack. She ties him, then descends through the trap door and swims for shore, where she enlists the help of the secret service and leads them to Kelly's rescue. Unlike the Purple Mask, Kelly escapes confinement. He is attempting to fight his way out of the pirate ship's hold when Cunard's character arrives with reinforcements.

Although one could understand the difference in rescues to confirm a stereotypically gendered division of labor—he fights, she carries messages— overall the serial makes clear that neither could be safe absent the cunning, mobility, and physical prowess of the other. And while viewers might have understood these to be manly traits, the Purple Mask nonetheless possesses them in full measure. Episode thirteen, for instance, features a sequence in which Kelly chases her across urban rooftops: felling him with a powerful uppercut, she delays him long enough to make the sneak—despite the high, white Spanish heels on her black boots.

The formula propelled Cunard and Ford to global stardom. In November 1916, the *Weekly* printed a story from "Our Japanese Correspondent," K. Yamana, describing an issue of *Katsudo No Sekai* (Movie world) devoted to Cunard and Ford. It reproduced from the magazine a caricature of Ford as a turbaned Hugo Loubuque as well the cover image of Cunard, noting that the image had given the actress "Japanese eyes." It also included a partial translation of an article offering a "Psychological Explanation of Cunard's Expression."[4] The preceding May, the *Weekly* had reported that the "Ford-Cunard Popularity

Wave Hits India"; the associated story describes their enthusiastic reception in Singapore, where Universal had recently established a branch office.[5] Looking back on her career in 1932, Cunard reported her salary increasing from $125 per week for work on *Lucille Love* to the astonishing sum of $750 per week during the production of the *Broken Coin,* their second serial.[6]

Undeniably a phenomenon, Ford and Cunard received no small attention from Universal's publicists, who depicted their method of working in ways that corroborated their onscreen partnership. In 1915, the *Weekly* described Cunard as "one of the most capable directors in 'the business,'" noting that "when Mr. Ford is in a scene Miss Cunard directs, and when she appears without her virile co-star, Mr. Ford takes charge."[7] Ford himself is less defensive about his virility when describing their collaboration: "Miss Cunard and I are an ideal team. We even work out the story together. Sometimes one of us, sometimes the other, has the original idea, and then she usually puts it into scenario form. She can dream scenarios. We play into each other's hands. She is a very capable director herself, you know."[8] Describing the arrangement as incredibly efficient in 1916, *Photoplay* declared: "Both Ford and Miss Cunard are able to write, direct, and act with equal brilliance."[9] In sum, the Cunard-Ford films supply an onscreen configuration that makes the man and woman appear equally capable, combined with a work model that emphasizes fungible roles, reinforced by publicity that attributes success to this collaboration. In all areas they "play into each other's hands."

Here, it would seem, is the sort of a package a profit-oriented enterprise might be expected to reproduce, yet Universal did not do so. Cunard is the only woman it credited with directing a serial, and the Ford-Cunard relationship remained unique in its production of star personae that explained and supported a filmmaking partnership.

This much is clear from the follow up to *Lucille Love, Trey o' Hearts* (August–November 1914). Wilfred Lucas and Bess Meredyth worked as director and screenwriter on the serial. They are the only stable male-female team other than Ford and Cunard to have worked in the genre. Lucas and Meredyth had made a few shorts for Universal before *Trey o' Hearts* and later produced two features, including *Morgan's Raiders,* the Civil War drama Meredyth is credited with codirecting. The serial did not star them, however, and Lucas shared the directing credit with Henry McRae, while Meredyth shared the screenwriting credit with Allen Dwan. This was not a Meredyth-Lucas production. It was identified with its star, Cleo Madison, and her success in it likely gave her the

leverage necessary to secure a directing position—but not one in serials. As was typical, she began with an apprenticeship in shorts before taking charge of her own company of actors, with whom she made several shorts and two feature-length dramas.

Other Universal women directors associated with serials followed a similar trajectory, including Ruth Stonehouse, who had a supporting role in *Adventures of Peg o' the Ring,* and Ruth Ann Baldwin, the uncredited script-doctor for *The Black Box* (March–July 1915).[10] Nell Shipman, who went on to have a directing career as an independent producer, wrote the scenario for *Under the Crescent* (June–July 1915) and in her memoir recalls her first (uncredited) directing experience on a location shoot for a subsequent Universal film.[11] If serials helped to open directing opportunities for Meredyth, Madison, Baldwin, Stonehouse, and Shipman, this did not set a precedent for a second wave of serial stars such as Marie Walcamp and Neva Gerber. Before 1918, women other than Cunard who wrote or acted in Universal's serials might end up directing, but not in serials. After 1918, they did not direct.

Industry-wide, according to the historian Karen Mahar, the first serial queens benefited from the flexibility of work roles habitual in kindred theatrical productions. The movement of such actresses as Cunard and Kalem's Ruth Roland into decision-making positions, she proposes, derived from their professional leverage as stars combined with an ideological fit between the heroine's onscreen authority and the assumption of authority offscreen.[12] This is persuasive, but a consideration of the institutional development of the genre reveals why such factors did not produce a more general phenomenon.

Advertising and the Division of Labor

The national advertising campaigns Universal began to organize around *Lucille Love* focused a good deal of attention on the writer. Early serials inevitably entailed a newspaper tie-in; one read in print the weekly installment that appeared on the screen.[13] Universal promoted the *Lucille Love* series to exhibitors by pointing to the size of the readership guaranteed by the circulation of the papers that had agreed to print the stories. By the end of May 1914, it claimed seventy million readers.[14] This marketing plan encouraged an emphasis on the newspaper story as a text both captivating in its own right and preliminary to the film version. Significantly, Universal dissociated *Lucille Love's* writer from its performer-producers by attributing Cunard's stories not to Cunard,

the "Girl of Mystery," but to the equally enigmatic "Master Pen," "the greatest writer of modern times."[15] Universal stuck to this strategy in the three major serials that followed. Advertising for *Trey o' Hearts* explained that the series would "rewrite" literary as well as moving-picture history in adapting the prose of the popular author Louis Joseph Vance.[16] Universal similarly proclaimed the "writing fame" of John Fleming Wilson in marketing *The Master Key,* costaring Ella Hall and the director Robert Z. Leonard.[17] It turned to the English mystery writer E. Phillips Oppenheim for *The Black Box,* produced by the "dean of directors" Otis Turner and starring Anna Little.

The Broken Coin, the next major serial on Universal's agenda and the second Cunard-Ford chapter play, would seem calculated to break the association with a famous writer, since, in a fabulously recursive turn, its newspaper-reporter heroine writes up her weekly adventures for publication within the film's diegesis. Here again, however, publicity extolled the writer Emerson Hough (although it did credit Cunard as scenario writer). A piece puffing Hough in the *Universal Weekly* explained, "The Universal has been very fortunate in the selection of all the men who have written its former serials. Such names as Louis Joseph Vance, John Fleming Wilson, and E. Phillips Oppenheim are as mighty in the literary world as are those of Ford and Cunard in the motion picture world." Hough cuts a manly and aristocratic figure in this piece as a big-game hunter and collector of antiques.[18]

The studio tended publicly to celebrate male authors of serial stories more than female ones, but already-known women did receive attention. For example, Universal publicized the fact that Eustace Hale Ball penned *Voice on the Wire* (March–June 1917) and that Elsie Van Name wrote *The Mystery Ship* (November 1917–March 1918).[19] Although marketers clearly relished the ability to link the derring-do onscreen with the writers' masculine personae, this manliness was ultimately less important than writerly renown. The job of writer was conceived as a specialty valuable for its distinction from those of director and star.

So committed was Universal to marking the author of the newspaper tie-in as a selling point that it preserved this component of the formula even while sacrificing the genre's characteristic episodic structure.[20] Worried that the public might be wearying of the cliffhanger, the Universal publicist Joe Brandt takes credit for an elaborate variation on the great-authors strategy in planning *Graft* during the fall of 1915. The *Universal Weekly* explained that this would be a "series-serial," with narratives complete in each chapter (but tied together

by longer story arcs), and that a different well-known author would write each of the sixteen installments. Universal did not repeat the *Graft* experiment. It did turn again and again to Cunard and Ford. Thus, it seems clear that it regarded their approach as the more bankable proposition. It seems equally clear, however, that it interpreted "the great writer" as a key component of the Cunard-Ford serials' success.

Far more is at stake in this interpretation than whether or not a serial required a writer's name as a positive selling point. Serials were relatively expensive and risky.[21] They required a long-term commitment, and they circulated in a crowded market in which success required convincing exhibitors and newspaper editors in advance that the audience would return week after week. The name-brand writer had insurance value, guaranteeing exhibitors a known standard and easing negotiations with the newspaper syndicate. Considered as an element in the filmmaking process, moreover, the writer's involvement delimited the authority of the director and scenario writer in favor of those managers who coordinated publicity and production. This was true even when "he" was a pseudonym: marketing "the Master Pen" effectively separated authorship of that persona from the person of its writer.

Whereas directors and scenario writers had broad authority over projects produced for Universal's shorts program, coverage of the *Graft* experiment indicates that serials were birds of a different color. Not only did Brandt, Universal's publicist and point man in negotiations with the newspaper syndicate, play a key role in serials production from the outset, coordination of the effort required the studio head to assume supervisory functions akin to those of later producers. The *Weekly* limns hierarchy in action:

> "Make it a stem-winder," said Carl Laemmle . . . in a dispatch to Director General Henry McRae about the serial, adding, " . . . Don't spare the expense. . . ." That was enough for the tireless head of the Universal Company at Universal City and, calling Business Manager George Kann, director [Richard] Stanton, Technical Director Ormston, and Scenario Editor Clapp into conference, he told them to arrange for a production that would be eminently satisfactory to President Laemmle.[22]

While it is impossible to know whether such a conference actually occurred or how routine such meetings might have been under McRae's leadership in 1915, the *Weekly* reported it as a notable exception and in this way struck a theme that continued in the years that followed: serials production required extraordinary feats of planning and hierarchical supervision.

Given the high stakes of serials production, it only makes sense that executives like Laemmle, McRae, and Kann would take equal care in selecting directors as they did in choosing and marketing writers. Credits confirm that no director debuted in serials production. All serials directors had track records indicating an ability to produce on a steady schedule. In addition to Cunard and Ford, only one other serials star directed himself: Robert Z. Leonard, who had at least twenty-nine short films under his belt at Universal before directing *The Master Key*.

The physical demands posed by the rigid production schedule and hazardous stunt work also encouraged specialization. In touting Jacques (pronounced "Jack") Jaccard as the "red blooded" director of *Liberty*, the *Weekly* asserted: "Playing in the serial, of which the episodes must be out on scheduled time, no matter that delays ensue, is never a joke; but playing in a serial directed by a human dynamo like Jaccard is strenuous enough to suit Theodore Roosevelt himself."[23] By the thirteenth episode, the dynamo had run down; McRae had to take over for an ailing Jaccard.[24]

Legends of energetic male directors had a counterpart in ritual recountings of the hair-raising feats preformed by actresses. During the filming of *Trey o' Hearts*, for example, the *Weekly* reported that Madison "does not know the meaning of fear" and "allowed herself to be carried a half mile through the death-dealing rapids of the San Gabriel river"—a story picked up by other trade publications and the *Los Angeles Times*.[25] Such wide-eyed accounts of female bravery were not unique to serials, but what derring-do could mean for tight production schedules became clear during the production of *The Broken Coin*. In the midst of making episode seventeen (out of twenty), Cunard either sustained a new injury or suffered the aggravation of an incompletely healed wound from *Lucille Love* and was forced to abandon production. Ford worked around her absence, and Cunard hastened back to complete the project, but she required a third hospitalization and a much longer rest when it was finally finished.[26] This episode can only have increased institutional interest in distributing key roles across personnel and thereby minimizing the demands placed on individuals.

Interpreted according to the schema indicated by credits, marketing, and published accounts of production, what mattered in serials was not a partnership of charismatic equals with flexible roles but a well-coordinated hierarchy in which reputation and a specialized division of labor functioned as principles of risk management. Cunard returned to work on *The Broken Coin;* Jaccard did

not return to work on *Liberty*. From this, the company might have taken the lesson that women could prove more reliable supervisors than men. Whereas Cunard codirected only two more serials, however, Jaccard continued to be credited with their supervision more or less continuously through 1921. In effect if not intention, the institution judged it better to employ fragile but eminently replaceable male "dynamos" than a woman superstar who excelled in several facets of serials production. The publicity apparatus was not alone in urging such an interpretation of the genre. The films themselves—including those of Ford and Cunard—could be understood to emphasize hierarchical specialization over professional collaboration. If understood thusly, serials would underscore the perception that women were unfit to command. By placing the Cunard-Ford serials back in conversation with their contemporaries, we can see how Universal institutionalized such an interpretation.

Competing Theories of Supervisory Power

At some risk of overgeneralization, one can say that serial-queen melodramas imagine a world in which, for better and worse, organizations constantly meddle. Criminal gangs, spy networks, the police, and teams of private detectives function as tropes for the modern and pretexts for a highly suppressive narration. The famous twists and turns of serial plots often rely on the discovery that some complex enterprise hovering just outside the frame has arranged circumstances or is about to intervene. Villainy and heroism alike are organized: Ford's Loubeque heads a gang of smugglers; his Detective Kelly collaborates with the secret service to foil the anarchist plot. In short, the serials present worlds rife with risk that contending organizations vie to manage. They also define organizational power as normatively masculine. The genre does offer examples of commanding women. In Pathé's *Patria* (1917), for example, the heroine leads a private army as the owner of giant munitions factory.[27] Nonetheless, the generic prototypes established their criminal masterminds and genius detectives as organization men and their heroines as gifted amateurs who temporarily eschew domesticity for a life of adventure.

In the first episode of *Perils of Pauline,* the eponymous heroine, bereft of natural parents and losing her guardian, Stanford Marven, puts off her marriage to his son Harry. Declaring that she wishes "to be absolutely free for a year," she sets off on an adventure. Had she accepted Harry's proposal, control of her fortune would, by the will, have passed to him, but her refusal clears

the way for the schemes of Marven's secretary, the traitor who repeatedly plots her murder in hopes of winning the money for himself. Thus, as Shelley Stamp points out, the narrative establishes Pauline's refusal of marriage, rather than her quest for an adventurous life per se, as the source of her peril. On the one hand, the serial queen's thrilling adventures—her mobility, athleticism, and defiance of traditionally ladylike decorum—bespeak independence from family life. On the other hand, these films present such independence as dangerous and temporary.

In *Adventures of Kathlyn,* the daughter who sets out to rescue her kidnapped father finds herself embroiled in a struggle for control over an Indian principality. She must survive foes animal and human, as well as stand in temporarily as queen, before arriving at a conclusion in which her father and her romance with the big-game hunter Bruce are secure. To arrive at this condition of safety typically means a return home: "Despite their initial break from home life," summarizes Stamp, "heroines' lives are inevitably circumscribed by familial ties in the end, since heredity and lineage come to assume central importance in virtually all of the plots, and marriage, though initially forsaken, usually marks the conclusion of a young woman's escapades."[28]

Universal's serials developed this basic pattern. *Lucille Love* begins with the theft of documents entrusted to Lucille's father, General Sumpter Love, and the arrest of her fiancé, Lieutenant Gibson, who is falsely accused of the crime. Overhearing a phone call between the villain Loubeque and his inside man, Lucille acts on the spur of the moment to save her father and her intended. Appropriating a convenient hydroplane, she sets off in pursuit of Loubeque.[29] By episode six, after several thrilling encounters, the pattern of their relationship has been set. On board a ship in the Pacific, Lucille, disguised as a sailor, peers through a crack in Loubeque's stateroom door as he disguises himself with dark face paint, robes, and a hat with a feather. Recruiting the help of a ship's mate, she follows him unseen (at one point taking the helm) and learns that he is in fact the ship's owner. This leads to the discovery that the ship is smuggling ammunition to China. The captain catches Lucille in the hold at the instant of this discovery, and she recoils as the brute pursues her. Through cross-cutting, we see that above deck Loubeque hears their struggle, and he races to rescue her from the captain's grasp. Later in the episode (in a portion that does not survive), the crew mutinies and takes from Lucille the stolen government papers that provide the serial

its "weenie," or narrative pretext.[30] Set adrift, Lucille rescues Loubeque, who has been thrown overboard.

Here, as throughout the Cunard-Ford corpus, stealth and disguise allow one principal to observe the other unseen until circumstances require a rescue, which often brings recognition. Invariably, however, the pair is forced apart, enabling a renewal of disguise. Through this pattern, the weenie changes hands and impels the narrative toward the next adventure. Although it invents a villain who is also a helper, the serial ends on the model of its predecessors, "with the heroine at home with her rubies and the 'papers' in the hands of 'Washington.'"[31]

Apparently eager to test the parameters of the young and evolving genre, Universal next innovated a wicked father. In *Trey o' Hearts* (August–November 1914), Seneca Trine (Edward Sloman), unsatisfied by the suicide of a romantic rival who crippled him in an automobile accident, makes the rival's son, Alan Law (George Larkin), the object of his obsessive vengeance. In the first installment, he involves his twin daughters, Rose and Judith (both played by Cleo Madison), in a plot to destroy Junior. Not knowing of her father's intentions, Rose, the good sister, is maneuvered into the path of young Law, and immediately she falls in love with him. Once it becomes clear that their relationship places him at risk, however, she breaks with him. Trine then sends Judith, the evil sister, to capture or kill him. Not only does she fail but Law rescues her as her canoe verges on a fatal plunge over a Canadian waterfall. The bond thereby established makes the identical twins romantic rivals of sorts, and subsequent episodes have Judith and her father scheming, sometimes at cross-purposes, to do away with Rose and Law, an intention unfailingly signaled by the ominous deployment of the death card: the trey of hearts. According to synopses, in the end Rose and Law marry, but a freak lightning strike kills Rose, and a reformed Judith takes her place at Law's side.[32]

If the relationship between Judith Trine and Alan Law owes something to the competition and collaboration of Lucille Love and Hugo Loubeque, *The Master Key* (November 1914–February 1915) reproduced the globetrotting treasure-hunt component of *Lucille Love* but minimized the sense of competition between the leads: a young mine engineer (Robert Z. Leonard) and the mine owner's daughter (Ella Hall). Here, as in *Perils of Pauline,* father and mother are deceased. The heroine's adventures do not interrupt her engagement, however. Rather, repeated perils bring engineer and daughter together as

they race her father's enemies to secure clues that guarantee control of a mine and access to a hidden treasure. The surviving scraps of the serial reveal her temporarily trapped in a hidden room in San Franciso's Chinatown, embroiled in a standoff with the Mexican army, racing to recover a sunken chest on the high seas, and finally besting the villain and his henchmen in Calcutta.

By absenting the patriarch in one way or another, these serials allow for the heroine's adventures by interrupting the tradition in which she would be passed from father to husband. More importantly, they also demonstrate the superiority of organizational power over patriarchal power. *Lucille Love* provides Universal's inaugural demonstration by showing that Sumpter Love, though a general, cannot secure his home from infiltration by the world's shadowy powers. While a clever dad might act from beyond the grave by leaving clues that guide his daughter to her legacy, as in *The Master Key,* it is clear that to recover that legacy she will require masculine helpers capable of matching the organizational prowess of her adversaries. According to this schema, a father becomes villainous when, as in *Trey o' Hearts,* he refuses to behave like an obsolete power and instead treats one daughter as a pawn and her sister as a henchman.

In the *Black Box* (March–June 1915), the organizational and technological aspects of the new authority become the principal focus, and their normative gendering is clear. This serial shifts emphasis to the genius detective, Sanford Quest (Herbert Rawlinson), and gives him a team of female assistants: Laura (Laura Oakley) and Lenora (Anna Little), a former maid whom he recruits after freeing her from a criminal husband in episode one. After the husband is killed in episode four, a romance develops between Quest and Lenora as they travel from New York City to London, Egypt, and San Francisco in pursuit of a criminal mastermind, whom we see only as a pair of murderous hands. To apprehend him will require the solution to the riddle of the black box. This riddle, episode one informs us, is somehow connected with the evolutionary "missing link."[33] In their pursuit, Quest, Laura, and Leonora face many perils. Although difficult to judge in the absence of a surviving print, it seems that Quest does most of the rescuing, and he invents or controls a series of fantastic technologies that assist the constantly imperiled investigators: the "Phototelsme, a wonderful instrument which enables the individual at one end of the telephone wire to see clearly what is happening at the other end in motion pictures"; an apparatus for "electric thought transference," allowing the memories of hypnotized persons to appear before the detective in

visual form; "aniahlydte," a special explosive that makes shaped charges; and a "pocket wireless."[34] In sum, *The Black Box* provides a familiar gendering of technological mastery and investigatory insight as masculine qualities that clever women might adopt, but never possess in full measure.

True to their star personae, the next Cunard-Ford outing partly reversed the tendency in *The Master Key* and *The Black Box* to cast the adventurous heroine as the male lead's assistant and rescue object. In *The Broken Coin*, Cunard's newspaper reporter explicitly professionalizes the amateur-sleuth daughter of *Lucille Love*. Discovering by chance the broken coin inscribed with a clue to Gretzhoffen's treasure, Kitty Grey convinces her editor, played by Carl Laemmle himself, to allow her to pursue the story. She soon finds herself beset by mysterious forces led by Count Frederick (Ford).[35] Through a series of close scrapes with fatal disaster, the serial's twenty-two episodes (extended from the originally planned fifteen) redefine Count Frederick's villainy as heroism and supply the pair a common rival in the form of Count Sachio (Earnest

Grace Cunard and Francis Ford on the set of *The Broken Coin,* 1915. Courtesy Margaret Herrick Library, Academy of Motion Picture Arts and Sciences.

Shields).[36] After they unite in vanquishing him, Kitty at last discloses that she possesses the other half of the coin, and Frederick is revealed as the true king. "Terrific fights bring most successful of Universal serials to a close" with an "American queen on a Balkan throne" and, presumably, the end of Kitty's newspaper career.[37]

Interpreted according to the logic suggested by other Cunard-Ford films, this union could be understood as a partnership of equals. Until the very end, each controls half of the weenie. The developing generic pattern, however, favored an interpretation in which Kitty contributes to the triumph of an organization. This triumph creates a home life for her while securing the public authority of her husband.

After the "series-serial" *Graft,* Universal turned again to Ford and Cunard for *Adventures of Peg o' the Ring,* a particularly baroque rendition of the well-established pattern.[38] In the first episode, Ford's Dr. Lund Jr. falls instantly in love with Cunard's Peg and proposes marriage. A prologue has informed us that Dr. Lund Sr., owner of the circus, is Peg's true father, a secret contained in a letter written by her deceased mother and held by her stepfather Flip, the circus clown. As if this were not enough of a romantic obstacle, Peg is overtaken by a violent mania—an inheritance from her mother—that routinely consumes her at the stroke of midnight. She chokes young Lund, rushes off, and finding his mother alone, "attacks her savagely."[39] Continuing the legacy of *The Trey o' Hearts'* Seneca Trine, Dr. Lund Sr. and his wife unite in efforts to do away with Peg. Flip and Lund Jr. work, often at cross-purposes, to secure her safety. Given her eruptions of mental instability, Peg herself fulfills the narrative function of the threat as well as those of rescuer and victim. Fifteen episodes later, Lund Sr. has been eliminated. Dr. Lund Jr. rescues Peg a final time and "performs an operation with an X-ray apparatus to remove the effects of Peg's strange inheritance." The letter comes to light and establishes Peg as heir to the Lund fortune. And Peg finally accepts the young doctor's proposal.[40]

Universal's next serial, *Liberty* (August–December, 1916), established Marie Walcamp as the star who would replace Cunard as the company's reigning serial queen. The ripped-from-the-headlines plot focuses on the adventures of Liberty Horton, all-American heir to her father's estate in Mexico, who finds herself kidnapped by local "insurrectos" and thereby embroiled in geopolitics. The first episode appeared little more than five months after Pancho Villa's forces attacked Columbus, New Mexico, on March 9, 1916—a

battle reenacted as an assault on "Discovery, New Mexico," in episode four. The serial continued while the retaliatory expedition led by General John J. Pershing was still in progress (it ended, without capturing or killing Villa, in February 1917). According to synopses, Liberty, the dashing Captain Bob Rutledge (Jack Holt), and the loyal servant Pedro (Eddie Polo) take turns being held prisoner by and rescuing one another from "evil Mexican revolutionaries" while attempting to get word about their location and plans to American forces led by Major Winston (Neal Hart).[41] Cliffhangers leaving viewers in suspense about the fate of protagonists and villains would have played off against equally enigmatic reports from the Pershing Expedition. "Nobody in this country knows for a fact whether Villa is alive or dead," pronounced the *New York Times* in September.[42] The serial gave Walcamp plenty of opportunities to show off her athleticism—she was an adroit rider. It appears not to have developed a sense of competition between her and either of the two men who rescue her and share her peril. She remains a gifted amateur compared with the masculine military organizations that chase one another back and forth across northern Mexico. (The actors chased one another across the San Fernando Valley, which had been northern Mexico a scant seventy years earlier.) In the final episode, the president of the United States commends Liberty's patriotism, but Mexican spies have shadowed her to Washington, and she requires saving one final time by Pedro, who dies in the effort. Having secured permission from her two guardians as provided by her father's will, she marries Bob.[43]

In the final Cunard-Ford serial, the stars' unique dynamic again disturbed the generic pattern in the service of reproducing it. By endowing the Purple Mask with the commanding qualities of a serial villain, Cunard and Ford underscore the adversarial component of their onscreen chemistry and emphasize that they are equally matched. In disguise as the Purple Mask, the socialite Patsy Montez heads a gang of ex-Apaches from the Paris sewers that repeatedly foils Ford's Detective Kelly and the police. It only makes sense that this Robin Hood figure would partake of the iconography reserved for criminals, and just so, Patsy's bedroom contains a secret revolving fireplace. On one side, she plays the socialite, and on the other side, the criminal genius. In episode eleven ("The Garden of Surprises"), we see her at work in her lair, a rough, dark chamber dominated by a large table around which her minions have gathered disguised in Teutonic costumes of (one assumes) a purple hue. Flanked by standing guards, the Purple Mask sits at the head of the table,

selects underlings with an emphatic jab of her index finger, and, pounding her fist through the center of the frame, barks out her orders.

The serial ends with an acknowledgment that the generically mandated resolution forecloses the mutual danger and competitive derring-do that makes their relationship fun to watch. Kelly secures a pardon for Montez and marries her. After a title card reading, "five years later," we find Mr. and Mrs. Kelly seated in a richly carpeted room reading in front of its baronial fireplace. After a brief exchange of looks reestablishes their mutual regard, a large group of Kelly's associates enters from frame left. Cunard leaves the room and returns with a little girl clad in a tiny version of the Purple Mask costume. An intertitle reads: "Gentlemen, let me introduce my successor—the new Purple Mask." After everyone has hugged the child, we arrive at a final medium shot in which Ford and Cunard gaze at one other and embrace as the child mounts a convenient piece of furniture behind them so as to appear in the frame between them. Patsy's henchmen are notably absent. Presumably, the daughter will need to gather her own gang.

As much as the Cunard-Ford serials depict the pair as equally capable adversaries and partners, they also remained within the generic pattern in depicting the woman's adventures as a preamble to the domestic life and defining them as an appropriate activity for daughters, but not for wives. Later chapter-plays continued to revise and update this formulation, but *The Purple Mask* set the limit beyond which serials could not go, at least at Universal, in establishing the heroine herself as an organizational leader. Although Universal released eleven more serials in the next two years (through the spring of 1919), synopses indicate that no other created a situation in which the heroine could be so clearly understood as an organizational authority.

One final example will suffice to demonstrate that Universal institutionalized an interpretation of the genre that marginalized the competitive-collaborative partnership of Cunard and Ford. *The Red Ace* (October 1917–February 1918) begins as Walcamp's character "refuses the hand of a society man" and receives news that her family's platinum mine has been robbed and her father framed for the theft of the militarily critical metal.[44] The serial conflates and reprises, in other words, the opening situations of *Perils of Pauline* and *Lucille Love*. The Lucille-Loubeque relationship, however, is not repeated. Rather, *The Red Ace* develops the pattern of nearly every other serial that appeared in the intervening years and makes Walcamp's costar a masculine helper, connected

with officialdom, with whom she becomes romantically involved. Enlisting the help of a sympathetic Mountie (Lawrence Payton), she risks her life many times before restoring the family honor and marrying him. Perhaps as a way of continuing the association between Walcamp's character and patriotic military service established in *Liberty,* a synopsis indicates that the newlyweds plan to join the British war effort together. After he professes his desire to "join the boys in France," she pledges to go with him "to do a woman's part . . . for the good of humanity and to make the world safe for democracy."[45] In this way, *The Red Ace* interprets its predecessor heroines as crafty and resourceful amateurs who perform feats of great daring; these women do not command the sorts of organizations that imperil them and will prove necessary to secure their safety; they are highly capable partners for, but not rivals of, the men they will eventually marry.

Conclusion

It might have gone differently. We would do well to remember that the account of genre retrospective criticism makes possible was not available to Universal when it began trying to reproduce the success of *Lucille Love* in 1914. In an alternate timeline, Universal might have attributed the film's success to the frisson generated by a heroine who outsmarts her male rival, secures the nation, and mimes the capacities of the star, writer, and codirector who rendered her. Such an interpretation would have been consonant with the corporation's playful attitude in publicizing Universal City as an infinitely fungible workplace and would have drawn out elements evident in the successful prototypes of other manufacturers (Kathlyn's collaboration with the big-game hunter Bruce in *Adventure's of Kathlyn*; Pauline's adventures with Harry Marven, the suitor she puts off, in *Perils of Pauline*). Instead, Universal ignored those features of the Cunard-Ford serials that made the professional partnerships of men and women seem intelligible, fun, and equal. It fastened instead on the marketing tie-in that promoted a writer and distributed responsibility and risk. It institutionalized an interpretation of "partnership" as mutual assistance rather than competitive collaboration and in this way smoothed the narrative path toward the domestic "partnership" that closed each chapter-play. This predisposed it to understand serial success as an organizational triumph to which women might temporarily contribute but which

they could not reliably orchestrate in the long term. This interpretation, in turn, affirmed the geographical separation between workspace and domestic space that increasingly defined Universal City itself.

The historian and critic Jennifer Bean notes the frequency with which fan magazines and trade publications described serial queens as insensible to danger. Walcamp, for instance, is called "absolutely stupid when it comes to defining the word 'fear.'"[46] Similarly, Madison "does not the know that name of fear, and it is not a question of what her director, Wilfred Lucas, can prevail upon her to do, but what he can prevail upon her not to do."[47] Such accounts interpret the star as "a subject volatized beyond recognition and reason," observes Bean, a self "staged in opposition to a 'they' or, more often, a 'he' who knows better—more simply, one who *knows*." For Bean, it comes as no big surprise that such discussions would credit knowledge as masculine. She is struck, rather, by that fact that in contemporary fan culture, "the star's ability to act without thinking—to take play seriously—registered as a sign of enviable resiliency." The resiliency was enviable because it was precisely what the abundant shocks and hazards of modern life seemed to demand.[48] Cunard's madcap persona certainly evinces this quality. Her signature laugh— mouth open, head thrown quickly back—typically punctuates her escapades and makes clear that she's having a wonderful time as she spontaneously launches herself into the most hair-raising situations.

As we have seen, however, such playful fearlessness did not have to be interpreted as opposite to a type of knowledge construed as masculine. *Lucille Love* progresses by repeatedly affording Cunard's amateur temporary advantage over Ford's professional spy. *The Broken Coin* makes her journalist his professional counterpart. Through the device of the mental fit, *Peg* explicitly divides her circus rider into sensible and dangerously crazed personae. And *The Purple Mask* makes her a mock supervillain, certainly "one who knows." By these lights, the star discourse identified by Bean performs an aggressive interpretation of what gender means for the genre when it casts the serial queen as the unreasonable counterpart to a more knowledgeable male director and collapses the plural "they" responsible for film production into the singular "one" presumed to know.

By following the development of the serials at the institutional scale, it becomes possible to see the difference between the interpretations genre makes possible and those that define a genre as such. Like Bean, Stamp and Ben Singer see serials as ambivalent in their address to the young women who

constituted a large part of their audience and a fan base for their stars. These films encourage women to take advantage of the possibilities of modernity, which allowed and required them to move among the strangers of the urban crowd. Nonetheless, they limit those possibilities within what can seem to be traditional configurations of domestic life and reinforce the correlate assumption that authority over politics and business will be masculine. Thus, Singer writes, "The serial-queen's oscillation between agency and vulnerability expressed the paradoxes and ambiguities of women's new situation in urban modernity."[49] Even as women circulated through the city with an ease unknown to their respectable counterparts a half-century before, the anonymity of such spaces, the pace at which they moved, and their saturation by technologies of transportation and communication posed novel dangers that they were typically presented as unfit to manage. Similarly, Stamp emphasizes, the freedom to move outside the home was constrained by the expectation that the woman would return to it.

This configuration of possibility and constraint, novelty and tradition, was predicated on two theories of social power. First, serials demonstrated that the power responsible for imperiling modern individuals and securing their safety was organizational in character. Second, they demonstrated that such organizations properly subordinated professional collaboration to hierarchical specialization, with a man at the top of the hierarchy. Temporary collaboration was desirable, in other words, so long as this more durable hierarchy was clear. Universal's serials came to formulate the relation of the heroine's public adventures to her domestic position in this way; the travails she shared with her masculine counterpart established her as a new sort of helpmate for him. One could perceive this narrative development as a foreclosure of her life of adventure. One could also see it as a state of security that amounted to a fulfillment of that life.

It bears underscoring that the two theories of power that make such divergent interpretations possible were not givens of the genre for Universal in 1914. They were institutionalized accomplishments of it by late 1917. That accomplishment had serious and abiding consequences for the studio's gendered division of labor.

Gender and the Dramatic Feature

By the end of 1917, Universal had institutionalized an interpretation of the serial that valued hierarchical supervision above professional collaboration. Beginning in November of that year, the studio scaled back and reorganized production. Feature-film dramas replaced the shorts program as the company's principal product. These changes strengthened central coordination and hardened the division of labor. By early 1918, the majority of individual titles produced by the studio received the same kind of attention in the planning and marketing phases as serials and Special Features had received in 1914. The shift eliminated the sorts of apprenticeships through which Universal's most prominent women directors had won their positions. At the same time, generic interpretation became increasingly important in the marketing and production of feature films—now genre, more than brand, distinguished titles from one another. The company began to promote women as directors of a particular type of film. In late 1917 and not before, Universal settled on an understanding of what a "woman" is and assumed that directors who were women would be particularly skilled at handling womanly material. It thereby instituted a double bind that effectively banished women from the director's chair.

Universal's efforts to explain and reproduce Lois Weber's success provide the most illuminating example of this twofold change; indeed, those efforts in large part determined it. From 1915 through the end of the decade, advertising for Weber's features emphasized her genius and her femininity. Nonetheless, Universal did not seriously attempt to market the work of other women directors by associating it with Weber's until late 1917, after she had set up

her own largely independent studio. Then, publicity began to figure Ida May Park as her replacement, and it explicitly linked Park's 1918 films *A Model's Confession* and *Bread* with Weber's 1916 *Shoes*. All of these films starred Mary MacLaren, and all were described as "sociological." A process of reinterpretation had shifted the meaning of this label, however. In 1916, the term had explicitly likened Weber's film with social science. In 1918, it pointed more vaguely to the thematic association of poverty with sexual impropriety.

The change partly explains why Universal's advertising could in 1918 link Weber with Park but did not in 1916 link Weber with Cleo Madison. Although Weber and Madison each directed films labeled "problem plays," these films must have seemed more different than alike in their mode of address to audiences and their manner of presenting sexuality onscreen. Not only did Universal decline to associate Weber's work with Madison's, it also made no connection between Weber and Ruth Ann Baldwin, Ruth Stonehouse, or Lule Warrington, each of whom it credited with more than one title in 1917. Universal's house organ, then called *Moving Picture Weekly*, regularly mentioned individual women directors in this period and not infrequently pointed to the numbers of women directing at the studio. Only in the case of Weber, however, did it develop a rhetoric associating a particular type of film with her authorship.

That rhetoric emphasized not what made Weber a woman but rather what made her Weber. Universal's most profitable director of feature films by far, the studio interpreted her as unique. Marketing exaggerated the difference between Weber films and all other features. From her diverse output, it selected an exemplary corpus distinguished by its morally upright treatment of sexually controversial subject matter. As critics have noted, it was useful for the studio to be able to attribute such films to a woman's direction because such attribution could rhetorically pitch the presumption of a middle-class white woman's virtue against arguments that cinema posed a moral hazard and should be censored.[1] It remains striking, however, that the ability to treat Weber films in this manner did not provide the company with a model it extended to other women. This changed in the fall of 1917, when Universal formulated a rough conception of a type of film *Moving Picture World* identified as a "woman's feature," reinterpreted Weber's work as exemplary of it, and likewise associated Park and Elise Jane Wilson with it.[2] By then, however, Weber could be described as making a different type of film.[3]

Preachment and Profit

In 1915, *Hypocrites* established Weber as a household name. The film opened in New York on January 20, 1915, where, according to the historian Anthony Slide, it "played to capacity crowds, with a minimum seat price of twenty-five cents, and would have run indefinitely at the theater had it not been required to give way to a legitimate production there in February."[4] By August, the film had set attendance records in major cities throughout the country and had the distinction of a rare New York revival. In its exposure of hypocrisy, the film personifies the Naked Truth via the altogether nude teenager Margaret Edwards, whose image hovers in superimposition over various scenes as she holds an allegorical mirror up to contemporary society.

This was controversial. Ohio banned the film, and Boston's mayor mandated that Truth be clothed (a task accomplished by hand painting). Nonetheless, the film received a notably enthusiastic reception among arbiters of taste and their middle-class addressees. Karen Mahar attributes this reception to the film's canny appropriation of artistic and religious convention. The figure of the Naked Truth, she points out, bears a resemblance to Hiram Power's 1844 sculpture *The Greek Slave,* as well Jules Joseph Lefevre's 1870 allegorical painting *Truth*—both artifacts connoting cultural legitimacy in 1915. Similarly, the film associates the nude figure with a sermon within the film. In the opening sequence, her image passes in superimposition through the "Gates of Truth." A sermon on hypocrisy follows, in which the camera looks down on evidently discomfited parishioners and up at the minister, who takes as his text Matthew 23:28: "Even so, ye outwardly appear righteous unto men, but within ye are full of hypocrisy and iniquity." In this way, *Hypocrites* establishes the Naked Truth as an occasion for the audience to reflect on its own moral and aesthetic virtue.

Weber's declaration of authorship buttresses this interpretation. The film begins, before the opening sequence, with a still portrait of Weber looking every inch the proper middle-class lady. It is signed, "Sincerely, Lois Weber." In efforts to manage the controversy generated by the film, Weber extended this persona, branding the censorious as so obsessed with obscenity that they were unable to appreciate the moral and aesthetic qualities of the film. They were, thus, ideal targets for its critique of hypocrisy. The film's financial success, its explicit inclusion of Weber as author-function, and the controversy it generated defined Weber as a public figure with a moral voice: she preached.[5]

In retrospect, critics have tended to see Weber's moral voice as a, if not the, defining feature of her films of this period, and contemporary publicity did describe many of them as "preachments"—a not uncommon term for contemporary films that urged audiences to reform such vices as philandering, dissipation, and laziness. Weber herself characterized them as "missionary pictures," "editorials," and, looking back in 1918, "heavy dinners."[6] In truth, however, Weber's output in this period was more various than such labels suggest. Recalling the tremendous productivity of her years as a Rex director before 1915, it encompassed ten shorts, one of them, *The Face Downstairs,* a suspenseful chase film. It also included several features not advertised as "preachments."

The evolution of studio publicity for Weber films in 1916 shows a decision-making process at work. We can see how Universal arrived at an interpretation that made Weber a director of "preachments" first and foremost while pushing aside interpretations that would have given her more in common with the studio's other directors. We can also see how Weber's moralizing came to be understood as counterpoint to sexual suggestion primarily, as opposed to sermonizing or editorializing on a range of current issues.

Although Weber did not work for Universal at the time of *Hypocrites'* release, the company quickly brought her back into the fold. The film had been shot at Universal City but produced by the actor-director Hobart Bosworth's company, for which Weber and Smalley made six features and one dramatic short (*The Traitor*) in 1914 and early 1915. At least two of these features, *It's No Laughing Matter* and *Betty in Search of a Thrill,* were "comedy dramas."[7] By April 1915, the pair had rejoined Universal, bringing with them Bosworth and his wife, the screenwriter and actress Adele Farrington. The U promptly set all four to work on features released under the newly created and heavily advertised Broadway, Bluebird, and Jewel feature-film brands.

Edwards, who at age fourteen had won an international "perfect woman" contest, retired from the screen to pursue a career as a dancer and physical-culture advocate. The controversy over Edwards's Naked Truth reinforced a national preoccupation with physical beauty then in the process of redefining the ideal female body as athletic, healthy, graceful, and proportioned like the Venus di Milo.[8] In this effort, Edwards had a counterpart (and competitor) in the vaudevillian and swimming star Annette Kellerman, who had appeared in Universal's 1914 Special Feature *Neptune's Daughter.* In 1916, Universal produced another success in this vein by featuring the champion swimmer

(and former captain of the New York Female Giants baseball team) Ida Schnall in *Undine,* based on the German fairy tale.[9]

The first of Weber's Universal features clearly aimed to reproduce the formula of *Hypocrites'* success—but not by feeding interest in physical perfection. In place of the Naked Truth, Weber and Smalley's *Scandal* delivered an allegorical gossip monster, "a slimy, shapeless creature which, dwelling in a swamp, throws mud upon all within reach of its talons, befouling and besmirching everyone."[10] Advertisements claimed that *Scandal* was "Written by Lois Weber, Author of 'Hypocrites'—and bigger than 'Hypocrites,' it is the biggest thing this wonderful woman has ever done!"[11] The story had been suggested to Weber by a newspaper editorial, and publicity repeatedly referenced Weber's intention to become "the editorial page of the studio," a metaphor that associated her moral voice with a civic one.[12]

Weber's next feature could be said either to extend or depart from this strategy, depending on whether one accepted the equation of preaching and editorializing. In *Jewel,* Ella Hall portrays an eponymous angel-child who, through her cheerful disposition and belief in Christian Science, reforms the household of variously ill-tempered and degenerate relatives in which she is temporarily placed. Advertised as "a child's play for grown-ups—a grown-up's play for children" and as likely to produce "happy tears," *Jewel* was compared with *Hypocrites* and *Scandal* based on the quality of Smalley's direction. Publicity mentioned its "feminine touches" and described it as a "preachment." Rather than emphasizing its connection to newspaper editorials and contemporary controversies, however, advertisements emphasized Clara Louise Burnham's 1903 novel as its source material.[13] While likewise perceived as a preachment, *Scandal,* like *Hypocrites,* more clearly depicts a social problem through its allegorical gossip monster, which roams the city corrupting working relationships as well as personal ones. *Jewel,* in urging the reform of vice through childlike innocence and Christian virtue, could be seen as a meditation primarily on individuals' failures and virtues.

Jewel and *Scandal* had been released as "Broadway features" available on the regular program. Beginning in 1916, Universal switched most of Weber's features to the newly created Bluebird brand, although it exploited a handful of "specials" on a states'-rights basis. Altogether, Universal credited a dozen features to Weber and Smalley between February 1916 and February 1917. Four of these dealt with what would now be called "social issues." *Hop, the Devil's Brew* (1916) condemns "the opium evil"; *Where Are My Children?* (1916)

makes a eugenicist argument against abortion, advocating birth control for some and reproduction for others; *The People vs. John Doe* (1916) inveighs against the death penalty; and *Shoes* (1916) deals with the working poor, consumerism, and casual prostitution. One film, the ten-reel *Dumb Girl of Portici,* provided a vehicle for the ballet star Anna Pavlova. The remaining seven treated moral problems of a less distinctly topical sort. *The Flirt* illustrates the irresponsibility of a flirtatious young woman; *John Needham's Double* deals with murder and impersonation to defraud an estate; and *The Eye of God* depicts a murderer's guilty conscience and a woman's attempt to exploit it for revenge. In *Saving the Family Name,* a chorus girl turns out not to be the vamp the newspapers have made her out to be. *Idle Wives* teaches a metacinematic lesson about adultery. In *Wanted: A Home,* a homeless and unemployed maid impersonates a nurse and becomes embroiled in a murder plot. And *The Mysterious Mrs. M* provides a lighthearted look at a suicidal but healthy and wealthy young man whose friends conspire with a fortune teller to give him a reason for living.

Publicity for these films did not uniformly emphasize Weber's contribution. Consonant with the Bluebird strategy of promoting "the play" above "the players," the authors of the source material often received top billing.[14] An advertisement for *Hop,* for instance, printed "by the famous *Saturday Evening Post* author Rufus Steele" above and in bigger print than "with Lois Weber and Phillips Smalley," implying that Steele "authored" the film, and Weber and Smalley merely starred in it.[15] The ad for their next Bluebird feature, *The Flirt,* named its *Saturday Evening Post* author, Booth Tarkington, above but in smaller type than the star, Marie Walcamp. Both names appeared above "directed by Lois Weber and Phillips Smalley."[16] Because of its subject matter, historians have been particularly interested to assess Weber's contribution to the controversial Special Feature *Where Are My Children?,* but at the time its lead actor, the stage star Tyrone Power, also received considerable attention.

Weber and Smalley directed two more films with Power for Bluebird: *John Needham's Double* and *The Eye of God.* Advertisements gave Power the most prominent billing, and when publicity extolled the quality of Weber's direction and acting (she played the female lead in *Eye of God*), it emphasized not her moral voice but the skillful handling of novel plot devices: complex doubling and impersonation in *John Needham,* a story told almost entirely in flashback in *Eye.* These films were not billed as "preachments," and reviews and synopses do not suggest that they urged the audience to reform. Such

a maneuver would seem difficult in any case, since it would apparently have required viewers to construe themselves as frauds and murderers.[17]

Shoes was a Bluebird of a different color. The typically minimal advertisement for its June 1916 release read: "Bluebird Photoplays, (Inc.) / Present / MARY MAC LAREN / In An Extraordinary Cinema Production / "SHOES" / By Stella Wynne Herron / From Jane Addam's [*sic*] Famous Book "An Ancient Evil" / Produced By That Master Genius / Of The Films / LOIS WEBER."[18] The identification of Weber as "master genius," the lack of a credit for Smalley, the role of MacLaren (a Weber discovery who would star in all her remaining Bluebirds), the association with the noted social reformer Addams, and the treatment of "an ancient evil" (prostitution) in combination confirmed certain elements of Weber's directorial persona at the expense of others. In this way, the success and marketing of *Shoes* constrained future interpretations.

The year-end report established *Shoes* as the most frequently booked Bluebird of 1916.[19] Even so, Universal doubtlessly perceived its sober treatment of an "ancient evil" to entail certain marketing risks. The *Chicago Tribune's* Kitty Kelly voiced a commonplace wisdom in her January 1916 review of two Triangle films (*The Price of Power* and *The Green Swamp*). Calling them "heavy fare," she notes, "while we like to be preached to, when the matter is skillfully done, also we like to get our suggestions through the pleasant sugar pill of semi-comedy."[20] Accordingly, Universal's advertising department made sure to promise touches of comedy, pathos, or salaciousness along with a moral lesson in its treatment of Weber's films.

To contain the implication that a film decrying "the opium evil" might be unpleasantly didactic, for example, prerelease publicity for *Hop* explained that the film "teaches a lesson without preaching it."[21] Similarly, the *Weekly* quotes Louella Parsons as writing that *Shoes* "loosens the heartstring, stirs the pulse, and makes one choke with emotion."[22] The *Weekly* distinguished MacLaren's second Weber film, *Saving the Family Name,* from *Shoes* as "not a 'problem drama,' but a serious and purposeful handling of a certain phase of stage life that will provide engaging entertainment without guile."[23] Then again, the house organ told exhibitors that they would find the third Weber-MacLaren film, *Idle Wives* (a "State's Rights Feature"), to be "the most dignified and moral preachment ever presented on the screen—Endorsed and applauded by Press, Public, and Clergy."[24] In this neat bit of sloganeering, reassurance that the film has the endorsement of "Press, Public, and Clergy" confirms the title's implication that it would need it, as exhibitors and their patrons are

encouraged to imagine what idle wives might do. *Wanted: A Home,* a fourth MacLaren film written and produced by Weber, but credited to Smalley's direction alone, was simply billed as a "heart interest story."[25]

If Universal uniformly sought to contain the implication that a moral lesson would be dreary or pedantic by promising entertainment value, it preferred to invoke sermonizing as a counterweight to suggestions of sexual and especially feminine impropriety—the Naked Truth of *Hypocrites,* abortion in *Where Are My Children?,* prostitution in *Shoes,* adultery in *Idle Wives.* Indeed, after *Jewel,* Universal avoided the language of "preachment" when the moral issue was not primarily of a sexual character. *Hop* "teaches" without "preaching." *The People vs. John Doe* is "the most powerful arraignment ever presented on the evils of Capital Punishment." Advertising associated the film with the "producer of such huge successes as 'Where Are My Children?' 'Hypocrites,' 'Scandal,' 'Jewel,' 'Shoes,' and others." Nonetheless, it tended not to cast Weber as educating and reforming viewers through moral suasion. Rather, she was characterized as an advocate making an "argument" to a deliberative audience akin to a jury.[26] At this point, the interpretation of Weber as "preaching" was not the only nor necessarily the prevailing interpretation, but it was clearly linked to the management of sexual suggestion.

In April 1917, another allegorical picture provided an opportunity to reappraise thoroughly Weber's oeuvre. *Even as You and I* personifies Lust, Drink, and Self-Pity, dispatched by the Devil to tempt an artist (Ben Wilson). It gives them counterparts in Loyalty, Wisdom, and Experience, which ultimately redeem him and save his marriage. In an article for the *Weekly,* Marjorie Howard places the film in the context of Weber's work since *Hypocrites.* With no mention of Smalley, she finds in "every one" of Weber's films "a purpose beyond that of mere entertainment." Billing her as the "world's greatest woman director," she praises Weber's "soaring imagination" and "unfailing sense of the dramatic" and explains that she "can deal successfully with subjects which other directors would not dare to touch for fear of condemnation." The characterization finds support in *Hypocrites, Scandal, Idle Wives, Where Are My Children?, Shoes,* and *The People vs. John Doe.* It ignores the not-particularly-controversial Bluebirds—*The Flirt, John Needham's Double, Eye of God,* and *Saving the Family Name.* It explicitly exempts *Dumb Girl of Portici* as not like Weber's others, distinctly a vehicle for its star. Howard strains to include the "ethereal" *Mysterious Mrs. M:* although made "with apparently no purpose on earth but to amuse," the film "yet bore a message more powerful than that

of many sermons on that which makes life really worth while." Nonetheless, she emphasizes that Weber's films are not "dreary propaganda." They are the "work of a poet of the screen—yet they pay!"[27]

Interestingly, in unifying Weber's work thematically, Howard emphasizes its stylistic variety: "Sometimes she works through the extreme of realism, through a fidelity to the last sordid detail which is typical of a modern Russian, as in the Bluebird 'Shoes.' Sometimes she joins the 'open air' school and gets effects with cloud studies, flowers, and natural surroundings like an impressionist painter. . . . Again she frankly employs the resources of allegory, as she did in 'Hypocrites.'" Coding *Shoes* as "Russian" distinguishes it from the allegories not only in its realist style but also in its depiction of social class, particularly of "sordid" poverty—an indication of a variant interpretation to which I will return.

In the context of the article, Howard's treatment of style makes a different point. Although it might seem to be auteurist, her review is in fact a generic account. In naming a relatively large number of Weber feature films and explaining in some detail what they have in common, Howard's piece on *Even as You and I* differs in approach from celebrity profiles of the director with which it nonetheless shares key themes. Amply supported by quotes from Weber herself, celebrity profiles praising the director's genius also emphasized her conviction that film could do more as an art form than simply entertain. Through the spring of 1917, they accented her interest in message films.[28] Once she began working at her own largely autonomous studio that summer, they were more likely to underscore her avoidance of "propaganda" and her commitment to making a profit.[29] Publishing her review on the cusp of this shift, Howard's objective is less to find a set of concerns that structure Weber's oeuvre in toto than to characterize it in a way that will increase interest in *Even as You and I,* the review's pretext.

Accordingly, Howard's procedure differs from the mid-twentieth-century accounts of Hollywood directors that, for example, established Weber's contemporary John Ford as a source of stylistic as well as thematic unity by finding such unities across genres (Ford is Ford whether directing *Young Mr. Lincoln* or *Stagecoach*). In contrast, she downplays style as more elusive and difficult to market than theme, plot structure, character type, and personnel. Weber's "touch" does not appear, as later criticism will have it, as a predilection for certain patterns of editing, framing, and so on, but rather as an elusive "genius." The occulting of style supports a cult of personality and at the same

time eases generic categorization. This allows Howard to pick up key motifs that publicity had attached to Weber films, particularly after *Shoes*, while dropping traits that a different interpretation might have accented.

For example, neither the novel plot constructions of the Power films nor the disputatious quality of *The People vs. John Doe* are made general features. Similarly, the exclusion of lighter films less plainly engaged with social problems (*The Flirt, Saving the Family Name,* and *Wanted: A Home*) strands *The Mysterious Mrs. M* as a film that diverges from (what the article counts as) Weber's typical emphasis in that it has "apparently no purpose on earth but to amuse" and requires that it be interpreted in a way that places it back within the corpus such that it nonetheless has a sermonlike "message." In these particulars, Howard's interpretation accords with Universal's subsequent publicity efforts. By the spring of 1917, through a process of selective interpretation, a "Weber film" had been established as a mark of quality that treated controversial subject matter, most typically of a sexual nature, in a morally defensible manner and that entertained while sermonizing.

"Yet they pay!" exclaims Howard. In elevating Weber and in selecting those films felt to exemplify her corpus, the interpretation she offers does in fact hew closely to the balance sheet. It does so, however, only provided one makes an effort to understand how that document itself would have been interpreted. The article favors Weber's high-profile Special Features. A November 1916 semi-annual report shows *Where Are My Children?, Dumb Girl of Portici,* and *Idle Wives* to have been the Feature Booking Department's most profitable releases that year by far.[30]

The article also mentions several Bluebirds, and here the evidence is more equivocal. A report summarizing Bluebird's first year provided four indices of success. It listed gross rentals. It showed profit, which it tabulated in two different ways: one column weighed gross rentals against total film (negative) cost and a portion of operating expenses; another included income from and expenses for promotional materials. The balance sheet also recorded the number of bookings and the average booking price (rental receipts divided by the number of bookings). As explained in chapter 1, the "profit or loss" column likely taught the most ambiguous lesson. Of fifty-three Bluebirds released in 1916, only five (*Jeanne Dore, Secret Love, Undine, The Strength of the Weak,* and *Shoes*) showed a profit after the accountants apportioned operating and home-office expenses. Film cost was clearly a major factor. At midyear, the company increased what it spent in making Bluebirds from around fifteen

thousand to around twenty thousand dollars, most likely because grosses for the first handful of Bluebirds indicated that they might return as much. By year's end, however, each of the more expensive titles showed a loss of at least six thousand dollars—some as much as eleven thousand dollars—despite numbers of bookings roughly comparable to profitable or nearly profitable features made for less. Clearly, the task of setting appropriate budgets loomed large in early 1917. In this effort, Universal might have found the "average rental price" figure, which appeared in the final column of the statement, most relevant. When read in tandem with the number of bookings, it demonstrated that exchanges could expect a higher price from exhibitors for certain titles and thereby provided prognosticators an index of how the market valued particular titles over time, apart from the question of costs.

With the single exception of *Hop, the Devil's Brew,* the Weber Bluebirds Howard names turned a profit.[31] *Hop* showed a small loss, but its average rental price of $13.59 placed it in the top quartile of Bluebird titles with one thousand bookings or more.[32] The Tyrone Power films *John Needham's Double* and *Eye of God* lost substantially more and averaged under twelve dollars in rentals. Subsequent marketing collaborated in excluding these films from the Weber corpus—although Universal did make an effort to win repeat bookings by associating them with more popular Weber releases in early summer 1917.[33] Two other Weber money-losers not mentioned by Howard appear likely to have made a profit, or at least to have recouped the cost of production, had they been produced at the fifteen-thousand-dollar level. *Wanted: A Home* had an average rental price of $13.71, and *Saving the Family Name* came in at an impressive $14.38. Subsequent advertising mentioned these films, but only in connection with other Weber films starring MacLaren.[34] Walcamp, who starred in *The Flirt,* did not continue to work with Weber. While that film did gross enough to recoup the cost of its negative, it showed a loss, and its average rental price of $12.45 was middling. Universal did not mention *The Flirt* in connection with Weber after its release. Although the balance sheet does not record the production cost of *The Mysterious Mrs. M* (not yet released at the end of 1916), a mid-1917 reckoning indicates that it averaged fourteen dollars per rental, which likely explains its inclusion in Howard's article.[35]

As one might expect, Howard's interpretation of what made a Weber film a Weber film accented profit. Such an interpretation, however, also reinforced and required a particular interpretation of the books themselves; a marginally unprofitably film like *Hop* might be included in the corpus because it

accorded with a definition of Weber's films as controversial, an unprofitable film that nonetheless commanded a relatively high rental price, such as *Saving the Family Name,* might be parsed less as a typical Weber film than as evidence of its star's drawing power. The numerical certainty of "profit" is perpetually shadowed by the necessity of interpreting it in the service of future profit: it presents a puzzle in its self-evidence. Solutions to the puzzle of profit must have taken the broader marketplace of films into account. Nonetheless, they worked concretely with variables (balance sheets, production schedules, scripts in development, personnel under contract) available at the institutional scale.

In early 1917, no other Universal director even began to approach Weber's track record as a maker of profitable feature films. More interestingly, the other directors to whom the company most frequently entrusted its Bluebirds in 1916—and continued to employ most regularly in the following year—generally lost money. Universal credited Weber and Smalley with eight Bluebirds in 1916 and 1917; it credited De Grasse with fourteen, Rupert Julian with twelve, Lynn Reynolds with nine, Jack Conway and William Worthington with eight each, Rex Ingram with seven, and Robert Z. Leonard with six. With the possible exception of Ida May Park, no other director made more than three.[36]

According to the first annual report, Leonard's *Secret Love* was the only film made by a Bluebird regular other than Weber to have turned a profit. Conway's *The Social Buccaneer* and Ingram's *Chalice of Sorrow* (which starred Cleo Madison) averaged around fourteen dollars per rental, but they failed to recoup the cost of their negatives and were among the brand's biggest first-year losers at over eleven thousand dollars each. By comparison, *The Grip of Jealousy,* the De Grasse film that fetched the highest rental price, cost exhibitors $12.76 on average. Its grosses covered production costs but not overhead, and it lost nearly two thousand dollars. Reynolds came to Bluebirds late in 1916, and judging from the account books, one would not have thought his first ventures particularly auspicious. Neither *The Girl of Lost Lake* nor *The Secret of the Swamp* (a.k.a. *The Story of the Swamp*) averaged over thirteen dollars per rental; each lost around nine thousand dollars. Returns on Julian's first Bluebirds, *Naked Hearts* and *Bettina Loved a Soldier,* were just as bad, as were those on Worthington's *Love Never Dies* and *Stranger from Somewhere.*[37] Plainly, when it came to deciding what made a director employable, profit was not the main factor.

Presumably, these decisions were not wholly irrational. The company did not plan to continue indefinitely to make films that failed to recover their cost of production. More probably, it found reasons to believe that the directors to whom it frequently turned would make successful films provided they were of the right sort, for the right market, and that appropriate budgets could be set. These problems required no small interpretive effort on the part of a diverse cast of decision makers and contributed to tumultuous struggles over studio leadership in the spring of 1917 (see chapter 1). Placing Weber's work in this context not only clarifies why Universal would be interested in it but also underscores the importance of generic interpretation to the sort of feature-film production that was fast becoming the main focus of the studio's efforts. For the "Weber film" to seem profitably reproducible, it had to be constituted as a type. The feat of typification amounted to an interpretive juggling act whereby Universal could understand a record of cost and income, the fact of Weber's direction, and a particular approach to a particular sort of subject matter as bundled traits. Evidence suggests that Universal had not yet found such an interpretation for the other directors it regarded as competent or for the other Bluebirds that turned a profit.

In terms of subject matter and address, the non-Weber Bluebirds that showed a profit would likely have been difficult to distinguish from the brand's money-losers. *The Strength of the Weak,* directed by Lucius Henderson, made close to three thousand dollars, but mainly because it had been produced for under eleven thousand dollars (average rental price: $12.45). It describes the odyssey of a young, poor, beautiful country girl, Pauline D'Arcy (Mary Fuller), whose middle-aged lover puts her through college, where she becomes a successful author and falls in love with his son. Although a rival suitor and the father threaten to sabotage the relationship by revealing her past, love triumphs in the end.[38] Leonard's *Secret Love* netted closer to two thousand dollars (average rental price: $13.39). Set in 1870s England, the film tells of a mine-owner's daughter (Helen Ware) in love with the new mine supervisor (Harry Carey) who campaigns to reform working conditions and thereby attracts the father's wrath. After a dramatic fistfight instigated by the father but won by Carey's character, the mine owner is himself done in by a much-abused employee, clearing the way for romance and reform.[39]

That neither film generated successors explicitly marketed as in one way or another like them suggests that they were not perceived to be particularly

unique or exemplary of any generic type. And indeed, in the synopses that constitute the only surviving evidence for most of Universal's feature-length dramas from this period, country and city frequently represent opposed ways of life, the virtuous poor and/or progressive professionals often triumph over the decadent and/or greedy rich, and the monogamous love of a young white man and woman appears safer, more stable, and more satisfying than the sexual adventures and perils that provide narrative foils. The young woman "on her own"—cut off in one way or another from family and community—provides a recurrent trope. Generational confusion and struggle are common: the older generation must either be killed off or made to recognize and value new kinds of social relationships, such as college as a marriage market and progressive industrial management. Chance meetings of past acquaintances, abandoned children who as adults become entangled in romances involving a parent, wills placing draconian conditions on inheritance, adoptions, impersonations, and twins or doubles mistaken for each other are among the privileged plot devices for working out such themes. Considered at this level of abstraction, Universal's output probably did not seem distinct from 1910s cultural production more broadly. While the success of *Strength of the Weak* and *Secret Love* may have made their plots or settings seem worth repeating, it makes sense that neither would be perceived as formula defining.

Weber's work was seen as successful because it was different. When publicity set aside her chorus-girl film *Saving the Family Name,* for example, it marginalized a title that arguably had more in common with her colleagues' features than it did with the likes of *Scandal, Where Are My Children?,* and *Hop, the Devil's Brew.* According to advertising copy, *Saving the Family Name* answered the question, "Can an actress make a good wife?"[40] So did De Grasse's *Bobbie of the Ballet,* and it likewise answered in the affirmative. In the Weber film, a chorus girl (MacLaren) is misrecognized as a vamp, whereas in the De Grasse version a young actress (Louise Lovely) masquerades as the widowed mother of two children to save them from the orphanage.[41] Once each young woman can be seen as herself despite society's opprobrium, marriage and prosperity follow. This comparison, however, does not occur in Universal's marketing. By selectively interpreting Weber's films so that sermonizing about controversial subjects (particularly of a sexual character) seemed to be their most characteristic feature, Universal exaggerated the difference between them and the more typical fare of her less profitable male counterparts.

Different Women

Through the end of 1917, women other than Weber also directed more typical (and various) fare. In late April of that year, publicity for Eugenie Magnus Ingleton's first and only Universal feature indicates the prevailing approach to other women directors. Ingleton, formerly an actress and newspaper reporter, came to Universal City as its scenario editor in the fall of 1916. Her *Birth of Patriotism* was released as a Special Attraction and provided the *Weekly* an opportunity to report that "the ranks of women directors . . . are augmented every year. There are now at least six at Universal City alone, doing some of the best work which the industry produces." The paper deemed Ingleton's gender noteworthy, but it did not present the film itself as different in subject matter or style because a woman directed it. Ingleton "has already shown her skill in a short picture," the *Weekly* explains, and *The Birth of Patriotism*, based on a *Saturday Evening Post* story, is "her first important photoplay."[42] The film, set in London, has dissolute Johnny leave his wife Mary for a cockney girl. Military service changes his ways, and while he's away at war, the self-sacrificing mistress befriends Mary and ends up saving their marriage. The film is most easily grouped with a set of contemporary features meant to ready Americans to support the war effort, and Ingleton's familiarity with England, from whence she had immigrated, was likely more relevant than her gender for choosing her as the director.[43]

Ruth Ann Baldwin, like Ingleton a screenwriter with a newspaper background, had a much longer run as director, but the announcement of her directorial debut in November 1916 struck a similar tone. The article's title— "Another Woman Directing"—imagines a reader who will consider a woman director unusual enough to be newsworthy and also well within Universal's routine.[44] The *Weekly* reports with interest that Baldwin adopted practical masculine garb for outdoor work as Reynolds's apprentice on *The End of the Rainbow* and, in the next breath, finds it "very appropriate" that her first solo release, a one-reel Thanksgiving drama entitled *The Mother Call,* "should have been produced by a woman, as it idealizes motherhood." Consonant with the then-prevalent spirit of gender play at the studio, Universal perceives no major contradiction between the roles of motherhood-advocate and outdoorsy professional who will "wield the baton of authority."[45] A follow-up piece in January describes Baldwin shooting on location in downtown Los Angeles. The novelty of a woman director drew huge crowds, reports the *Weekly,* but

the disruption was minimal, "for the director had the scene so well mapped out that with the aid of the traffic officer and other policemen she was able to keep the crowds moving."[46] As in coverage of Ingleton, assertions of professional competence counterbalance the presumption that this is an unusual job for a woman.

Universal credited Baldwin with thirteen films, mostly shorts, through the fall of 1917. They were not generally marketed as "Baldwin" films, although reviews emphasize her competent handling of familiar stories and the introduction of unusual plot twists.[47] Announcements of her 1917 two-reel film *The Woman Who Would Not Pay* are exceptional in calling attention to female authorship and typical in how little they make of that fact. "Three clever women combined their work to make this picture the success that it emphatically is," declares the *Weekly*, referring to Madison, its star; Ingleton, its screenwriter; and the director Baldwin. In the film, a husband punishes his wife's infidelity by trapping her lover in a wall safe where she has attempted to secret him; he asphyxiates.[48] An appeal to women's authorship may have been intended to offset the lurid subject matter, but there is no suggestion of this in the synopsis, nor is effort taken to interpret the women's contribution to the film as anything other than "clever."

The Woman Who Would Not Pay was released as a Star Featurette, a brand created in 1917 in an ultimately unsuccessful bid to convince exhibitors that Universal could provide the entertainment value of a feature-length drama in a shorter format on its program. In truth, Baldwin's first five-reel feature, *A Wife on Trial* (July 1917), does not seem to have been much more substantial than the "featurette." In both films, plot development is almost entirely circumscribed by a single situation. Billed as "the story of a girl who married for a rose garden and what came of it," *A Wife on Trial* stars Mignon Anderson as a lonely librarian who agrees to marry and care for a wealthy invalid because she is taken with his family rose garden. Baldwin's husband Leo Pierson wrote the scenario and plays the invalid, whose paralysis turns out to be psychosomatic. On the verge of annulment, the marriage of convenience gives way to a love match when the invalid recovers use of his legs in time to save the librarian from an intruder's assault. Anderson had starred as the loyal wife of the sculptor who succumbs to temptation in Weber's *Even as You and I*, and the roles would seem comparable in their validation of self-sacrificing femininity. Nonetheless, marketing did not associate them, nor do the few

mentions of Baldwin's feature identify it generically in anything like the way that *Even as You and I* was presented as a typical Weber allegory. Setting—the location filming of the rose garden—was among the most notable aspects of the film.

Baldwin's second and final Butterfly feature, *'49–'17*, defied generic placement. It did poke fun at the Western tropes male directors like Ford took more seriously, but it was neither a "comedy-drama" nor the sort of spoof that might have been released as a short. (An example of such a spoof is *Even as Him and Her*, the 1917 L-KO parody of *Even as You and I*.) Nor did *'49–'17* continue in the dramatic tradition of *The Woman Who Would Not Pay* and *Wife on Trail*. The film does interpret the gendered work of putting on shows at Universal (see chapter 3), but there is no indication that the studio noticed. Certainly, it did not extend such an interpretation to Baldwin's body of work. In publicity overall, Baldwin's competence at narrative construction and her ability to work on location seem far more important.

Cleo Madison's directing career provides perhaps the most instructive point of comparison with Weber's. Like Baldwin and Ingleton and unlike Weber, Madison films were of a piece with Universal's routine output. Unlike Ingleton and Baldwin and like Weber, however, Madison came to directing as an actress and began by directing herself in short dramas for the Rex brand. Her reputation as "an emotional actress" complicated efforts to create her directorial persona in ways that point to the contemporary instability of "woman" as a category and indicate the difficulty Universal would have had subsuming filmmakers as different as Madison and Weber within it. Simply put, a comparison of the two reveals that Universal as an institution did not know what "a woman" was.

In September 1915, the *Weekly* presented a full-page headshot with the caption, "Cleo Madison, Who Is Now Directing Her Own Photoplays."[49] In October it published a brief story asserting that Madison "has demonstrated to the satisfaction of Henry McRae, director general of the company at the Pacific Coast studios, and also to the other officials there that she is a capable director." It goes on to explain that in *The Cowboy Girl* (released as *The Ring of Destiny*), Madison portrays a woman who disguises herself as a cowboy and "displays a knowledge of the manly art that will surprise her many admirers." In truth, Madison's knowledge of the manly art cannot have come as a complete shock to fans familiar with her derring-do from the serial *Trey o' Hearts*, released the previous year. In any event, interest in, if not exactly celebration

of, gender play and the assertion of competence are the hallmarks of this announcement, as they would be with the notice of Baldwin's directorial debut the following fall. Little more than a month later, the *Weekly* found Madison "directing her own company, playing the principal roles in the productions and attending to the business details which accompany the management of a large moving picture company with a thoroughness which has astonished those who thought they 'knew' her."[50]

What looks like astonishing competence in the pages of Universal's house organ appeared as a contradiction in the fan magazine *Photoplay* the following January (1916). According to William Henry, "To see [Madison] in pictures tells you absolutely nothing of her real character. Before the camera she smiles and weeps with the wonderful sympathy of which a woman alone is capable. You never even stop to think whether or not she has a brain." In person, however, she is "a cool, calculating business machine," and Henry "couldn't help thinking that she would have made a great diplomatic agent or railroad president."[51] Although Henry's response to Madison's "cold" competence voices the stereotypical anxiety of a man confronted with a more capable woman, his article affirms the *Weekly's* contention that a woman can successfully inhabit a professional role perceived to require masculine skills. Universal's house organ embraced the notion that bodies gendered in one way might perform tasks—like managing crowds and fisticuffs—gendered in another. In contrast, Henry seeks to reconcile the two by revealing the warm onscreen woman to be a calculating performance enacted by the coldly masculine Madison qua director. Almost by definition, celebrity profiles strive to make a person the author of his or her performances, a maneuver that requires the role of private person to be reconciled with more explicitly theatrical roles.[52] Henry's approach to Madison is notable not so much for performing this gesture but for pointedly declining to feminize her in the process.

Perhaps to counter Henry's portrait, Madison compared herself to Weber the following July in *Moving Picture Stories,* a Universal promotional weekly that novelized film plots for fans and also published celebrity profiles. In "The Dual Personality of an Actress," Madison's two personalities are not, as in Henry's piece, a warm brainless woman and a cold "business machine" but "a professional woman and a domestic one." The article praises her technical competence as a director and notes her penchant for gardening, cooking, and "artistic clothes"—an interest that unites the professional and domestic personae. It also quotes Madison as declaring, "Every play in which women

appear needs the feminine touch. . . . Lois Weber's productions are phenomenally successful, partly because her woman creations are true to the spirit of womanhood."[53] These are indeed themes familiar from contemporary celebrity profiles of Weber, which, as surveyed by Shelley Stamp, sought to blur the lines between her professional and domestic roles while elevating her as an exemplary "middle-class matron."[54] The matronly mantle sits uneasily on Madison, however. Unlike Weber, whose marriage to Phillips Smalley seemed for a time to echo and validate her professional collaboration with him, Madison did not marry until after she had directed her last Universal title. Discussions of her home life had to make do with an invalid sister (Helen Bailey) for whom she cared.[55] More importantly, the actor-directors' onscreen personae differed dramatically, with Madison frequently portraying impoverished rural or urban working-class heroines as well as figures of action in serials and Westerns. It would have been almost impossible to see these directors' "woman creations" as imbued by a common "spirit of womanhood."[56]

In December 1915, the *Weekly* advertised Madison's first feature, *A Soul Enslaved,* as a "notable problem play" featuring "Cleo Madison and a brilliant cast." "This thrilling drama of a woman's bondage," gushes the *Weekly,* "touches on the double standard of morals, and while it is clear, powerful, and absorbing, it is replete with the most intensely dramatic situations."[57] In the film, Madison plays Jane, an impoverished "child of sorrow" who is much abused in her youth. After being kept by two men—the owner of the factory where she works and the well-to-do Paul Kent—she makes a break with her past, donating everything to charity and marrying Richard Newton, whom she does not know to be Paul's old college friend. She has a daughter with Newton but lives in guilt and fear that her past will catch up with her. When it does, her life collapses. She retreats to an asylum. In the end, however, her husband, recalling an episode from his college days in which his seduction and abandonment of a young woman led to her suicide, "realizes he is as much a sinner as she is" and returns to her.[58]

In its baroque interweaving of past and present seductions and betrayals to arrive, through suffering, at love and redemption, *A Soul Enslaved* resembles *A Mother's Atonement* (October 1915), the final film in which Madison starred before assuming direction of her own company. In this three-reeler, directed by De Grasse and written by Park, she portrays both mother and daughter. The two are separated when a wealthy man from the city leads the mother astray. He subsequently abandons her. They are reunited when his younger

Cleo Madison in *A Mother's Atonement,* 1915, frame enlargement.
Courtesy Library of Congress.

Cleo Madison in *A Mother's Atonement,* 1915, frame enlargement.
Courtesy Library of Congress.

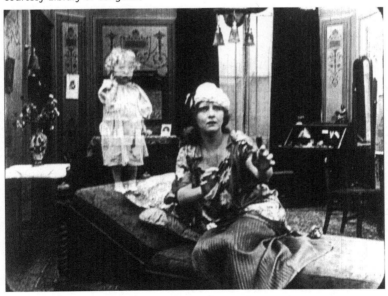

counterpart lures the daughter to the city. The daughter's return brings about the mother's reform and lands each Madison character a stable romantic partner. A partial print of this film survives and indicates the visual strategies that supported such classically melodramatic scenarios. We see Madison as the fallen mother, supine on her chaise lounge, absorbed in her cigarette and the pleasures it affords, sent upright by the vision of her longed-for daughter, which appears in double-exposure over her shoulder. Envisioning a conscience, the film instantly transforms the wicked woman into a good one—a shift that generates ambiguity about how different these women really are. The double-exposure also encourages us to identify with Madison's decadent mother, since we share the vision that nags her. True to form, the transformation encourages a complex and even contradictory attitude toward the character, one that shifts from potential condemnation paired with fascination to empathy and hope for redemption.

Madison's second and final feature as director continued to work in this vein. *Her Bitter Cup* was, according to advertising, "a thrilling and intensely gripping drama of a woman's supreme sacrifice for her people—the poor and lowly."[59] Even more clearly than *A Soul Enslaved,* the film depicts improper sexual relations as the logical extension of poverty and labor exploitation. The heroine, Rethna (played by Madison), has an affair with one of a factory owner's sons (the bad seed), then marries the other (the upright brother). She does so to extract money from the family and divert it to "her people," the downtrodden workers. To arrive at a happy ending in which true love redeems past wrongs and the factory owner changes his ways, Madison subjects Rethna first to a factory fire, from which her estranged husband rescues her, and then to a crucifixion. In what was likely depicted as a dream sequence, the deranged younger brother catches her unawares and pins her to a door with nutpicks. According to the synopsis, the film ends with Madison forgiven in her husband's arms.[60] Here, too, for a poor woman to be kept by a man—or even a series of men—looked like a possible route to happiness (conceived in the usual way as monogamous heterosexuality plus prosperity), provided her suffering is extreme enough to motivate redemption. Both Madison features layer a drama of class relations over a drama of marital relations, making it appear as though the woman's "atonement" has a counterpart in capital's recompense. Capital's guilty privilege is not only material, in that the wealthy are shown to live much better than the workers do, but also as sexual, in that the rich man's money enables him to buy sex while avoiding commitment.

Madison's surviving short, *Her Defiance*, indicates how she might have conveyed such relations onscreen. After establishing a romance between Adeline, a country girl played by Madison, and Frank, a wealthy suitor from the city (Ted Duncan), Madison uses parallel editing to develop a series of categorical oppositions. His father calls him back to the city. She remains in the country, where her brother works to sabotage communications between these two zones and thus to drive the lovers apart. Through the juxtaposition of images, we see what Adeline and Frank cannot: they still love each other. Pregnant, believing herself abandoned by Frank, and pushed by her thuggish sibling, Adeline consents to marry an elderly and grotesque local landowner. After the marriage ceremony, however, she recoils from his embrace and flees, stealing a nearby buggy. The husband gives chase and, again through the power of parallel editing, we see that unbeknownst to her, he dies in the pursuit.

Meanwhile, in his urban office Frank fights with his father over his attachment and despairs to learn of her marriage and subsequent disappearance. Through his investigations we learn that Adeline has inherited her dead husband's estate. But he does not know what we soon discover: she mops floors in the office building where he works. Resolution occurs when he discovers their child living in the broom closet. Following the sound of the cries, he opens the closet door to discover the babe and then takes it back to his office to comfort it. Meanwhile, Adeline leadenly mops up. She too turns to follow the baby's cries and is set on a path that will at last unite the family in a single frame. As the editing pattern separates and reunites Adeline and Frank while indicating that they remain a couple, it also opposes knowledge to limited vision, wealth to want, city to country, and the petty possessiveness of father, brother, and husband to the connective force of heterosexual romance.

Although blocked communications thwart romance for both partners, we see that this proves far more consequential for her. As in other Madison films, we are thereby invited to perceive the injustice of the sexual double standard along with that of economic disparity. Reunion both does and does not provide justice. Transposing capitalist inequalities into a moral register, the plot contrives to make two of its villainous figures—his father, her husband—also the couple's material benefactors. Depending on how much satisfaction one finds in this reversal, it might be perceived either as righting moral failings (wicked, wealthy old men get their comeuppance) or as a down payment on a more systemic redistribution. Similarly, as perceived through the device of

parallel editing, the sexual double standard receives an individualist framing and solution. Reunion ends her suffering and his guilt, and again, depending on how satisfactory one takes this resolution to be, one might perceive it either as a validation of the nuclear family or an indication of its pathology. The Madison films implicitly critique bourgeois comfort as exploitative and bourgeois sexual mores as hypocritical. They do so, however, in a way that ultimately confirms the norms of middle-class culture. Madison films thus exemplify the political, sexual, and affective ambiguities and potentialities we associate with popular melodrama.[61]

The Madison films more closely resemble the (male-directed) *Secret Love* and *Strength of the Weak* than the other profitable Bluebirds that retrospectively composed Weber's oeuvre. Like Madison's *A Soul Enslaved,* Weber's *Shoes* (June 1916) was labeled a "problem play," and it too enabled critique of prevailing sexual and economic relations—but a critique of a very different sort than Madison's films likely made available. A print of *Shoes* survives, and recent discussions of it qualify the view of a "Weber film" provided by Universal's publicity, realigning what Howard saw as its "Russian" quality with a thoroughly American project of social reform.

Constance Balides notes that *Shoes* was one of several mid-1910s films that "invite the spectator to take up a position of reformer in relation to the social problems represented" and notes its participation in the political and social-scientific discourse circulated in reformers' surveys and trade-union tracts. This discourse, she argues, defined consumption as "a site for public debate about a working woman's character."[62] Visually, the film presents itself as a case study. In its opening, a close-up of its protagonist, Eva, isolated against a black background is followed by an image of Jane Addams's book *A New Conscience and an Ancient Evil,* implying that Eva is an example drawn from its pages. In its content as well as its form, Weber's film compares itself with sociology. Like so many contemporary examples of that young science, it addressed an audience comprising not the Evas of the world so much as those who, if made sympathetic to her plight, might support and manage those political and economic reforms designed to promote her "welfare" (her material well-being and her virtue).

Stamp points out that this amounted to a claim about filmmaking itself. *Shoes* did not merely address middle-class spectators with the idea of recruiting them to the Progressive cause, she maintains, but like other Weber "heavy dinners" it was meant "to suggest a broader congruence between film viewing

and reformist sensibilities—to suggest, in other words, that cinema might aspire to much grander aims than commercial recreation for the masses."[63] Weber films did so at a time when the industry was still working out the implications of the Supreme Court's 1915 decision in the *Mutual vs. Ohio* case that movies are "a business pure and simple" and not entitled to First Amendment protection. In seeking to approximate sociological description, *Shoes* implicitly suggests that filmmaking is a professional labor akin to social science and that Weber is a professional akin to Addams. Although, as Stamp points out, Weber more consistently associated herself with the old professionalism of the clerisy (and particularly missionary work) than she did with the emerging professionalism of social work, Progressive Era arguments often blurred the distinction between the two.[64] In any event, *Shoes* differs from Madison's typically melodramatic approach to poverty, first, in its suggestion that professional care of some sort will be necessary to safeguard the Evas of the world and, second, in addressing viewers as the agents, rather than the objects, of such attention.

And yet melodrama is not entirely foreign to *Shoes*. Stamp finds two scenes from the film particularly indicative of the complexity of Weber's address to middle-class viewers. The first, early in the film, introduces the button-up boots for which Eva will ultimately trade her virtue and the seducer who plots her downfall. On her way home from work with her coworker Lil, Eva lingers before a display window. An inserted close-up reveals the object of her desire, but not from her point of view. Rather, Weber has Eva reach out for the boots and matches that action in cutting to the close-up "so that her gesture is continued across the two images, her hand serving as synecdoche for her desire." In the close-up, the window glass palpably thwarts the hand's movement toward the longed-for boots, which seem to hover magically behind it (see page 162). We will later discover that these boots are objects of direst need: Eva's crumbling footwear imperils her health and her livelihood, as it will neither keep out the rain nor support her long days standing behind the counter as a retail clerk. We do not know this yet, however, and so the boots seem fashionable commodities first and foremost. The film encourages a viewer's identification with Eva's desire for the lovely boots, yet it also objectifies that desire in the image of the hand against the glass.

As the sequence continues, the film accents this objectification of consumer desire by situating it within what Stamp describes as "a broader framework of sociological observation, one that hinges (cinematically) on viewers seeing

what Eva fails to see and (culturally) on understanding her social position in the consumer economy." Specifically, Eva fails to see Charlie, who enters the frame from a doorway behind her. Two close-ups follow. In the first, Charlie turns to look out of frame and takes an obviously erotic interest in Eva, his eyes and smile widening in an exaggerated leer. In the second, which interrupts the first, Eva looks back over her shoulder to catch Charlie's gaze and turns away, then looks down, modestly averting her eyes. Weber cuts back to the master long shot to reveal Lil and Charlie exchanging glances while Eva, framed between them, returns her look to the shop window. The sequence thereby establishes Lil and Charlie as conspirators in Eva's seduction and Eva herself as a desirable object akin to the boots, which bait the trap that will ultimately ensnare her. "Viewers are asked to watch as if through two pairs of eyes," Stamp observes, "empathizing at first with Eva's longing for the lovely boots, then gradually seeing what she cannot see, the web of winks and implications spun by Charlie and Lil just outside her line of vision." In this way, the film defines Eva's consumer desire as itself a social problem distinct from, but thoroughly entwined with, the poverty and sexual predation endemic to her urban environment.[65]

 Whereas the scene of Eva lingering in front of the shop window makes an object lesson of her plight, another sequence emphasized by Stamp develops the viewer's identification with her. Mechanically, resignedly, Eva readies herself for her "date" with Charlie. She pins up her hair and is about to change her workaday shirtwaist for a more sheer one with a more open neckline, when she confronts herself in the mirror. The back of Eva's head fills the foreground of the right half of the frame, while on the left a small oval mirror holds her face as if in a cameo. A crack in the mirror fractures her reflection across her eyes, and she cannot sustain the look. In her slow turn away from the mirror, she and her reflection are briefly framed together in profile, mirror images of a woman who cannot bear to see herself as an image. "Watching herself as if onscreen in this sequence," Stamp argues, "Eva understands her place in the sexual economy for the first time. She also functions as a stand-in for the film viewer, conceived here not as a reform-oriented middle-class woman struggling to comprehend the plight of poorly paid working women, but as one of those women themselves. . . . [M]iddle-class women, those chiefly targeted by the film's address, are asked to see Eva's image as their own reflection, to ask, would I be able to look myself in the eye in similar circumstances?"[66]

 Stamp sees the ability to pose this question as the film's advantage over

the reform tracts from which it borrows. At the same time, she emphasizes the limitations of its "melodramatic frame, where individual virtue and vice, rather than larger social and political forces, are held accountable for injustice."[67] In the end, the moral failings of Eva's lazy father, her seducer, and her "friend" Lil seem more plausible explanations for her ruin than, for example, her substandard wages or the system of values equating a woman's virtue with her sexual continence and supervision of the home.

A comparison with Madison-Park films reveals the extent to which Weber's interest in objectifying social problems as moral failings differed from the more conventional melodramatic formulae on which her films also drew. Madison and Park not only invited identification with the wronged or fallen woman but enabled her redemption. Weber's pre-1917 films deny their viewers such catharsis. This difference is part and parcel of their effort to develop onscreen a more explicitly professional approach to the social. Whether through allegory (*Hypocrites, Scandal, Even as You and I*) or by miming the sociological case study, this effort was distinguished by what Howard called "a purpose beyond that of mere entertainment" and above all entailed a claim to objectify problems requiring solutions outside the narrative world of the film. Accordingly, they often ended unhappily.

It is significant, therefore, that publicity described Weber's address as "preachment" more frequently than as "sociological," which labeled only *Shoes*. The former gave Weber a decidedly old-fashioned cast, one associated with historic virtue rather than up-to-date professional competence. There is also reason to believe that Universal hoped "sociological problem play" might have connotations other than those suggested by the reference to Addams. Balides points out that the *Moving Picture World* writer Louis Reeves Harrison uses the term "sociological" in 1913 "to characterize a new trend in feature films involving a 'strong leaning toward investigation of laws regulating human society.'"[68] The theme of social investigation is not, however, evident in Universal's marketing for the 1914 white-slavery film *Manna*, described as a "modern sociological drama." Rather, publicists assured exhibitors that the film "will offend no one for the moral lesson that it teaches is as beautiful as the words from the Old Testament."[69] In context, "sociological," like the word "problem" with which it was often paired, coded a representation of sexuality in which a moral lesson counterbalanced titillation and disciplinary knowledge regulated desire.

While *Shoes* and its marketing make it possible to conceive the director

as a modern professional involved in Progressive social work, a type who could be a woman, it is also clear that Universal was reluctant to extend that interpretation to other Weber films. The important point is that these interpretations—Weber the sociologist, Weber the missionary—were coeval and could appear both to support and to contradict one another, just as Weber's address could oscillate between objectification of Eva's desire and mobilization of viewer identification with her plight.

What made Madison's films and Weber's impossible to talk about under a shared rubric in 1916 is nothing more or less than the multiple and contradictory character of contemporary femininity. A "woman" was the sort of virtuous middle-class lady who supervised the home, a professional with authority and responsibility in the public sphere, and a desperate free agent making her way in a city of strangers. She supervised the social, exhorted and exemplified it. Working in a variety of occupations outside the home, she encountered a husband who would ensconce her within it. Heterosexual monogamy, while clearly the norm, perpetually confronted her with the problem of reconciling material and erotic desires—her own and those of her prospective partners.

The Woman's Feature

By the fall of 1917, Universal had made this last point of confusion a common denominator. Eliminating Madison's melodramatic emphasis on the atonement for sexual and material sins and jettisoning "preachment," it made balancing sex appeal with sexual continence *the* feminine project. On the outcome of this balancing act, monogamy and material security would depend. For the first time, marketing grouped women directors with each other and with particular sorts of films. They became experts in women's "psychology"—a term so frequently abused that in 1918 Universal joked about forbidding it.[70]

In May 1917, the *Weekly's* initial announcement that Park had joined "the very few women directors" described her as a stand-in for her vacationing husband De Grasse, with whom she had long worked as a scenario writer. The following week the house organ announced that she would alternate with De Grasse in directing Dorothy Phillips productions for the Bluebird brand. In July, *Moving Picture World* positioned Park as Weber's replacement: "During the eighteen months Bluebird's program has been progressing," it told exhibitors, "there has always been a woman director concerned in the picturemaking for that firm. . . . Lois Weber was a great factor in promptly establishing

Bluebirds, and when she decided to begin producing on her own account Ida May Park was assigned to the work of directing Dorothy Phillips, thus keeping a woman's hand in the Bluebird game." As with coverage of Madison and Baldwin, the article considers Park to have masculine and feminine qualities, but it takes greater pains to establish the latter as essential.

> Her first picture [*Flashlight*] was largely acted out-of-doors and Miss Park climbed mountains and waded streams with all the facility and disregard for obstructions that any man might demonstrate. The surging mob scenes in [her second film] "Fires of Rebellion" were expertly handled, and in directing "The Rescue" the woman director fitted to a nicety, because, the July 23 Bluebird is distinctively a "woman's feature," with society scenes and fine gowns dominating incidentals to the problem-plot. Thus has Miss Park fitted into her niche—made for herself an essential place, equal to that of most men in creating features for a program of the first class. As Miss Phillips and Miss Park are under long contract, exhibitors and their public may look forward to repeated evidences of the artistry and skill in "team work" possessed by these talented women.[71]

What *Moving Picture World* described as a "problem-plot," the *Weekly* depicted as "the tale of feminine duel fought with weapons almost as deadly as those in use in the trenches."[72] Phillips portrays an actress who seduces her ex-husband to save a friend's daughter from marrying him. This rescue operation places her in competition with the younger woman and ends up restoring her former marriage. By October, De Grasse had been reassigned to direct Franklin Farnum while Park continued to manage the Bluebird company starring Phillips, Lon Chaney, and William Stowell. In the spring of 1918, she began a series of Special Attractions starring the Weber alumna Mary MacLaren. With one exception, these projects and their marketing fitted Park into the feminine niche *Moving Picture World* established for her. In this way, they confirmed and extended its interpretation of a "woman's feature" as comprising society scenes, fine gowns, and a plot rich with sexual misunderstanding.

In bracketing "women's feature" with quotation marks, *Moving Picture World* indicates its dissatisfaction with the phrase as a generic label, and my research suggests that it was not widely used in this manner. What did become widespread in these years, however, was the conviction that women would be reliably interested in films of this loosely defined type, which was perhaps most frequently called a "society drama."[73] This occurred at roughly

the same time as fan magazines began to treat the movie fan as quintessentially female.[74]

In October 1917, *Photoplay* announced Weber's intention not to produce "propaganda pictures" at her new studio, by which it meant such films as *Hypocrites, Where Are My Children?, Idle Wives,* and *Even as You and I.* Rather, Weber would offer entertaining pictures to help distract the public from the "jumping toothache" of the war. The new films do differ from her earlier work, although there are continuities. Universal, which continued to distribute Weber's films, exploited some of these in marketing her late 1917 output by association with certain of her past successes. The past was reinterpreted yet again to suggest a continuity of concerns.[75] Although publicity no longer described Weber's films as "preachments," it continued to play on the idea that she could be relied upon to handle suggestions of sexual impropriety in a morally satisfactory manner.[76] This morality was complemented by the appearance of notably fine gowns in several of the new Weber features.[77]

If Universal was able successfully to rethink Weber's contribution in this way, that had everything to do with the fact that its apparatus for grouping films was much better developed in the fall of 1917 than it had been the previous year. The company relied on its new certainty about genre to affirm that Weber and Park, unlike Weber and Madison, made films that were similar to one another and addressed particularly, although not exclusively, to women. Publicity now regularly named comparison films. The star's name almost always indexed a comparison. "Park" and "Weber" were among the few director's names that did so, and publicists used the fact that the two directors had worked with the same stars to bolster Park's reputation by association with Weber's. Publicity for *Bread,* for example, pointed back to MacLaren's Weber films and also identified Park as the "consummate genius [who] created *The Grand Passion* and *Broadway Love,*" which had starred Phillips.[78]

Tag-lines, a now standard publicity device, indicated that Park and Weber films share a preoccupation with a woman's difficulty in achieving material security and emotional satisfaction while maintaining sexual propriety. In October 1917, Park's *Bondage* told "the Story of a Discontented Woman." In late November, Weber's *The Price of a Good Time* was "the story of the Great Temptation known to every working woman."[79] In January 1918, Park's *Broadway Love* revealed "the Heart of the Great White Way in all its nakedness" in its story of a country girl seeking stage success who finds a wealthy husband instead.

In March, Weber's *The Doctor and the Woman* provided an "intimate disclosure of life as we live it." The plot matched a brilliant doctor with a landlady's daughter.[80] In April, Park's *Risky Road* was "the drama every woman should see." An enormous cautionary devil loomed behind Dorothy Phillips in pictorial advertising.[81] In May, Weber's *For Husband's Only* was "as tantalizing as a wink."[82] In June, Park's first film with MacLaren, *The Model's Confession*, was a "fashion show" with an "unusual theme" in which "a father loves his own daughter unknowingly."[83]

In July, *Scandal Mongers*, the reissue of Weber's 1915 film, was itself an occasion for gossip as "one of the most talked about Photo Dramas ever Screened." It represented "the jealousy of a loveless marriage."[84] In September, Park's *Bread* was "an Enormously Dramatic Picture of a Young Girl's Struggle Against the Temptations of the Footlights."[85] In December, the *Weekly* recommended advertising Park's *Vanity Pool* with the line, "She thought his kiss an offer of marriage," while Weber's *Borrowed Clothes* was "a picture that will fill every woman's heart to overflowing." In advertisements, a photo of Harris bowing

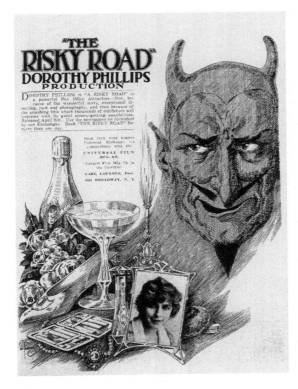

Advertisement for *Risky Road*, April 1918. Courtesy Margaret Herrick Library, Academy of Motion Picture Arts and Sciences.

to the viewer in crinoline from *For Husbands Only* is flanked by medium close-ups from *The Price of a Good Time* and *Borrowed Clothes* in which she recoils from something out of frame—presumably a man's unwelcome advances.[86] In April 1919, potential patrons for Park's *Amazing Wife* were invited to "picture beautiful Mary MacLaren in this hugely dramatic situation—a penniless young widow, she claims a deceased man's name to keep from starving—is accepted by society—and then, with horror struck eyes, sees the dead come to life again." In July, Weber's *Home* told "The Story of Every Girl," and in September her *Forbidden* depicted "the Awakening of a Small Town Wife."[87]

Although synopses indicate that the heroines of these films are often misperceived as having strayed, they typically end up happily married women. *The Price of a Good Time* provides an exception of sorts. In that film, the shopgirl protagonist throws herself under a car in despair once she realizes that her relationship with the store owner's son will be seen as improper. Her sister salesclerk, however, finds a happy match with a "worthy young chap in her own walk of life."[88] More typically, as in *Vanity Pool*, the heroine

Advertisement for *Scandal Mongers,* July 1918. Courtesy Margaret Herrick Library, Academy of Motion Picture Arts and Sciences.

Dorothy Phillips in
Risky Road, 1918, frame
enlargement. Courtesy
Swedish Film Institute.

maintains her virtue in the face of an older, wealthier man's attentions and "finds she has a Prince Charming after all." Nonetheless, in that Park film, and more explicitly in *Risky Road,* she agrees to live with him for a time before discovering that he is Prince Charming.[89] While the films do hint that for a woman to have sex before marriage will not destroy her chances and might prove a preamble to a good match, synopses and advertising give no indication that they explicitly presented the double standard as an obstacle after the fashion of *Her Bitter Cup* or *Where Are My Children?*

In *A Mother's Atonement,* a telling double exposure envisioned a fallen woman, her conscience, and the possibility of her redemption. In contrast, a recently restored fragment of *Risky Road* provides us with an image of Dorothy Phillips that defines her problem as one of isolation. Lonely and despairing, unable to abide an "experimental" arrangement that looks to the whole world like being kept as a mistress, she sends for her old sweetheart from the country, who misunderstands the situation and "insults her like many others had done."[90] This creates the perfect opportunity for her wealthy lover to come to her rescue, see the error of his ways, and devote himself to her. In place of the scenarios of parallel transgression that characterize the earlier shorts, *Risky Road* gives us a lonely woman who waits for the right man.

If the films reinforced particular norms of sexual conduct, they also articulated sexual relations to class relations in a specific and familiar manner. A woman brought sex (the attraction of it and the ability to control desire for it) to a marriage; a man brought social position and money. The woman

comes from the country, a small town, a convent, or the tenements. She might be a salesgirl, an aspiring actress, a model, a scandal-sheet reporter, or a stenographer. Whatever the occupation, she will give it up when the right match arrives. He might be a millionaire, a lawyer, or a famous doctor with a secret past. While marriage often improves her class position, it never does his—with the possible exception of *A Model's Confession,* in which the young dressmaker's model and her beau (who has been impersonating a wealthy man) benefit from a scheme to make her rich father acknowledge her as his illegitimate daughter. (It works; she inherits.) The last two 1919 Weber films, *Home* and *Forbidden,* differ in making explicit the lesson that their heroines would be less happy in "society" than they would be with their lots as, respectively, a plumber's daughter and a country girl married to a wealthy man from the city. Feature films of 1916 do offer such scenarios, and it would be hazardous to underestimate Weber's capacity to complicate these themes through editing and mise-en-scène. Taken as a group defined and nurtured by Universal's promotional apparatus, however, the post-1917 films seem notably to foreclose interpretations that would establish economic justice and sexual morality as parallel problems or that would understand a woman's sexual choices as a function of her material circumstances rather than her beauty and morals.[91]

Comparison of Park's first MacLaren features with *Shoes* indicates the extent of the revision. *Moving Picture World* suggested that exhibitors advertise *The Model's Confession* and *Bread* via association with *Shoes* as a "sociological experiment."[92] Since neither Park film references social science explicitly, "sociology" here must refer to the depiction of women's poverty and the opportunities it creates for sexual predation, a conclusion urged by the *World's* subsequent promotion of *The Amazing Wife* with the line, "Pretty Mary Mac-Laren, Star of 'Shoes' and Other Problem Plays, Now Comes in Drama of Woman's Psychology."[93] "Sociology" and "problem" function as descriptive equivalents. The fragment of *Bread* that survives indicates that Park's film does indeed reinterpret Weber's case study accordingly. Despite the language of "experiment" used in advertising, it addresses the audience in a manner typical of the contemporary mainstream entertainment film.

Bread reincarnates the struggling shopgirl of *Shoes* as an aspiring actress. Whereas Eva supports her lazy father and overly abundant siblings, the country girl Helen is, like the protagonist of Park's early film *Broadway Love,* on her own in the city and urged toward the "crimson alternative" by a more experi-

enced actress. Her refusal leaves her without money or prospects. Faint from hunger in her tiny, threadbare room, she takes off her only dress to mend it. These images are intercut with scenes of fat Krause, the theatrical manager who attempted to seduce her, eating a steak behind a table piled with food. An iris tightens to mask an image of her sewing in the bottom right corner of the frame while the rest of the frame fills, in double exposure, with her vision of married life with the playwright Arnold Train. We see what she sees with her mind's eye. The happy pair sits at a table covered in a pristine white cloth with palms in the background. A butler brings a silver salver. With an iris out, the fantasy future disappears, leaving her alone again in her dingy room. She pricks herself with the needle, faints at the sight of blood, and spills out of the chair to land on the floor. The protagonist's loss of consciousness inspires our sympathy, but it also interrupts the identification encouraged by our ability to share her vision. Accordingly, Park cuts in scenes of Train's success with a play called *Innocent Eyes* and its afterparty, before returning us to the apartment where Helen regains consciousness. In her camisole, hands at her cheeks, she weeps at her image in the mirror and contemplates the few coins in her purse. An intertitle informs us: "BREAD! Bread was the only thing her pennies would buy." Here is an echo of the scene in which Eva confronts her fractured image, but without the complication posed by her inability to face it.

Helen meets a very different fate. Scenes of the celebration of Train's play are intercut with Helen steeling herself and leaving her apartment for what may be the last time—she cannot pay the rent. She crouches forward into the rainy night, holding her long skirt over her head. To begin a sequence that echoes Eva's enthrallment by the shoes, Helen enters a high-angle long shot from frame right. The window of the Home Bakery fills the left half of the frame on a diagonal line through it. Rather than providing a confrontation between hand and object, as in *Shoes,* in Park's film we first look through the window at Helen as she reaches out to the glass and then, in a reverse shot representing her point of view, see the richly decorated cake she cannot afford. Entering the bakery, Helen hands over her pennies, and the kindly woman behind the counter gives a misshapen loaf with a bit more bread for no extra charge.

Rather than having the ravenous woman eat it, however, Park transforms the bread into a talismanic narrative device. A title reads: "The mis-shapen loaf was surely a good omen. She felt certain of a change of luck," and a close-up

Mary MacLaren in *Bread,* 1918, frame enlargement. Courtesy Library of Congress, Washington, D.C.

The object of her stare in *Bread,* 1918, frame enlargement. Courtesy Library of Congress, Washington, D.C.

Mary MacLaren's hand in *Shoes,* 1916, frame enlargement. Courtesy Filmmuseum, Amsterdam.

confirms her brightening mood. She bundles the loaf under her shawl as if it were a child and exits the bakery into the rain. Crossing the street between cars, she collides with a man carrying groceries, grabs a light pole to steady herself, and drops the bread onto the running board of a passing car. The drunken swells singing inside the car are, of course, ignorant of her plight. In the sequence that follows—only part of which remains extant—she chases the loaf through the city streets, a journey that eventually brings her into the path of Arnold Train, whose marriage proposal she accepts.

Although MacLaren's stare through the shop window as Helen clearly invokes her performance as Eva, Park's film is not structured in a way that would allow us to understand Helen's consumer desire as part of the trap than ultimately ensnares her. Rather, the sequence at the bakery window extends our empathy with Helen's growing desperation. Cross-cutting and double-exposure function at once to convey her mental state, to underscore a contrast between wealth and want, and to set in motion the chain of coincidences that will ultimately reunite her with the playwright. While pre-1917 Weber films used cross-cutting to develop moral contrasts and to associate them with differences of social class (for example, in *Where Are My Children?*), the procedure here more closely resembles that of Madison in two respects: first, in its use as a narrative device to link the lovers despite their separation and then reunite them, and second, in its mobilization of empathy with the suffering woman and outrage at the greed and obliviousness of the idle rich. Given the working association of Park and Madison, this is not surprising. Yet *Bread* notably blunts the edges of films like *A Mother's Atonement* and *Her Defiance,* above all by eliminating the motif of redemption from sexual misconduct and/or economic exploitation. Helen preserves her virtue, and *Bread* does not invite us to see her plight as evidence of the double standard or as emblematic of a fundamentally unjust distribution of wealth. While it extends the tradition of melodrama far more clearly than it does the quasi–social scientific address of *Shoes, Bread* also mutes that mode's critical potential.

For *Shoes,* explicit attention to the position from which the social might be seen and ordered, anchored by the reference to Addams, made it logical to raise the question of how that authority was gendered. In 1916, for "woman" to modify "director" arguably qualified the professional authority of directors in general, establishing them as the sort of professionals who might be expected to care for and improve the society they depicted. Such a definition would have made the job of director analogous to the feminized

"helping professions." Judging by Universal's marketing and by its filmmakers' selection of projects, interest in such a conception of the profession was not widespread. Nonetheless, the Weber-Addams comparison arose from an institutional context delighted by the prospect that directing might be the sort of job either men or women could do, provided one could figure out what exactly those categories referenced.

Bread and its publicity indicate much greater certainty about this vexing question. The film does not participate in an argument over the kind of authority movies should have and whether or not the director's authority can be compared with that of the social reformer. Nor does its treatment of Helen question the social treatment of women in general—a questioning, Madison's films demonstrate, that *mutatis mutandis* could be accomplished using the resources of melodrama as well as of sociology. In 1918, for "woman" to modify "director" no longer inflected the meaning of that term so much as it invoked a subset of directors understandable as women. If the films made by these directors differed from those of directors in general (that is, men), this difference did not implicate the authority of directors or the coherence of the category "women." Rather, it indicated a predilection for a particular subject matter and a certain fashion sense.

That Universal had indeed delimited the "woman's feature" becomes plain when we consider the Park and Weber films that clearly exceeded the limit and examine the arc of Wilson's career. In January 1918, *Moving Picture World* described Park's *Grand Passion* as "not a problem story as the title would indicate but a frankly melodramatic offering, with the scenes laid out in a rough Western camp near which a power plant is located."[94] Universal may have wanted the hint of "problem story" as well as the distinction of a "rough Western" setting, but it tended to follow the *World* in marketing it as a different type of film from Park's earlier offerings. It was an action-packed story of masculine devotion, sacrifice, and redemption. The plot involved Phillips's character in a love triangle with the political boss of the town and his friend, a reform-minded newspaper editor. Both men rush to the rescue when she is kidnapped by the labor agitator "Red Pete" and imprisoned in a brothel. The film ends with the town in flames and the reformed boss dead in Phillips's arms. Advertising compared it to the "lawless Western" *Pay Me!* (1917), also starring Phillips, which had been directed by De Grasse from a Bess Meredyth screenplay.[95] In fact, Park seems to have had something of a talent for action sequences. The press sheet for *The Model's Confession,* for example, described

it as including the "greatest auto wreck ever staged," and the *World* noted the "surging mob scenes" of *Fires of Rebellion*.[96] Yet *Grand Passion* remains very much the exception among Park's films in the emphasis marketing places on manly struggle.

A year after *Grand Passion,* Universal released Weber's *When a Girl Loves,* "a new kind of Western—the Lois Weber kind—with Mildred Harris—the former society woman—the former shop-girl—doing things that only a rough-rider might be expected to do. And the hardest, biggest hand-to-hand fight you ever saw between two men!"[97] In the film, a minister's daughter (Harris) reforms a notorious outlaw (William Stowell). Although reviewers noted its resemblance to "previous numbers in which an outlaw has played the part of a minister," they found the Weber touch in its "strong psychological theme." This was "a Western drama with a real plot" that did not "depend upon mere shooting and riding to get it over." Exhibitors were advised to "make this fact plain and assure them that they will see a play as well as a star. Tell that it is a Lois Weber production, one of her last made for Jewel."[98] Whereas the Park

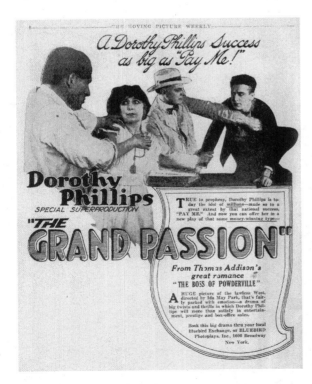

Advertisement for *The Grand Passion,* March 1918. Courtesy Margaret Herrick Library, Academy of Motion Picture Arts and Sciences.

"Western" looks incongruous in the context of her work overall, the oddity of a Weber Western is a selling point and in this way confirms that women were not expected to direct such films while positing Weber as an auteur who might overcome that expectation. Neither experiment was repeated.

Alone among the Universal women directors, Elsie Jane Wilson's first credited title is a feature film, and her case best exemplifies how genre and gender, by 1918, worked in tandem to set the institution's division of labor. With a few exceptions, marketing did not use Wilson's name to promote her films. In this she resembles the majority of Universal directors and differs from Weber and Park. True to precedent, early press sheets for Wilson films located her in the "front rank" of directors as "one of the very few successful woman directors in the field today."[99] Perhaps a better indication of how the company regarded her work lies in the fact that it rapidly promoted her during a time of severe cutbacks. Wilson began directing in 1917 as an assistant to her husband, the actor-director Rupert Julian, when working on films in which she also acted. That year she made five features starring the child-actress Zoe Rae: *The Circus of Life, The Little Pirate, The Cricket,* and *My Little Boy.*[100] The first four were released as Butterflys, and with the Christmas film *My Little Boy,* Wilson made the jump to the more prestigious Bluebird brand.

These "kid pictures" extended a genre of short films in which women directors had been well represented, although they did not direct the majority of films. Lule Warrenton directed at least three short children's films for Universal beginning in 1916, and in 1917 Ruth Stonehouse directed herself in ten shorts as Mary Ann, a willful and independent orphan waif. After *My Little Boy,* Universal produced fewer kid pictures and moved Wilson to other projects. From January 1918 to January 1919, it released a total of six films credited to Wilson's direction. There were two with each of three different leading ladies. One film of each pair was more intensely dramatic, and the other was lighter in its treatment of a woman's difficulty marrying well. This distribution of projects bespeaks an institutional plan that expanded slightly the conception of "woman's feature" evident in the contemporary marketing of Park and Weber features, while nonetheless remaining of a piece with it.

Wilson began her busy year directing Ella Hall in *New Love for Old,* a Big Woods Drama. In advertising, the film's familiar tale succumbed to telegraphic communication: "Love at first sight—thrown down hard—thinks he'll die— goes off to the big woods—picks up heart—falls in love harder than before— saves his little woods girl from worse than death—protects her unrecognized

sister—happy hearts all united. Why?"[101] Hall's girlishness, here a pretext for the masculine salvation of innocent virtue, becomes in the next outing a prompt for young love that defies the unjust strictures of Spanish village life. *Beauty in Chains* offered "sun-bright romance, laid in luxurious settings whose beauty is only equaled by the star. . . . Girlish, sweet, and adorable."[102]

Just as Wilson was about to become a director of romantic outdoor settings, Carmel Myers entered the picture. *The City of Tears* featured her in an "Italian role similar to *My Unmarried Wife*" (dir. George Siegmann) and told a story familiar to viewers of Park's films *Broadway Love* and *Bread:* an immigrant actress struggles to survive in the city while preserving her virtue. The second, "light," "quaint," and "piquant" Myers film capitalized on her vaguely Latin persona in a different way, by making her a mock Gypsy.[103] After Myers herself, Universal considered the main selling point of *The Dream Lady* to be its "novel plot; a young girl setting herself up as a fortune-teller and thereby directing the destiny in love and fortune of those who seek her sage advice." The film, a print of which survives, includes a subplot involving a woman cross-dressing as man, but marketing does not emphasize this playful element.[104]

Wilson's last two Universal features starred Ruth Clifford. Its title clearly invoking the perils well known to viewers of the society drama, *Lure of Luxury* offered itself in display advertisements that featured Clifford giving a broad wink.[105] The film gives Clifford's character the job of reforming the hereditary drunkenness of her childhood sweetheart, whom she ultimately will prefer to the wealthy suitor who visits her country town. Released in January 1919, Wilson's final Universal feature was a "rollicking comedy-drama bordering almost on the burlesque" in which Clifford's character, to masquerade as a successful artist, hires a chauffeur who is secretly a millionaire. The *Weekly* suggested as an "advance notice" press story: "Four hundred cabaret girls descended on Universal City in a body when Elsie Jane Wilson, the feminine director, who created *The Game's Up*, Ruth Clifford's latest starring vehicle, advertised for a dozen members of the 'merry merry' for a café scene in the production." The Board of Health, the article continues, had shut down restaurants in Los Angeles due to the influenza epidemic, placing cabaret showgirls out of work.[106] Whereas Baldwin and Park had in 1917 been noted for handling crowd scenes as well as any man, now the "feminine" Wilson finds herself mobbed by out-of-work showgirls. Accordingly, the masculine attire that had, in Baldwin's case, seemed an interesting concession to pragmatism (see chapter 3) now

looked like a fashion statement. "During the filming of this picture," the press sheet points out, "Miss Wilson appeared at the studio in a natty khaki suit, with trousers, and wore pigskin putties and masculine telescope hat."[107] Baldwin "adopts" masculine garb for outdoor work; Wilson "appears" in it at the studio.[108]

A February 1918 *Photoplay* story indicates how increased emphasis on a normative femininity subordinated women in the name of parity. Frances Denton profiled Wilson and Park together and presented them as a referendum on the social standing of women in general. Did the fact that women occupied such positions promise the return of "Chinese-Babylonian-Frankish" days when women ran everything, or did they indicate "a new scene" in which "there will be no question as to whether some particular work belongs more to a man than to a woman, but each will do whatever he or she can do the best"? Was "The Cause [the feminist project organized through suffrage campaigns] working to Man—the Slave, or Woman—the Partner"? On the evidence of Park's and Wilson's directorships, Denton concludes that it will be "Woman—the Partner," and proceeds to describe what that partnership will entail through its obligatory reminders that women directors are in fact women. Park wears "a dainty pink and white blouse. . . . It is absolutely true that she did not wear puttees and carried no megaphone." "Being perfectly normal," she hates housework, but she keeps roses. Wilson is pictured in puttees and in one image hovers over a fight scene with a clipboard in one hand, the other clenched in a fist. But her natty jacket flares out like a skirt, and she expresses "a woman's natural horror of freckles." Denton quotes both women as emphatically stating that directing is men's work. They seem to have arrived at their jobs reluctantly, by an accident of talent and opportunity. There is no sense that the company has systematically trained and promoted them. Whereas once the woman directing had been intriguingly unusual, now she was an exception that proved the rule.[109]

From 1917 to 1919, a process of generic interpretation succeeded in associating women directors with the narrative problem of matching sex to money. A fundamental irony of this process is that women were allowed a broader range of roles in pictures directed by men. Not only did men direct the types of dramas and comedy dramas that Weber, Park, and Wilson directed, but they also produced tales of adventure in which the leading lady might be a thief (for example, *The Exquisite Thief* and *Wicked Darling*, directed by Tod Browning in 1919) or a revolutionary (*The Right to Happiness*, directed

by Alan Holubar in 1919). On the cusp of the change, moreover, men associated with the Universal women directors made films that would seem to have encouraged feminist interpretations: in July 1917, Universal credited Phillips Smalley with directing *The Double Standard*—from a story by the U.S. minister to Belgium—and Joseph De Grasse with an adaptation of Henrik Ibsen's *A Doll's House*.

The End of the Rainbow (1916), on which Baldwin apprenticed, provides perhaps the best surviving emblem of the possibilities swept aside in the rise of the feature-film drama. In it, Lynn Reynolds directs Myrtle Gonzales as the daughter of the boorish timber king Elihu Bennett. Although Ruth has graduated business college, old Bennett will not allow her to work in his office. Meanwhile, Jerry (Val Paul), a self-taught backwoods lawyer who practices his oratory before an ancient redwood and his collie, has come to the city in search of justice for the "squatters" who live in the woods and are mercilessly exploited by Bennett's corrupt foreman. Impressed by Jerry, whom her father ignores, Ruth borrows the identity of Kitty Mitchell, a woman who will later become notorious for abandoning her child, to win a job as stenographer in the timber camp. Like Jerry, she appreciates the majesty of Old Sentinel, the giant redwood whose gratuitous destruction by the wicked foreman precipitates the film's climactic final act. The happy ending unmasks Kitty as Ruth, establishes the justice of Jerry's case, and unites the pair in a partnership of professional equals. Her business acumen complements his powers of moral suasion; together they secure a new order that seems more fair to people and kinder to nature. Ruth, in short, is much more like the sort of woman Baldwin, Ingleton, Madison, Park, Weber, or Wilson must have been than the heroines they would end up directing at decade's end.

Conclusion

Universal's shift from a production model emphasizing the shorts program to one emphasizing the dramatic feature film entailed intensified central coordination, made generic interpretation far more important, and established a more rigid division of labor. None of these developments was sexist by logical necessity. Work became gendered in the way it did because the institution interpreted filmmaking and gender in tandem and in a particular manner. It developed, particularly via its serials, an understanding of organizational effectiveness as predominantly hierarchical rather than collaborative. Through

that genre, it came by late 1917 to understand women's contributions to male-headed organizations as important but subordinate to their destinies as wives and mothers. At around the same time, it developed an understanding of dramas directed by women as different from those directed by men, a feat that required it to develop a normative idea of what a woman was and what a woman wanted. The generic conceptions of "woman" differed—the serial queen got out more often than the feature-film heroine—but they were complementary in their emphasis on domesticity and marriage as the feminine counterparts to masculine work and wealth.

The genres in tandem performed, in other words, the early-twentieth-century update to gender norms described in the preface. This update retained a woman's association with home while giving her a working life outside it, albeit one that often seemed preliminary to it. The revision linked the value of her sex appeal with that of her virtue in a relation requiring constant vigilance, correction, and revision.

While such an interpretation of "woman" would have resonated broadly, Universal developed it locally. To institute it was effectively to banish women from the director's chair. Park, Weber, and Wilson temporarily flourished, but the question of why women *should* direct found no institutional answer. In an important sense, the question itself was to blame. Before 1917, the question did not even exist.

Through 1917, Weber's films had more in common with those of her male colleagues and less in common with those of other Universal women directors than her status as the period's exemplary "woman director" would suggest. To point this out should not diminish her talent, undermine discussion of her unique voice, or make her appear less important to film culture. On the contrary, it should call into question the centrality of Weber's gender to the case for her historic importance. From the moment Universal interpreted her as like other women directors, it instituted a double bind: these directors had to be "as good as" their male counterparts and also produce work valuable for its distinction from that of men.

This happened in a context wherein the evolving conventions of the commercial entertainment film imposed a limit on how distinctions among films could be made. Unlike *Shoes,* which thematized its vantage on society as one of professional concern and intervention, the ordinary feature film submerged professionalism in the technical and aesthetic details of narrative construction. With the authority of filmmaking per se an apparently settled question,

significant differences among types of fiction films were not to be found in their manner of addressing their audiences so much as in the types of stories they told. The notion that women would be especially suited to direct films on subjects of interest to other women took for granted a masculine professional norm. In theory, identifying what women wanted to see made it possible for any competent director to deliver that content. In practice, the particular definition of "woman" made competence in direction seem a masculine quality. By 1924, when the Universal studio head Irving Thalberg asserted that all "pictures should be made primarily for the feminine mind," he could simply assume that men would direct them.[110]

Although such a state of affairs remains familiar, its contingency should not escape our notice. To achieve the assumption that directing is men's work, Universal had to forget or ignore much of what it knew about Baldwin, Cunard, Park, Weber, and Wilson. It had to learn to think of their womanliness as fundamentally modifying the quality of their direction rather than being notably incidental to it. But here the poverty of language reveals itself, for to describe the institution as "forgetting," "ignoring," and "learning" mistakes its character by personifying it.

Universal *is* the villain of this story, but one cannot separate the company from its constituents. The assumption of commonality between Weber's and Park's 1918 films, for example, determined their fate and that of the women who would have followed them. One could hardly claim that the directors themselves had no role it in. Weber, as head of her own facility, almost certainly had more say in the selection and execution of her projects than did Park, who worked on the lot at Universal City. Nonetheless, each must have participated in the selection of scripts, just as each must have been aware of the other's work, felt constrained by the studio's marketing expectations, and been aware of corporate interpretations of what audiences wanted to see onscreen. In thinking about their audiences, moreover, Park and Weber had concerns other than the gendered division of labor. Weber explicitly embraced the project of distracting a nation at war, for example. Similarly, it would be interesting to consider how pre-1917 interest in representing women as part of class struggle was inflected by the success of the Russian Revolution.[111] Contexts ramify. There is no reason to believe that filmmakers' circumstances motivated them any more or less than ours would motivate us.

Propelled toward various objectives, stars, directors, writers, publicists, and studio executives all participated, not equally but significantly, in develop-

ing the sort of film *Moving Picture World* identified as a "woman's feature" and associating women directors with it. Available sources will not allow us retrospectively to separate individual contributions to this project from individual acquiescence to it. Precisely because Universal is more than the sum of its parts, however, we can chart the process whereby genre instituted a gendered division of labor that excluded women from the director's chair.

Postscript

Eleanor's Catch

This book began with the puzzle of Universal's promotion and subsequent elimination of women directors. I limned premises about the key terms in this puzzle, including gender, historical change, and institutions. I proposed that Universal reached a decision about its division of labor through an interpretation of its films. To prove that argument, the book's chapters have described what it means for "Universal" to interpret. In defining this process, I have presented the institution both as an historical actor and as a site of struggle. A close look at a single film can summarize the difference in perspective such an approach affords, not only on Universal but on changing norms of gender, domesticity, and work.

On May 2, 1916, Universal released Cleo Madison's eighth credited title as a producing director. If all went according to Universal's plan, audiences would have seen the one-reel *Eleanor's Catch* preceded by a two-reel drama, *The Purple Maze,* and followed by a short comedy, *When Slim Was Home Cured:* an example of the company's incipiently outmoded "strong and well-balanced program."[1] The synopsis of *Eleanor's Catch* published in Universal's *Moving Picture Weekly* tells a formulaic story about an impoverished young woman from the tenements, Eleanor, played by Madison herself, who is misled by a rake named "Flash" Dacy, played by William V. Mong, who also wrote the scenario. In the end, a studious former suitor, "Spike" McGuire (Ed Hearn), rescues her from his clutches.[2]

The surviving print of the film offers a surprise ending not predicted by the copyright description. It turns out that Flash does not really assault Eleanor. She accosts him, whipping out a pistol to arrest him in the name of the law at the very moment her ruin seems certain. In an earlier scene, Flash teaches her

to pick pockets. The technique involves a mock yawn with hands outstretched to make the grab. Eleanor does not appear to be good at it. Nonetheless, in the climactic scene Flash maneuvers her into a yawn-grab situation. He brings home a large swarthy fellow and coerces her into flirting with him. Thanks to tight framing around Eleanor's face and Flash's, we have no difficulty following her progress from fear, as he backs her against the wall and brings his fist up to her chin, to avoidance, as she withdraws her eyes from his to look out of frame, and finally to resignation, as her gaze restlessly follows his hand's reaching and plucking motions before looking down in submission.

Flash leads her back to their guest and hovers between them in medium shot, orchestrating what the visitor clearly believes to be a romantic encounter. The deliberateness of the staging, Flash's ever-present encouragement, the man's awkwardness as he fidgets, sneezes, and glances away from Eleanor's unmistakable, although evidently contrived, overtures—all this paints a scenario of casual prostitution. Although the film does not spell it out in so many words, it seems clear that Flash has offered to sell Eleanor's sex so that she can steal the fellow's money.

By the time he perches her on the mark's knees and she begins her expected yawn, our attention is likely to be on Eleanor's left hand in the foreground as it creeps toward the man's jacket. Like Flash, we may come late to the realization that her right hand has feigned a knuckle-over-the-mouth gesture only to extend itself into the background, where she snatches Flash's gun from inside his coat. A title card interrupts the action: "I've got the goods on you Dacy—I'm Detective Eleanor McGrady of the Secret Service." This surprise precipitates the "rough-and-tumble fight" indicated in the copyright description, but the promised rescuing is notably absent. Spike—called Red in the print of the film—arrives, having summoned reinforcements, but he shows up only after Eleanor has mostly subdued her man.

This turn of events retroactively implies an unexpected complicity between Eleanor and the film's narration. The first scenes show us Flash's true colors but encourage us to believe that Eleanor does not notice. A close-up accomplishes this. Inebriated and happy-go-lucky, Flash has been willing to roll up his sleeves and help Eleanor at her washboard. All smiles for her in the medium shot, he looks out past the camera with pursed lips and a hard stare in a tighter shot that removes her from the frame. As he casts a sidelong glance in Eleanor's direction, his upper lip curls into a thin lopsided smile: an unmistakable indication of villainy.

Just as editing and framing collaborate to suggest that Eleanor does not notice Flash's treachery, so too these devices suggest her ignorance of Red's sincerity. When solitary Red hovers on the threshold of the ramshackle cabin Eleanor shares with her mother (Lule Warrenton), we see him looking in with yearning and despair as she makes time with the other man inside. Because Eleanor and Red occupy nearly the same space—nothing prevents Eleanor from returning his look—we are led to think that she is ignoring him and thus does not see, as we do, that reliable Red would be a better choice than party-boy Flash. Our hearts go out to Red—or else we think he's a sap—when, in a title and a medium two-shot, Eleanor whispers to Flash that he should come back when Red goes off to night school. Seconds later, a high-angle shot of them all sitting around a rough table confirms that she has rejected her former beau. We see plainly that Eleanor could return Red's steady gaze if she wanted to, but she merely glances at him, focusing her attention on Flash instead.

Eleanor's unmasking as an undercover agent obliges us to rethink this earlier scene. It now seems noteworthy that Eleanor and her mother did not shut Red out entirely. While his position at the table did not encourage a relationship, neither did it discourage him from looking at her. Perhaps she admitted him as far as was possible without tipping her hand. In any case, we are encouraged to reinterpret her interest in Flash as essential to her effort to snare him. Flash's sinister aside to the camera, which generates suspense by suggesting Eleanor's unsuspecting peril, may now strike us as narrative entrapment. Like Flash, we have been fooled about Eleanor's true character. If so, however, we were fooled not by Eleanor herself but by the film's narration. Film is to heroine as viewer is to villain.

By means of this loose analogy, the surprise ending establishes a similarity between two orders of knowledge that we initially understood to be very different. What Eleanor knows and what the film shows start out as wholly divergent categories, as emphasized by the close-up of Flash's leer, and indeed every other framing that purports to clue us in on something she does not see. In retrospect, however, it seems that the narration, like Eleanor, knows more than it is willing to show. When it has Eleanor steal a pistol and turn the tables, the film reminds us that the frameline excludes as well as includes and that an unseen agent controls it.

It is easy to fall into the habit of equating this agent with the director. Although criticism repeatedly cautions against taking that plunge, *Eleanor's*

Catch invites us to leap in headfirst and pretend that the director has somehow been in cahoots with the character she portrays.[3] If Eleanor usurps a masculine prerogative in her feat of derring-do, we might attribute this reversal to a kindred usurpation on the director's part. Eleanor's ersatz entrapment exemplifies the narrative convention of the imperiled heroine: a woman's body is at risk from bad men and in need of safeguarding by good men because it encloses something of special value. Because this special value is felt to be extractable through sexual activity, sex, unlike doing laundry (for example), seems like it should be more and other than a means to extract money from strangers. Madison the director does not challenge the assumption that sex and work should ideally participate in incommensurable systems of value (in fact, of course, moments of exchange proliferate). Nonetheless, we might think that her film upends the convention that reproduces the assumption. In the time it takes Eleanor to get her gun out, Madison establishes her heroine as an agent of the law rather than a rescue object. In the process, one might assert, she exercises her own authority as director, defies the "approved" story of the copyright description, and affirms the value of her work as opposed to her sex.

Unlike Flash, however, we are not exactly deceived, or at least not in the same way. The high-angle shot of Red, Flash, Eleanor, and her mother, for example, shows us everything and nothing. If the plot initially led us to draw the wrong conclusion, we can in retrospect see the right conclusion before us in our mind's eye—she wants Red there even as she leads Flash on. The film's narration is not duplicitous, in other words, but simply suppressive. We might feel actively tricked by the frameline's exclusions, or we might feel that they have kept us in the dark so that we might have the pleasure of sudden illumination. In any case, it is not by showing something that never happened but rather by limiting what can be seen that the film's narrative encourages the spectator's misreading of its heroine's agency and thus lays the groundwork for its gotcha. Accordingly, the one who frames the shots plays a different part than the undercover agent qua laundress who deceives Flash within them. Not only do they have different secrets, but the director keeps hers, taking to the grave most of what she knows about how and why she put herself onscreen in this way. The film itself does not and cannot speak in Madison's voice in the way its intertitles speak in Detective Eleanor McGrady's.

In truth, Madison's megaphone was nothing like Eleanor's gun. The divergence between copyright description and completed film indicates an offscreen

process that produces and relates the two renditions of *Eleanor's Catch*. This process may, by its collective and (to outsiders) occult nature, make us yearn to discover the moments of individual agency within it. Nonetheless, it is not, finally, well grasped by the hypothesis that the finished film represents Madison/McGrady's defiance of the more conventional printed description. For one thing, a corporate process produced and released the film and its plot summary. For another, the surprise ending does not really upend convention so much as develop it: *Eleanor's Catch* achieves resolution through the sort of unexpected twist that is a staple device of short films and serials.[4]

Eleanor's duplicity references that of Rose and Judith, the twin sisters, romantic rivals, and narrative antagonists whose portrayal established Madison as a Universal star in the 1914 serial *Trey o' Hearts*. Like Eleanor, the twins took turns providing the serial with rescue objects and agents who advanced the plot through bold action. Madison drew on their personae when directing herself in numerous shorts. In *Her Defiance,* for example, her character commandeers a buggy to flee the man she has been forced to marry and evades the wedding party after a thrilling chase. And in *The Power of Fascination,* her Senorita Juanita wrests from the jealous Don Rafael the knife he has used to stab her gringo lover. In both, the "surprise" ending has the virtue of bringing the narrative quickly to a close while keeping alive tensions that inspire further storytelling. *Her Defiance* brings its family back together in an office building when the baby daughter's cries cause the father, who manages the place, to collide with the mother, who happens to mop floors there. In *The Power of Fascination,* the stabbed lover makes a miraculous recovery. It seems apt to describe such fictions as "reconciling" thematic oppositions rather than "resolving" conflicts, as longer fictional explorations of characters' psychologies tend to do. These narratives tidy up without working through.

Which is simply to say: not all that much really seems settled by Eleanor's catch. A title explains, "Having run down her last case, Eleanor returns to her home life," and a line of sheet music cues the accompanist to bang out the standard: "Be it never so humble there's no place like. . . ." Subsequent images of Eleanor's home life leave a great deal of ambiguity about the nature of this "return." For one thing, she is doing laundry again. Granted, she now wears a neat gingham dress as opposed to the tattered frock of the opening scene, and her surroundings, while indeed humble, do not suggest the desperate poverty of the earlier shack. Still, one is led to conclude that Eleanor's "real" home is just a nicer version of the pretend one that in retrospect turns out

to have been her office. Laundry as housework has replaced laundry as police work, which must lead one to ask, is the gingham dress really worth it?

If the relative psychological poverty of the short leaves this question hanging, so too does it generate ambiguity regarding the extended family that joins Eleanor in the conclusion. Through parallel editing, the film associates a subplot with the story of Eleanor's apparent seduction. A title introduces "Eleanor's sister, a forgotten thing of the shadows" (Margaret Whistler), a woman we see sobbing and lurking in a doorway on a city street. She appears to proposition a well-dressed man who passes by, smoothing her hair and dress and approaching him with hands smartly on her hips, elbows out. When he refuses her, she begs money from him. The film cuts from this scene to Eleanor's preparations for her first date with Flash, suggesting a parallel between the falling sister and the fallen and "forgotten" one. The ending reunites the siblings. Shots of Red discovering the sister and returning her home are intercut with the scene in which Flash coerces Eleanor's seduction. The return complicates the arrest in that it distracts Eleanor long enough for Flash to kick the gun from her hand and forces her to combat him hand-to-hand. In addition to requiring us to revise our understanding of Eleanor's relationship with Red, then, her surprise unveiling as a super-cop forces an about-face in our interpretation of her relationship with her sister. We had been following Eleanor's all-too-certain progress down the path that ruined her sibling. Now we see the two as contrasting cases, and the sister's restoration to the household appears as a kind of redemption.

Mom also finds herself repurposed. She had appeared to collaborate in her daughters' downfalls (in one hilarious shot, Warrenton portrays her as drunk on Flash's beer: hands balled into fists on her knees support a wobbly torso as she mugs crosseyed for the camera). Now, as the mother welcomes her prodigal daughter with open arms, we consider whether she might have been Eleanor's secret collaborator. The apparently happy family of the final frame, which centers on Eleanor and Red with sister in the background and mother in the fore, thus arrives badly in need of a back story. What explains one sister's ruin and the other's detective career? Was mom wise to Eleanor's disguise? Why does the Secret Service agent need Red's help to find her lost sister? What happened to fracture this family of women into such a discordant assemblage of roles and situations—each familiar from other fictions but perhaps surprising in their recombination here?

In addition to seeing the conventions of the short film in this ambiguous

conclusion, we should not hesitate to recognize its inflection of modernity.[5] Madison's film addresses and interprets a world in which urbanization and mobility estrange families and create seemingly endless misrecognitions even as they enable individuals to reinvent themselves and establish new sorts of social connections. Here, as often, the roles of wife and mother register most clearly an architectonic shift—still in progress—that must necessarily also shake the roles of husband and father (the latter, as is not atypical, has simply gone missing from *Eleanor's Catch*). This was the world of possibility that inspired Universal City's heterotopian experiment through 1917. It was also the world of viewers who craved the serial heroines Universal created: competent women who dramatically set forth into the crowd of strangers but ultimately need the protection of a masculine organization to find themselves safely at home. And it was the world of feature-length dramas. Yet, it must be said, the potentialities of modernity became less apparent in those longer works as they increasingly posed the question of the new in the more restricted terms of sexual appeal, fidelity, and consumer fashion.

Desire for and fear of change are evident in Eleanor's "return" from the workforce to a home that never before existed. With Red grinning by her side, Eleanor seems to have "settled down." The film deems him worthy. Not only does he restore the fallen sister, but an arresting, indeed quite beautiful image of him at his studies leaves no doubt that hunky Red is the anti-Flash. Madison positions him in profile in front of a mirror so that in the background we see the reflection of one side of his face peering in concentration at his book, while in the foreground we see that same look from the other side. An open book: any way you look at him, this is a studious fellow. Although the film provides little suggestion that Eleanor loves Red, one could hardly fault his wholesome drive for self-improvement. Thus one cannot balk at the title's insinuation that he is a "catch" in the domestic sense, just as Eleanor catches Flash in the penal sense. And yet—the perversity of it!—she still does laundry, just like she did when the film began. If the ending restores her to her washboard, it nonetheless remains unclear why she cannot also continue to be a cop, why her "return" home is career-ending while Red's return abets his bookish future.

Hovering over all the film's conundrums about who knows, or should have known, what and when, this hasty conclusion cannot help but raise the question of how we can be certain that this *really* is Eleanor's last case, because we do not want it to be. Home ensnares Eleanor just as she catches Flash and

Red. The "catch," for us, is how to embrace our desire for her to continue as a detective even as the film urges us to take satisfaction in the happiness she finds at home.

I suspect, but cannot demonstrate, that audiences in 1916 wanted Eleanor's law-enforcement career to continue. For another year at least, Universal remained convinced that women of the gun-snatching sort would compel audiences. Without a doubt, however, early-twenty-first-century viewers are expected to want this alternative outcome. Back-of-the-box marketing for the 2008 DVD release tells us so when it encourages interest in the title because "a terrific surprise ending gives Eleanor and Cleo an early claim to promoting women's equality in the workforce."[6] For this to be the import of the surprise ending, we have to, first, defy the interpretation urged by the title card that asserts Eleanor's "return" home, and, second, assume that the film's narration tells us all we need to know about what it leaves out of frame. The word "claim" acknowledges that this would be a strong interpretation; the word "early" suggests that it remains a relevant interpretation. And yet the analogy this marketing pitch posits between Eleanor and Cleo is misleading. Though the film encourages a wish (and a fear) inherent in the possibilities created by modernity—namely, that gender will matter less in deciding what we do—the film occults as much as it illuminates about its wish-making labor.

Individual heroics did not produce and will not change the gendered division of labor.[7] Eleanor might grab a gun, but the Universal Film Manufacturing Company put Madison behind a megaphone. We can be certain of this, although we may never know exactly why it decided to promote her in particular. In 1915, *Moving Picture Weekly* split the credit between Madison and Henry McRae: "For more than a year," it reported, "Miss Madison . . . has been ambitious to direct her own company, and a few weeks ago Director General McRae complied with Miss Madison's oft-repeated request."[8] The statement might indicate Madison's overeagerness and McRae's indulgence. It might indicate appropriate ambition on her part and recalcitrance on his. She might exceed her station or claim it. He might help or hinder her inevitable promotion. While the differences among these interpretations would have mattered enormously for Madison in 1915, it matters more in retrospect that an institutional context existed that could make them all seem plausible.

If I have not yet succeeded in explaining that institutional context and its transformation, no last-minute surprise could suffice to tidy up the loose ends, nor could *Eleanor's Catch* help me do so. The film provides a lousy ex-

planation of gender at work, even if it expresses a durable wish that gender might matter less there. Sexual victimization does not turn into workplace empowerment and back into domestic confinement through tricks and surprises engineered by an invisible agent out of frame. Rather, it happens through the plodding yet mutable habits of institutions like those in which we might ourselves participate.

The insufficiency of the explanation *Eleanor's Catch* provides is itself partly to blame for exiling women from the director's chair. As the conventions of the shorts program developed into those of feature-film genres, home looked less like a space of awkward reconciliation that audiences wanted and hated to see arrive. Increasingly, it seemed a space of normative resolution to narratives emphasizing women's psychology, consumer acumen, sexual desires, and marriage prospects. Indisputably, women directors participated in working out that change. We will likely never know enough to feel confident in characterizing that participation as acquiescence or collaboration. In contrast, retrospection clarifies that the various reasons the Universal women directors individually had for "returning" home or portraying it in a particular manner do not matter as much as the fact that the institution structured a version of home and particular sorts of careers as incompatible. It did so in two ways. First, Universal City's spatial evolution located lived homes off the lot. Second, corporate movie making made the production of a stridently idealized home a central goal. An institutional interpretation of "woman" cemented these two developments together. That nexus made it seem inevitable that directors would be men.

This insight into Universal's decision-making process comes from paying attention to what sources leave out as much as what they reveal and from acknowledging that the difference is itself significant.[9] This is the real lesson of *Eleanor's Catch:* when it establishes that the invisible machinations of filmmakers outside the frame are every bit as important as Eleanor's visible sleight of hand, it ought to remind us that they remain invisible. The disappearance of women from the director's chair happened beyond the borders of the picture created by available sources rather than through an abracadabra we have yet to notice within those sources. There was no magic trick other than publicity in its normal course of business. While eventually the disappearance of women directors in general would be news, one rarely publicized losing a job.[10]

Madison, for example, got married and dropped off the radar for two years. In late November 1916, the *Los Angeles Times* announced her marriage to "Don

Peake of San Francisco, western sales manager for the Briscoe Motor Corporation," and a month later *Moving Picture World* reported that her colleagues at Universal had been "greatly surprised" to learn about it. The wedding ceremony took place at the Mission Inn in Riverside, California, where some two years previously she had enacted the role of a bride in the Universal serial *The Trey o' Hearts*.[11] In the same issue, the *World* announced the formation of the Cleo Madison Film Corporation with Isadore Bernstein as president, hich had acquired ten acres for a studio in Boyle Heights and planned to make pictures starring, although probably not directed by, Madison.[12]

As one expects publicity to do, these upbeat and congratulatory reports serve to harmonize Madison's various personae, her career and her romance, her onscreen and offscreen lives. To find dissonant notes, records kept by public authorities come in handy. Riverside County, for example, retains a marriage license that identifies Madison legally as Lulu Bailey, and in the archives of the Los Angeles County Superior Court one discovers that Madison/ Bailey and Peake filed for divorce some eight months after their wedding on July 30, 1917. Earlier that month, the complaint alleges, Don (Adoniram) Peake "did bring into the Whitcomb Hotel [in San Francisco] and into the room occupied by said plaintiff, a loaded revolver, and did threaten with said revolver to kill plaintiff." What is more:

> Plaintiff further says that defendant is a man of very violent, cruel and extreme temper, and because of the threats heretofore made to this plaintiff by this defendant . . . plaintiff is in fear that said defendant while under the influence of liquor will attempt to annoy, molest, interfere and carry out the threats so made as aforesaid; that plaintiff is, has been, and now is, earning a living and depending upon her own labor and earnings for support as an actress upon the stage . . . that the plaintiff is in fear that defendant will attempt to interfere with, by violence and otherwise, this plaintiff at such times as she may be so engaged as aforesaid [as an actress working with other performers], and may attempt by threats and otherwise to intimidate, prevent and stop this plaintiff from pursuing her profession.[13]

The court documents propose two explanations for why Madison's screen credits stop so abruptly in 1917 (although they hint that her theatrical career continued). In the first place, she moved to San Francisco. In the second place, she married an abusive drunk.[14]

If the parade of bad husbands turned out to be endless, it would still not reveal as much about why Universal stopped promoting women directors as

the limit revealed by the court records when they call attention to publicity's partiality. This limit includes as well as excludes. What should concern us is not so much that publicity can be misleading, nor that it does not tell us what we really want to know, but rather that there is so much publicity for us to parse. Advertisements for films are easier to come by than films themselves, and both are easier to find than records of production. Unusual happenings are more noteworthy than ordinary ones. Good news about the lives and careers of directors and executives is more common than bad. The home lives of professional women receive far more attention than those of professional men. In and of itself, what remains in the pile of archival material tells a story of individuals and institutions who worry a great deal about their public face because the value of their labor and its products depends on it.

Madison returned to the screen in 1919, when the *World* again reported that she would organize her own company. Whether she aimed to revive her arrangement with Bernstein is not clear, but it seems that this plan too bore no fruit.[15] Instead, Universal cast her in its new serial, *The Great Radium Mystery*. By the time the first episodes appeared in September, Ida May Park had left Universal. We know this because the *Los Angeles Times* reported that the actor Lew Cody and the manager-producer Louis J. Gasnier had signed her "to direct Lew Cody Specials at the Gasnier Glendale Studios," noting "subtlety and delicacy" as characteristic of "Miss Park's style of production."[16] She apparently made at least one picture with Cody, *The Butterfly Man*, before moving on to direct two pictures—her final credits as director—for Andrew J. Callaghan Productions.[17]

In July 1919, Mae Tinée reported to readers of the *Chicago Daily Tribune* that Lois Weber Productions would release through Paramount. It put out four pictures this way, and then one more—*What Do Men Want?* (1921)—through Wid Gunning, Inc. Weber divorced Phillips Smalley in 1922—there was no public announcement—and returned to Universal to make *A Chapter in Her Life* (1923), *The Marriage Clause* (1926), and *Sensation Seekers* (1927).[18]

When Elsie Jane Wilson's *The Game's Up* appeared in January 1919, one could not have known from the press that it would be her final title as director. One could learn, however, that her ribs had been broken in a dog-walking accident. Apparently, her mastiff Thor ran away with her, dragging her up the sidewalk.[19] Puzzling through various sources, it seems that Wilson left Universal as she had joined it, together with her husband Rupert Julian. In 1923, the *Los Angeles Times* announced that she would come out of retirement

to direct Baby Peggy pictures for Universal.[20] This never happened. Instead, Universal revived the career of Julian, to whom she remained married. The American Film Institute's database credits only one title to his direction in the interval (*The Honey Bee,* American Film Co., 1920), but after rejoining the U he directed his most highly regarded films: *The Merry Go Round* (1923) and *Phantom of the Opera* (1925).

In 1932, Grace Cunard told the story of her 1918 nervous collapse to readers of *New Movie Magazine.*[21] Fans of 1919, however, would have welcomed her return in the new Universal serial *Elmo the Mighty.* They could also have learned, through *Motion Picture Magazine,* that Ruth Stonehouse retained her ambition to direct despite a happy home life with her husband Joseph Roach, an invalid recently home from the war.[22] The following year, the magazine reported that Stonehouse and Madison "have dressing-rooms at the Metro studio."[23] Credits reveal that in 1919, without fanfare, Ruth Ann Baldwin continued her screenwriting career with Fox. Thus went the news of the most prolific of Universal's women directors. Why exactly they left the company is the last thing we can expect these reports to tell us. The story, rather, resides in publicity's interest in such matters as the womanliness of the directors, their homes, and their films.

The same kinds of sources that leave out the Universal women's departures might be expected to reveal who managed the studio in 1919 and early 1920, as they do during prior transitions. It is significant, therefore, that the papers paint a murky picture. In February 1920, the *Los Angeles Times* reported that the journalist-turned-screenwriter Tarkington Baker had six months earlier been appointed business head of the studio and would assume the responsibilities of general manager.[24] By June, however, Baker was apparently out, as the *Times* reported that "a commission" would supervise the plant: the old hand Isadore Bernstein would be manager of production, Louis A. Loeb would be financial manager, and twenty-one-year-old Irving Thalberg would be Laemmle's personal representative. Thalberg would soon run the studio, although the precise timing of the promotion and the process by which he wrested control from his seniors remain uncertain. A new corporate era would begin, the question of women directors having already been decided not by this or that executive but by a process of genre formation.

If it was not at first evident that genre had that power, this book has nonetheless spent a lot of time stating the obvious. Modern capitalist gender relations neither rose nor fell in its pages. Insofar as they were transformed,

the nature of that transformation was elaborated, rather than discovered, here. I have been all too happy to repeat the truisms, first, that lived gender and work relations might make us want gender and work to be otherwise, and second, that fictions might express that wish even as, third, they work to reinstitute the very norms that vex us.

The contribution claimed herein concerns what it means to institute a gendered division of labor and, more specifically, how it is that institutions matter to that process of instituting. They matter in that they are concrete places, constellations of persons and property, that acquire life through a process of interpretation. Genre is such a process. By investigating the corporate movie studio as a geography and by charting shifting interpretations of genre, we grasp that institutions can and do tolerate a great deal more play in their correlation of gender and labor than we may typically assume.

In 1919, when Universal stopped promoting women to the director's chair in the normal course of business, its most prolific women directors continued to work. Madison, Baldwin, Stonehouse, and Cunard returned to their former occupations. Park and Weber continued to direct. If Park's directing career soon sputtered out, and Weber's took a bit longer to do so, we should nonetheless remember that so too it went with the careers of many early directors who happened to be men. The import of 1919 does not lie in the invisibility of the Universal women. Nor does it lie in the difficulties and rewards of their domestic lives. Rather, it resides in their dispersal. As individuals, they present to us an unknowable combination of personal and professional reasons to leave the company. From the vantage of the company, however, the accumulation of gendered constraints on the occupation of director is clear. And so too should be the moral of the tale. If you would have gender done differently, begin by interpreting your institution.[25]

Notes

Preface

1. The pioneering statement of this periodization is Robert H. Wiebe, *The Search for Order, 1877–1920* (New York: Hill and Wang, 1967).

2. For example, in 1915 the *Des Moines Daily News* credited Cunard with directing almost all of the films for which she wrote the scenarios, whereas Universal credited her costar, Francis Ford. See M. C. Larkin, "Movie Star Is Now Director," *Des Moines Daily News,* Dec. 28, 1915, 5. The year before, the *Weekly* identified her as a producing director for Joker, an indication that she had charge of a regularly working company of actors. See "The Universal's Remarkable Staff of Picture Producers," *Universal Weekly,* Apr. 11, 1914, 28–29. There is also good evidence that Ella Hall, Nell Shipman, and Helen Gibson all directed or codirected films at Universal for which they were not officially credited. See Kay Armatage, *The Girl from God's Country: Nell Shipman and the Silent Cinema* (Toronto: University of Toronto Press, 2003), 57; Mabel Condon, "What Film Folk Are Doing on the Coast," *New York Dramatic Mirror,* Mar. 31, 1917, 32; "How They Direct," *Moving Picture Weekly,* Aug. 11, 1917, 24–25.

3. These figures are based on Richard Braff's Universal filmography and my own research. Three qualifications are necessary: 1) in each of these years Universal released a large number of titles for which no director credit is known; 2) in cases where a woman is one of two directors credited, I've counted the title as woman-directed; 3) many titles credited to men were products of teams in which a woman credited as the scenario writer probably did some of the work of directing, but I have not included these in the "women-directed" count. Richard E. Braff, *The Universal Silents: A Filmography of the Universal Motion Picture Manufacturing Company, 1912–1929* (Jefferson, N.C.: McFarland, 1999).

4. Directors Guild of America, *DGA Annual Report on Women and Minority Hiring* (Los Angeles: Directors Guild of America, 1997); Directors Guild of America, "DGA Annual Report on Women and Minority Hiring Reveals Bleak Industry Record for 1999," *DGA*

Magazine 25.5 (January 2001); http://www.dga.org/news/v25_5/news_minorityhire .php3 (accessed June 4, 2009).

5. Lauzen's study examines credits from approximately 225 films each year, selected based on box-office receipts. See Martha M. Lauzen, "2007 Celluloid Ceiling Report," July 15, 2009, http://magazine.women-in-film.com/Home/POV/StatisticalResearch/ tabid/81/ArticleID/110/Default.aspx.

6. Assuming: 1) that Universal, its corporate successors and subsidiaries, was the producing company (as opposed to the distributor merely); 2) that the AFI database completely lists Universal titles up to 1970 and the Internet Movie Database completely lists them from that year up to 1982; and 3) that standard references such as Gwendolyn Audrey Foster, Katrien Jacobs, and Amy L. Unterberger, *Women Filmmakers and Their Films* (Detroit: St. James Press, 1998), have identified those directors who might have worked at Universal. In other words, it is entirely possible that I've missed someone.

7. See, for example, Florence M. Osborne, "Why Are There No Women Directors?," *Motion Picture Magazine* (Nov. 1925): 5.

8. Ida May Park, "The Motion-Picture Director," in *Careers for Women,* ed. Catherine Filene (Boston: Houghton Mifflin Company, 1920), 337.

9. On the "her-own-film-company" phenomenon, see Karen Mahar, *Women Filmmakers in Early Hollywood* (Baltimore: Johns Hopkins University Press, 2006).

10. I. G. Edmonds, *Big U: Universal in the Silent Days* (South Brunswick, N.J.: A. S. Barnes and Co., 1977); Richard Koszarski, *Universal Pictures: Sixty-Five Years* (New York: Museum of Modern Art, 1977); Richard Koszarski, *An Evening's Entertainment: The Age of the Silent Feature Picture, 1915–1928* (Berkeley: University of California Press, 1990); Thomas Schatz, *The Genius of the System: Hollywood Filmmaking in the Studio Era* (New York: Pantheon Books, 1988).

11. Mabel Condon, "The City Universal," *New York Dramatic Mirror,* Aug. 5, 1916, 26–28, 32–36, 44.

12. David Bordwell, Kristin Thompson, and Janet Staiger, *The Classical Hollywood Cinema: Film Style and Mode of Production to 1960* (New York: Columbia University Press, 1985), 136.

13. Koszarski, *Evening's Entertainment,* 89; Kristin Thompson, *Exporting Entertainment: America in the World Film Market, 1907–1934* (London: British Film Institute, 1985).

14. Ally Acker, *Reel Women: Pioneers of the Cinema, 1896 to the Present* (New York: Continuum, 1991); Armatage, *Girl from God's Country;* Cari Beauchamp, *Without Lying Down: Frances Marion and the Powerful Women of Early Hollywood* (New York: Scribner, 1997); Giuliana Bruno, *Streetwalking on a Ruined Map: Cultural Theory and the City Films of Elvira Notari* (Princeton, N.J.: Princeton University Press, 1993); Patricia Erens, *Sexual Stratagems: The World of Women in Film* (New York: Horizon Press, 1979); Foster, Jacobs, and Unterberger, *Women Filmmakers and Their Films;* Jane Gaines, "Of Cabbages and Authors," in *A Feminist Reader in Early Cinema,* ed. Jennifer M. Bean and Diane Negra (Durham, N.C.: Duke University Press, 2002),

88–118; Louise Heck-Rabi, *Women Filmmakers: A Critical Reception* (Metuchen, N.J.: Scarecrow Press, 1984); Alison McMahan, *Alice Guy Blaché: Lost Visionary of the Cinema* (New York: Continuum, 2002); Barbara Quart, *Women Directors: The Emergence of a New Cinema* (New York: Praeger, 1988); Marjorie Rosen, *Popcorn Venus: Women, Movies, and the American Dream* (New York: Coward, 1973); Anthony Slide, *Early Women Directors* (South Brunswick, N.J.: A. S. Barnes and Co., 1977); Anthony Slide, *The Silent Feminists: America's First Women Directors* (Lanham, Md.: Scarecrow Press, 1996).

15. Mahar, *Women Filmmakers*.

16. Slide, *Early Women Directors*.

17. John Drinkwater, *The Life and Adventures of Carl Laemmle* (London: W. Heinemann, 1931), 195.

18. Slide, *Early Women Directors*, 52, 102.

19. Koszarski, *Evening's Entertainment*, 87.

20. Mahar, *Women Filmmakers*, 97; Grace Cunard, "Crowded out of Stardom," *New Movie Magazine* (Feb. 1932): 38–39, 117; Cal York, "Plays and Players," *Photoplay* (Apr. 1917): 122–26.

21. "War Tax Limits Universal Production," *New York Dramatic Mirror*, Nov. 3, 1917, 14; "Universal Cuts Down Program," *New York Dramatic Mirror*, Oct. 27, 1917, 22.

22. J. Searle Dawley Notebooks, 1942[?], J. Searle Dawley Collection, folder 20, Margaret Herrick Library, Beverly Hills, Calif.; Lisa Mitchell, "Ties That Bind: Searching for the Motion Picture Directors Association," *DGA Magazine* 26.4 (November 2001); http://www.dga.org/news/v26_4/feat_mpda.php3 (accessed June 4, 2009); Souvenir, Annual Ball Motion Picture Directors Association, Feb. 17, 1923, Pamphlets, PAM1434, Margaret Herrick Library; *Motion Picture News*, Mar. 24, 1917, reprinted in *Taylorology* 95 (2000); http://silent-movies.com/Taylorology/Taylor95.txt (accessed July 31, 2009).

23. Lee Grieveson, *Policing Cinema: Movies and Censorship in Early-Twentieth-Century America* (Berkeley: University of California Press, 2004).

24. Joan Wallach Scott, "Gender: A Useful Category of Historical Analysis," *American Historical Review* 91.5 (1986): 1053–75.

25. Much of the work cited below elaborates this point, but for overviews see Richard Ohmann, *Selling Culture: Magazines, Markets, and Class at the Turn of the Century* (London: Verso, 1996); Wiebe, *Search for Order*.

26. Daniel J. Walkowitz, *Working with Class: Social Workers and the Politics of Middle-Class Identity* (Chapel Hill: University of North Carolina Press, 1999), 91.

27. Olivier Zunz, *Making America Corporate, 1870–1920* (Chicago: University of Chicago Press, 1990).

28. According to U.S. census figures, the percentage of married women in the civilian labor force roughly doubled from under 6 percent in 1900 to just under 11 percent in 1910, declining to 9 percent in 1920, after which it gradually increased to just over 40 percent by 1970. The proportion of single women who worked remained far more stable, fluctuating between 43 and 51 percent from 1900 to 1970, so that the century's increase in the proportion of women in the workforce overall

may be attributed largely to the growing numbers of employed married women. See Bureau of the Census, *No. HS-30 Marital Status of Women in the Civilian Labor Force: 1900–2002* (2003); http://www.census.gov/statab/hist/HS-30.pdf (accessed July 15, 2009); Julia Kirk Blackwelder, *Now Hiring: The Feminization of Work in the United States, 1900–1995,* 1st ed. (College Station: Texas A&M University Press, 1997); Michael Denning, *The Cultural Front* (New York: Verso, 1997); Claudia Dale Goldin, *Understanding the Gender Gap: An Economic History of American Women* (New York: Oxford University Press, 1990); Alice Kessler-Harris, *Out to Work: A History of Wage-Earning Women in the United States* (New York: Oxford University Press, 1982).

29. Nancy Cott, *The Grounding of Modern Feminism* (New Haven, Conn.: Yale University Press, 1987), 3.

30. Denise Riley, *"Am I That Name?": Feminism and the Category of "Women" in History* (Basingstoke, Hampshire: Macmillan Press, 1988); Rosalind Rosenberg, *Beyond Separate Spheres: The Intellectual Roots of Modern Feminism* (New Haven, Conn.: Yale University Press, 1982).

31. James Livingston, *Pragmatism, Feminism, and Democracy: Rethinking the Politics of American History* (New York: Routledge, 2001), 6.

32. A convenient and comprehensive survey of what is meant by "urban modernity" may be found in Ben Singer, *Melodrama and Modernity: Early Pulp Cinema and Its Contexts* (New York: Columbia University Press, 2001).

33. Kristen Whissel, *Picturing American Modernity: Traffic, Technology, and the Silent Cinema* (Durham, N.C.: Duke University Press, 2008), 161–214.

34. Estelle B. Freedman, "The New Woman: Changing Views of Women in the 1920s," *Journal of American History* 61.2 (1974): 372–93; Pamela S. Haag, "In Search of 'the Real Thing': Ideologies of Love, Modern Romance, and Women's Sexual Subjectivity in the United States, 1920–40," in *American Sexual Politics: Sex, Gender, and Race since the Civil War,* ed. Maura Shaw Tantillo and John C. Fout (Chicago: University of Chicago Press, 1993), 161–91; William Leach, *Land of Desire: Merchants, Power, and the Rise of a New American Culture* (New York: Pantheon Books, 1993); Jackson Lears, *Fables of Abundance: A Cultural History of Advertising in America* (New York: Basic Books, 1994); Lary May, *Screening Out the Past: The Motion Picture and the Birth of Consumer Society, 1900–1929* (New York: Oxford University Press, 1980); Kathy Peiss, *Cheap Amusements: Working Women and Leisure in Turn-of-the-Century New York* (Philadelphia: Temple University Press, 1986); Kathy Lee Peiss, *Hope in a Jar: The Making of America's Beauty Culture* (New York: Henry Holt, 1999).

35. Nan Enstad, *Ladies of Labor, Girls of Adventure: Working Women, Popular Culture, and Labor Politics at the Turn of the Century* (New York: Columbia University Press, 1999); Anne Friedberg, *Window Shopping: Cinema and the Postmodern* (Berkeley: University of California Press, 1993); Sumiko Higashi, *Cecil B. Demille and American Culture: The Silent Era* (Berkeley: University of California Press, 1994); Linda Mizejewski, *Ziegfeld Girl: Image and Icon in Culture and Cinema* (Durham, N.C.: Duke University Press, 1999); Shelley Stamp, *Movie-Struck Girls: Women and Motion Picture Culture after the Nickelodeon* (Princeton, N.J.: Princeton University Press, 2000);

Gaylyn Studlar, *This Mad Masquerade: Stardom and Masculinity in the Jazz Age* (New York: Columbia University Press, 1996).

36. Lauren Rabinovitz, *For the Love of Pleasure: Women, Movies, and Culture in Turn-of-the-Century Chicago* (New Brunswick, N.J.: Rutgers University Press, 1998), 185.

37. Janet Staiger, *Bad Women: Regulating Sexuality in Early American Cinema* (Minneapolis: University of Minnesota Press, 1995), 182.

38. This is not a sneak attack on feminists who have insisted on the importance of bodies by emphasizing that they are irreducible to and indispensable for the descriptions culture gives them. On the contrary, some such conception of bodies strikes me as a necessary correlate to the proposition that culture organizes and hierarchizes them. It is not, however, the sex-body-culture relation that principally concerns me here, but rather the gender-work relation. To investigate that relation, I am interested in how the category "woman" achieves and loses coherence, and gender feminisms help me do that more than sexual-difference feminisms do. See Luce Irigaray, *This Sex Which Is Not One* (Ithaca, N.Y.: Cornell University Press, 1985); E. A. Grosz, *Volatile Bodies: Toward a Corporeal Feminism* (Bloomington: Indiana University Press, 1994); Brian Massumi, *Parables for the Virtual: Movement, Affect, Sensation,* (Durham, N.C.: Duke University Press, 2002); Rosi Braidotti, *Metamorphoses: Towards a Materialist Theory of Becoming* (Cambridge: Polity Press, 2002).

39. François Ewald, "Norms, Discipline, and the Law," *Representations* 30, Special Issue: *Law and the Order of Culture* (1990): 138–61; Michel Foucault, *Society Must Be Defended: Lectures at the College de France, 1975–76,* trans. David Macey (New York: Picador, 2003); Michel Foucault, *Discipline and Punish,* trans. Alan Sheridan (Vintage Books, 1979); Michel Foucault, "Truth and Juridical Forms," in *Power,* ed. James D. Faubion, *The Essential Works of Foucault, 1954–1984,* vol. 3 (New York: The New Press, 2000), 1–89; Judith Butler, *Undoing Gender* (New York: Routledge, 2004); Pierre Macherey, "Towards a Natural History of Norms," in *Michel Foucault, Philosopher: International Conference, Paris, 9, 10, 11, January 1988,* ed. T. J. Armstrong (New York: Routledge, 1991); Mary Poovey, *A History of the Modern Fact: Problems of Knowledge in the Sciences of Wealth and Society* (Chicago: University of Chicago Press, 1998).

40. Butler, *Undoing Gender,* 43.

41. Ibid., 49.

42. Rosabeth Moss Kanter, *Men and Women of the Corporation* (New York: Basic Books, 1977).

43. Janet Staiger, Introduction to *The Studio System,* ed. Janet Staiger (New Brunswick, N.J.: Rutgers University Press, 1995), 7.

Part I: Possibility

1. Studio History, ca. 1916, Richard Koszarski, Private Collection (hereafter Richard Koszarski Collection); Kristin Thompson, *Exporting Entertainment: America in the World Film Market, 1907–1934* (London: British Film Institute, 1985); "To Conquer South America for Universal," *Universal Weekly,* Oct. 10, 1914, 5, 33; Peter Pepper,

"The Foreign Possessions of the Universal," *Moving Picture Weekly,* July 8, 1916, 21, 34. Universal dominated the Indian market by the late 1910s and was the main supplier of serials to southern India after 1917, according to Stephen Hughes, "House Full: Silent Film Genre, Exhibition, and Audiences in South India," *Indian Economic and Social History Review* 43.1 (March 2006): 31–62. Along with the Motion Picture Sales Company, Universal was one of two U.S. firms with distribution in the Netherlands before World War I. See Ivo Leopold Blom, *Jean Desmet and the Early Dutch Film Trade* (Amsterdam: Amsterdam University Press, 2003), 183.

2. For an effort to visualize the monstrosity of corporate persons, see *The Corporation,* dir. Mark Achbar, Jennifer Abbott, and Joel Bakan (Big Picture Media, 2005).

3. Raymond Williams, "Institution," in *Keywords: A Vocabulary of Culture and Society,* rev. ed. (New York: Oxford University Press, 1983), 168.

4. Ibid., 291–95.

5. Here and throughout, I use the word "interpretation" in the sense derived from the pragmatist philosopher and semiologist Charles Sanders Peirce. Against those who would separate "facts" from their "interpretations," Peirce points out that to describe something at all is to interpret it as some thing—as a unity, for instance, rather than as a series of distinct attributes or characteristics. Our ability to make sense to one another in language (to the extent that we do) depends on shared habits of interpretation. Samuel Weber extends this line of thought to consider processes of institutionalization. With respect to proper names specifically, a classic account provided by the speech-act theorist John Searle can be parsed in Peircean terms. Starting from the observation that proper names separate the "referring function from the describing function of language," Searle explains that they also link reference and description together. Names identify by providing "pegs on which to hang descriptions." In order for "John" to name a particular John and not some other requires additional signs that interpret it. Although Searle aims to explain proper names in general, his example contains an additional insight about institutional names specifically. "Bank of England," "Mount Sinai Hospital," "Heritage High School," and "Universal Film Manufacturing Company" reference particular organizations as well as describe them by relating them to functionally similar institutions. In this convention, institutional names reference a particular entity by also characterizing its social function, another instance of how institutions conjoin the concrete and abstract. See Samuel Weber, *Institution and Interpretation,* expanded ed. (Stanford, Calif.: Stanford University Press, 2001); John R. Searle, *Speech Acts: An Essay in the Philosophy of Language* (London: Cambridge University Press, 1969); Charles Sanders Peirce, "Some Consequences of Four Incapacities," in *Peirce on Signs,* ed. James Hoopes (Chapel Hill: University of North Carolina Press, 1991), 54–84.

6. Brand architecture is "the strategic analysis and development of optimal relationship structures among multiple levels of company, brand, product, and feature names." It also references the results of that analysis and development. See Master-McNeil, Inc., "Glossary," www.naming.com/resources.html (accessed July 15, 2009).

7. The brand was reintroduced in 1925.

8. Rosabeth Moss Kanter, *Men and Women of the Corporation* (New York: Basic Books, 1993), chap. 7.

9. The following offer surveys of approaches: Amitai Etzioni, *A Sociological Reader on Complex Organizations,* 2nd ed. (New York: Holt Rinehart and Winston, 1969); Victor Nee, "Sources of the New Institutionalism," in *The New Institutionalism in Sociology,* ed. Mary C. Brinton and Victor Nee (New York: Russell Sage Foundation, 1998), 1–16; Walter W. Powell and Paul DiMaggio, *The New Institutionalism in Organizational Analysis* (Chicago: University of Chicago Press, 1991); W. Richard Scott, *Institutions and Organizations: Foundations for Organizational Science* (Thousand Oaks, Calif.: Sage, 1995).

Chapter 1. Universal's Names

1. Master-McNeil, Inc., founded in 1988, exemplifies this development. The self-described "thought leaders in naming" flourished in the areas of "product naming, company naming, brand naming, and naming strategy." See their Web site at www .naming.com. On the general neglect of names in the sociology on institutions, see Mary Ann Glynn and Rikki Abzug, "Institutionalizing Identity: Symbolic Isomorphism and Organizational Names," *Academy of Management Journal* 45.1 (2002): 267–81.

2. J. Boddewyn, "The Names of U.S. Industrial Corporations: A Study in Change," *Names* 15 (1967): 39–51.

3. I. G. Edmonds, *Big U: Universal in the Silent Days* (South Brunswick, N.J.: A. S. Barnes and Co., 1977), 9.

4. Two other members of the MPPC, Kalem and Essanay, each took a phonetic name derived from the first letters of the last names of their founders: George Kleine, Samuel Long, and Frank J. Marion (Kalem); George K. Spoor and Gilbert M. "Broncho Billy" Anderson (Essanay).

5. Certificate of Incorporation of Universal Film Manufacturing Company, Apr. 29, 1912, Office of the Secretary of State, State of New York; Richard Koszarski, *An Evening's Entertainment: The Age of the Silent Feature Picture, 1915–1928* (Berkeley: University of California Press, 1990); Eileen Bowser, *The Transformation of Cinema, 1907–1915* (Berkeley: University of California Press, 1990); Robert Grau, *The Theatre of Science: A Volume of Progress and Achievement in the Motion Picture Industry* (New York: B. Blom, 1969).

6. Bowser, *Transformation of Cinema,* 80–81; David Bordwell, Kristin Thompson, and Janet Staiger, *The Classical Hollywood Cinema: Film Style and Mode of Production to 1960* (New York: Columbia University Press, 1985), 397–98.

7. William Horsley, "From Pigs to Pictures: The Story of David Horsley," *International Photographer* (April 1934), 2–3, reprinted at *The Silent Film Bookshelf* (1999); http:// www.cinemaweb.com/silentfilm/bookshelf/29_hor_2.htm (accessed June 5, 2009).

8. Balshoffer claims to have owned Sterling, which was distributed by Universal.

Fred J. Balshofer and Arthur C. Miller, *One Reel a Week* (Berkeley: University of California Press, 1967). A similar arrangement likely existed for Crystal and Frontier. See "Frontier and Crystal Dropped from Program," *Universal Weekly,* Dec. 26, 1914, 9.

9. "Universal Film Mfg. Company, Universal Film Mfg. Company Specials," *Moving Picture World,* Jan. 8, 1916, 263. The Laemmle drama *Blind Fury* concerned a barroom loafer. From Rex, *His Return* is described as an "absorbing story, written by Helen Brady, of a young married woman who craves a child. Her husband says children are too expensive. She becomes an artist's model, which brings on a quarrel." The L-KO comedy with Gertrude Selby is described as "exceptionally pleasing," the other as "low." The two Powers titles are a contortionists' act and an actuality offering "pleasing glimpses of the way big logs are handled in the Swedish forests." The Nestor belonged to Fred and Joe Evans's "Fliver" series, listed elsewhere as "Nestor Western" to distinguish these films from the usual Nestor comedies. The Victor drama involved an Indian prince who falls for an English girl. *Uncle Sam at Work* was based on *The American Government* by Frederick J. Haskin and provided an inside look at many government departments. This installment featured scenes of life onboard a battleship. It was apparently sold through a separate booking agent, A. Warner, in New York. Advertisement for *Uncle Sam at Work, Moving Picture Weekly,* July 10, 1915, cover. I am grateful to Robert Birchard for the tip on L-KO pronunciation.

10. "This Week's Program," *Moving Picture Weekly,* Jan. 1, 1916, 38.

11. It was not a dead giveaway, however, since Universal shared the building with other producers. In late 1915, for example, Vitagraph and Atlas had offices there. See "Fire in Film Exchange," *New York Times,* Dec. 19, 1915, S10. In January 1916, the *Chicago Tribune* found the Bluebird backers "elusive." See Kitty Kelly, "Flickerings from Filmland, Film Preachments at the Studebaker," *Chicago Daily Tribune,* Jan. 11, 1916, 14.

12. "M. H. Hoffman Outlines Bluebird Policy to Insure Finest Features Yet Made," *Moving Picture Weekly,* Jan. 8, 1916, 16–17, 35.

13. "Announcement of Jewel Productions," *Moving Picture Weekly,* Sept. 8, 1917, 6–7.

14. "The Chief Trade Topics of 1917," in *Kinematograph Year Book, Film Diary, and Directory* (London: Kinematograph and Lantern Weekly, 1918), 59.

15. Advertisement for Bluebird Photoplays, *Bioscope,* Jan. 27, 1916, 356c.

16. The dearth and condition of surviving prints makes any conclusion speculative, but it seems likely that Universal's trademark could easily disappear in circulation given the practices of: 1) retitling films abroad, particularly in non-English-speaking markets, 2) assigning rights to distributors who would then append their own brands to prints, and 3) unlicensed sales of copies.

17. Dissolved Company File: Universal Film Company, Limited, 1911–1916, Board of Trade Records BT31/13541/114541, National Archives, Kew, Richmond, Surrey, U.K.

18. Dissolved Company File: Universal Film Company, Limited, 1915–1930, Board of Trade Records, BT31/22715/139364, National Archives, Kew, Richmond, Surrey,

U.K.; Dissolved Company File: Trans-Atlantic Film Company, Limited, 1913–1930, Board of Trade Records, BT31/21763/131580, National Archives, Kew, Richmond, Surrey, U.K.

19. Koszarski, *Evening's Entertainment*, 47–48; "Universal Cuts Down Program," *New York Dramatic Mirror*, Oct. 27, 1917, 22; Carl Laemmle, "Exposing Some Big Secrets!!!," *Moving Picture Weekly*, Dec. 29, 1917, 8–13.

20. The company trend does not differ hugely from the industry trend. In 1917, for example, the last year Universal released its variety program of shorts, Ben Singer estimates that 75 percent of the films produced by U.S. manufacturers were shorts, and 25 percent were features. Universal released 84 percent shorts and 16 percent features. See Ben Singer, "Feature Films, Variety Programs, and the Crisis of the Small Exhibitor," in *American Cinema's Transitional Era: Audiences, Institutions, Practices*, ed. Charlie Keil and Shelley Stamp (Berkeley: University of California Press, 2004), 81. Singer explains these changes from the exhibitor's point of view, and of course they also affected the economics of production. A crucial change was the shift from per-reel to per-title pricing of shorts. See Carl Laemmle, "Important News: No. 208 Straight from the Shoulder Talk," *Moving Picture Weekly*, May 18, 1918, 12.

21. On the evolution of the exchange system, see Max Alverez, "The Origins of the Film Exchange," *Film History* 17.4 (2005): 431–65. Universal offered a subscription service. See Edmonds, *Big U*, 40.

22. Laemmle and Powers kept the exchanges they owned out of the initial merger, the subject of an early controversy. See "Film Fraud Deals Laid to Directors," *New York Times*, Jan. 30, 1913, 7; "Film Trust Denies Changes by Henkel," *New York Times*, Jan. 31, 1913, 7. In July 1916, it was reported that they sold these exchanges to Universal for one million dollars: "Big Universal Deal Closed," *Chicago Daily Tribune*, July 18, 1916, 17; "Universal Makes a Record Purchase," *Moving Picture Weekly*, July 29, 1916, 33. A 1923 audit by the U.S. Internal Revenue Service, however, suggests that this acquisition occurred in late 1917 for just under half a million dollars, as part of a major consolidation of corporate holdings. See Internal Revenue Service Report, 1923, Richard Koszarski Collection.

23. For two-reel films, production costs could be higher.

24. "A Trip through the Home of the Universal (V)," *Universal Weekly*, July 26, 1913, 10, 31.

25. On the earlier development of these ways of handling features, see Richard Abel, *Americanizing the Movies and "Movie-Mad" Audiences, 1910–1914* (Berkeley: University of California Press, 2006), 23.

26. Advertisement for *Idle Wives, Moving Picture Weekly*, Nov. 18, 1916, 30–31.

27. "M. H. Hoffman on Flying Inspection Trip," *Moving Picture Weekly*, Aug. 14, 1915, 45; "M. H. Hoffman Outlines." Bluebird was incorporated in December. See Certificate of Incorporation of Bluebird Photoplays, Inc., 1915, Records of the New York County Clerk File 06393–15C.

28. Bluebird Photo Plays, Inc., 1st Year [Financial Report], Jan. 21, 1917, Richard Koszarski Collection.

29. Costs were apportioned roughly according to the volume of business done by (or expected from) each exchange. Of the nineteen branches, only two (New York and Toronto) showed a profit in the first year. The New York branch, which did by far the most business, paid Universal $127,827.87 for film prints and had approximately fifteen thousand dollars in additional costs, mostly related to advertising materials, for a total cost of sales (exclusive of overhead costs) of $143,083.93. Gross revenues for that branch were $193,800.43, $184,011.64 of which came from film rentals. The Charlotte branch, which did the lowest volume of business, posted a total sales cost of $46,315.47 and gross revenues of $12,030.12.

30. Terry Ramsaye, *A Million and One Nights: A History of the Motion Picture through 1925* (1926; reprint, New York: Simon and Schuster, 1964), 582.

31. Balshofer and Miller, *One Reel,* 84–88. See also Edmonds, *Big U;* Grau, *Theatre of Science;* Bowser, *Transformation of Cinema.*

32. Edmonds, *Big U;* Balshofer and Miller, *One Reel.*

33. Grau, *Theatre of Science.*

34. Ibid., 48.

35. Marc Wanamaker, "History of the Universal Film Company" (2005), unpublished ms. in author's possession; Tom Link, Laura Cordova-Molmud, and Robert J. Kelly, *Universal City—North Hollywood: A Centennial Portrait, an Illustrated History,* 1st ed. (Chatsworth, Calif.: Windsor Publications, 1991); "Celebration Opens New Foothill City," *Los Angeles Times,* May 12, 1913, II2.

36. "A Trip through the Home of the Universal Accounting Department—Cashier—XIII," *Universal Weekly,* Sept. 20, 1913, 12.

37. Agreement between C. E. Boag and Universal Film Manufacturing Company for Lot "E," Mar. 31, 1914, Los Angeles County Deed Book, No. 5719, 288–90, County of Los Angeles, State of California; Agreement between Rodeo Land and Water Co. and Universal Film Manufacturing Co. for Lots "B" And "C", Mar. 31, 1914, Los Angeles County Deed Book, No. 5719, 284–87, County of Los Angeles, State of California.

38. Richard Koszarski, *Fort Lee: The Film Town* (Bloomington: Indiana University Press, 2004), 272–82.

39. "Universal Combines All Its Exchanges," *Moving Picture Weekly,* May 25, 1918, 10; "Universal Products to Be Distributed by Single Organization Controlling All Exchanges," *Exhibitor's Trade Review,* May 25, 1918, 1988; Kristin Thompson, *Exporting Entertainment: America in the World Film Market, 1907–1934* (London: British Film Institute, 1985), 33.

40. Although the announcement of this new company does not mention Park, subsequent credits strongly suggest that she was its writer. "Pauline Bush to Head New Rex Company," *Universal Weekly,* July 25, 1914, 13.

41. This may be the impression left by Eileen Bower's history, but in saying that brand marketing preceded star marketing she describes the period before 1910. In the period under discussion here, brands and stars coexisted and supported one another as marketing strategies. Bowser, *Transformation of Cinema,* 103–19. That

brands, stars, and genres evolved together as marketing devices is made clear by Abel, *Americanizing.*

42. They were produced by Balshofer and directed (for the most part) by H. "Pathé" Lehrman. Balshofer and Miller, *One Reel,* 108–21. Jeanette Delamoir offers another illuminating case, that of the Bluebird star Louise Lovely, who in 1917 was elevated to make three feature films under the banner of "Louise Lovely Productions" and was in the same year shunted into a series of short Imps, Laemmles, and Bisons. Available records do not allow Delamoir to say precisely why, when, and in what order Universal promoted and demoted Lovely, but they lead Delamoir to infer a struggle between star and management to control the name Lovely, which Universal had created for the Australian actress Louise Carbasse and to which it may have claimed a legal right. See Jeannette Delamoir, "Louise Lovely, Bluebird Photoplays, and the Star System," *Moving Image* 4.2 (Fall 2004): 64–85.

43. Karen Mahar, *Women Filmmakers in Early Hollywood* (Baltimore: Johns Hopkins University Press, 2006), 29–76.

44. For a comparative historical survey of motion-picture branding in the United States, France, and Britain that considered stars as a form of branding, see Gerben Bakker, "Stars and Stories: How Films Became Branded Products," *Enterprise and Society* 2 (June 2001): 461–502.

45. As noted in the preface, credits likely underreport Cunard's contribution.

46. The screenwriter E. Magnus Ingleton may be the exception that proves the rule. She is credited with a single five-reel feature, *The Birth of Patriotism* (Red Feather, 1917), and her prior directing experience is uncertain.

Chapter 2. Universal's Organization

1. "Continuous rational activity of a specified kind will be called *enterprise;* an association with a continuously and rationally operating staff will be called a *formal organization.*" Max Weber, *Economy and Society: An Outline of Interpretive Sociology,* vol. 1 (Berkeley: University of California Press, 1978), 52.

2. "The living cell contains nothing but mineral particles, as society contains nothing but individuals. Yet it is patently impossible for the phenomena characteristic of life to reside in the atoms of hydrogen, oxygen, carbon, and nitrogen. . . . Life could not thus be separated into discrete parts; it is a unit. . . . Let us apply this principle to sociology." Emile Durkheim and George Edward Gordon Catlin, *The Rules of Sociological Method,* 8th ed. (New York: Free Press of Glencoe, 1964), xlvii–xlviii.

3. James G. March and Herbert Alexander Simon, *Organizations* (New York: Wiley, 1958), 4.

4. Robert K. Merton, "Bureaucratic Structure and Personality," in *A Sociological Reader on Complex Organizations,* ed. Amitai Etzioni (New York: Holt Rinehart and Winston, 1969), 53.

5. Philip Selznick, "Foundations of the Theory of Organization," *American Sociological Review* 13.1 (February 1948): 25–35.

6. This was a pattern set by the first historians of the U.S. film industry: Benjamin Bowles Hampton, *History of the American Film Industry from Its Beginnings to 1931* (New York: Dover Publications, 1970); Terry Ramsaye, *A Million and One Nights: A History of the Motion Picture through 1925* (1926; reprint, New York: Simon and Schuster, 1964). The habit endures despite ample demonstration of the industry's corporate nature. See Tino Balio, *Grand Design: Hollywood as Modern Business Enterprise* (Berkeley: University of California Press, 1995); Thomas Schatz, *The Genius of the System: Hollywood Filmmaking in the Studio Era* (New York: Pantheon Books, 1988); David Bordwell, Kristin Thompson, and Janet Staiger, *The Classical Hollywood Cinema: Film Style and Mode of Production to 1960* (New York: Columbia University Press, 1985).

7. He was forced out a year and a half later. "Laemmle Sells Film Corportation," *New York Times,* May 15, 1936, 35; "Universal Pictures Elections," *New York Times,* May 2, 1936, 24; "Film Holding Unit Files to Refinance," *New York Times,* May 23, 1936, 23; "Universal Pictures Demotes Cochrane," *New York Times,* Dec. 1, 1937, 27.

8. "Universal Goes to Court," *Moving Picture World,* July 5, 1913, 27; "Throws Out Books and Company Seal," *New York Times,* June 17, 1913, 20.

9. Twenty people owned 8,395 shares of par-one-hundred-dollars preferred stock; Laemmle owned 3,554 shares, and Powers owned 2,625 (6179 shares combined), according to List of Universal Stockholders at Close of Business May 19, 1916, Richard Koszarski Collection. Preferred stock paid a 6 percent dividend but was nonvoting. See Certificate of Proceedings of Stockholders' Meeting for Purpose of Classifying the Authorized Capital Stock into Common and Preferred, Dec. 11, 1912, Office of Secretary of State, State of New York. It is possible that preferred stockholders were subsequently allowed to vote, but no documentation to this effect survives in New York State files.

10. "Election of Universal's Officers," *Motography,* Jan. 23, 1915, 118; I. G. Edmonds, *Big U: Universal in the Silent Days* (South Brunswick, N.J.: A. S. Barnes and Co., 1977), 29; *Motion Picture Studio Directory and Trade Annual* (New York: Motion Picture News, 1920), 361; "Notice to Stockholders," *New York Times,* Jan. 30, 1915, 13.

11. Joining Laemmle and Cochrane on the board of directors in 1915 were J. A. McKinney and John B. Stanchfield, a prominent lawyer and former New York gubernatorial candidate who also served as Universal's attorney. Neither of these men held shares in May 1916. Stanchfield's firm continued to represent Universal throughout the 1910s, and by 1917, Siegfried Hartman was the lead attorney on the Universal account. The 1915 board elected George E. Kann (a.k.a. Kahn) as assistant secretary and Joe Brandt as manager of the home office. See "Election of Universal's Officers," *Motography,* Jan. 23, 1915, 118.; "Joe Brandt," Obituary, *Variety,* Mar. 1, 1939.

12. Mabel Condon, "The City Universal," *New York Dramatic Mirror,* Aug. 5, 1916, 26–28, 32–36, 44.

13. "Isadore Bernstein to Manage Western Universal," *Moving Picture World,* July 5, 1913, 29. Another report has Bernstein replacing Joe Engel as studio manager,

although it does not make clear what position Engel held when Bernstein replaced him. See "J. C. Graham, on West Coast Affairs," *Universal Weekly,* July 26, 1913, 14–15.

14. In May of that year, the trade paper *Motography* published a ghetto-boy-made-good story about his life: he had risen by his bootstraps to become superintendent of the New York Boy's Institute, landed a job as a special reporter with the *Christian Herald,* and worked his way up to associate editor there, becoming "the only Hebrew employed in an editorial capacity by that great paper." Bernstein entered motion-picture work and had been general manager of Monopol before joining Universal at age thirty-six. See "A 'Close-up' of Isadore Bernstein: Whom You Probably Know," *Motography,* May 22, 1915, 826; "Isadore Bernstein to Manage Western Universal," *Moving Picture World,* July 5, 1913, 29.

15. "George Magie Turns Accident to Advantage," *Universal Weekly,* Apr. 10, 1915,

16. The five business managers were Beverly H. Griffith, Stanley Twist, Don Meaney, Marshall Steadman, and Charles V. Henkle. Magie had been with the company since at least 1913, when he was Laemmle's "special representative." "A Trip through the Home of the Universal Special Representative—XVI," *Universal Weekly,* Oct. 11, 1913, 4. He remained general manager at least through June. See "The Making of Moving Pictures at Universal City, California," *National Magazine* (June 1915): 409–17.

16. "Kann Goes to Coast," *Moving Picture World,* Oct. 16, 1915, 423; "Farewell Dinner to Geo. Kann," *Moving Picture Weekly,* Oct. 9, 1915, 25.

17. McRae is referred to as director general in "Wonderful Company Selected for Next Universal Serial 'Graft' in Thirty-Four Reels," *Moving Picture Weekly,* Nov. 13, 1915, 18–19; "Cleo Madison a Successful Director," *Moving Picture Weekly,* Oct. 2, 1915, 21.

18. "Studio Directory," *Motion Picture News,* Oct. 21, 1916, 150.

19. "Big Saving in Film Consolidation," *New York Times,* June 29, 1917, 15; Mabel Condon, "In Film Circles on the West Coast," *New York Dramatic Mirror,* May 26, 1917, 32.

20. Mabel Condon, "Making Things Hum in West Coast Studios," *New York Dramatic Mirror,* June 2, 1917, 32.

21. "Universal Gets Harry Kline," *Exhibitor's Trade Review,* June 7, 1919, 49; *Kinematograph Year Book,* ed. John Dunbar (London: Kinematograph and Lantern Weekly, 1920), 126.

22. "Now Control's U.'s Policies: Tarkington Baker's Duties Are Enlarged," *Los Angeles Times,* Feb. 29, 1920, III13; "Written on the Screen," *New York Times,* Apr. 11, 1920, X2.

23. "Commission Rule for Film Company: Universal Finds Method Yields Satisfactory Results," *Los Angeles Times,* June 6, 1920, III2.

24. *Motion Picture Studio Directory and Trade Annual* (New York: Motion Picture News, Inc., 1921); Studio Telephone Directory, Universal Pictures Corp. (n.d.), in unnumbered folder collection, "Studios A–Z," 26, Seaver Center for Western History Research, Natural History Museum, Los Angeles.

25. R. H. Cochrane to Siegfried Hartman, Mar. 15, 1917, Richard Koszarski Collection.

26. R. H. Cochrane to Siegfried Hartman (telegram), Mar. 23, 1917, Richard Koszarski Collection.

27. For a long history of this attitude toward numbers, see Mary Poovey, *A History of the Modern Fact* (Chicago: University of Chicago Press, 1998).

28. H. O. Davis to Carl Laemmle, Mar. 23, 1917, Richard Koszarski Collection.

29. Marc Wanamaker has established that Julius Stern had a longstanding relationship with Laemmle as confidant, business partner, and "fixer." At around the time the Stern brothers were put in charge of the Sunset and Gower studio, they created their own company, Century Comedies, which Universal distributed. See Marc Wanamaker, "History of the Universal Film Company" (2005), unpublished ms. in author's possession.

30. "Universal Concentrates in West: All Eastern Companies Will Be Transferred to Hollywood under General Direction of H. O. Davis," *Moving Picture World,* June 10, 1916, 1862.

31. Janet Staiger, "Dividing Labor for Production Control: Thomas Ince and the Rise of the Studio System," *Cinema Journal* 18.2 (Spring 1979): 16–25; Bordwell, Thompson, and Staiger, *Classical Hollywood Cinema.*

32. "A Trip through the Home of Universal," *Universal Weekly,* June 28, 1913, 5, 27; "A Trip through the Home of the Universal (II)," *Universal Weekly,* July 5, 1913, 13, 27; "A Trip through the Home of the Universal (III)," *Universal Weekly,* July 12, 1913, 13; "A Trip through the Home of the Universal (V)," *Universal Weekly,* July 26, 1913, 10, 31; "A Trip through the Home of the Universal Foreign Department (VI)," *Universal Weekly,* Aug. 2, 1913, 4; "A Trip through the Home of the Universal Purchasing Department—VII," *Universal Weekly,* Aug. 9, 1913, 4–5; "A Trip through the Home of the Universal Poster and Photo Department—VIII," *Universal Weekly,* Aug. 16, 1913, 4, 5; "A Trip through the Home of the Universal Projection Booth and Its Presiding Genius—XIV," *Universal Weekly,* Sept. 27, 1913, 9; "A Trip through the Home of the Universal Accounting Department—Cashier—XIII," *Universal Weekly,* Sept. 20, 1913, 12; "A Trip through the Home of the Universal Special Representative—XVI," *Universal Weekly,* Oct. 11, 1913; "A Trip through the Home of the Universal Assistant Secretary and Pres. Laemmle's Shadow—XVIII," *Universal Weekly,* Oct. 25, 1913, 4; "A Trip through the Home of the Universal President Carl Laemmle—XIX," *Universal Weekly,* Nov. 1, 1913, 4–5.

33. "All Aboard for Universal City," *Universal Weekly,* Jan. 17, 1914, 4–5, 32.

34. "The Universal Company has eliminated its staff of scenario writers and substituted writers whose chief duties will be to adapt stories, books, and ideas which are being purchased by Universal," reports "Universal Buys Book Rights," *Motography,* Feb. 5, 1916, 310.

35. Davis clearly swam against the tide as a public opponent of the star system. While he preferred to think of actors as personnel to be managed, the industry increasingly treated them as brand names to be marketed. Davis's position on stars

looks even more rear-guard after he left Universal for Triangle. In contrast, his advocacy of efficiency seems prescient. "'Stars *or* No Stars'—That Is *the* Question," *Photoplay* (Jan. 1918): 95–96.

36. Bordwell, Thompson, and Staiger, *Classical Hollywood Cinema,* 121–41. For an alternative periodization, see Charles Musser, "Pre-Classical American Cinema: Its Changing Modes of Production," in *Silent Film,* ed. Richard Abel (New Brunswick, N.J.: Rutgers University Press, 1996), 85–108.

37. "Efficiency in Big U. Production," *Motography,* Feb. 10, 1917, 313.

38. "Doings at Universal City," *Moving Picture Weekly,* Jan. 13, 1917, 22–23.

39. Peter Miller and Ted O'Leary, "Governing the Calculable Person," in *Accounting as Social and Institutional Practice,* ed. Anthony G. Hopwood and Peter Miller (London: Cambridge University Press, 1994), 98–115; Paul J. Miranti, *Accountancy Comes of Age: The Development of an American Profession, 1886–1940* (Chapel Hill: University of North Carolina Press, 1990); Gary John Previts and Barbara Dubis Merino, *A History of Accountancy in the United States: The Cultural Significance of Accounting* (Columbus: Ohio State University Press, 1998).

40. Miller and O'Leary, "Governing the Calculable Person," 99.

41. "The executive board of the Universal don't limit directors as long as they produce something worthwhile for the money expended." "All Aboard for Universal City," 5.

42. Robert S. Birchard, "The (Continued) Adventures of Francis Ford and Grace Cunard," *American Cinematographer* 74.8 (August 1993): 64–86; "Universal Concentrates in West."

43. Irene Padavic and Barbara Reskin, *Women and Men at Work,* 2nd ed. (Thousand Oaks, Calif.: Sage, 2002), 57–95.

44. A development of this hypothesis might consider the possibility that Davis's routines counted formally (that is, recorded and tracked) work that women already did informally (as a matter of course, but without being officially assigned it by the production department) and thus encouraged their mobility into credited positions. Evidence for this hypothesis exists, but not enough to test it.

45. Insofar as I have been able to determine, production manager, cameraman, laboratory head, and art director were men's jobs. As elsewhere, women did the laboratory work of joining and finishing positive prints. "Fire Destroys Cutting Rooms of Universal Hollywood Studios," *Universal Weekly,* Jan. 24, 1914, 5. On industry-wide norms, see Karen Mahar, *Women Filmmakers in Early Hollywood* (Baltimore: Johns Hopkins University Press, 2006). This may have led some of them to the occupation of editor. According to Robert Birchard, Universal's editors were men, but at least one of the Universal women directors, Ruth Ann Baldwin, claimed to have worked for six months as a film editor. See *Motion Picture Studio Directory and Trade Annual* (New York: Motion Picture News, 1920), 317.

46. Condon, "City Universal." Lewis had been appointed in June 1916. "New Scenario Editor for Universal," *Moving Picture World,* June 24, 1916, 2214. Ingleton's appointment to this critical post is still noteworthy. By way of comparison, a 1922

Universal City directory lists three women department heads: telegraphic, sewing, and post office. "Universal City Directory," *Universal City News* (Nov. 1922): 10.

Chapter 3. Universal City

1. "Universal's Chameleon City: The Most Remarkable Town Ever Built," *Universal Weekly,* Sept. 26, 1914, 4–5, 8–9, 37.

2. Gaston Bachelard, *The Poetics of Space* (New York: Orion Press, 1964). In making the claim, Bachelard also inaugurates a controversy insofar as he can be seen as universalizing a particular version of home as its prototype: namely, the European house as a space of maternal care, security, and comfort. Such a house cares for the little boys who grow up to be Bachelards by confining the moms who function as its appendages. The lesson is this: if the idea of home is liable to strike modern persons as a human universal, the particular form home takes matters a great deal to social organization. This point has been particularly clear in feminist critiques of Bachelard and is a conclusion reached by a range of sociological, historical, and psychoanalytic approaches. For a survey, see David Morley, *Home Territories: Media, Mobility, and Identity* (London: Routledge, 2000). Clearly, it is possible for movies and institutions to imagine a variety of different types of spaces and relations as homelike. In what follows I describe the consequences of making a particular version the norm.

3. Lary May, *Screening out the Past: The Motion Picture and the Birth of Consumer Society, 1900–1929* (New York: Oxford University Press, 1980); Robert Sklar, *Movie-Made America: A Social History of American Movies,* rev. ed. (New York: Random House, 1994); Sumiko Higashi, *Cecil B. Demille and American Culture: The Silent Era* (Berkeley: University of California Press, 1994); Kathryn H. Fuller, *At the Picture Show: Small-Town Audiences and the Creation of Movie Fan Culture* (Washington, D.C.: Smithsonian Institution Press, 1996); Alison M. Parker, "Mothering the Movies: Women Reformers and Popular Culture," in *Movie Censorship and American Culture,* ed. Francis G. Couvares (Washington, D.C.: Smithsonian Institution Press, 1996), 73–96; Lauren Rabinovitz, *For the Love of Pleasure: Women, Movies, and Culture in Turn-of-the-Century Chicago* (New Brunswick, N.J.: Rutgers University Press, 1998); Nan Enstad, *Ladies of Labor, Girls of Adventure: Working Women, Popular Culture, and Labor Politics at the Turn of the Century* (New York: Columbia University Press, 1999); Shelley Stamp, *Movie-Struck Girls: Women and Motion Picture Culture after the Nickelodeon* (Princeton, N.J.: Princeton University Press, 2000); Ben Singer, *Melodrama and Modernity: Early Pulp Cinema and Its Contexts* (New York: Columbia University Press, 2001); Mark Garrett Cooper, *Love Rules: Silent Hollywood and the Rise of the Managerial Class* (Minneapolis: University of Minnesota Press, 2003).

4. "Snappy Little Stories of the One Reelers," *Universal Weekly,* June 20, 1914, 20; "Laura Oakley, 'Black Box' Sleuth," *Universal Weekly,* Mar. 27, 1914, 16; Peter Pepper, "Peter Pepper Enjoys Picking out Boy's Clothes for Violet Merereau in Her New Bluebird Play 'The Boy Girl,'" *Moving Picture Weekly,* Feb. 24, 1917, 16.

5. Henri Lefebvre, *The Production of Space,* trans. Donald Nicholson-Smith (Oxford:

Blackwell, 1991), 38–39. Another source of inspiration for considering corporate space as important to institutional definition is Erving Goffman, *Asylums: Essays on the Social Situation of Mental Patients and Other Inmates* (Garden City, N.Y.: Anchor Books, 1961).

6. Joseph P. Eckhardt, *The King of the Movies: Film Pioneer Siegmund Lubin* (Madison, N.J.: Fairleigh Dickinson University Press, 1997), 144–56.

7. Inceville Clippings File, Core Collection, Margaret Herrick Library, Beverly Hills, Calif.; G. P. Harleman, "Motion Picture Studios of California," *Moving Picture World,* Mar. 10, 1917; http://employees.oxy.edu/jerry/mpstud01.htm (accessed July 15, 2009).

8. Fred J. Balshofer and Arthur C. Miller, *One Reel a Week* (Berkeley: University of California Press, 1967), 76–81.

9. Eckhardt, *King of the Movies,* 147.

10. "Woman Police Chief," *Los Angeles Times,* May 21, 1913, I16; "Film City Actors Drop Masks at Election; Woman's Slate Smashed; Elect Man Mayor," *Los Angeles Examiner,* May 21, 1913, 1.

11. "Celebration Opens New Foothill City," *Los Angeles Times,* May 12, 1913, II2.

12. "Inhabitants of Moving Picture City, Planning to Incorporate and Elect Mayor and Board of Aldermen, Thwarted When Actresses Start Suffrage Movement," *Fort Wayne (Ind.) Journal-Gazette,* May 18, 1913, 13.

13. The statute required five hundred residents. California, *An Act to Provide for the Organization, Incorporation, and Government of Municipal Corporations, Statues* (1883), chap. 49, 93–99.

14. "Where Work Is Play and Play Is Work," *Universal Weekly,* Dec. 27, 1913, 4–5.

15. "Although experience contradicts theory, social life validates cosmology by its similarity of structure. Hence cosmology is true." Claude Lévi-Strauss, *Structural Anthropology,* trans. Claire Jacobson and Brooke Grundfest Schoepf (New York: Basic Books, 1963), 216.

16. "The California Senate Endorses the Universal," *Universal Weekly,* Feb. 28, 1914, 32; "Three More Accidents at Pacific Coast Studios," *Universal Weekly,* Feb. 28, 1914, 32.

17. "A Trip through the Home of Universal," *Universal Weekly,* June 28, 1913, 5, 27.

18. "A Trip through the Home of the Universal (II)," *Universal Weekly,* July 5, 1913, 13, 27.

19. "A Trip through the Home of the Universal President Carl Laemmle—XIX," *Universal Weekly,* Nov. 1, 1913, 4–5; "A Trip through the Home of the Universal Foreign Department (VI)," *Universal Weekly,* Aug. 2, 1913, 4; "A Trip through the Home of Universal (II)"; "A Trip through the Home of the Universal Purchasing Department.—VII," *Universal Weekly,* Aug. 9, 1913, 4–5.

20. The Western exhibitor has difficulty parsing Miss Viola Van Loan's job, indicating that she is both a stenographer who takes dictation and a writer attached to the scenario department, but he has no difficulty placing her in the office hierarchy

as to-be-ogled. "A Trip through the Home of the Universal (III)," *Universal Weekly,* July 12, 1913, 13.

21. "All Aboard for Universal City," *Universal Weekly,* Jan. 17, 1914, 4–5, 32.

22. "All Aboard for Universal City, No. 2.," *Universal Weekly,* Jan. 24, 1914, 4–5.

23. "Universal City through Eastern Eyes, No. 4," *Universal Weekly,* Feb. 7, 1914, 4–5.

24. "Mrs. Laemmle Unwitting Appears in Film Play," *Universal Weekly,* Mar. 21, 1914, 25.

25. "All Aboard for Universal City."

26. "Bernstein's Broadside," *Universal Weekly,* Sept. 5, 1914, 5, 17

27. "J. C. Graham, on West Coast Affairs," *Universal Weekly,* July 26, 1913, 14–15.

28. Unnumbered folder of clippings on election in Laura Oakley Accession, Seaver Center for Western History Research, Natural History Museum, Los Angeles.

29. "Stella Adams Succeeds Laura Oakley as Universal City Chief of Police," *Universal Weekly,* March 7, 1914, 17.

30. "Universal Miscellany," *Universal Weekly,* Aug. 29, 1914, 13.

31. Certificate from the Board of Police Commissioners, Laura Oakley Accession, Seaver Center for Western History Research, Natural History Museum, Los Angeles.

32. "She Hands Him to Police Station; Then Marries Him," *Universal Weekly,* Mar. 21, 1914, 21.

33. See, for example, *Making a Man of Her* (Nestor, 1912), *Some Chaperone* (Nestor, 1915), and *Nearly a Chaperone* (Star Comedy, 1918).

34. Oakley describes the fun of learning to play a man and a detective later in the issue. "Laura Oakley, 'Black Box' Sleuth," *Universal Weekly,* Mar. 27, 1914, 16.

35. Chris Straayer, *Deviant Eyes, Deviant Bodies: Sexual Re-Orientations in Film and Video* (New York: Columbia University Press, 1996), 42–78.

36. Susan Hanson and Geraldine Pratt, *Gender, Work, and Space* (New York: Routledge, 1995); Doreen B. Massey, *Space, Place, and Gender* (Minneapolis: University of Minnesota Press, 1994). Although these geographers tend to work on communities larger than particular enterprises, the insight that gender, work, and space inform one another applies to Universal's mock city.

37. Guiliana Muscio, "Women Screenwiters in American Silent Cinema," Paper delivered at Les Femmes et le Cinéma Muet/Women and the Silent Screen conference, Montréal, June 2004. See also Giuliana Muscio, "Le Sceneggiatrici Del Muto Americano," *Acoma: Rivista Internazionale di Studi Nordamericani* 2.4 (Spring 1995): 88–95.

38. Agreement between Rodeo Land and Water Co. and Universal Film Manufacturing Co. for Lots "B" and "C," Mar. 31, 1914, Los Angeles County Deed Book, No. 5719, 284–87, County of Los Angeles, State of California; Agreement between C. E. Boag and Universal Film Manufacturing Co. for Lot "E," Mar. 31, 1914, Los Angeles County Deed Book, No. 5719, 288–90, County of Los Angeles, State of California.

39. "The New Universal City," *Universal Weekly,* Sept. 5, 1914, 9, 12.

40. "Universal's Chameleon City." See also "Universal City, the Chameleon Studio Town," *Universal Weekly*, Dec. 19, 1914, 9.

41. "Universal's Chameleon City." Entire passages of this article recur in "The Strangest City in the World: A Town Given Over to the Moving Picture," *Scientific American*, Apr. 17, 1915, 365. Trade publications other that Universal's in-house paper adopted similar rhetoric. *Motography* portrays Universal City as "a real city, planned to make make-believe things. While it is always to be Universal City, there is no reason why it may not be ancient Troy tomorrow, modern New York the day after, and an African jungle by Saturday afternoon at three o'clock." See Ed Mock, "The Cruise of the Universal Special," *Motography*, May 22, 1915, 816–19.

42. Although undated, the map must have been produced between late March 1914, when *Southwest Contractor* published a notice that the Los Angeles architects S. Tilden Norton and Frederick Wallis had been retained to draw up plans, and November of that year, when the beginning of the rainy season prompted the planners to redesign a garage on the north edge of the property as an electric indoor studio (the map shows it as a garage). See Mabel Condon, "The Completion of Universal City," *Motography*, Jan. 2, 1915, 17–18; "Los Angeles Notes," *Southwest Contractor*, Mar. 21, 1914, 13.

43. Charlton Lawrence Edholm, "In Filmland by the Pacific," *Technical World*, Aug. 19, 1913, 906–10.

44. Spencer Cramps, *Ride the Big Red Cars: How Trolleys Helped Build Southern California*, 3rd ed. (Costa Mesa, Calif.: Trans-Anglo Books, 1970). Cramps does not include a timetable; my estimates are based on distance and total running time.

45. "Universal City Walled In," *Universal Weekly*, Mar. 13, 1915, 28.

46. Mae Tinée, "Latest News from Movie Land," *Chicago Daily Tribune*, Feb. 13, 1916, G3; Grace Kingsley, "Along the Rialto," *Los Angeles Times*, Jan. 27, 1916, III4; "How Universal Cares for Its Child Players," *Moving Picture Weekly*, Dec. 23, 1916, 34; "Primary School for Child Photo Players Opens at Universal City," *Moving Picture Weekly*, Feb. 19, 1916, 18; "Public School Installed at 'U' Hollywood Studios," *Universal Weekly*, Apr. 4, 1914, 54.

47. My conclusions about who worked where are distilled from a wide range of sources, but see particularly Mabel Condon, "The City Universal," *New York Dramatic Mirror*, Aug. 5, 1916, 26–28, 32–36, 44. An intriguing Nestor short, *Behind the Scenes at Universal Studios* (1915), shows a woman surrounded by men at work in the scenario department.

48. "First Child Born in Universal City," *Universal Weekly*, Dec. 26, 1914, 17; "Around the West Coast Studios," *Universal Weekly*, May 30, 1914, 29; "Population of Universal City Makes Three Jumps," *Moving Picture Weekly*, Oct. 28, 1916, 19.

49. A year later, the company reported the child's name as "Carl Laemmle Oelze." H. H. Van Loan, "The Motion Picture City," *Picture Play Magazine*, Dec. 1, 1915, 53–60. State of California birth records list him as Karl B. Oelze.

50. "Sifted from the Studios," *Motography*, Oct. 14, 1916, 892; "Population of Universal City Makes Three Jumps." See also "Universal City's Third Baby," *Moving Picture Weekly*, Apr. 29, 1916, 22.

51. "Eileen Sedgwick Becomes a Bride," *Moving Picture Weekly*, Sept. 8, 1917, 21; "With the Players at Universal City," *Moving Picture Weekly*, Oct. 14, 1916, 22; Cal York, "Plays and Players," *Photoplay* (Apr. 1917): 122–26.

52. Kitty Kelly, "Flickerings from Filmland," *Chicago Daily Tribune*, May 5, 1915, 12.

53. Gertrude M. Price, "The Screen Girl, Latest Edition of the Matinee Girl, Travels Miles to Worship at Shrine of Her Moving Picture Idol," n.d., in Laura Oakley Accession, Clippings Folder, Seaver Center for Western History Research. Oakley's project of regulation would become more general. See Heidi Kenaga, "Making the 'Studio Girl': The Hollywood Studio Club and Industry Regulation of Female Labor," *Film History* 18.2 (2006): 129–39.

54. There were speeches by executives, mandatory "fancy caps," and the trade papers reported the guest list. See Mabel Condon, "Happenings on the Pacific Coast," *New York Dramatic Mirror*, June 30, 1917, 33; "Laemmle Entertains Universal City," *Moving Picture Weekly*, June 23, 1917, 19; Mlle. Chic, "Universal Girls Hold Adamless Party," *Universal Weekly*, Feb. 27, 1915, 17; "Mr. Laemmle Visits Universal City," *Universal Weekly*, Nov. 21, 1914, 12; "Universal's Employees Celebrate," *Moving Picture World*, Jan. 9, 1915, 202.

55. "Ida Schnall Organizes Fair Sex Baseball Team at Universal City," *Moving Picture Weekly*, Dec. 4, 1915, 13.

56. Van Loan, "Motion Picture City"; "Three Big U Moving Picture Stages," *Moving Picture Weekly*, Sept. 11, 1915, 17; "Women Are for Kerrigan," *Motography*, Feb. 5, 1916, 302; "Dark Horse May Become Film City Mayor," *Moving Picture Weekly*, Apr. 1, 1916, 26; "What They Are Doing, in Spare Moments, at Universal City," *Moving Picture Weekly*, Nov. 25, 1916, 24–25; "'Grips' Sympathize with Rawlinson," *Moving Picture Weekly*, Oct. 14, 1916, 23.

57. Stites's "spinal column was driven into his skull" when he fell to his death in front of thousands of spectators. See "Dash to Earth Ends Life and Its Hope," *Los Angeles Times*, Mar. 17, 1915, II1.

58. "Three Big U Moving Picture Stages."

59. "Official Opening and Dedication of Universal City, Cal." (program), Ephemera Folder, William Horsley Papers, 1915–1940, UCLA Special Collections. For a wonderful account of Universal's opening day, see Richard Koszarski, *An Evening's Entertainment: The Age of the Silent Feature Picture, 1915–1928* (Berkeley: University of California Press, 1990).

60. "Isadore Bernstein to Manage Western Universal," *Moving Picture World*, July 5, 1913, 29; H. H. Hoffman, "The Newsboy Who Built a City," *Photo Play Topics*, Sept. 20, 1915, 8–9, 16–18.

61. "'Napoleon' McRae," *Universal Weekly*, Aug. 8, 1914, 27.

62. Condon, "City Universal."

63. "Universal's Chameleon City."

64. Carl Laemmle to Joseph Laemmle, Dec. 18, 1920, Carla Laemmle Collection,

box 2, Seaver Center for Western History Research, Los Angeles, Natural History Museum, Los Angeles.

65. Clipping from *Famous Monsters of Filmland,* Nov/Dec 1997, Carla Laemmle Collection, box 6, Seaver Center for Western History Research, Natural History Museum, Los Angeles.

66. Van Loan, "Motion Picture City." Senator Young confirms that "when quitting time comes automobiles are flying in all directions taking actors and actresses to their bungalows a few miles away, or into Los Angeles city." See "'Lafe' Young Describes Screen City Trip," *Moving Picture Weekly,* Nov. 13, 1915, 6–7, 17.

67. Denise McKenna, "For Those Who Follow: Working Women and the Labor Organization of Early Hollywood," Paper delivered at Les Femmes et le Cinéma Muet/Women and the Silent Screen conference, Montréal, June 2004. See also Denise McKenna, "The City That Made the Pictures Move: Gender, Labor, and the Film Industry in Los Angeles, 1908–1917," Ph.D. dissertation, New York University, 2008, chap. 1.

68. "A Little Gossip about Everybody and Everything," *Moving Picture Weekly,* June 16, 1917, 18–19.

69. This was distinguishing feature of the discourse on the first movie stars. See Richard deCordova, *Picture Personalities: The Emergence of the Star System in America* (Urbana: University of Illinois Press, 1990).

70. Kelly, "Flickerings from Filmland."

71. "Another Woman Directing," *Moving Picture Weekly,* Nov. 18, 1916, 23. For more on Baldwin's preference for practical garb, see "Ruth Ann in New Sartorial Regalia," *Moving Picture Weekly,* Sept. 30, 1916, 42.

72. "Cleo Madison in 'The Guilty One,'" *Moving Picture Weekly,* Aug. 5, 1916, 28.

73. Richard Abel, *Americanizing the Movies and "Movie-Mad" Audiences, 1910–1914* (Berkeley: University of California Press, 2006), 105–21.

74. Michel Foucault, "Of Other Spaces (1967), Heterotopias," trans. Jay Miskowiec, http://www.foucault.info/documents/heteroTopia/foucault.heteroTopia.en.html (accessed June 11, 2009). For a recent appreciation of the variety of ways Hollywood has been able to mobilize a desire for a sense of home it defines as both ideal and impossible, see Elisabeth Bronfen, *Home in Hollywood: The Imaginary Geography of Cinema* (New York: Columbia University Press, 2004).

75. For example, a recruiting station opened on the lot, and the actress Mignon Anderson replanted her tennis court as a vegetable garden in the spirit of preparedness. See "Latest War News from Universal City," *Moving Picture Weekly,* May 5, 1917, 18–19.

76. "Universal Cuts Down Program," *New York Dramatic Mirror,* Oct. 27, 1917, 22; Carl Laemmle, "Exposing Some Big Secrets!!!," *Moving Picture Weekly,* 29 Dec. 1917, 8–13.

77. "Universal Big Enough for A[ll]," *Moving Picture Weekly,* Feb. 16, 1918, 10; "Universal City Shuts Up," *Variety,* Jan. 25, 1918, 49.

78. Shelley Stamp, "Presenting the Smalleys, 'Collaborators in Authorship and Direction,'" *Film History* 18.2 (2006): 119–28.

79. Elizabeth Peltret, "On the Lot with Lois Weber," *Photoplay* (Oct. 1917): 89–91.

80. Fritzi Remont, "The Lady Behind the Lens," *Motion Picture Magazine* (May 1918) 59–61, 126.

81. G. P. Harleman, "News of Los Angeles and Vicinity," *Moving Picture World,* June 30, 1917, 2106.

82. On the purchase of the ranch, see "Moviegrams," *Moving Picture Weekly,* May 12, 1917, 18–19; "Harry Carey Trading Post Brochure " (ca. 1920), *Santa Clarita Valley History in Pictures,* http://www.scvhistory.com/scvhistory/carey.htm (accessed June 11, 2009).

83. Sally Steele, "Vignettes of the Studios—Universal City Studio," *Motion Picture Magazine* (Feb. 1924): 35.

84. "The Spectator," *Outlook,* Aug. 4, 1915, 822–23.

Part II. Impossibility

1. Carl Laemmle, "Back from Hell," *Moving Picture Weekly,* Feb. 15, 1919.

2. "Universal had all but written off the first-run market by 1920," according to Thomas Schatz, *The Genius of the System: Hollywood Filmmaking in the Studio Era* (New York: Pantheon Books, 1988), 21. See also Richard Koszarski, *An Evening's Entertainment: The Age of the Silent Feature Picture, 1915–1928* (Berkeley: University of California Press, 1990), 63–94.

3. Universal later released three Weber titles (in 1923, 1926, and 1927).

4. Publicity for these films is treated at length in chapter 6.

5. Key treatments of the social-problem film by Kay Sloan and Kevin Brownlow pull in different directions and leave us with a genre that includes films ranging from Griffith's 1909 adaptation of Frank Norris's "A Deal in Wheat" as *A Corner in Wheat* (Biograph) to the cycle of white-slavery films prompted by *Traffic in Souls* (Universal, 1913) and Cecil B. DeMille's remarriage comedy *Why Change Your Wife?* (1919). Mahar places many of the films directed by women in the 1910s and 1920s in this genre, which she sees as the opposite of DeMille's late 1910s approach in its participation in contemporary discourses of uplift. My account is indebted to Mahar's thoughtful overview. The character of the change and the mechanisms whereby it occurred look different, however, when approached at the institutional scale. See Kevin Brownlow, *Behind the Mask of Innocence* (New York: Knopf/Random House, 1990); Kay Sloan, *The Loud Silents: Origins of the Social Problem Film* (Urbana: University of Illinois Press, 1988); Karen Mahar, *Women Filmmakers in Early Hollywood* (Baltimore: Johns Hopkins University Press, 2006).

6. Mahar, *Women Filmmakers,* 133.

7. See Lee Grieveson, *Policing Cinema: Movies and Censorship in Early-Twentieth-Century America* (Berkeley: University of California Press, 2004), 193–215.

8. Publicity for Park and Weber is treated in more detail below, but for examples

see "Mary MacLaren Returns," *Moving Picture Weekly,* May 11, 1918; Advertisement for Lois Weber, *Moving Picture Weekly,* Jan. 26, 1918, 40–41.

9. Mahar notes that Florence Turner was hired to direct short comedies in 1919, but I have not been able to confirm that they were actually produced or released. Mahar, *Women Filmmakers,* 193.

Chapter 4. Genre

1. Rick Altman, *Film/Genre* (London: British Film Institute, 1999), 16.

2. "Mediation" is my term; Altman writes of "indirect communication" (see ibid., chaps. 9 and 10). I believe we have similar processes in mind, but I prefer "mediation" because it more strongly connotes that shared signs constitute the group that shares them (which Altman terms the "constellated community").

3. Stephen Neale, *Genre and Hollywood* (London: Routledge, 2000). Neale borrows the term "inter-textual relay" from Gregory Lukow and Steven Ricci.

4. Altman, *Film/Genre,* 44.

5. See Neale, *Genre and Hollywood,* chap. 7.

6. On the development of advertising practice in the film industry and its division of labor, see Janet Staiger, "Announcing Wares, Winning Patrons, Voicing Ideals: Thinking about the History and Theory of Film Advertising," *Cinema Journal* 29.3 (Spring 1990): 3–31.

7. Paul DiMaggio, "Market Structure, the Creative Process, and Popular Culture: Toward an Organizational Reinterpretation of Mass-Culture Theory," *Journal of Popular Culture* 11.2 (Fall 1977): 436–52.

8. Denise D. Bielby and William T. Bielby, "Women and Men in Film: Gender Inequality among Writers in a Culture Industry," *Gender and Society* 10.3 (June 1996): 248–70.

9. See Richard Abel, *Americanizing the Movies and "Movie-Mad" Audiences, 1910–1914* (Berkeley: University of California Press, 2006).

10. "Jottings from Universal City," *Universal Weekly,* July 12, 1913, 7, 9.

11. Staiger, "Announcing Wares"; see also Eileen Bowser, *The Transformation of Cinema, 1907–1915* (Berkeley: University of California Press, 1990), 103–19.

12. Altman in particular is a bit fuzzy about the timing of the shift, due in part to the organization of his volume and in part to the need for more research along these lines. See Altman, *Film/Genre,* 115–17, 87.

13. Bluebird Photo Plays, Inc., Semi-Annual Report, July 22, 1917, Richard Koszarski Collection; Bluebird Photo Plays, Inc., 1st Year [Financial Report], Jan. 21, 1917, Richard Koszarski Collection.

14. Advertisement for *Hop, the Devil's Brew, Moving Picture Weekly,* Feb. 5, 1916, f–g.

15. Advertisement for Violet Mersereau, Bluebird Star, *Moving Picture Weekly,* July 14, 1917, inside cover.

16. Advertisement for *The Dream Lady, Moving Picture Weekly,* July 20, 1918, 20.

17. Alongside this information is another box with "Advertising Display Lines," the

most intriguing of which is surely the incongruous: "She roped and threw happiness at the Rodeo of Love" (the film lacks any sort of rope play). See "Press Sheet for Carmel Myers in 'The Dream Lady,'" *Moving Picture Weekly,* July 20, 1918, 14–15.

18. "Press Sheet for Ruth Clifford's 'The Game's Up,'" *Moving Picture Weekly,* Jan. 18, 1919, 16–17; "Press Sheet for Dorothy Phillips in 'A Soul for Sale,'" *Moving Picture Weekly,* May 18, 1918, 30–31.

19. Universal's rival Paramount, however, was listed as an exception to the rule. Robert H. Cochrane, "Advertising Motion Pictures," in *The Story of the Films, as Told by Leaders of the Industry to the Students of the Graduate School of Business Administration, George F. Baker Foundation, Harvard University,* ed. Joseph Kennedy (Chicago: A. W. Shaw Co., 1927), 234.

20. Richard deCordova, *Picture Personalities: The Emergence of the Star System in America* (Urbana: University of Illinois Press, 1990). On genre and stars as overlapping, rather than coincident, ways of classifying films, see Neale, *Genre and Hollywood,* 239–40.

21. Halsey, Stuart, and Co., "The Motion Picture Industry as a Basis for Bond Financing" (1927), in *The American Film Industry,* ed. Tino Balio (Madison: University of Wisconsin Press, 1985), 195–217.

22. "Come to Bluebird," *Moving Picture Weekly,* Jan. 5, 1918, 4–5.

Chapter 5. Serials

1. Eileen Bowser, *The Transformation of Cinema, 1907–1915* (Berkeley: University of California Press, 1990), 209; "Lucille Love," *Moving Picture World,* Apr. 4, 1914, 4–5.

2. I. G. Edmonds, *Big U: Universal in the Silent Days* (South Brunswick, N.J.: A. S. Barnes and Co., 1977), 42–48; Robert S. Birchard, "The Adventures of Francis Ford and Grace Cunard," *American Cinematographer* 74. 7 (July 1993): 72–82.

3. A capsule review of the second Lady Raffles film gives a sense of the formula: "This is a two-reel offering, written by Grace Cunard. The author and Francis Ford play the principal parts. The plot is of the thrilling, melodramatic sort. It is full of mystery and action, but the story is not very clear in parts. The yarn is so ridiculous in places that it almost becomes burlesque. There is a Lady Raffles, a deep-dyed villain, a fearless hero, and plenty of wild animals. The conglomeration is not to be taken seriously and is by no means without interest." Review of *The Mysterious Leopard Lady, Moving Picture World,* Mar. 28, 1914, 1682.

4. "Our Japanese Correspondent," *Moving Picture Weekly,* Nov. 11, 1916, 34.

5. "Ford-Cunard Popularity Wave Hits India," *Motion Picture Weekly,* May 27, 1916, 31.

6. In a later reminiscence, she credits the raise to "killing" Eddie Polo's character. Grace Cunard, "Crowded out of Stardom," *New Movie Magazine* (Feb. 1932): 38–39, 117.

7. Hugh C. Weir, "She Has Written Four Hundred Scenarios: A Chat with Grace Cunard by Hugh C. Weir," *Moving Picture Weekly,* Sept. 4, 1915, 26–27.

8. Mlle. Chic, "Talking to Francis Ford," *Moving Picture Weekly,* May 13, 1916, 9.

9. William M. Henry, "Her Grace and Francis," *Photoplay* (April 1916): 27–30.

10. "Ruth Ann Baldwin Sails for Europe," *Moving Picture World,* Jan. 9, 1915, 197; "Sifted from the Studios," *Motography,* Aug. 26, 1916, 510–14.

11. See Kay Armatage, *The Girl from God's Country: Nell Shipman and the Silent Cinema* (Toronto: University of Toronto Press, 2003), 57.

12. Karen Mahar, *Women Filmmakers in Early Hollywood* (Baltimore: Johns Hopkins University Press, 2006), 101–32. Roland moved from Kalem to Balboa in 1915 before starting her own company in 1919. On Roland as a director, see "Ruth Roland," *Taylorology* 36 (December 1995); http://www.silent-movies.com/Taylorology/Taylor36 .txt (accessed June 12, 2009).

13. P. A. Parsons, "A History of Motion Pictures Advertising," *Moving Picture World,* Mar. 26, 1927, 301, 304–5, 308–9; Ben Singer, *Melodrama and Modernity: Early Pulp Cinema and Its Contexts* (New York: Columbia University Press, 2001), 276–79.

14. "Lucille Love."

15. "Universal Releases," *Moving Picture World,* Apr. 25, 1914, 456–57. Universal revealed that the Master Pen was Grace Cunard the following month, when it claimed that the serial was based on her life story. "Lucille Love Founded on Fact," *Universal Weekly,* May 16, 1914, 4–5.

16. "'The Trey o' Hearts,'" *Universal Weekly,* July 4, 1914, 19.

17. "'The Master Key,'" *Moving Picture World,* Nov. 14, 1914, 870–71.

18. "Author of 'The Broken Coin,'" *Moving Picture World,* June 12, 1915, 1753.

19. Van Name was married to Francis Ford.

20. For a detailed description of this structure, see Singer, *Melodrama and Modernity,* 208–10.

21. "In 1916, *Photoplay* estimated that while the average feature cost between $5,000 and $25,000 to produce, the cost of making a serial ran between $100,000 and $500,000. While that figure may have been closer to $45,000–$80,000, the price was still quite steep." Mahar, *Women Filmmakers,* 118. Mahar goes on to point out that the amount of money risked militated in favor of a more rigid division of labor and "eroded creative control from the former director-producer."

22. "Wonderful Company Selected for Next Universal Serial 'Graft' in Thirty-Four Reels," *Moving Picture Weekly,* Nov. 13, 1915, 18–19.

23. "Jacques Jaccard Is a Red Blooded Director Who Is 'Taking' Twenty Weeks of 'Liberty,'" *Moving Picture Weekly,* July 29, 1916, 24–25.

24. "McRae Now Directing 'Liberty,'" *Moving Picture Weekly,* Nov. 18, 1916, 24–25.

25. "Strenuous Job for an Actress," *Los Angeles Times,* Aug. 12, 1914, III4; "Cleo Madison Has Narrow Escape," *Moving Picture World,* Aug. 8, 1914, 846; "Actress Risks Life," *Motography,* Aug. 1, 1914, 172; "Cleo Madison in Daring Swim," *Universal Weekly,* Aug. 1, 1914, 25.

26. Robert S. Birchard, "The (Continued) Adventures of Francis Ford and Grace Cunard," *American Cinematographer* 74.8 (August 1993): 64–86; Birchard, "Adventures of Francis Ford and Grace Cunard"; "Grace Cunard in Hospital for Third Time, Plucky Actress Sustains Third Severe Accident," *Moving Picture Weekly,* Jan. 22, 1916, 15.

27. Singer, *Melodrama and Modernity*, 226.

28. Shelley Stamp, *Movie-Struck Girls: Women and Motion Picture Culture after the Nickelodeon* (Princeton, N.J.: Princeton University Press, 2000), 128.

29. "Synopsis of 'Lucille Love,'" *Universal Weekly*, Apr. 18, 1914, 16.

30. The term "weenie" comes to us from Pearl White via Ben Singer.

31. "'Lucille Love,'" *Moving Picture World*, Jul. 25, 1914, 573.

32. Edmonds, *Big U*; "'The Trey o' Hearts,' by Louis Joseph Vance," *Universal Weekly*, Aug. 1, 1914, 7.

33. "The New Universal Serial Starts," *Motography*, Feb. 20, 1915, 275–76; "Synopsis of 'The Black Box' Episode No. 4," *Moving Picture World*, Mar. 27, 1915, 2006.

34. "Synopsis of 'The Black Box' Episode No. 4."; Small Press Book for *The Black Box*, 1915, BFI Special Collections, London.

35. "First Installment of 'The Broken Coin,'" *Universal Weekly*, June 19, 1915, 13.

36. "'Broken Coin' Serial Must Be Extended," *Moving Picture Weekly*, Aug. 28, 1915, 19.

37. "Episode Twenty-Two of 'The Broken Coin,'" *Moving Picture Weekly*, Nov. 13, 1915, 20.

38. Ford and Cunard became embroiled in a dispute with the actor Eddie Polo and the Universal City manager H. O. Davis during the production, which resulted in a good deal of confusing publicity. The best accounts are provided by Birchard, "Adventures of Francis Ford and Grace Cunard"; "Ruth Stonehouse and Eddie Polo in 'Peg o' the Ring,'" *Moving Picture Weekly*, Apr. 15, 1916, 9

39. "'Peg o' the Ring,' Episodes One and Two," *Moving Picture Weekly*, Apr. 29, 1916, 22.

40. "Final 'Peg o' the Ring' Chapter, 'Retribution,'" *Moving Picture Weekly*, Aug. 5, 1916, 19, 47.

41. "'Fangs of the Wolf,' 1st Espisdoe of 'Liberty,'" *Moving Picture Weekly*, Aug. 5, 1916, 20–21, 47.

42. "Mexican Mysteries," *New York Times*, Sept. 26, 1916, 10.

43. "'Liberty, a Daughter of the U.S.A.,'" *Moving Picture Weekly*, Dec. 23, 1916, 30, 42.

44. "Episode One of 'The Red Ace' with Marie Walcamp," *Moving Picture Weekly*, Oct. 6, 1917, 11, 14.

45. "Synopses: Marie Walcamp in 'The Red Ace,'" *Moving Picture Weekly*, Jan. 19, 1918, 39.

46. Elizabeth Peterson, "The Serial Girl—Marie Walcamp," *Motion Picture Magazine* (Sept. 1919): 82–83.

47. "Actress Risks Life." See also "Cleo Madison in Daring Swim."

48. Jennifer M. Bean, "Technologies of Early Stardom and the Extraordinary Body," *Camera Obscura* 16.3 (2001): 9–57.

49. Singer, *Melodrama and Modernity*, 262.

Chapter 6. Gender and the Dramatic Feature

1. Karen Mahar, *Women Filmmakers in Early Hollywood* (Baltimore: Johns Hopkins University Press, 2006); Anthony Slide, *Lois Weber: The Director Who Lost Her Way in History* (Westport, Conn.: Greenwood Press, 1996); Shelley Stamp, "Lois Weber, Progressive Cinema, and the Fate of 'The Work-a-Day Girls' in *Shoes*," *Camera Obscura* 19.2 (2004): 140–69.

2. "Ida May Park, Director," *Moving Picture World,* July 14, 1917, 222.

3. There are also continuities in Weber's oeuvre across these periods. My aim here is not to refute that interpretation but to explain that it was not exactly Universal's interpretation, and that it does not account for why women directors in general too briefly flourished there.

4. Slide, *Lois Weber,* 72.

5. Ibid., 70–74; Mahar, *Women Filmmakers,* 92–97.

6. The use of these descriptors has been discussed by Constance Balides, "Making Ends Meet: 'Welfare Films' and the Politics of Consumption during the Progressive Era," in *A Feminist Reader in Early Cinema,* ed. Jennifer M. Bean and Diane Negra (Durham, N.C.: Duke University Press, 2002), 174; Stamp, "Lois Weber"; Kay Sloan, "The Hand That Rocks the Cradle: An Introduction," *Film History* 1.4 (1987): 341–66.

7. "'Scandal,' a Film of Tremendous Power," *Moving Picture Weekly,* June 12, 1915, 14. I am grateful to Shelley Stamp for information about the Bosworth films. In addition to the titles named in the text, Weber directed *Sunshine Molly, Captain Courtesy,* and *False Colors.*

8. David Shields, *The Magic Mirror: Photography and American Silent Cinema* (Cambridge, Mass.: Harvard University Press, forthcoming).

9. "Ida Schnall Organizes Fair Sex Baseball Team at Universal City," *Moving Picture Weekly,* Dec. 4, 1915, 13; "'Undine' with Ida Schnall," *Moving Picture Weekly,* Feb. 5, 1916, 16–18, 27. In the film, Schnall was supported by twenty-five water nymphs.

10. "Scandal," *Moving Picture Weekly,* June 19, 1915, 7.

11. "Announcing a Great Picture: 'Scandal'—a Drama You'll Never Forget," *Moving Picture Weekly,* June 12, 1915, B-C. See also advertisement for *Scandal, Moving Picture Weekly,* June 26, 1915, B-C.

12. "'Scandal,' a Film of Tremendous Power"; "Lois Weber's Graphic Screen Conception for 'Scandal,'" *Moving Picture Weekly,* May 8, 1915, 14.

13. "'Jewel' the Gem in Universal Diadem by the Critic," *Moving Picture Weekly,* Aug. 7, 1915, 16–17.

14. "Universal Buys Book Rights," *Motography,* Feb. 5, 1916, 310.

15. Advertisement for *Hop, the Devil's Brew, Moving Picture Weekly,* Jan. 29, 1916, 2.

16. Advertisement for *The Flirt, Moving Picture Weekly,* Mar. 18, 1916, 4.

17. "John Needham's Double," *Moving Picture Weekly,* Apr. 8, 1916, 12–13, 30;

advertisement for *John Needham's Double, Moving Picture Weekly,* Apr. 1, 1916, 4; "'The Eye of God,'" *Moving Picture Weekly,* June 3, 1916, 16–17; Kitty Kelly, "Flickerings from Filmland," *Chicago Daily Tribune,* May 30, 1916, 12.

18. Advertisement for *Shoes, Moving Picture Weekly,* June 17, 1916, 1.

19. Bluebird Photo Plays, Inc., 1st Year [Financial Report], Jan. 21, 1917, Richard Koszarski Collection.

20. Kitty Kelly, "Flickerings from Filmland, Film Preachments at the Studebaker," *Chicago Daily Tribune,* Jan. 11, 1916, 14.

21. "Smalleys Film Rufus Steele Story 'Hop,'" *Moving Picture Weekly,* Nov. 20, 1915, 19.

22. "Shoes," *Moving Picture Weekly,* June 24, 1916, 12–13, 34.

23. "'Saving the Family Name'—Bluebird," *Moving Picture Weekly,* Sept. 2, 1916, 16–17, 31.

24. "Idle Wives," *Moving Picture Weekly,* Nov. 18, 1916, 20–21.

25. "'Wanted: A Home,' Bluebird Photoplay," *Moving Picture Weekly,* Sept. 30, 1916, 16–17.

26. Advertisements for *The People vs. John Doe, Moving Picture Weekly,* Dec. 9, 1916, 50–51; Dec. 23, 1916, 8.

27. Marjorie Howard, "'Even as You and I,'" *Moving Picture Weekly,* Apr. 14, 1917, 18–19.

28. Mlle. Chic, "The Greatest Woman Director in the World," *Moving Picture Weekly,* May 20, 1916, 25; H. H. Van Loan, "Lois, the Wizard," *Motion Picture Magazine* (July 1916): 41–44.

29. Arthur Denison, "A Dream in Realization," *Moving Picture World,* July 21, 1917, 417–18; Elizabeth Peltret, "On the Lot with Lois Weber," *Photoplay* (Oct. 1917): 89–91; Fritzi Remont, "The Lady behind the Lens," *Motion Picture Magazine* (May 1918): 59–61.

30. Universal Film Manufacturing Co. Semi-Annual Report, Nov. 15, 1916, Richard Koszarski Collection.

31. Bluebird Photo Plays, Inc., 1st Year; Universal Film Manufacturing Co. Semi-Annual Report.

32. For all titles, the average rental price declined dramatically after around a thousand bookings, indicating that Universal had developed something like a system of runs and zones as early as 1916.

33. Advertisement for *John Needham's Double, Moving Picture Weekly,* May 26, 1917, 6; Advertisement for Bluebirds, *Moving Picture Weekly,* June 16, 1917, 4.

34. "The Mysterious Mrs. M.,'" *Moving Picture Weekly,* Feb. 3, 1917, 20–21.

35. Bluebird Photo Plays, Inc., Semi-Annual Report, July 22, 1917, Richard Koszarski Collection.

36. Ida May Park is credited with four, but over a different period, beginning in 1917. In 1916, she is credited as De Grasse's screenwriter and likely codirected.

37. Bluebird Photo Plays, Inc., 1st Year. Worthington's films, released in October, had not been out long enough to develop a comparable track record, but this conclusion is supported by the 1917 semiannual report.

38. "Mary Fuller in 'The Strength of the Weak,'" *Moving Picture Weekly,* Mar. 11, 1916, 12–13. See also "Strength of the Weak," *American Film Institute Catalog of Feature Films,* http://www.afi.com/members/catalog/AbbrView.aspx?s=&Movie=16842 (accessed July 31, 2009).

39. "'Secret Love,' a Remarkable Photoplay," *Moving Picture Weekly,* Jan. 29, 1916, 18–19. See also "Secret Love," *American Film Institute Catalog of Feature Films,* http://www.afi.com/members/catalog/AbbrView.aspx?s=&Movie=16816 (accessed July 31, 2009).

40. "'Saving the Family Name'—Bluebird."

41. "Louise Lovely in 'Bobbie of the Ballet,'" *Moving Picture Weekly,* June 10, 1916, 16–17.

42. "'The Birth of Patriotism,'" *Moving Picture Weekly,* Apr. 28, 1917, 12–13. I have been unable to determine the title of the short. *The Birth of Patriotism* is her only credited title as a director, according to Richard E. Braff, *The Universal Silents: A Filmography of the Universal Motion Picture Manufacturing Company, 1912–1929* (Jefferson, N.C.: McFarland, 1999).

43. For examples of marketing of preparedness films, see "Miss Irene Hunt, Preparedness Apostle," *Moving Picture Weekly,* Apr. 21, 1917, 12; "'If My Country Should Call,' Red Feather Masterpiece," *Moving Picture Weekly,* Sept. 16, 1916, 10–11, 35.

44. "Another Woman Directing," *Moving Picture Weekly,* Nov. 18, 1916, 23.

45. She wields the baton in a later article describing her collaboration with Reynolds: "Doings at Universal City," *Moving Picture Weekly,* Jan. 13, 1917, 22–23.

46. "Universal Woman Director Films Scene in City," *Moving Picture Weekly,* Jan. 6, 1917, 36.

47. For instance, a brief *Moving Picture World* notice for Baldwin's penultimate film, *The Storm Woman,* reads: "A three-reel subject of a tragical life, featuring Clair McDowell. This is unusual in theme, and presented artistically. The Italian scenes are picturesque and attractive, and the manner of unfolding the story is novel and pleasing. The tragedy is mitigated by an unexpected humorous ending." Review of *The Storm Woman, Moving Picture World,* Oct. 6, 1917, 74.

48. "Cleo Madison in 'The Woman Who Would Not Pay,'" *Moving Picture Weekly,* 21 July 1917, 11.

49. "Cleo Madison, Who Is Now Directing Her Own Photoplays," *Moving Picture Weekly,* Sept. 25, 1915, 18.

50. "Cleo Madison in 'The·Ring of Destiny,'" *Moving Picture Weekly,* Nov. 13, 1915, 23.

51. William M. Henry, "Cleo, the Craftswoman," *Photoplay* (Jan. 1916): 109–11.

52. Richard deCordova, *Picture Personalities: The Emergence of the Star System in America* (Urbana: University of Illinois Press, 1990).

53. Adrienne L. McLean, "'New Films in Story Form': Movie Story Magazines and Spectatorship," *Cinema Journal* 42.3 (Spring 2003): 3–26.

54. Shelley Stamp, "Presenting the Smalleys, 'Collaborators in Authorship and Direction,'" *Film History* 18.2 (2006): 119–28.

55. "Cleo Madison Supports Mother and Invalid Sister," *Universal Weekly,* Sept. 19, 1914, 9.

56. Madison had directed her final feature by the time the piece in *Moving Picture Stories* appeared. *The Guilty One* (a.k.a. *Along the Malibu*), discussed in chapter 3, exemplifies the shorts that followed. Mahar identifies a divergence between the "New Woman" figures of shorts and serials and the "true woman" figure of the Weber films. I also see a difference, but in these years at Universal it was less clearly attached to a difference in film format than Mahar's industry-level survey indicates. Mahar, *Women Filmmakers,* 101–53.

57. Advertisement for *A Soul Enslaved, Moving Picture Weekly,* Dec. 11, 1915, 2.

58. Copyright Description for *A Soul Enslaved,* 1916, CIL7411, Library of Congress. Intriguingly, the synopsis confuses the characters of Paul and Richard, making it difficult to be certain who wrongs the college girl (they spend the night with her together), who marries Jane, and who returns to her in the end. See also Lobby Card for *A Soul Enslaved,* Core Collection—Production File, Margaret Herrick Library.

59. Advertisement for *Her Bitter Cup, Moving Picture Weekly,* Apr. 1, 1916, 2.

60. Ibid.

61. Linda Williams, *Playing the Race Card: Melodramas of Black and White from Uncle Tom to O. J. Simpson* (Princeton, N.J.: Princeton University Press, 2001); Christine Gledhill, ed., *Home Is Where the Heart Is: Studies in Melodrama and the Woman's Film* (London: British Film Institute, 1987); Jane M. Gaines, *Fire and Desire: Mixed-Race Movies in the Silent Era* (Chicago: University of Chicago Press, 2001); Christine Gledhill and Linda Williams, *Reinventing Film Studies* (London: Oxford University Press, 2000); Peter Brooks, *The Melodramatic Imagination: Balzac, Henry James, Melodrama, and the Mode of Excess* (New Haven, Conn.: Yale University Press, 1976).

62. Balides, "Making Ends Meet," 171.

63. Stamp, "Lois Weber," 145.

64. See Nancy Cott, *The Grounding of Modern Feminism* (New Haven, Conn.: Yale University Press, 1987), 232; Alison M. Parker, "Mothering the Movies: Women Reformers and Popular Culture," in *Movie Censorship and American Culture,* ed. Francis G. Couvares (Washington, D.C.: Smithsonian Institution, 1996); Denise Riley, *"Am I That Name?": Feminism and the Category of "Women" in History* (Basingstoke, Hampshire: Macmillan Press, 1988), 44–66; Daniel J. Walkowitz, *Working with Class: Social Workers and the Politics of Middle-Class Identity* (Chapel Hill: University of North Carolina Press, 1999).

65. Stamp, "Lois Weber," 155

66. Ibid., 162

67. Ibid.

68. Balides, "Making Ends Meet," 169.

69. "'Manna,' a Modern Sociological Drama," *Moving Picture Weekly,* Nov. 13, 1914, 30.

70. "Notice to All Studios of the Universal Film Mfg. Co.," *Moving Picture Weekly,* Mar. 9, 1918, 11.

71. "Ida May Park, Director."

72. "Dorothy Phillips in 'The Rescue,'" *Moving Picture Weekly,* July 21, 1917, 24–25, 36.

73. Although it would take more research to bear this out, I think one can see here the beginning of the gendered genre-map (and associated arguments about taste) Lea Jacobs discovers in the 1920s. See particularly her chapter on the "romantic drama" in Lea Jacobs, *The Decline of Sentiment: American Film in the 1920s* (Berkeley: University of California Press, 2008), 217–73.

74. Kathryn H. Fuller, *At the Picture Show: Small-Town Audiences and the Creation of Movie Fan Culture* (Washington, D.C.: Smithsonian Institution Press, 1996).

75. The press sheet for *Doctor and the Woman,* for example, suggests comparison with *Where Are My Children?, The Dumb Girl of Portici, Shoes, The Eye of God,* and *The Price of a Good Time.* "Press Sheet for 'The Doctor and the Woman,'" *Moving Picture Weekly,* Mar. 9, 1918, 18–19.

76. See, for example, advertisement for *Forbidden, Moving Picture Weekly,* Sept. 27, 1919, 14–15.

77. See, for example, "Mildred Harris (Mrs. Charlie Chaplin) in the Lois Weber's [*sic*] Jewel, 'Borrowed Clothes,'" *Moving Picture Weekly,* Nov. 30, 1918, 16–17; Advertisement for *Forbidden.*

78. "Mary MacLaren Returns," *Moving Picture Weekly,* May 11, 1918.

79. "Bluebird Marketing Ideas," *Moving Picture Weekly,* Oct. 6, 1917, 36.

80. Advertisement for *The Doctor and the Woman, Moving Picture Weekly,* Mar. 2, 1918, back cover.

81. Advertisements for *Risky Road, Moving Picture Weekly,* Apr. 13, 1918, 6; Apr. 20, 1918, 9.

82. Advertisement for *For Husbands Only, Moving Picture Weekly,* June 22, 1918, 41.

83. "Putting It Over, a Department of Help for Exhibiters," *Moving Picture Weekly,* May 4, 1918, 29.

84. Advertisement for *Scandal Mongers, Moving Picture Weekly,* July 20, 1918, 21; "Press Sheet for Lois Weber's 'Scandal Mongers,'" *Moving Picture Weekly,* July 13, 1918, 30–31.

85. Advertisement for *Bread, Moving Picture Weekly,* Sept. 28, 1918, back cover.

86. "Mary MacLaren's Best Special Attraction 'Vanity Pool,'" *Moving Picture Weekly,* Dec. 7, 1918, 28–29; Advertisement for *Borrowed Clothes, Moving Picture Weekly,* Dec. 7, 1918, 41.

87. Advertisement for *Home* and *Forbidden, Moving Picture Weekly,* Nov. 29, 1919, 28.

88. Qtd. in Stamp, "Lois Weber," 164. Stamp contrasts the moralism of *The Price of a Good Time* with the sociological realism of *Shoes.* Whereas the former assumes that a happy ending will look like a middle-class marriage, the latter encourages identification with women who work for wages outside the home.

89. "Mary MacLaren's Best."

90. "Dorothy Phillips in 'The Risky Road'—Press Sheet," *Moving Picture Weekly,* Mar. 23, 1918, 42–43.

91. Cf. Stamp, "Lois Weber"; Thomas Slater, "Transcending Boundaries: Lois Weber and the Discourse over Women's Roles in the Teens and Twenties," *Quarterly Review of Film and Video* 18.3 (2001): 257–72; Jennifer Parchesky, "Lois Weber's the Blot: Rewriting Melodrama, Reproducing the Middle Class," *Cinema Journal* 39.1 (Fall 1999): 23–53.

92. "'The Model's Confession,'" *Moving Picture World,* June 8, 1918, 1483.

93. Robert C. McElravy, review of *The Amazing Wife, Moving Picture World,* Mar. 15, 1919, 1528.

94. Robert C. McElravy, review of *The Grand Passion, Moving Picture World,* Jan. 12, 1918, 241.

95. Advertisement for *Grand Passion, Moving Picture Weekly,* Feb. 13, 1918, 40.

96. "Press Sheet for the Mary MacLaren Special Production 'The Model's Confession,'" *Moving Picture Weekly,* May 4, 1918, 28.

97. Advertisement for Lois Weber Films, *Moving Picture Weekly,* Nov. 8, 1919, 20–21. See also advertisement for *When a Girl Loves, Moving Picture Weekly,* Mar. 22, 1919, 12–13.

98. "What the Moving Picture World Says about 'When a Girl Loves,'" *Moving Picture Weekly,* Apr. 26, 1919, 34–35.

99. "Press Sheet for Ella Hall in 'Beauty in Chains,'" *Moving Picture Weekly,* Mar. 2, 1918, 18.

100. *The Circus of Life* was credited to Julian's direction at its release but later attributed to Wilson. "Elsie Jane Wilson Directed 'The Cricket,'" *Moving Picture Weekly,* Nov. 3, 1917, 29.

101. Advertisement for *New Love for Old, Moving Picture Weekly,* Jan. 26, 1918, 17.

102. Advertisement for *Beauty in Chains, Moving Picture Weekly,* Feb. 16, 1918, 8.

103. "'The Dream Lady,' Light Summer Entertainment—Carmel Myers Stars," *Exhibitor's Trade Review,* Aug. 3, 1918; Advertisement for *The Dream Lady," Moving Picture Weekly,* Aug. 24, 1918, 19.

104. "Press Sheet for Carmel Myers in 'The Dream Lady,'" *Moving Picture Weekly,* July 20, 1918, 14–15.

105. Advertisement for *Lure of Luxury, Moving Picture Weekly,* Oct. 12, 1918, 6.

106. "Press Sheet for Ruth Clifford's 'The Game's Up,'" *Moving Picture Weekly,* Jan. 18, 1919, 16–17.

107. Ibid.

108. "Another Woman Directing."

109. Frances Denton, "Lights! Camera! Quiet! Ready! Shoot!," *Photoplay* (Feb. 1918): 50.

110. Irving G. Thalberg, "Women—and the Films," *Film Daily,* June 22, 1924, 29.

111. Universal's newsreel gave the revolution celebratory coverage in July: "Universal Releases Russian Revolution Film," *Moving Picture Weekly,* July 21, 1917, 24.

Postscript

1. "Universal Releases," *Moving Picture World,* May 6, 1916, 961; "Complete Record of Current Films," *Motography,* May 6, 1916, 1065–66.

2. "'Eleanor's Catch' (Synopsis)," *Moving Picture Weekly,* Apr. 29, 1916, 28.

3. The body of cautionary literature is voluminous. See Jane Gaines, "Of Cabbages and Authors," in *A Feminist Reader in Early Cinema,* ed. Jennifer M. Bean and Diane Negra (Durham, N.C.: Duke University Press, 2002) 88–118; William K. Wimsatt and M. C. Beardsley, "The Intentional Fallacy," *Sewanee Review* 54 (1946): 468–88; Michel Foucault, "What Is an Author?," in *Language, Counter-Memory, Practice,* ed. Donald F. Bouchard (Ithaca, N.Y.: Cornell University Press, 1977), 113–38.

4. As well as short fictions in general. I am indebted to Jennifer Horne for this point.

5. I will leave to others arguments over how, when, and why the conventions of the short film changed and are related to thematic materials of urban modernity. If this book contributes anything to the argument over the transition from shorts to the Hollywood feature film, it would be a thickening of Ben Singer's insight that shorts production coexisted with feature-film production for much longer than often supposed, and a reinforcement of Charlie Keil's insight that anyone wishing to revise the account of "classical Hollywood" (I believe it wants revising) will need compellingly to relate an alternative conception of film form to the industrial structures that produced it. Ben Singer, "Feature Films, Variety Programs, and the Crisis of the Small Exhibitor," in *American Cinema's Transitional Era: Audiences, Institutions, Practices,* ed. Charlie Keil and Shelley Stamp (Berkeley: University of California Press, 2004), 76–102; Charlie Keil, "'To Here from Modernity': Style, Historiography, and Transitional Cinema," in *American Cinema's Transitional Era: Audiences, Institutions, Practices,* ed. Charlie Keil and Shelley Stamp (Berkeley: University of California Press, 2004), 51–65.

6. The DVD has been released by Kino, thanks to the efforts of Jessica Rosner.

7. I mean to echo Kay Armatage here, who concludes her wonderful biography of Nell Shipman with the important reminder that Shipman and other early women filmmakers "were not ahead of their time, unique, extraordinary, or superwomen. They were, I am convinced, like the many of us who are still confronting, even in 2003, the hopes and failures of modernity and the possibilities of a satisfactory life for women." Kay Armatage, *The Girl from God's Country: Nell Shipman and the Silent Cinema* (Toronto: University of Toronto Press, 2003), 351.

8. "The Making of Moving Pictures at Universal City, California," *National Magazine* (June 1915): 409–17.

9. Carolyn Steedman, *Dust: The Archive and Cultural History* (New Brunswick, N.J.: Rutgers University Press, 2002).

10. For an early attempt to explain why the likes of Ida Mary Park, Lois Weber, and Elise Jane Wilson (misnamed in the story as Mary Jane Wilson) are no longer to be found, see Florence M. Osborne, "Why Are There No Women Directors?" *Motion Picture Magazine* (Nov. 1925): 5.

11. "Film Star Weds at Photoplay Scene," *Los Angeles Times,* Nov. 26, 1916, IV12;

"Cleo Madison a Bride," *Moving Picture World,* Dec. 23, 1916, 1789; "Untitled Announcement," *New York Dramatic Mirror,* Dec. 9, 1916, 30; "News of the Film World," *Variety,* Dec. 8, 1916, 27.

12. "Plan Studio on Historic Site," *Los Angeles Times,* Dec. 3, 1916, III A22; Mabel Condon, "Actress to Head Company," *New York Dramatic Mirror,* Nov. 11, 1916, 32; "Isadore Bernstein to Produce on Coast," *Moving Picture World,* Dec. 23, 1916, 1789.

13. *Peake v. Peake,* B53297 Los Angeles County Superior Court (1918).

14. A Salt Lake City newspaper provides yet another explanation when it reports that Madison, "on the verge of a nervous breakdown," gave up directing to return to her acting career. See "Movie Melange," *Salt Lake Tribune,* Aug. 6, 1916.

15. A. H. Giebler, "News of Los Angeles and Vicinity," *Moving Picture World,* May 3, 1919, 661.

16. "Sign up Directress," *Los Angeles Times,* Sept. 12, 1919, 16.

17. "Park, Ida May," *Motion Picture Studio Directory* (New York: Motion Picture News Inc., 1919); "Park, Ida May," *Motion Picture Studio Directory* (New York: Motion Picture News Inc., 1923); Anthony Slide, *Early Women Directors* (South Brunswick,. N.J.: A. S. Barnes Co., 1977), 60; Review of *The Butterfly Man, Variety,* May 21, 1920.

18. *Variety* published the news the following January. Anthony Slide, *Lois Weber: The Director Who Lost Her Way in History* (Westport, Conn.: Greenwood Press, 1996), 128.

19. "Woman Director Dragged through Street," *Moving Picture World,* Jan. 25, 1919, 474–75; "Elsie Jane Wilson Hurt," *Los Angeles Times,* Jan. 5, 1919, III14.

20. "Miss Wilson to Direct for Universal," *Los Angeles Times,* Mar. 17, 1923, I18.

21. Grace Cunard, "Crowded out of Stardom," *New Movie Magazine* (Feb. 1932): 38–39, 117.

22. Grace Lamb, "Pastel: A Descriptive Vagary of Ruth Stonehouse," *Motion Picture Magazine* (Feb. 1919): 54–55, 104.

23. "Ruth Returns," *Motion Picture Magazine* (Nov. 1920): 51. See also Truman B. Handy, "What Are They Doing Now? Concerning the Old Favorites of the Screen," *Motion Picture Magazine* (Oct. 1921): 32–33, 91–93.

24. It is not clear from whom Baker took charge. The 1919 *Motion Picture Studio Directory* (based on 1918 information) suggests that J. P. McGowan might have been director general and P. J. Lynch and/or Thomas S. Nash production manager.

25. I am not alone in urging this interpretive work. For academics, Jane Gaines has cautioned that histories of early women filmmakers need to attend to two questions simultaneously: not only the question of why the early women filmmakers flourished so briefly but also the question of why feminist film criticism forgot about them for so long and why we're interested now. See Jane Gaines, "Film History and the Two Presents of Feminist Film Theory," *Cinema Journal* 44.1 (Fall 2004): 113–19. Linda Seger has urged women in the film industry to attend to management style and strategy. See Linda Seger, *When Women Call the Shots: The Developing Power and Influence of Women in Television and Film* (New York: Henry Holt, 1996).

Index

Powers, Patrick A., 11, 29, *78*

preachments, 130–36. *See also* social problem film genre; sociological themes in films; Weber, Lois

press sheets, 106–7

The Price of a Good Time (Weber), 156, 158

problem plays, 129

production department, 38–39

production expense estimate, 39

production manager, 38

professional women, xxi–xxii

Progressive era cinema, xix, 46–47, 94, 150–54. *See also* sociological themes in films

The Purple Mask (Cunard, Ford), 110–11, 123–24, 126

Quadrelli, M., 65

Rabinowitz, Lauren, xxiii, xxiv

Rae, Zoe, 166

Ramsaye, Terry, 20

Rawlinson, Herbert, 95, 120

recurring themes, 140

The Red Ace (Cunard, Ford), 124–25

Red Feather films, 13, 14, 106

Return of the Twin's Double (Ford, Cunard), 48, 48, 62

Rex Motion Picture Company, 11, 22, 23, 24

Reynolds, Lynn, 23, 85, 139

The Right to Happiness (Holubar), 168–69

The Ring of Destiny (Madison), 144–45

risk management, 104

Risky Road (Park), 94–95, 157, *157*, 158–59, *159*

Roach, Joseph, 184

Roberts, Edith, 22

Sanders, Henry, 53

Saving the Family Name (Weber, Smalley), 133, 134, 138

Scandal (Weber, Smalley), 132, 135, 141

Scandal Mongers (Weber), 92, 108, 158

scenario department, 38

Schade, Betty, 22, 73

Schnall, Ida, 73, 131–32

Scott, Joan Wallach, xxi

Secret Love (Leonard), 139, 140, 141, 150

The Secret of the Swamp (Reynolds), 139

Sedgwick, Eileen "Babe," 73

Selig, 110

selling points, 106–7

Selznick, Philip, 27–28, 35

Sensation Seekers (Weber), 183

serials: advertising campaigns, 113–15; early, 110; feminine madcap persona v. masculine knowledge, 126; gendered labor divisions, 111, 116–17; gender role interpretation in genre, 124–26; gender roles and modernity, 126–27; identifying characteristics as a genre, 110; masculinity and mastery, 120–21; newspaper tie-ins, 113–14; plot and character formulas, 111, 112; power and organization portrayals, 117–24; production requirements, 115–16, 211n21

series-serials, 114–15

sexism, xx–xxi, xxv

sexual double standards and social messages, 150. *See also* conservatism; dating; happy endings

Sheen, Henry Holden, *78*

Shenck, Harry, 31

Shields, Ernest, 73, 121–22

Shipman, Bell, 113

Shoes (Weber, Smalley), 93, 129, 133–34, 150–52, *162*, 163–64

Siegmann, George, 167

Silverwood, F.B., *78*

Simon, Herbert Alexander, 27

Singer, Ben, 126–27

Sistrom, William, 57

Slide, Anthony, xvii, 130

Sloman, Edward, 119

Smalley, Phillips, 22, 23, 57, 73, 139, 183

Smith, Adam, 4

The Social Buccaneer (Conway), 139

social problem film genre, 93–94, 132–33. *See also* missionary pictures; preachments; Weber, Lois

society dramas, 155–56

sociological films, 129, 160–61

sociological terminology considerations, 25–28, 27–28

sociological themes in films, 150–54. *See also* missionary pictures; preachments; Weber, Lois

A Soul Enslaved (Madison), 147

space. *See* physical space; Universal City

Special Attractions, 92–93, 94–95, 142, 155

Staiger, Janet, xxiv, xxviii, 40, 103

Stamp, Shelley, 88, 118, 126–27, 146, 150, 151–53

standard costing, 41

Stanton, Richard, 115

Star Comedies, 22, 24

Star Featurettes, 22, 24, 143

stars and film genres, 94–95

star system, 40, 106–9, 107

States Rights Features, 134

Steele, Sally, 88

Sterling, Ford, 22

Sterling Comedies, 22

Stern, Abe, 35

Stern, Julius, 35, 200n29

Stonehouse, Ruth: acting career, 113, 166, 185; automobile as status symbol, 80; brands directed, 24; children's films, 166; films directed at Universal, xiv, 41, 92; post-directing years, 184, 185; self-direction, 166

Stowell, William, 155, 165

Straight Shooting (Ford), 84–85, 86

Stranger from Somewhere (Worthington), 139

The Strength of the Weak (Henderson), 140, 141

Studio Directory, 31

studio hierarchy, 100

Swanson, William, 11, 29

tag-lines, 156

The Target (Red Feather), 106

Thalberg, Irving, 31, 32, 171, 184

"the ranch." *See* Universal City

Tinée, Mae, 183

The Traitor (Weber, Smalley), 131

Trans-Atlantic Film Company, 13, 14

Trey o' Hearts (Lucas, Meredyth), 112, 114, 116, 119, 177

Turner, Otis, 23

Under the Crescent, 113

Undine, 73, 131–32

Universal: accounting department role, 34, 37–38; bicoastal hierarchy, 7–8; brands, 6–7, 12–19, 22–23, 196–97n41, 197n42; central booking office, 16; company concept, 23–24; competition, xvi, xvii; consolidation of business and brands, 20–24; contradictions in perception of women directors, 91–92; corporate aims, 2–3; cross-dressing films, 62; director role and function, 198n11; division of labor, 6–7; East Coast v. West Coast organizational relationship, xvi, 30; elections, 50–52; feature-film dramas, xv, xvi, 128–29; film formats, 14; film genre shift, 91–92, 156; founding merger, 11; gendered labor divisions, 180–81, 201n44; gender role portrayal as unstable and contingent, 61–62; genre distinctions, 23–24; genre v. star system, 106–9; hierarchies and informal relationships, 34–36; home and workplace separation, 180–81; incorporation, 10–11; as institution, 3–6; international distribution, 13, 15t; laboratory facilities, 21, 72; management power struggles, 20; name, 1–2, 6–7; New York offices, 56–57, 70; organizational power volatility, 25; practical challenges, 20; production budgets, 41–42; production volume, 16; property disputes, 20; relationship between division of moviemaking labor and film type, 169–70; release and distribution economics, 15–18, 21, 195n22, 196n29; scenario department, 72; serials, 6–7; short film statistics, 14–15, 195n20; standard costing, 41–42; star system v. genre, 106–9; stockholders, 198n9; subsidiary brands, 11–12, 13, 15t; trademark, 1, *2*; as umbrella for numerous brands and film types, 12; vertical integration, xviii; volatility of management and power, 28–32; volume of films produced, 63; West Coast v. East Coast facilities, 56–59; women directors, xiv, 24, 42–44, 184; women's features, 156–68; World War impact, 87; worldwide expansion, 2

impact, 168–69; film genre association, xix–xx, 24; hiring decision and profitability of films, 139; Hollywood development, xv; institutional/organizational habits and practices, 184, 220n25; limitations on film genres, 95–96; male actor limitations, 95; meritocracy and women directors, 42–44; 1918–1919 film themes, 92–93; 1919 return to former occupation, 184; occupations leading to, 63–64; post-1919 directing, 184; relationship between women directing and women acting, 176–77; role in movement away from women directing, 171–72; statistics for 1918–1919, 92; "track record" impact on hiring, 109; Universal contradictions in perception, 91–92; women's features impact, 171

women's features: delineation by Universal, 164–65; elements, 155–56; female psychology, 154; sexual aspects, 155; sexual double standards and social messages, 154, 159–60; themes and subjects, xix–xx, 158–69; Universal directors associated, 129; Universal film grouping and typing, 156. *See also* "women's" movie themes
"women's" movie themes, 94–95. *See also* women's features
women's suffrage, xviii, xxii
The Women Who Would Not Pay (Baldwin), 143
World War I, xviii, 87
Worthington, William, 139

Mark Garrett Cooper is an associate professor of English and film and media studies and the director of the Moving Image Research Collections at the University of South Carolina. He is the author of *Love Rules: Silent Hollywood and the Managerial Class.*

Women and Film History International

The University of Illinois Press
is a founding member of the
Association of American University Presses.

. .

University of Illinois Press
1325 South Oak Street
Champaign, IL 61820-6903
www.press.uillinois.edu